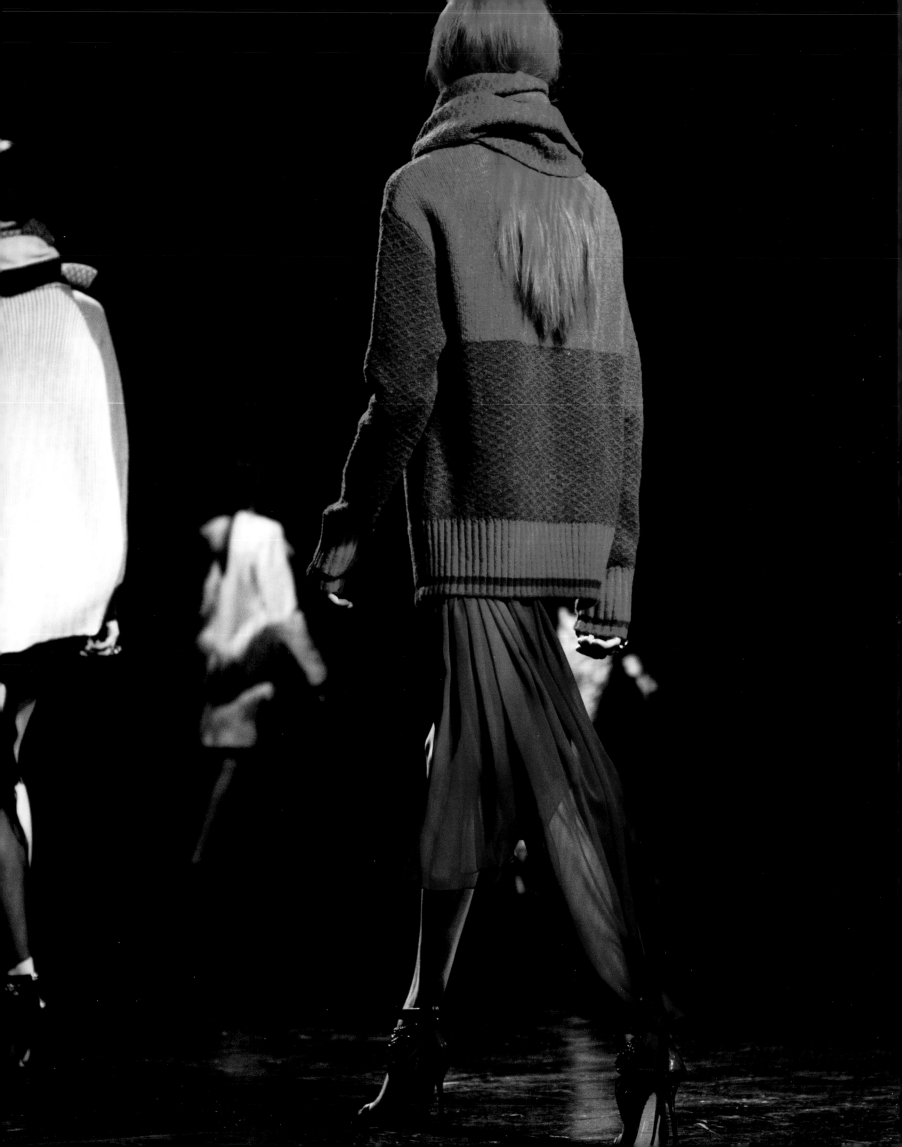

PRABAL GURUNG

Foreword by Sarah Jessica Parker

Conversation with Hanya Yanagihara

Abrams, New York

To my mother, Durga Rana, who always
made sure I had the correct shade of lipstick

Contents

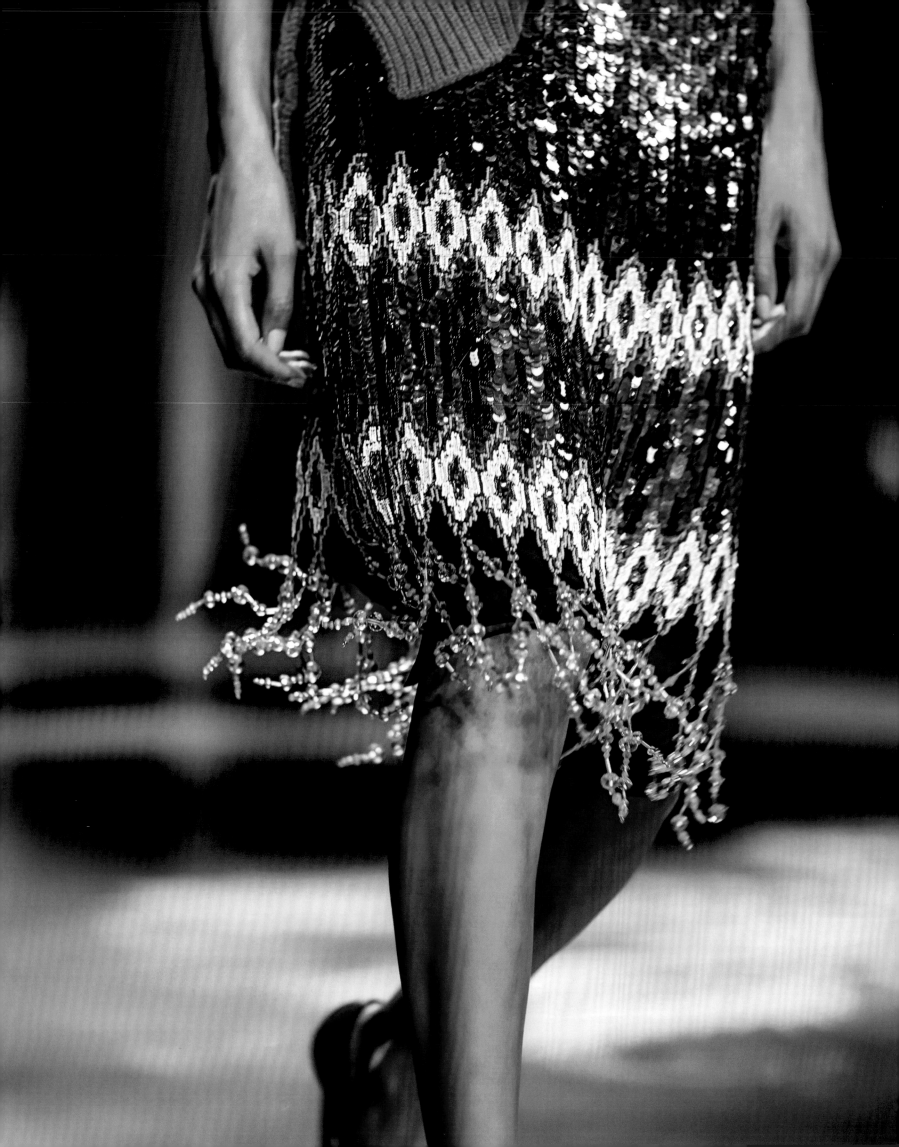

Foreword

by Sarah Jessica Parker

Almost everybody has had a moment in their life when they were getting ready for a special occasion, a secret rendezvous, an assignation, a wedding, an important job interview, simply an evening out, or celebrating a friend. In those moments, those solitary moments, you are often working toward a destination—your dress. Some might consider the dress their armor, others a more modest shell. For some it really is a protective covering, necessary for cultural or religious reasons, or tells the story of the person you are aiming to be. Pieces of cloth are married by design, effort, and inspiration that very personally communicate who you are and what you want to convey to others about the significance of the occasion. Or perhaps, more importantly, what you feel. It's the last thing you put on only when ready, prepared. It's the period at the end of the sentence.

Imagining this magical moment is at the heart of how Prabal Gurung designs. A woman is in her bathroom, or in front of a mirror, putting on her makeup or deciding on the ensemble in completion and the Prabal Gurung dress is hanging there. It waits for you to make it live. To speak without words.

As a young boy in Nepal, Prabal watched his mother go through this routine—washing her face, doing her eyebrows, accentuating her eyes with color, then her lips, and finally, transforming herself with a sari. She might have put her lipstick on first one time, then last another, but there was a ritual to it for her: things slowed down for a second. In that moment, as he witnessed his mother's quiet process, he felt in suspended animation. And forever as a designer recalled and called upon that quiet time, as his mother's audience.

Not everyone thinks this way—placing women at the center of their design process—and this is one of the many reasons why I love Prabal the person and Prabal the designer. You see the women who have been influential in his life woven into his clothing—the color of his mother's beloved Yves Saint Laurent perfume bottle reflected in a stunning evening gown, Gloria Steinem's powerful words embroidered on a dress, the vivid pink saris of India's female activist group the Gulabi Gang referenced throughout a collection. And always, the women of Nepal, wearing the most beautiful fabric that is rich in life and color. It is alive. It is speaking. It extends itself beyond the fortunate woman wearing the dress reaching out with its colors, intricate designs, and graceful, sweeping movement.

In a short but labor intensive and diligent ten years, Prabal has accomplished what so many young and emerging designers long for. A reputation wrapped in goodwill, great affection, and endless admiration from colleagues, fellow designers, and his customers. Despite the cautionary tales, he launched a brand at the beginning of a recession and went on to become much more than a designer. Prabal is a social activist. He has used his voice for good in the world—speaking out on diversity, women's rights, and body positivity—and embedded meaning into each of his pieces. He has created not just any brand, but a luxury brand with a soul.

Prabal's clothes, very simply, help you feel good about yourself, and they also bring joy. They give you power and confidence, so that when you reach your destination—your dress—you can step into it, go out the door, and feel like you. That is the power of fashion, that is the power of style.

And Prabal's great achievement.

Introduction

by Prabal Gurung

Sometimes my existence feels like a dream: surreal, poetic, a figment of my greatest fantasies. I was just a boy in Nepal, a misfit who was constantly bullied and harassed, who somehow managed to escape from that tormented existence to an alternate reality—perhaps for sheer survival—by my sketches. Dresses, shoes, jewelry, ball gowns, and beautiful faces all came to life on the pages of my notebook in the back of my all-boys school classroom. All in an effort to create a more kind and beautiful reality, to find my own special place under the sun.

Despite the tribulations that came with being different from the other boys, my childhood memories of Nepal and India are mostly idyllic. The raw, vivid landscapes, traditional art and architecture, rich history and culture, and, above all, the heroic single mother who raised me, accepted me, and encouraged me to embrace what makes me unique have all inspired me to see the world through a vibrant and colorful lens.

I grew up watching melodramatic Bollywood films and old Hollywood movies and reading classic English novels. I was always captivated by the grandeur and theatrics so fearlessly integrated into the stories. These stories—analyzed, dissected, and savored with my siblings over countless cups of tea from the early misty dawn until the skies turned blush at dusk—enabled me to dream the most impossible dreams, to feel that it was all within reach. My restless existence as a child eventually took me on a dizzying journey from Singapore to Nepal and India, with a few later stops in Australia and England. I gained invaluable experience, perspective, and connections, but none of those felt like quite the right place to establish my career and fulfill my grandest hopes and dreams.

When I finally came to America to study at Parsons, I knew no one and I knew nothing but my own yearning to experience New York, with its amalgamation of cultures, the glory and the grit of its streets, and the opportunity to pave my own destiny. From afar, I had witnessed the careers and lives of greats such as Patti Smith, Madonna, Debbie Harry, Andy Warhol, and Jean-Michel Basquiat, among countless other creative geniuses. They were some of the fearless, tried-and-true artists who were making a mark on the fabric of the city. I was so enthralled by the way New York was a place for nonconformists to rise and become empowered as celebrated trailblazers impacting the culture. It was New York—a city of misfits—where I had finally found the perfect place to fit in, by standing out.

New York captured my heart, but Nepal and India, where I was raised, will always have my soul. Growing up in South Asia and having traveled extensively have informed my perspective and understanding of the world; that is a defining part of who I have become—a citizen of the world—and is apparent throughout my designs. After my education at Parsons, my experience at Donna Karan and Cynthia Rowley gave me insights into the business of fashion. My time as design director at Bill Blass enabled me to appreciate the intricacies of the craft and to develop couture ideals that would eventually shape my own brand—a luxury brand with a soul.

I launched my own label amid the 2009 recession, against the advice of nearly everyone around me. I collected unemployment, downsized my apartment, and went on more dates than I could count, just to get a meal. From

the humble beginnings in my East Village studio apartment–turned–showroom, to the red carpet, the Met Gala, and the White House, my decade-long journey has led me to where I am today.

From day one, with everything I do, I strive to think about my impact. We make the majority of our clothes in New York City to reduce the environmental footprint, using a high percentage of natural fibers. We work with international factories that follow environmental and ethical practices, and we strive to have an international workforce that is made up primarily of women.

Further, due to my deep belief in the power of education, I started my foundation, Shikshya Foundation Nepal, in 2011 with my siblings and friends. Our organization works to provide comprehensive education to children to create a critical mass of leaders who will be instrumental in turning Nepali society into one that is sentient, thinking, questioning, just, and equitable. Since we launched, we have been able to provide education to more than three hundred children and have impacted more than fifteen thousand lives through both our relief efforts after the 2015 earthquake and programming with our partner agencies that gives women the opportunity to rebuild their futures.

Education has been a priority for me because it creates opportunities. While I had the privilege to go to one of the best schools in Nepal at the time, it wasn't without challenges. "You walk like a girl" was one of the most common insults hurled at me when I was young. Even though it hurt me deeply at the time, it is a phrase that empowers me today. The concept of "walking like a girl" has allowed me to celebrate every type of person, whether it's the models on our runway, the incredibly talented creatives on the red carpet, activists marching for their rights, or the everyday heroines and heroes who brave the pavement of their own towns and cities. It has become a powerful mantra, a celebration of feminine power, an acceptance of vulnerability, and an inspiring reminder to myself to resist with love.

The world I want to live in is full of hope and color. An inclusive, diverse, and representative world where all people have a seat at the table. It is a celebration of all races, ages, shapes, sizes, gender identities, and sexual orientations. I am so full of hope when I see the strength, action, and compassion of our next generation, and I cannot wait to see the world become a beautiful, flourishing place for everyone, not just a privileged few. With those ideals in mind, I wanted to share the story of my first ten years as an expression of my deepest gratitude to everyone who has helped shape my worldview and the ethos of my brand.

I believe that our world will become a more compassionate and just place with more women and minorities in power and with more men who embrace their feminine energy. Let us come together, uniquely different, with bravery, compassion, heart, and soul, because when we act in solidarity and lift up one another, we have the power to make the world a more beautiful place, which I truly believe is stronger in color.

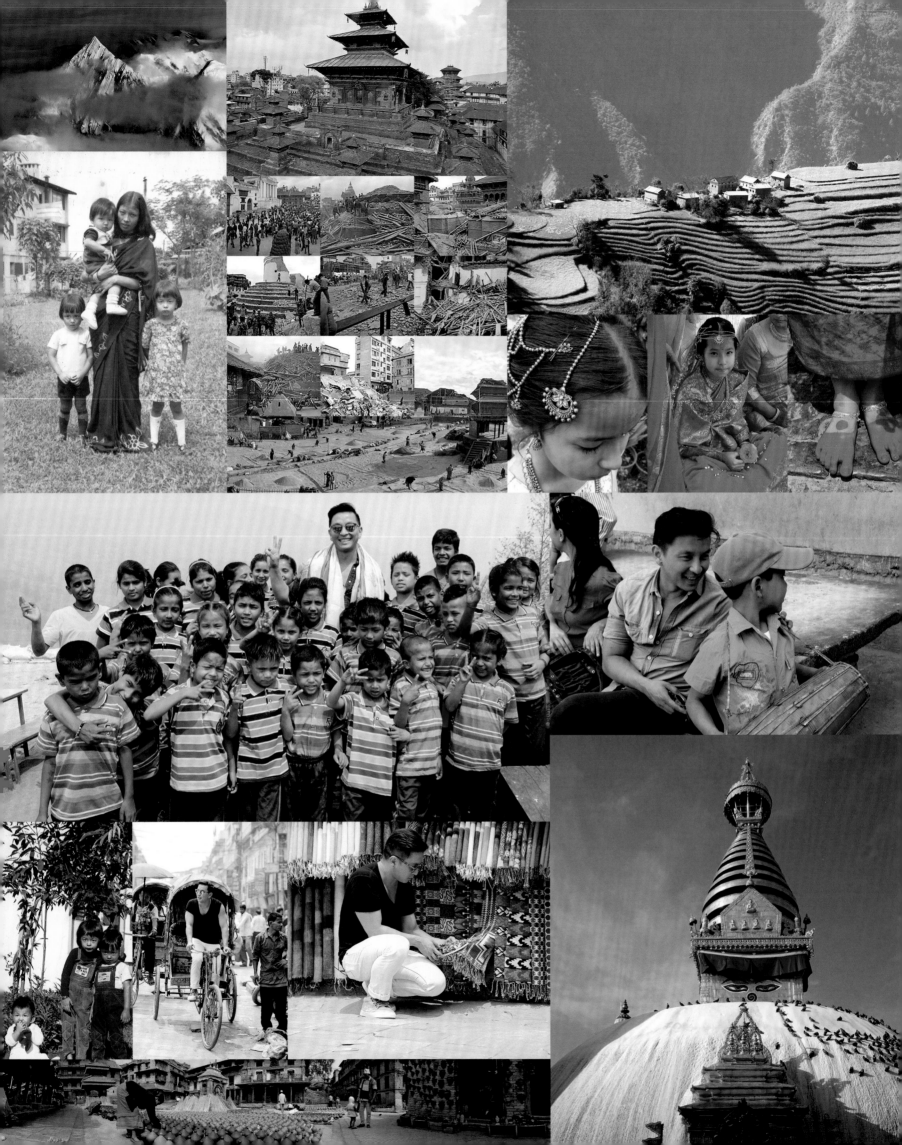

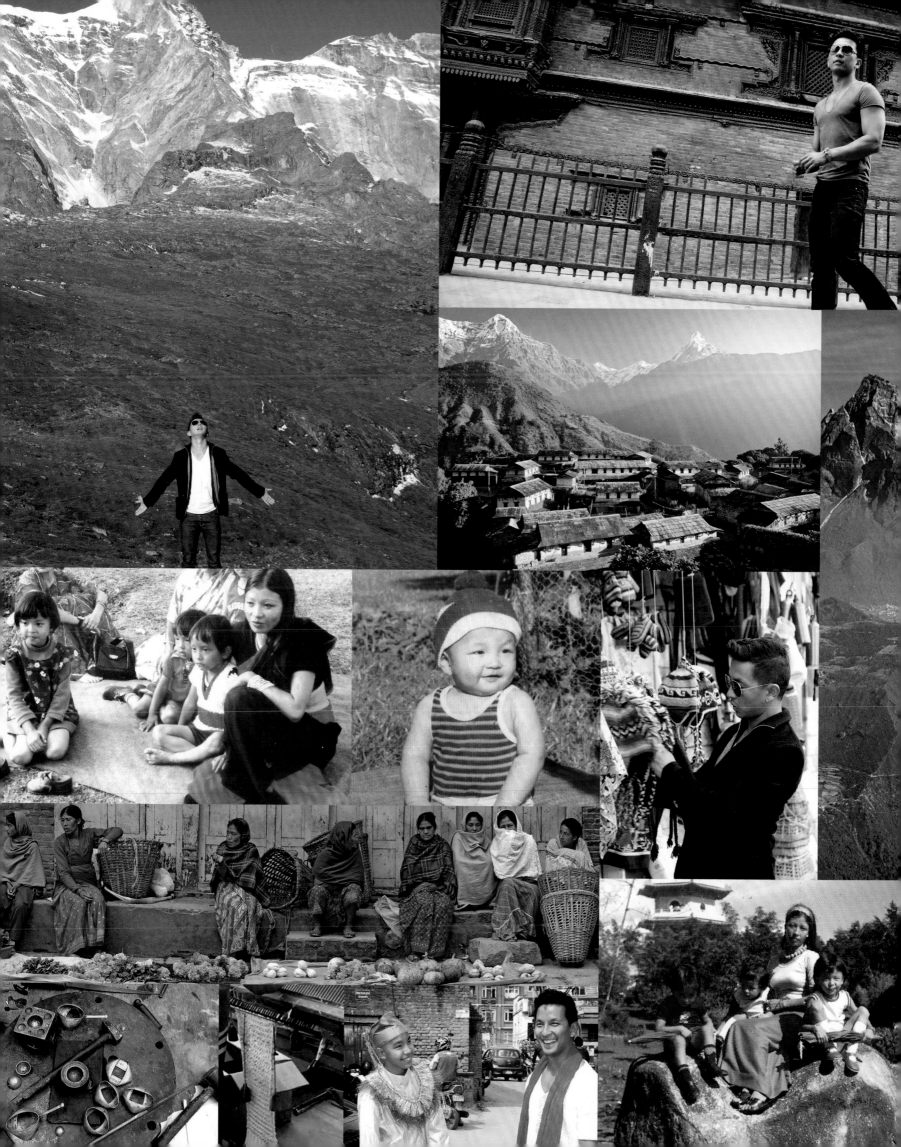

"I Needed to Change the Narrative"

A Conversation with Prabal Gurung
by Hanya Yanagihara

Hanya Yanagihara: Let's start with the woman: When you custom make a dress for her, how much do you feel you are leading a client toward a certain aesthetic, and how much is she pushing back? How much of a push-and-pull do you like in that relationship?

Prabal Gurung: I've never been afraid of conflict, confrontation, and you know, this kind of tension. Perhaps I grew up that way, so it's a familiar feeling. I also know for a fact that when you have that, you often reach a solution that's quite powerful. So I don't mind it—the push-and-pull. When it gets tough is when there are unrealistic demands.

You want to make sure that the woman who's wearing the dress is expressing her sense of style. And at the same time, I also want to stick to what I do, and so for me it is time to really go free, with things that I want. It's not just, "Oh, the bride is all about floral and princesses."

HY: Talk to me about Prabal Gurung Atelier. When and why did it begin, and how closely do you follow couture practices?

PG: Ever since we started, we had a private client business, and that's grown over time. And we make these one-of-a-kind gowns and stuff for them all the time. Last year we had an opportunity to dress a table at the Met Gala. We're talking eight women of diverse backgrounds, in different shapes and sizes, and I wanted it to be a true celebration. I thought it was an opportunity to celebrate these women and what I stand for.

So we launched Atelier probably around there. You know, my training was with an American couture-level house: Bill Blass. That's where I worked with seamstresses that had worked at Ungaro, Lacroix, Chanel, Oscar de la Renta, Yves Saint Laurent, Valentino. We had sixteen seamstresses, and all the tailors were from Armani, Ferragamo—these Italian tailors. That was my training for five years. And I worked really closely with them. Whatever I learned from school I had to unlearn. I had to truly understand that in order to get a perfect bias-cut dress, you cut it, and then you have to hang it: That's the only way it falls right. There, they did things the way couture used to be: first the piece was hand-basted, and then you'd try it on, and then it was taken back, and then it was sewn. Making one dress would take weeks. And that was my training.

HY: When you think about the women you like to dress, who you feel wear your clothes most beautifully, do they all speak of a single quality that they want to project?

PG: I always say there's an idea of "femininity with a bite." She wants to look feminine, but she doesn't want to look overly girly.

She doesn't come to me for streetwear. She comes to me for color. For texture. And for . . . I always say it's the idea of a celebration of a woman in her fullest feminine glory. Sensual. She doesn't come to me because she wants to look overly sexy. The overarching thing among them I've heard is: "I just felt beautiful and I also felt so powerful."

HY: Let's talk about your ready-to-wear collection. Has there ever been a time when you see a piece you *thought* you knew on a particular woman and you realize, "Wow, she totally transformed the meaning of it"?

PG: It happens all the time. Cate Blanchett, you know: you look at her in something and say, "Oh my god, she's given it a new life." The dress becomes—I wouldn't say *cooler*, but … it has more substance.

HY: It has more authority to it.

PG: Yeah, yeah. That's the word. And that's what I find powerful. It's really, truly inspiring to see that: for a woman to be taken seriously without having to tone down her femininity.

When I was at Bill Blass [in 2003–2008], women who cared about fashion—you'd think, oh she must not be that bright.

HY: When do you think that changed and why?

PG: Intelligence and style were never things I thought of as mutually exclusive. I grew up with a mother who had impeccable style, who was smart, a single mother, who ran her own business. And my sister was like that, too. And growing up in Nepal and India, I would see women in full jewelry and everything, running the household or in offices. I never thought it was one way or the other.

When I came here in 1999, the fashion industry was so set in its ways: The woman needed to be a certain size, certain race, certain look, for it to be considered high fashion. I always thought, "Really? It doesn't have to be that way." I've been so blessed that I've been able to travel all across the world before I came here. I saw Asian women, hijabi women, Muslim women, Indian women, all in positions of power and still looking fabulous. It was just here, in the West, where fashion was equated with frivolity. And then, about five years ago, it started to change.

HY: And why do you think that was?

PG: There are a few factors. I would say one is the digital age. Because of social media, all of a sudden we have—as much as we may dislike or like it—the influencers. We used to snicker at some of them, but then they became entrepreneurs. That was one shift.

The other shift was that the world had its awakening about women being in positions of power. All of a sudden, even in fashion publications, there were more women of a certain age, certain experience, in leadership positions. They had their own sense of style, own sense of fashion.

One person who particularly changed things was Chimamanda Ngozi Adichie. An amazing writer, an activist—and yet she loves fashion. She was one of those icons who kind of shifted things. As was Michelle Obama. Here was a woman, a first lady, who was no longer willing to act just like an old first lady. She was going to stake her claim, gracefully, and support designers, care about fashion—where it's made, how it's made, who is the person behind it—and bring it to the forefront.

HY: What's more thrilling: to see a woman on the red carpet or a woman who's a public figure wearing your clothes…or someone walking up Eighth Avenue? And can you remember the first time that happened, when you saw someone in the wild, just a New York woman, wearing your clothes? Did you talk to her?

PG: I didn't, because believe it or not, I was too shy to go over. But I will say this. For me, I'm grateful for all the moments with heads of states, celebrities, everyone—that's why I'm where I am today—but *this* woman who I don't know, who decides to spend her money, her hard-earned money, on my stuff, and wear it so proudly…that is a true, true, true moment of gratitude for me.

HY: Well, it's so intimate, right? Something that began as a sketch in your office ends with someone wearing it on her body. I can't think of a more intimate connection.

PG: One hundred percent. I always imagine this: You're in the bathroom, you're putting on makeup, and you're listening to music, maybe you have a glass of champagne, whatever, and you're drinking and you're getting dolled up and everything, and the last thing you put on is the dress. And I always imagine she's doing that and the dress is hanging there, you know, and it is the moment I feel really privileged—that somehow, through my clothes, I'm able to be a part of this intimate moment with her. And I find it quite poetic, lyrical, magical, because it is something I saw when my mom was getting ready. I would always watch her, and she was so in the world, and everything felt quiet. I felt like, "I get it. I get you. This is your moment."

HY: Well, in a very real way you were watching her put on her armor and get ready to face the world.

PG: One hundred percent. Women get judged constantly. Whether you're walking down the street, whether you're on the red carpet, whether you're just taking the subway, people are always looking at and scrutinizing you. Hair, jewelry, clothes—the world feels very free to comment on a woman's appearance. So in some way, if I'm able to give her some kind of support, just a tiny bit of support—well, that's what my job is supposed to be.

HY: Let's rewind a little bit. You're from Kathmandu and you went to boarding school in Delhi. At what point did you realize this was a career?

PG: I was born in Singapore, and when I was there, I used to play with paper dolls. At that time, I didn't know what fashion was, but I knew something was there.

Then we went to Nepal and I went to an all-boys' Catholic school, and that's where I realized how different I was—because I was constantly told I was different. I was bullied constantly. Sketching became a way of finding some peace. And there was this one teacher, her name was Michelle Monnin, an American. She used to wear this beautiful yellow cotton dress. I remember I was completely transfixed, transformed. Then when I went to India—boarding school, high school—and there were a bunch of designers starting out. There was an industry that was happening, you know? That's when I got curious: *This is a career?* And that's when I started studying fashion.

Then, in the late '90s, I started working with an Indian designer called Manish Arora. He was working with another designer called Rohit Bal and he was about to launch his own collection. And I was part of his first collection, and it was the most fabulous time. I learned a lot there. Around that time I was traveling a lot, and I remember one night I was walking through London and I turned a corner and I walked up to a window with this beautiful, beautiful ivory chiffon dress—it was a Chanel boutique. I was just transfixed by the dress. And I stood there for the longest period of time, thinking, "Should I take this leap of faith?" and I went back home to Nepal.

You know, when we grew up, we weren't allowed to watch too much television. We had to read books or watch classic movies or something. I remember going back home and turning on the television and *Phil Donahue* came on, and I didn't know who he was, and right after that was *Oprah*. And I still had zero idea who she was. But, for me, whatever little television I had seen, I had never seen anyone like her on television. The first episode was about living your dreams, fulfilling your dreams, and after the third episode, on the third day, I turned to my sister— who I'm really close to—and said, "You know what, I want to give it a shot in New York, I want to give it a shot in America." I'd never been to America, but I wanted to apply to Parsons, to see if I could get through it, and if it turns out to be a mistake, it's my mistake, you know? But I could never live with myself if I never tried.

HY: You were nineteen or so?

PG: Yeah. By that time, I was in my twenties. I came to New York, knowing no one, and got to Parsons and I still remember thinking… you read about the American Dream, and I was like, "Could it be possible for me? Do you think I could?" I also came out around that time. I had come out a couple of years ago, but I wanted to live my true self. I wanted to, you know, sleep around. I wanted to be the gayest I could be and be my true authentic self, so New York seemed like the place. I remember getting out of JFK and getting the taxi and coming through the Midtown Tunnel, and it was dark and we came out and I saw the buildings, and I knew I was home. And it's been twenty years that I've lived here. And I knew I was home because I knew that I was going to live in the East Village because it was gritty. It was what I needed. I always say that New York City is the city of misfits, you know.

HY: Yes, right. I agree.

PG: And I was. And I found home. I found people like me.

HY: I always say that New York is a city for people on the run, whether it's from something or to something, and full of people who're looking for their tribe. They can find it here.

PG: Yes, yes, it's true.

HY: And it's still like that.

PG: It is.

HY: You know, when I started at this job [as editor in chief of *T Magazine*], two years ago, I was shocked by the gap between the perceived glamour of what it is to be a fashion designer and the reality.

PG: *(laughs)* Yes.

HY: You're a successful young American designer, and you work all the time. It never ends. It's like having a restaurant.

PG: You couldn't have said it better.

HY: Which is a horrible job. *(laughs)*

PG: You look at all these amazing restaurants and everything and you think they're making a gazillion dollars, and they're not. It's glamorous, the idea of eating, dining, wining, and all that. It's the same thing with fashion. You do it because you're passionate about it.

HY: How difficult is the performative aspect for you? You've been doing this for ten years now, and you go out, you're photographed a lot, and you're very social—and yet you're also not. I've visited you at home and know there are parts of your life that you keep private. At what point did you really decide, "I'm going to keep these aspects of my life separate," and at what point did you feel you developed into your public face: Prabal Gurung, Designer?

PG: You know, I'm social and an extrovert, and when I go out to these events I like to talk to people because I'm curious. I like meeting people, I like to know stories. But there's this other side of me, which you've been privy to, which is very private and that is something that is very important for me to nurture.

HY: And I feel you've drawn hard lines.

PG: You have to. When I started my collection, when I ran with it, people were always trying to put me in a box. But I was unwilling to do that, simply because I'm not one person. I'm the sum of a lot of things. I am a designer. I love fashion. At the same time I care about what happens culturally, politically, around the world and here. I am a philanthropist with my foundation back in Nepal. I am also a sexual being who loves and desires. I am the sum of all of that.

HY: A book editor I know once told me: "You'll always have to make artistic compromises, but you should never have to make concessions." Have you ever walked away from a deal because you thought "I can't make that artistic concession"?

PG: Yes. You know, there was this one particular deal that was coming my way and it seemed like it would make me the next billionaire, the next Michael Kors, let's say. And everyone around me told me to do it. Every person in positions of power in the fashion industry, men and women, told me, "You're a fool to walk away from this." And

I did. Because instinctively, it didn't feel right. And I'm glad, looking back now, that I did. It was a hard decision to make, though. Mine is a completely self-financed independent company—we have zero outside investors.

HY: Really? That's extraordinary.

PG: Which means we have freedom. It also means we have massive cash flow issues, you know. You have all these problems and things to do. But it's taught me a real respect for hustle. And also, like, it really made me strong. Really made me resilient. Because when I launched my collection and all this attention started to come my way ... it was too much for me.

In hindsight, when I look back at what I went through in my school with all the bullying and everything, I'm glad I went through that, because I never got a validation from them, from anyone outside. I had to give myself the validation from day one. I had to tell myself, *you're enough.* And I learned to do that.

HY: When did you start believing it?

PG: Maybe in my twenties. I would go to gay bars and everything, and I didn't fit into people's idea of a muscular white gay. And I said to myself, "The world hasn't caught up to my worth." That's what I felt. It sounds arrogant. I would literally say, "Damn, I *am* beautiful." My siblings would always tease me, "You're so full of it."

And I'd say, "No, I love myself. I do. I genuinely love myself. And I can entertain myself. I think I'm my best friend." I always say that, you know. Because I get myself. And there's nothing that you can tell me about me that I don't know. Even my deepest, darkest flaws, I know it. And I'm willing to admit it.

HY: Let's talk about that: about the world catching up to you. When you did your collaboration with Lane Bryant in 2017, there was certainly some discussion about body positivity, but it wasn't as mainstream as it is now, just two years later. Did people tell you not to do the collaboration, and were you worried about that?

PG: I had a lot of private clients who were of different sizes. Even when I was at Bill Blass we used to have, like, women of different ages and sizes, and that was nothing alien to me. I grew up in a culture with skinny women, curvy women, all dressed up. In some way I guess I was immune to it. But working in fashion, where you're constantly dictated to, I remember doing casting during my first two seasons, when you're still unsure and listening to everyone, and people would be like, "Oh, two black models, two Asians, that's enough"—you know. It was that world.

Then a few years later, I was at a diversity panel, and it was me and a few other of the usual suspects, and we were talking about race and diversity and everything, and there was this one woman, a curvy woman, who raised her hand, and she goes, "You guys are talking about race diversity and everything, but what about size?" And this person, who was a leader in racial diversity, turned to her and said, "Oh, we'll get to you."

I sat there and looked at this woman, and the pain in her face, I'll never forget. I'll never forget that moment. I wanted to be like, "Oh honey, I want to talk to you." Then I was at a trunk show at Neiman Marcus Palm Beach.

This bunch of women, they came in trying on stuff, and all of a sudden, there's this one woman who kept on touching the clothes, and I said to her, "Listen, you should feel free; we do all different sizes," and she goes, "No, no, no, it's okay, it's okay, but I really love it," And right around that time I was thinking, how do I move fashion in a place where high-fashion designers don't go, and that was Lane Bryant. We had several conversations and what I said to them was, "I want to do this, but in the most elevated way. I want to shoot with Inez and Vinoodh, and I want a feature in *Vogue*. Not because a feature in *Vogue* is necessarily going to turn into sales, but because this woman deserves it. It's high time."

At that time, a lot of people were saying, "Are you sure, are you sure, are you sure?" because (a) it was mass market, and (b) it was plus size, which was the biggest stigma. And I was like, "I couldn't be *more* sure about something."

HY: You're one of the people who's really moved the needle. And yet do you think there'll ever be true size acceptance?

PG: I hope so. I am optimistic, but there's a lot of stigma attached to [being plus size], there's a lot of misinformation attached to it. You know, the minute you're of a certain size, you're unhealthy. But I grew up in a culture—it's maybe shifted now—where if you were thin, it wasn't good.

It used to be, in India and in Nepal, that if you were thin, you didn't have money. You didn't eat well. Whereas if you're big and plump, with a tummy, oh my god, you come from a well-to-do family.

HY: Let's talk about this other topic we've discussed: this assumption that, as Asians, we'll quietly step aside, that we won't demand our place at the table.

PG: Yes. When I first joined this fashion world, there were other Asian designers who I've since become really good friends with who used to say, "Oh my god, you tweet, you're so out there." I always get that: "You're so out there." And it's like, "Yeah, it's me. That's who I am." Because not every Asian needs to be submissive. It's also important for the world to see there are different kinds of Asians, you know. I needed to change the narrative.

HY: It's just too easy to maintain the status quo.

PG: It is. But as time went by, years went by, I got more power. I really understood: This is my story. This is *my* story. I'm the writer, I'm the narrator, and I need to be in control of it. For years, I was following what I was told was a good collection.

HY: So—is this the last stop for you? Or do you feel you might someday do something else altogether?

PG: No, this is not the last stop. At all. But this is what brings me absolute joy. So far.

This is something that has given me a platform and a medium and everything. In some way I hope I have helped change the narrative and direction on how a fashion designer looks, talks about things, you know. I know

that I have become, in a small way, a changer. My biggest fear growing up was to watch history pass me by, and not be a part of it. I was really scared of that. My sister had given me a book about different fashion designers back in Nepal, and I always said to her, "I just want one paragraph. When someone writes a book about designers, I just want one paragraph. I don't need a page, but I hope they remember." That's all I wanted to do. Now I have the privilege and access to a lot of people.

I want to continue doing this. I *love* what I do because . . . I don't need therapy, I just need a mannequin, a sketchpad, a couple of fabrics, some great music—and just me. And I'm happy. I'm happy. Happiness in its truest form is either that, or dancing to Bollywood music or singing Bollywood karaoke. But I do want to, one day, open a museum in Nepal.

HY: And show what kind of art, what kind of work?

PG: Different things. I want the museum to be a place where I'm able to house works from artists in Nepal, and juxtapose it with contemporary artists, and show that creativity is really kind of similar. The processes may be different and all, but there's so many connections there. I want that to be a center where art—fine arts, performing arts, any kind of art—has a home. Because in an underdeveloped country where the constant worry and need is about where to get the next meal, art is the first thing to be compromised.

And that's also what we're trying to do with the foundation my siblings and I started. We began by helping twelve girls, and now we're helping three hundred children. We've built shelters. We just started an initiative to educate female prisoners in Nepal. *That* is fulfilling. *That* I want to do even more. We run the foundation with zero overhead, a hundred percent goes to the students.

It has been the biggest joy. It has given me, in the darkest, most difficult times—a challenge. *That's* the reason why I wake up.

April 26, 2019
New York City

2009

MY REAL AMERICAN DREAM I launched my brand in February 2009, at which point I had lived in New York for ten years. I came here knowing no one and hustled—interning, assisting, and grabbing every opportunity I could to learn and immerse myself in the industry. I founded my brand amid the recession, and while so many people told me the timing was off, I knew in my heart this was my chance. I was crippled with fear, of course. It was a dark time for our country, but that provided me with an opportunity, a chance to get creative in order to overcome desperate times. For me, that was an absolute high. I had always dreamed of creating my own eponymous label. It was my "impossible dream," and 2009 felt like the time to take that leap of faith. Plus, I thought that the recession was a great excuse if I failed. I left my design director job at Bill Blass, the storied American couturier with a beautiful and rich heritage, to go off on my own. I went on unemployment, turned my studio apartment into an atelier and showroom, and to this day, never looked back.

Fall 2009 "A Thinking Man's Sex Symbol"

I was raised by a single mother. My mother continues to be the strongest, most intelligent, assured, and beautiful woman I know. She showed me that there is not a single definition of what it means to be a woman, an idea that I have forever been enamored by. I find such joy in celebrating the complex layers of a woman, and launched my brand on the idea of marrying style and substance, of connecting my home in the East with my experience in the West, of showing that what may seem like a dichotomy can coexist harmoniously. From day one, this has been my goal in launching my label.

I presented my first collection for Fall 2009 in February 2009. With the help from cherished friends and loved ones—including the incredible stylist Tina Laakkonen, who immediately dove in with support, and the seamstresses who I worked alongside in the Bill Blass Atelier—I put together our presentation at the FLAG Art Foundation in Chelsea. Growing up in Nepal, I always yearned for the glamour, the grit, and the pace of a place like New York. To launch my first collection, showing my vision to the fashion world, filled me with absolute humility, happiness, and pride. I shared my idea for the modern, glamorous, sharp, New York woman—a collection for the thinking man's sex symbol if you will. It was an ode to the confidence, the wit, the poise, the levity, and the love of our modern muse.

Using couture ideals learned during my time at Bill Blass, we celebrated the heritage of New York with our contemporary proposition. Luxe Taroni duchesse satin, double-face cashmeres, and hand-layered organza were shown in hues of cobalt, crimson, sand, and graphic black-and-white. These colors were inspired by the Newar community, a group with a rich history and strong roots in Nepal.

Our inaugural collection was a transcontinental journey, a juxtaposition of high glamour and exotic grit, and a story of my roots, my journey, and my homecoming—to a place where I may not have been born, but where I was given the ability to dream big and fulfill my destiny.

The morning after the Fall 2009 presentation, I woke up to find that I landed the cover of *Women's Wear Daily*, a moment that will forever bring me gratitude and excitement. The momentum continued to build, and in our first year, we dressed Oprah for the cover of her magazine, longtime friend Zoe Saldana for the premiere of *Star Trek*, and the inimitable and inspirational First Lady Michelle Obama. We even launched a Twitter account after Demi Moore tweeted about wearing one of our dresses. What a way to start a business. . . .

OPPOSITE: OUR BRANDING BOARDS, DEFINING WHO WE ARE, WHAT WE STAND FOR, AND THE WOMEN WHO INSPIRE. THESE ALSO SET THE TONE FOR THE INAUGURAL FALL 2009 COLLECTION.

FOLLOWING SPREAD: A LAUNCH IMAGE, PHOTOGRAPHED BY SEIJI FUJIMORI, FROM OUR INAUGURAL FALL 2009 COLLECTION. ONE OF OUR SIGNATURE LOOKS WAS THIS RUFFLE BLOUSE.

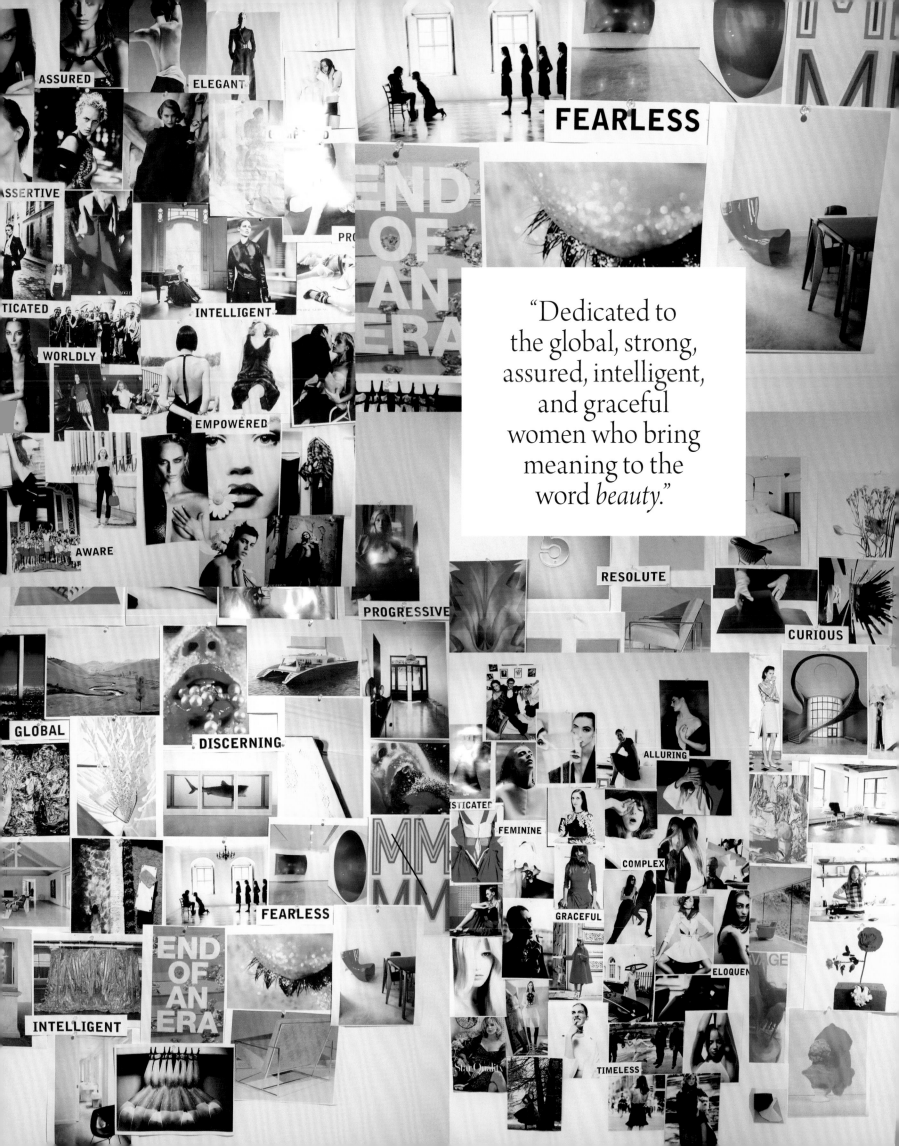

"Dedicated to the global, strong, assured, intelligent, and graceful women who bring meaning to the word *beauty*."

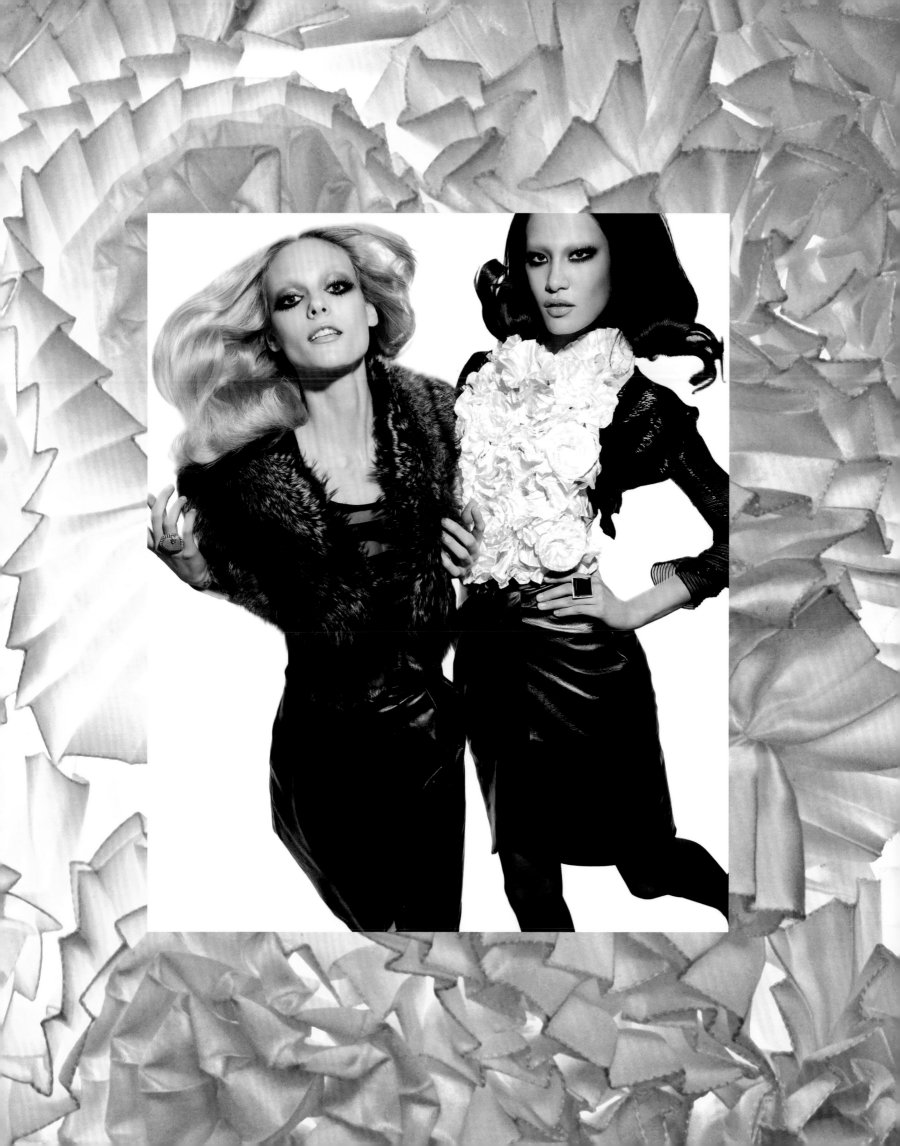

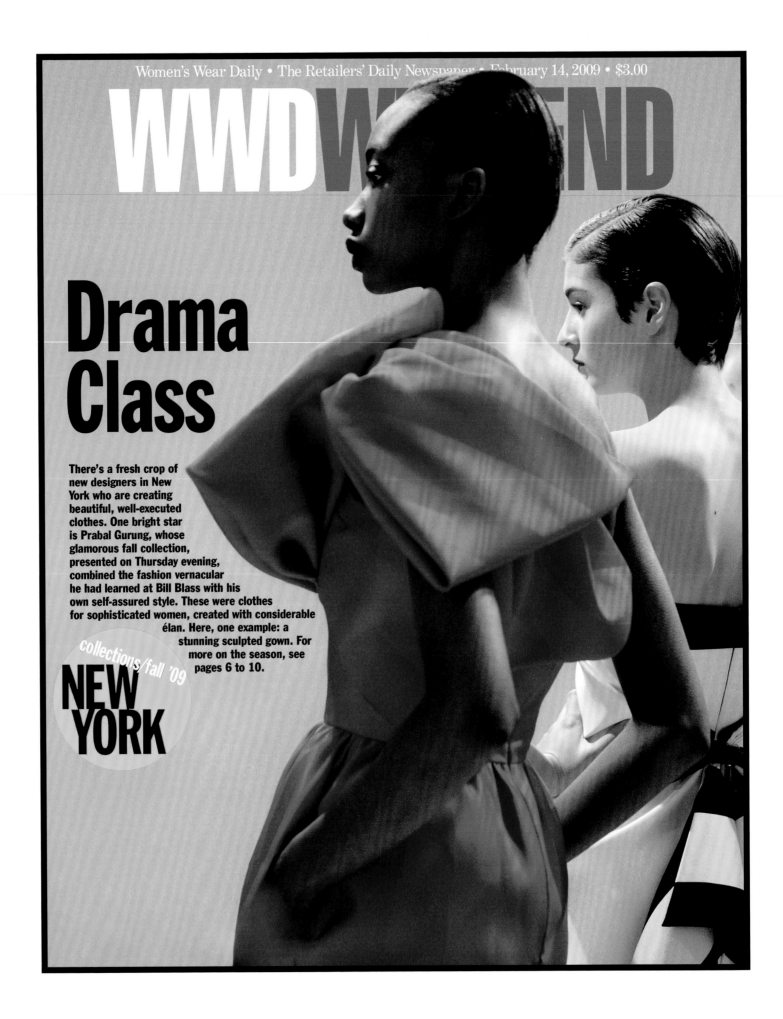

Women's Wear Daily • The Retailers' Daily Newspaper • February 14, 2009 • $3.00

WWD WEEKEND

Drama Class

There's a fresh crop of new designers in New York who are creating beautiful, well-executed clothes. One bright star is Prabal Gurung, whose glamorous fall collection, presented on Thursday evening, combined the fashion vernacular he had learned at Bill Blass with his own self-assured style. These were clothes for sophisticated women, created with considerable élan. Here, one example: a stunning sculpted gown. For more on the season, see pages 6 to 10.

collections/fall '09

NEW YORK

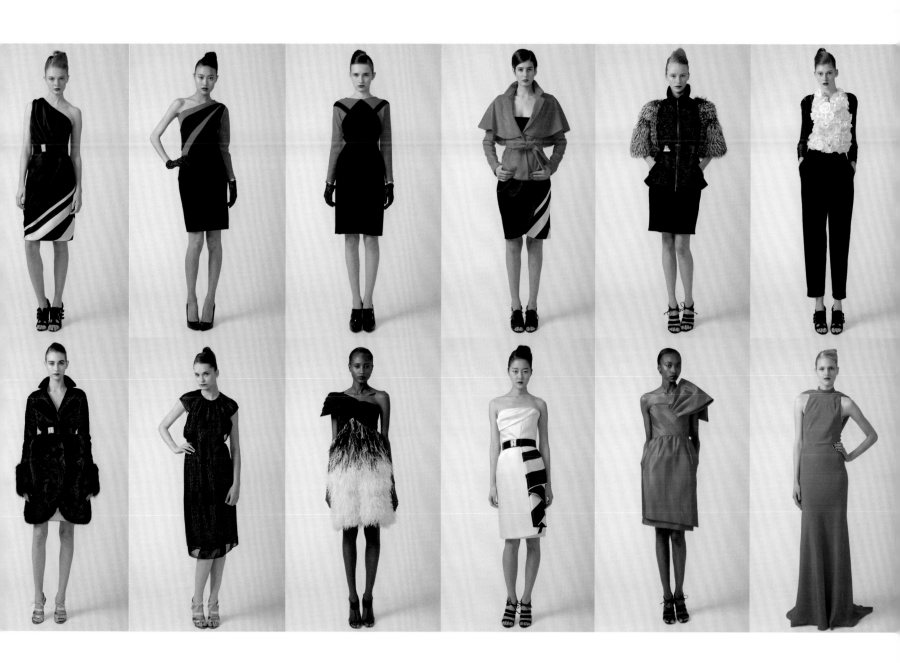

My Dream Come True

With help from cherished friends and loved ones, I put together my first presentation in February 2009 at the FLAG Art Foundation in Chelsea. My friends pitched in to cast the presentation, style the collection, model, and do hair and makeup. I knew some junior editors from my time at Bill Blass, so I invited them to come see the collection. They started calling their bosses—the senior editors and directors across renowned publications—and before I knew it, Cathy Horyn, Bridget Foley, Virginia Smith, and so many other esteemed editors showed up to see what we were doing. I woke up the next morning to find that I landed the cover of *WWD* (opposite).

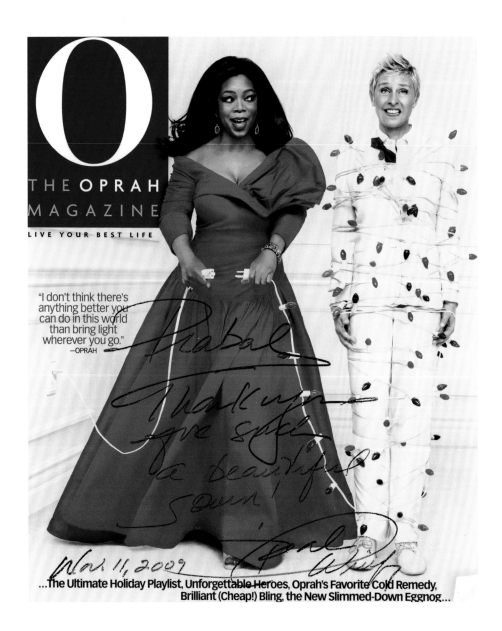

The Woman Who Brought Me Here

Oprah Winfrey has forever been a heroine for me. She is the woman who inspired me to move to America and live out my dreams after I first saw her on TV in Nepal. Fast-forward ten years, I was commissioned to make her a gown for the cover of her magazine. I remember flying to Chicago to meet her for our fitting. I started crying the moment I saw her. We took her dress back to New York, did final alterations, and literally ran it down the streets of Manhattan to make it in time for the cover shoot.

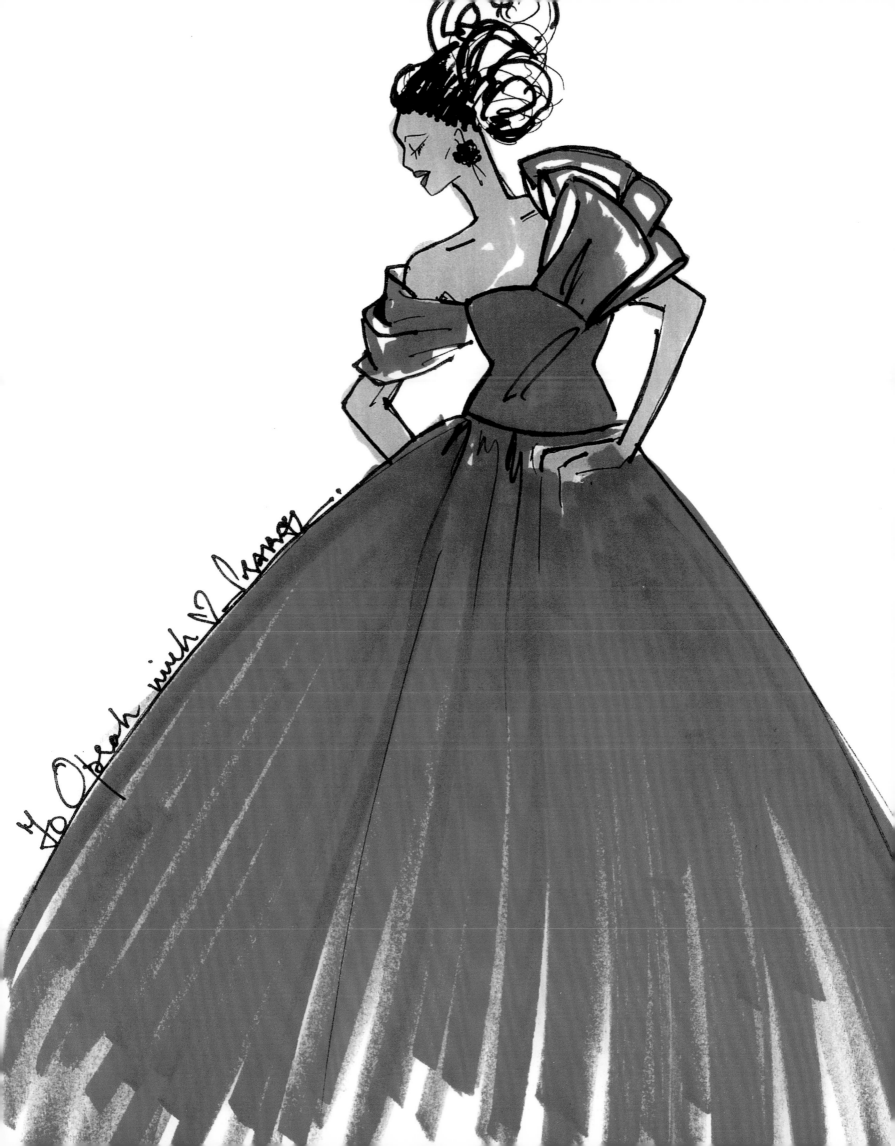

Spring 2010 "Nostalgia for the Future"

"In trying times, nostalgia returns." I read this sentence in a *New York Times* article months before designing my Spring 2010 collection, and it stayed with me. Living amid a tumultuous economic climate, the question of nostalgia, of longing for the past, reigned over my mind.

I was transported to my earliest memory of fashion in a dreamlike state. It was a vision of my strong, assured, beautiful mother sitting at her vanity, adorning herself and finishing with a spray of Yves Saint Laurent Rive Gauche perfume. This memory captures the essence of what piqued my interest in fashion and design. This memory was the beginning of my story.

Unearthing this moment, I so vividly recall how enamored I was with the Rive Gauche packaging as a young boy in Nepal. The bottle communicated an idea of glamour, of a certain lifestyle, a dream. It made me question the concept of packaging and who it is for. Is it for oneself? For society? A mirror on a life or a mere façade?

The women who lean into their femininity, who package themselves for the world with adoration and intention, are often pushed aside as frivolous by conventional society; those who disregard aesthetics are deemed substantive. My Spring 2010 collection was a melding of these worlds—clothing for a modern muse who celebrates her femininity as a powerful tool.

Drawing on the graphic lines and the striking cobalt hue of the Rive Gauche bottle, we incorporated luxe caramel double-faced charmeuse, brush-painted rose silk twill gazar, lightweight fabrics with an airy quality, and tropical wools against punctured patent. We looked to a future that would create a space with options for women, for two worlds to become one with strength and beauty.

This collection's point of inspiration still holds true: we reference our past, collage our memories, and find depth in our nostalgia, yet we forge a new perspective for a modern, optimistic future where beauty and substance live in unity.

OPPOSITE: A DETAIL SHOT FROM THE SPRING 2010 COLLECTION.
OUR HAND-DRAPED BOW DETAIL QUICKLY BECAME A BRAND SIGNATURE.

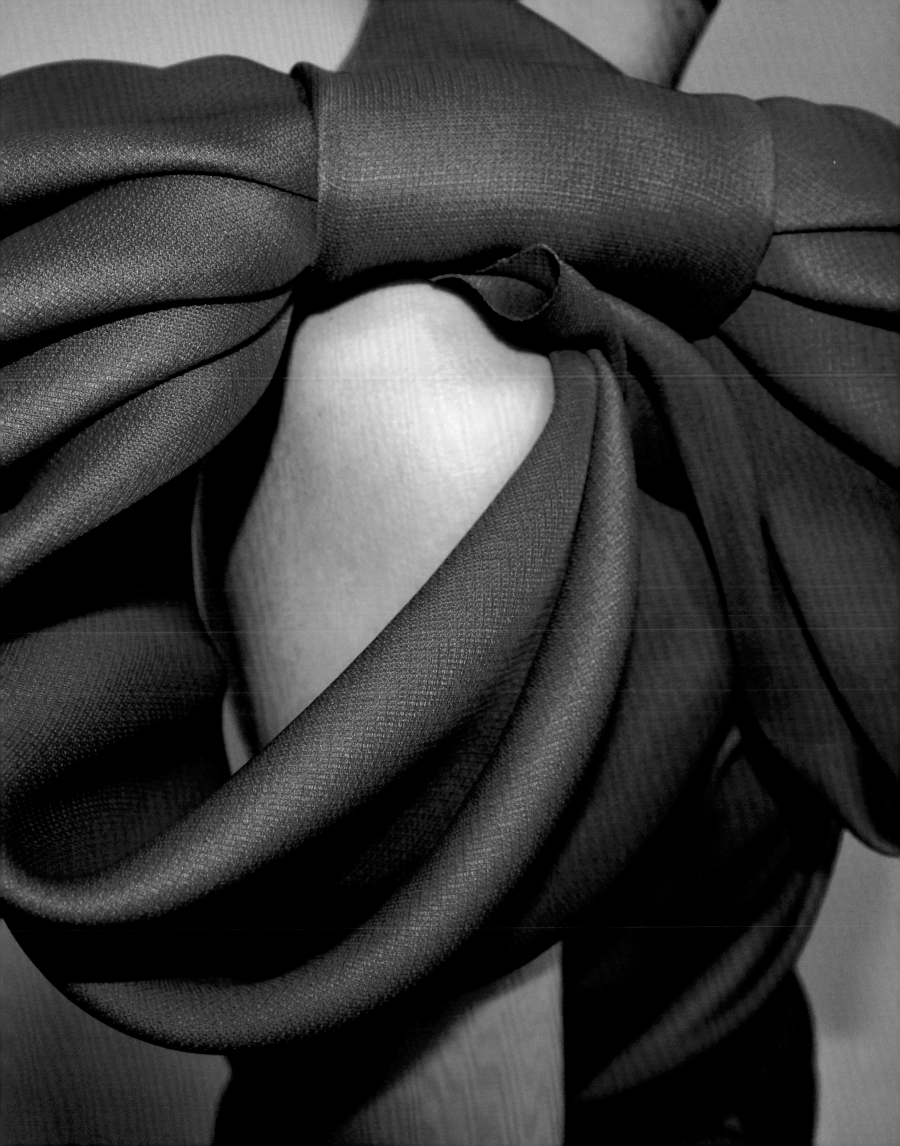

A SKETCH OF ONE OF THE SPRING 2010 LOOKS. THE COLLECTION WAS INSPIRED BY THE YVES SAINT
LAURENT RIVE GAUCHE PERFUME BOTTLE (ABOVE, RIGHT) THAT I WATCHED MY MOTHER USE.

My First Lady

I was asked to make a custom gown for our former first lady
Michelle Obama, which she wore at the White House Corre-
spondents' dinner. She is such an incredible woman—she is
poised, inspiring, responsible, striking, and so full of beauty,
substance, and soul. Dressing her was and continues to be an
absolute milestone in my career—one full of honor and joy.
When I first launched my brand, I started dressing celebrities,
and each time, I'd call my mother with excitement to tell her
the news. She'd always respond, "Call me when you dress the
first lady, Michelle Obama." I was so full of pride and happi-
ness when I was finally able to pick up the phone and deliver
that news. This time, she responded, "Now, you are not just a
designer. You are representing our country [Nepal]." Hearing
her words, I understood the global platform I was given and
the responsibility that came with it.

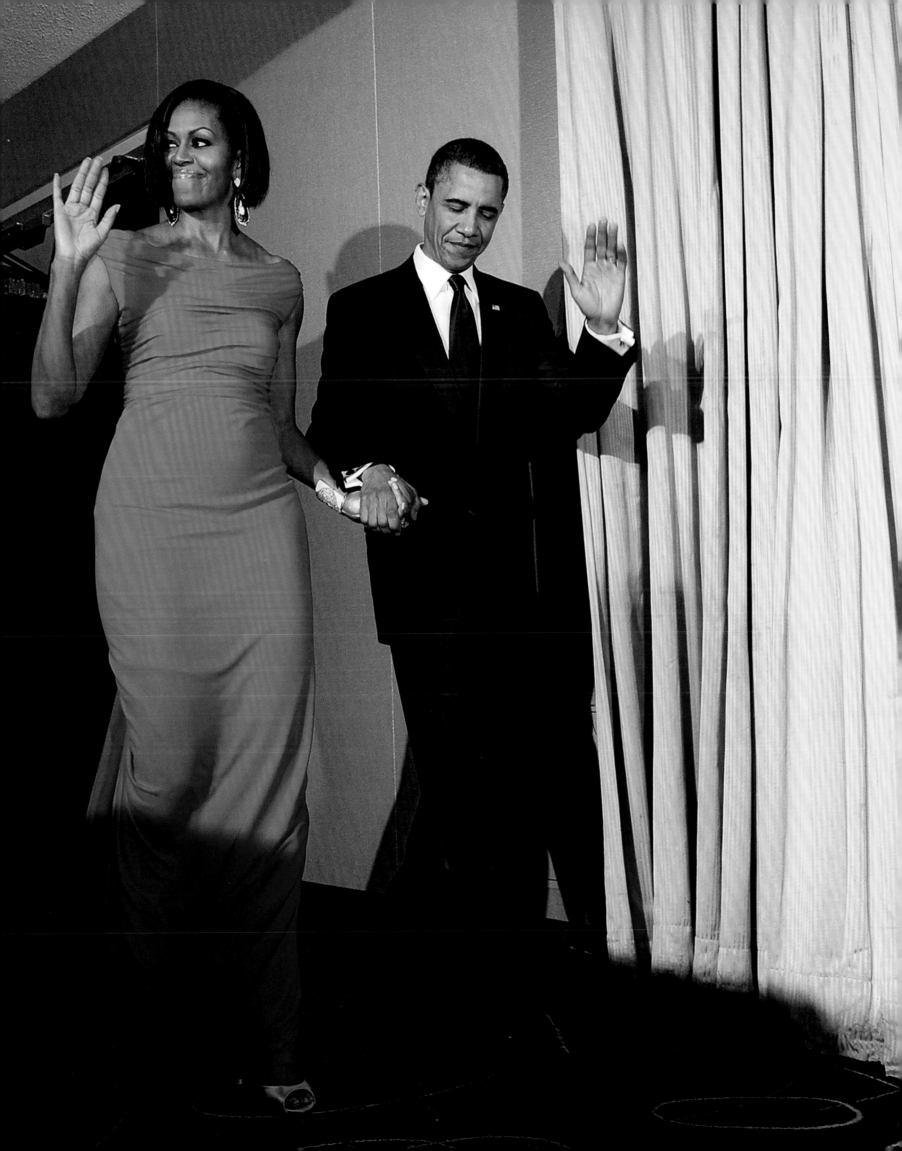

EDUCATION BY RUNWAY This year marked our first foray into runway shows. It was also the year I participated in the CFDA/Vogue Fashion Fund. While growing up and attending an all-boys school in Nepal, I'd sit in the back of my classroom and sketch. My dream has always been to build a luxury brand with a soul in New York—the glamour, pace, and spirit of the city invigorated me, and the melting pot culture always felt so welcoming coming from a place of tradition and convention. Fashion Week at Bryant Park symbolized all I hoped for. It had been my goal since I was young to be a part of it. I met the wonderful Fern Mallis, senior vice president of IMG and Fashion Week, at a party and told her of this dream. Showing at Bryant Park was far from what I, or any young designer, could afford; however, Fern said, "You got it." I am forever grateful to Fern for the platform she gave me and for the manner in which she made my dreams tangible. To see my collection on a runway for the first time ever—and to build a relationship with Anna Wintour and *Vogue*—truly felt like an achievement of all my hopes and dreams.

2010

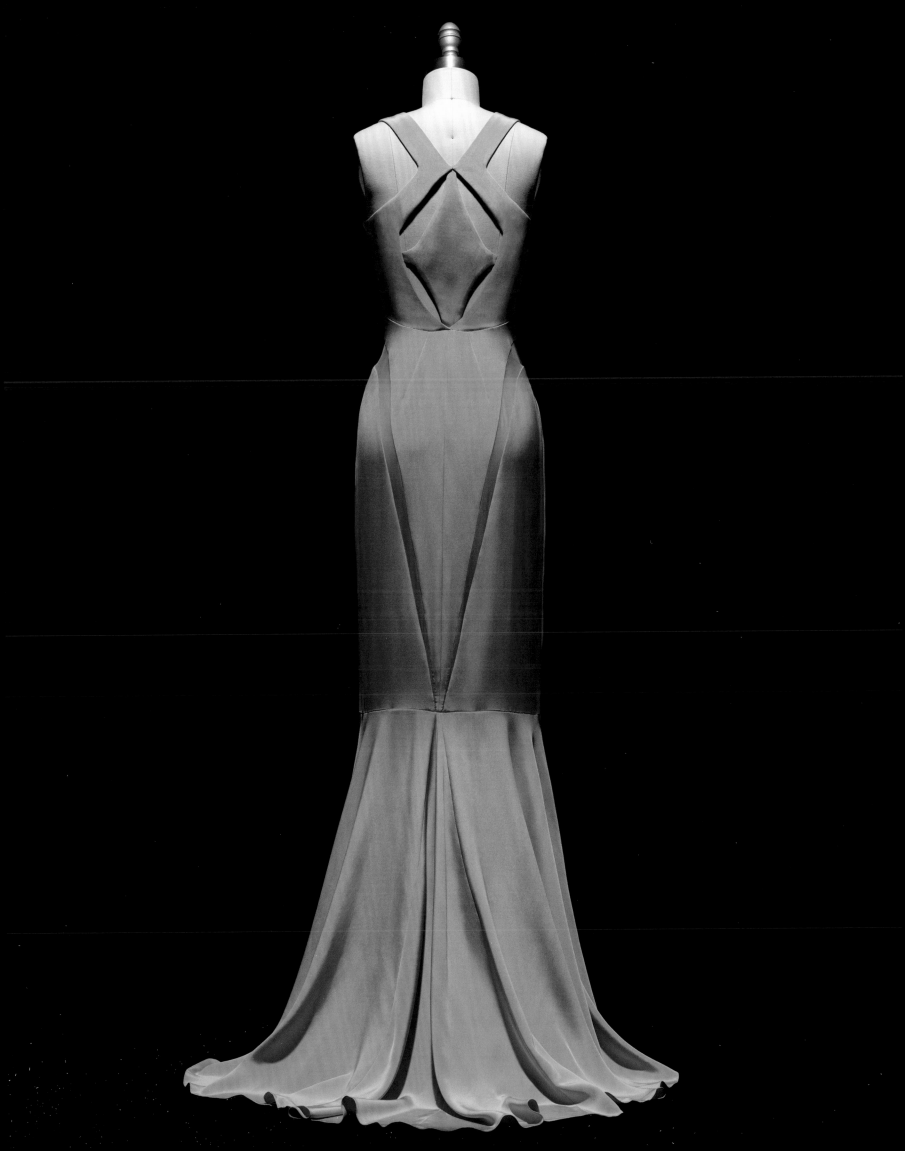

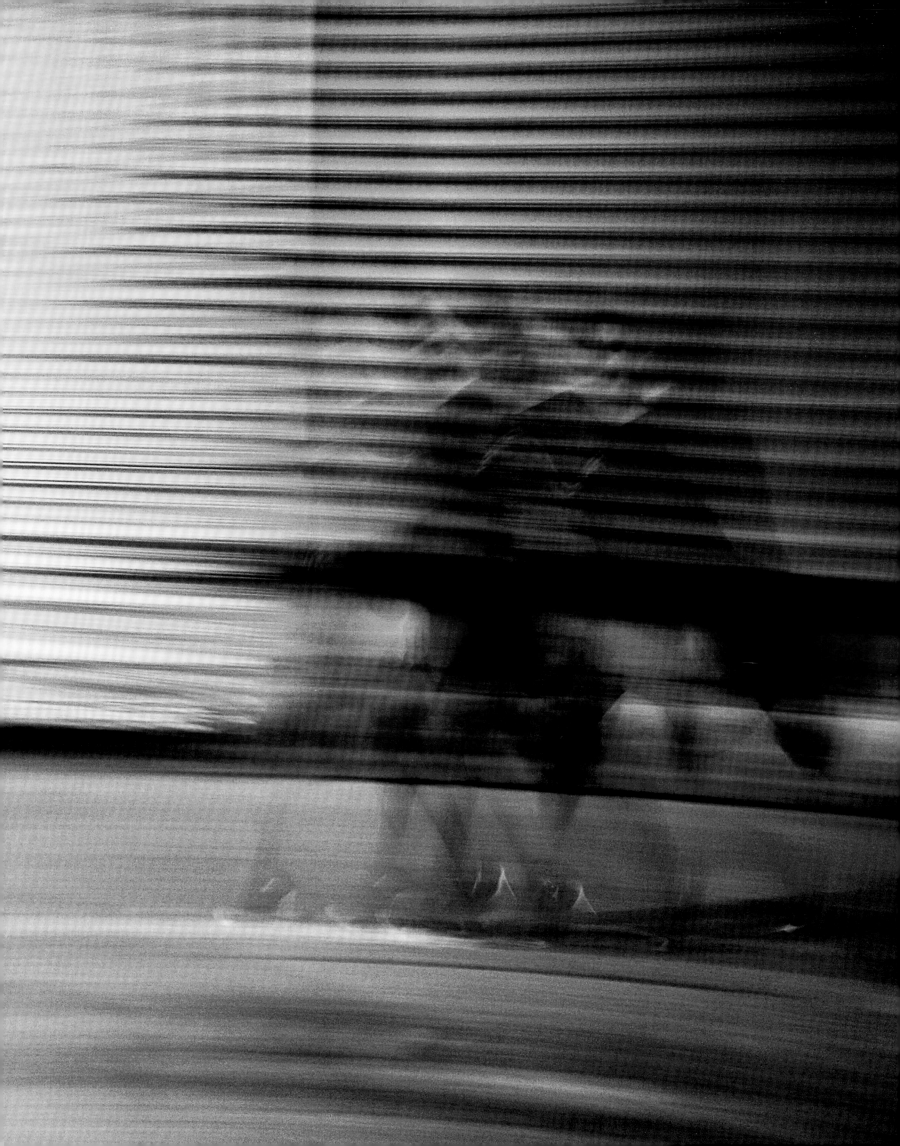

Fall 2010 "The Speed of the City"

For our very first runway show, I brought the movement and speed, the glamour, grit, and spirit of the city that is New York. I had moved to the city from Nepal a decade earlier and had lived in apartments throughout the Lower East Side and the East Village. These neighborhoods spoke to me deeply. They felt like the soul of the city, where music, poetry, art, and culture were born. While I was designing this collection, my apartment was in the East Village adjacent to a Hells Angels clubhouse that had speed, edge, and a bite to it. I had recently moved out of a Lower East Side apartment with a garden, and downsized to this studio to be able to launch my brand. I was reminded of the glory days of the East Village and felt lucky to occupy a little pocket that still felt untouched. The history, resilience, roots, and energy were kinetic.

Drawing on this energy, we broadened our range and introduced sharp and careful tailoring, inspired by the downtown spirit and juxtaposed with the high heritage of uptown, conveyed through elaborate cocktail dresses in oxidized colors of deep crimson, bottle green, and antique gold. Layered architectural silhouettes represented the many dimensions of the city that so inspire me. Joined alongside rising motorcycle hemlines, iridescent tones, and crystalized embroideries, we brought to life the pace and textures of New York.

We also found inspiration in the work of powerful women. We looked to the incredible Zaha Hadid—someone who defied convention and became a leader in the architectural space once strictly reserved for men. We incorporated graphic lines and unique curves inspired by her work and celebrated the contemporary New York woman who lives her life with no boundaries. She is an independent, urban nomad, moving about the streets, from the boardroom through motherhood to a black tie reception. She is unstoppable, she is heroic, she is uniquely herself with strength and beauty—she embodies what we like to call "femininity with a bite."

Hues of camel, crimson, gray, sage, white, and jet returned us to the place where the story of the collection began—the dark, moody, blocked colors of the East Village. Designed in rich double-face cashmeres, delicate draped chiffons, and luxe gazar—all created in New York's Garment District—we sang our ode to the vibrancy, utility, and speed of the city that has given us a home.

OPPOSITE: AN IN-MOTION INSPIRATION IMAGE FOR THE FALL 2010 COLLECTION.
I WAS INSPIRED BY THE PACE AND ENERGY OF NEW YORK CITY.

41

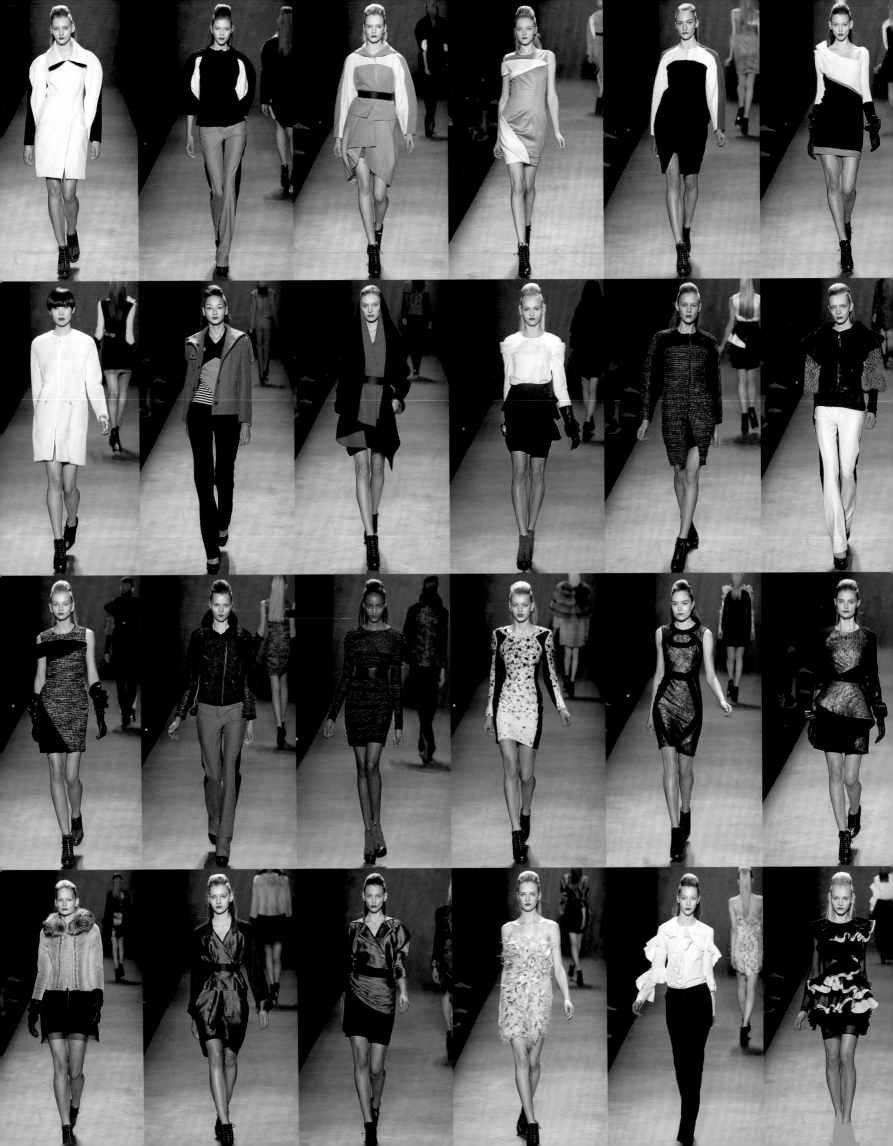

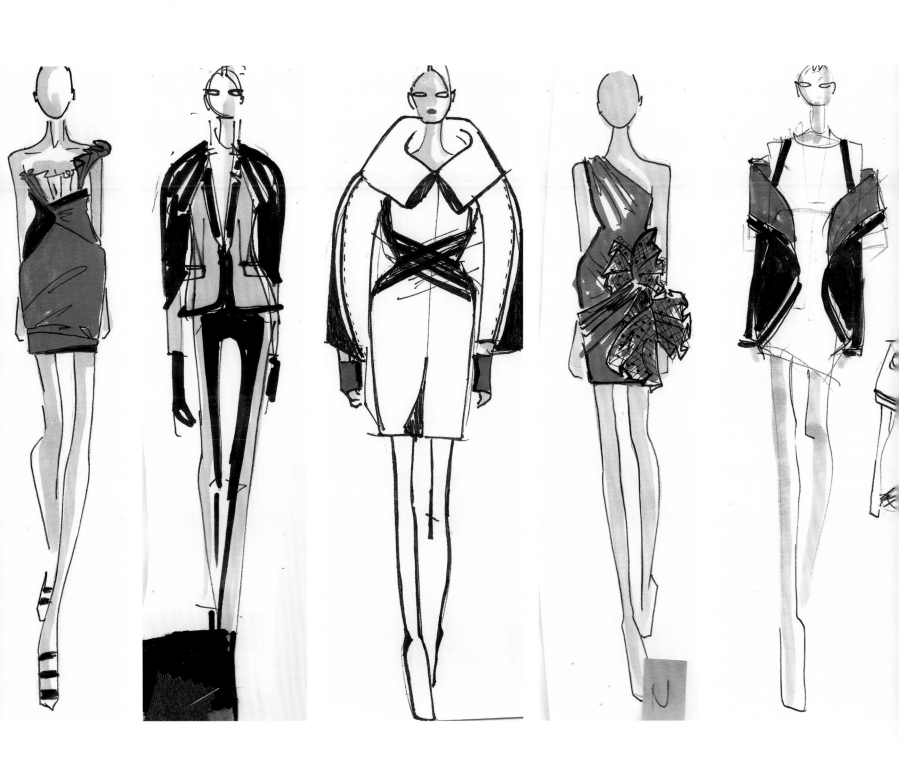

A Promise Kept

In 2005, I attended a screening for the CFDA/Vogue Fashion Fund (CVFF) documentary *Seamless* when I was working at Bill Blass as design director. *Vogue* editor-in-chief Anna Wintour was in attendance, and I decided to introduce myself to her. My friends tried to warn me not to; however, I couldn't be stopped. I told her how much I appreciated what she is doing to nurture young home-grown designers and how much I respected the CVFF program. She told me I should apply for the next season, and while I felt that was too soon, I did promise that she would see my application in the near future. And that she did: in 2010, I participated in the program and was a runner-up. The program itself is such a learning experience and enabled me to better understand my designs and my business. That year, the CFDA put together an editorial shoot for nominees for the Emerging Designer of the Year at the CFDA Awards. I was paired with the iconic Heidi Mount, who wore a dress from the Fall 2010 collection, and we sat for a portrait with the esteemed Sølve Sundsbø. This photograph will always serve as a memento for what was such a turning point in my career.

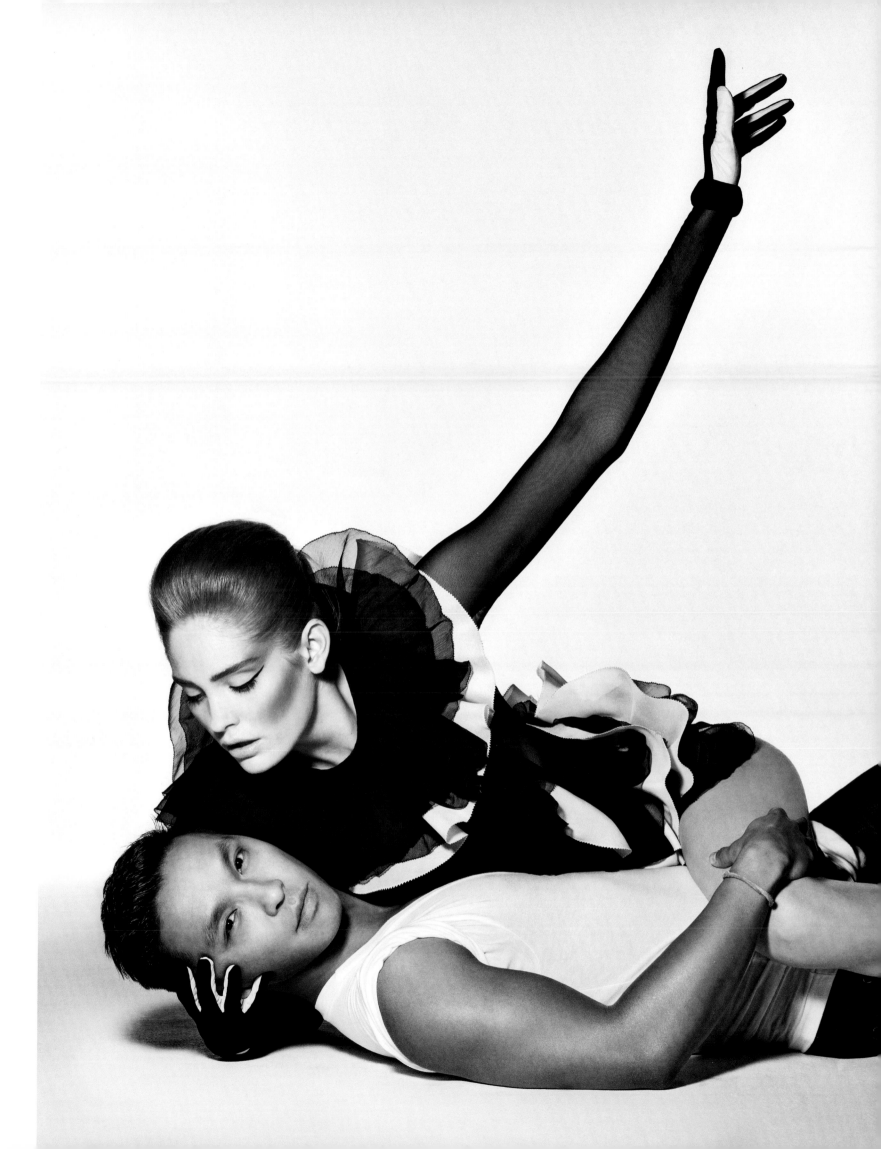

Spring 2011 "Modern Graphic Glamour"

This season I presented the brilliant and bold colors of my childhood in Nepal with the sensibility and restraint of sharp American sportswear. After living in New York for more than a decade, I missed the vibrant colors found back home in the East. In my experience, I rarely encountered them here. This collection was my proposition to bridge the gap between the two worlds that define me; my way to introduce the electricity of bright tones to my city of residence and belonging, adapting the ease of dressing so innate to the US.

We opened the show with a quartet of graphic color-blocked looks in hues of sky blue, poppy, and saffron, paying homage to the work of the great Ellsworth Kelly. The designs highlighted the innovation of his minimalist yet purposeful aesthetic and his fearlessness to embrace color in a way often unseen in the Western world.

Our inspiration also drew on the inimitable Tilda Swinton in the film *I Am Love*. Her exquisite representation of a strong woman in this movie beautifully captured the essence of our muses. We embodied this spirit through sharp tailoring, elegant embellishments, and silhouettes that showed reverence to the female form. We utilized layered organzas to speak to the marvelous complexities that make a woman the powerful force she is, and set them against creamy cashmeres, hand-sewn for this collection by artisans in Nepal. We mixed in paillette embroidery along with sculptural draping, strategic cuts, and athletic racer-back details that highlight a woman's curves and celebrate her natural essence.

At the time, I thought our world and future had never looked so optimistic. We were living in a happy democracy with leaders who inspired and created space for endless experimentation and growth. I now reflect on this moment in time with longing and nostalgia, yet am reminded to stay ferocious, active, and vigilant in a fight to reclaim a more beautiful world. This collection was an invitation to embrace what makes us unique and celebrate together with brightness, levity, strength, and love.

OPPOSITE: THE MOOD BOARD AND FABRIC PALETTE FOR THE SPRING 2011
COLLECTION, INSPIRED BY THE ART OF ELLSWORTH KELLY AND THE BRILLIANT
TILDA SWINTON'S FILM *I AM LOVE*.

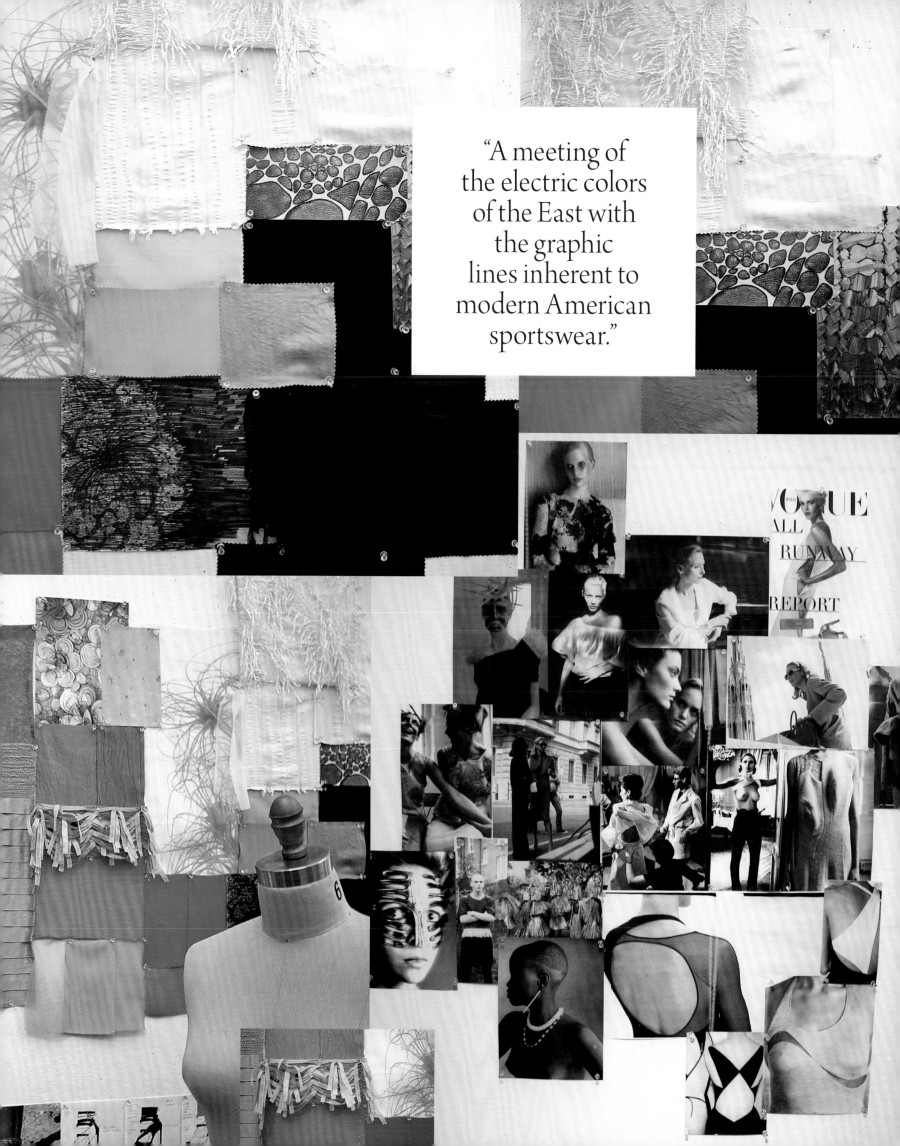

"A meeting of the electric colors of the East with the graphic lines inherent to modern American sportswear."

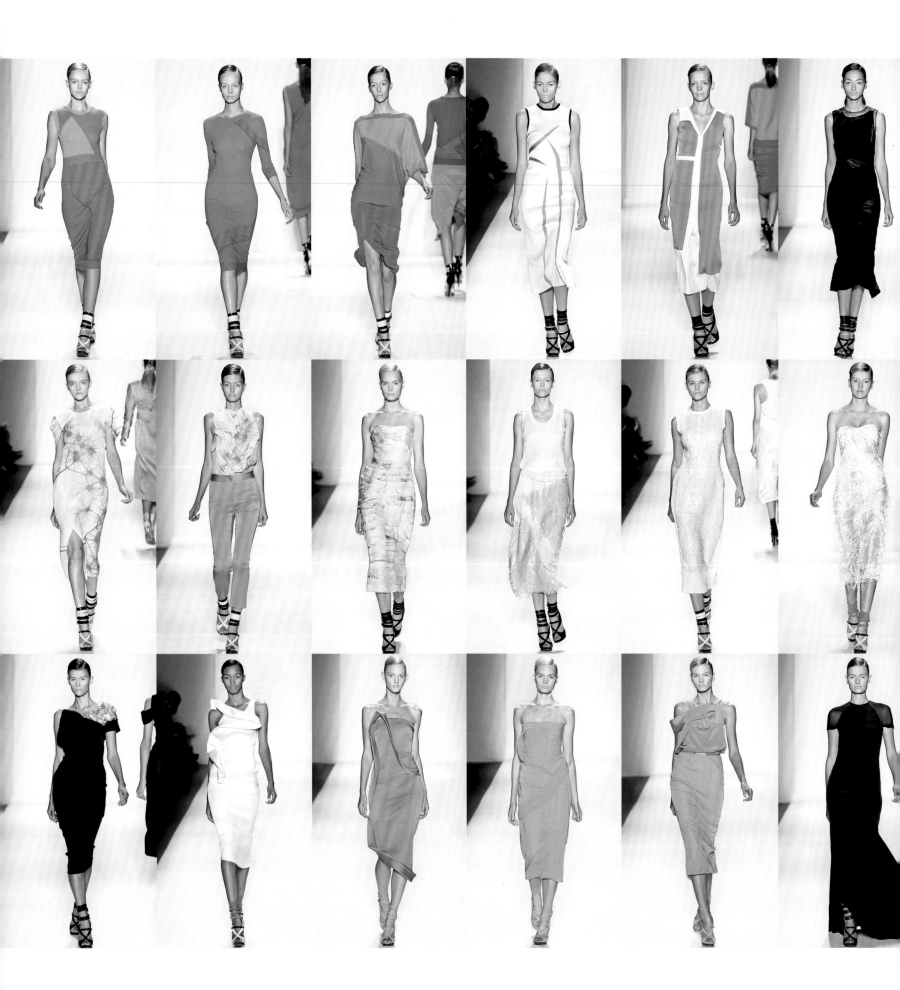

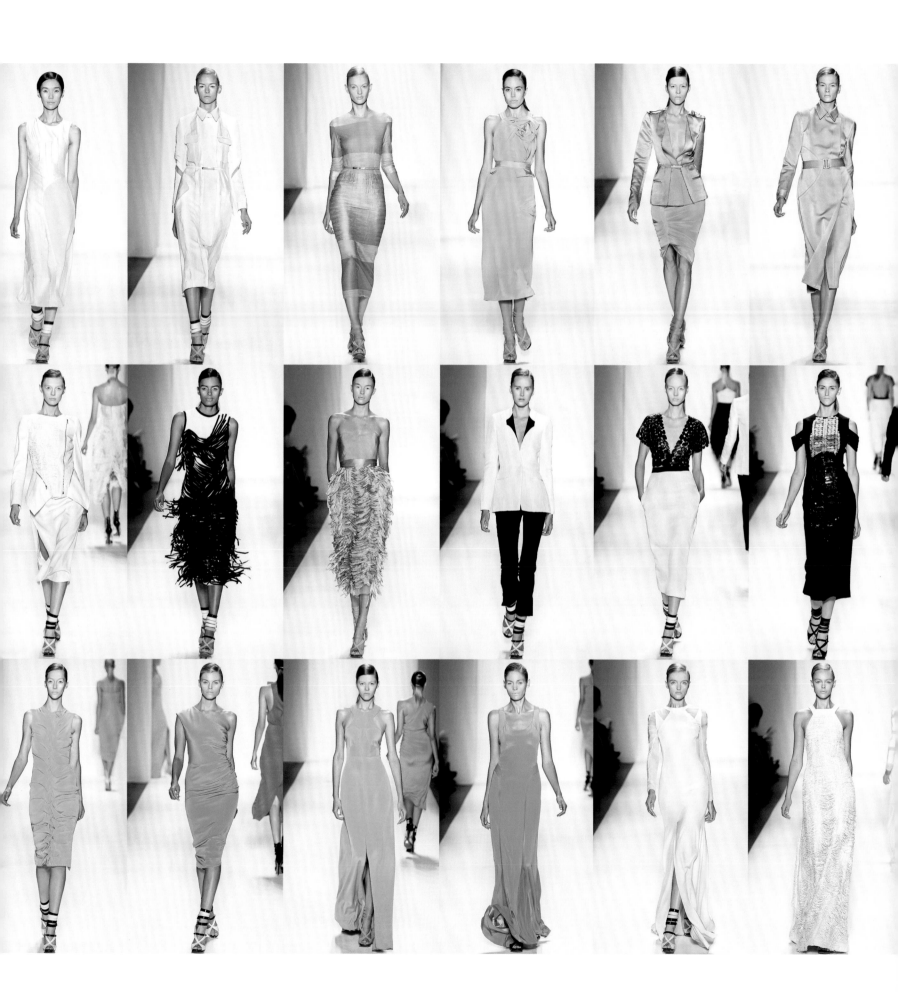

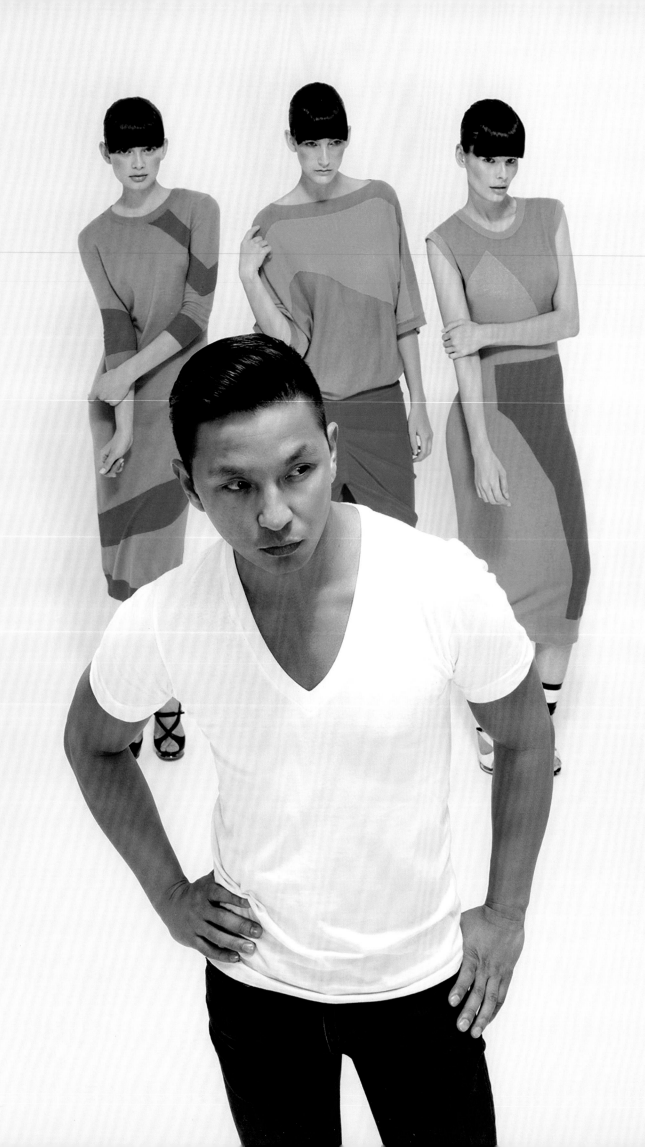

ELLSWORTH KELLY'S BOLD GRAPHIC ART WAS AN INSPIRATION FOR THIS COLLECTION,
AND I OPENED THE SHOW WITH THREE COLORBLOCKED DRESSES THAT DRAW ON HIS
WORK. FOR THE DECEMBER ISSUE OF *ELLE*, DANIEL KING PHOTOGRAPHED ME WITH MODELS
JEANNE BOUCHARD, YASMIN BRUNET, AND KATYA KULZHKA WEARING THESE DESIGNS.

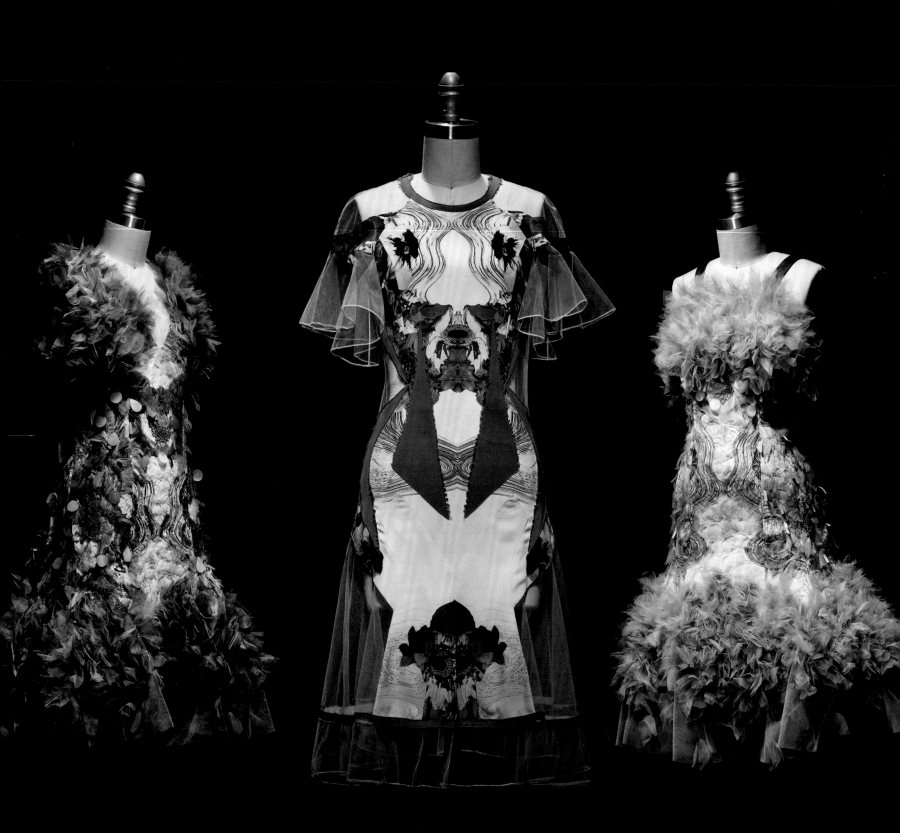

FEMININITY WITH A BITE This was a year of romantic heartbreak as well as rediscovering my individuality, independence, and inner strength. It was a year that came undone, and when I learned to stand up on my own. I channeled this newfound energy creatively on the runway, drawing on tragic heroines and overtly sensual art to celebrate the liberated, fearless women who embrace their femininity with a sharp-witted edge, or what we like to call "femininity with a bite." At the time, it was considered frivolous to care about fashion, a notion very much in defiance of what I've always believed. I wanted to show the power of a woman in all her feminine glory and show that intellect doesn't come at the sacrifice of style. There was no better way to bring this ideal to life than to have the fiercely independent Rooney Mara debut our Spring 2012 collection on the red carpet for *The Girl with the Dragon Tattoo*, a film that explores the beautiful complexities of the modern woman. This same year, I also recognized the power of my platform, and together with my siblings and friends, launched Shikshya Foundation Nepal, an organization with the goal of providing education to underserved children in my homeland. To this day, our ongoing efforts humble me, ground me, and remind me to use my voice responsibly. They inspire me to drive change for a better tomorrow.

2011

Fall 2011 "Beauty Undone"

"I'll tell you what real love is. It is blind devotion, unquestioning self-humiliation, utter submission, trust and belief against yourself and against the whole world, giving up your whole heart and soul to the smiter—as I did."

——GREAT EXPECTATIONS

This collection was a love letter to John Singer Sargent's *A Parisian Beggar Girl* and Miss Havisham, the brilliant antihero of Charles Dickens's *Great Expectations.* Her all-consuming, unrequited love evoked a savage bite in our romantic yet unhinged muse. Designing this collection hit very close to the heart for me. I had recently emerged from a broken relationship, channeling my heartbreak into an obsessive dedication to my craft. I was charmed by the imperfect, undone, somewhat ethereal and romantic qualities of both of these nontraditional heroines. In designing with these muses in mind, I experienced a release, a rebirth as a creative with a new perspective on the notion of perfection.

We opened the show with Florence Welch's "Addicted to Love." The lights went down. The inimitable Karlie Kloss stepped onto the runway, and began by questioning the idea of beauty—who has beauty and what does it mean? Is it elegant? Polished? Traditional? The collection was an invitation to open up the complex layers of this word and a presentation of a multifaceted definition that gives women the space to be uniquely themselves.

Through the designs, we dissected the conventional meaning of beauty and offered instead a space where imperfection is celebrated, diversity heralded, and flaws revered. This was translated into the highest quality Taroni silks and failles, duchesse satins, organza layers, and hand-done embroideries with a slightly disheveled edge in hues of crimson, rose, and iridescent metallics. Slinky silhouettes were introduced in a loosening of fabric, allowing for a freedom of expression and movement. Hard leather was softened by delicate pleats and billowing chiffons transformed with rich cashmere. We offered a new range of dresses slightly undone in nature—a slip off the shoulder, cascading embroidery that comes undone.

In a society so consumed by perfection, the collection romanced the idea of breaking down barriers, and replacing a traditional, somewhat Victorian notion with a modern perspective to evoke our muse's most inner essence. It is this unwavering commitment to defying norms and highlighting the artisanal spirit that so consumes us, not unlike the all-encompassing emotions felt by Miss Havisham. We feed our souls with creation, born out of heartbreak, to pave a more inclusive, beautiful world ahead.

OPPOSITE: THE MOOD BOARD WITH INSPIRATION FOR THE FALL 2011 COLLECTION,
DRAWING ON THE ANTIHERO MISS HAVISHAM IN *GREAT EXPECTATIONS* AND THE
ROMANTIC NATURE OF JOHN SINGER SARGENT'S *A PARISIAN BEGGAR GIRL.*

FOLLOWING SPREAD, FROM LEFT: THE FALL 2011 CAMPAIGN FEATURING JULIA SANER.
PHOTOGRAPHED BY DANIEL JACKSON; KARLIE KLOSS OPENS THE FALL 2011 SHOW,
SET AGAINST THE TEXTURE OF THE RUNWAY.

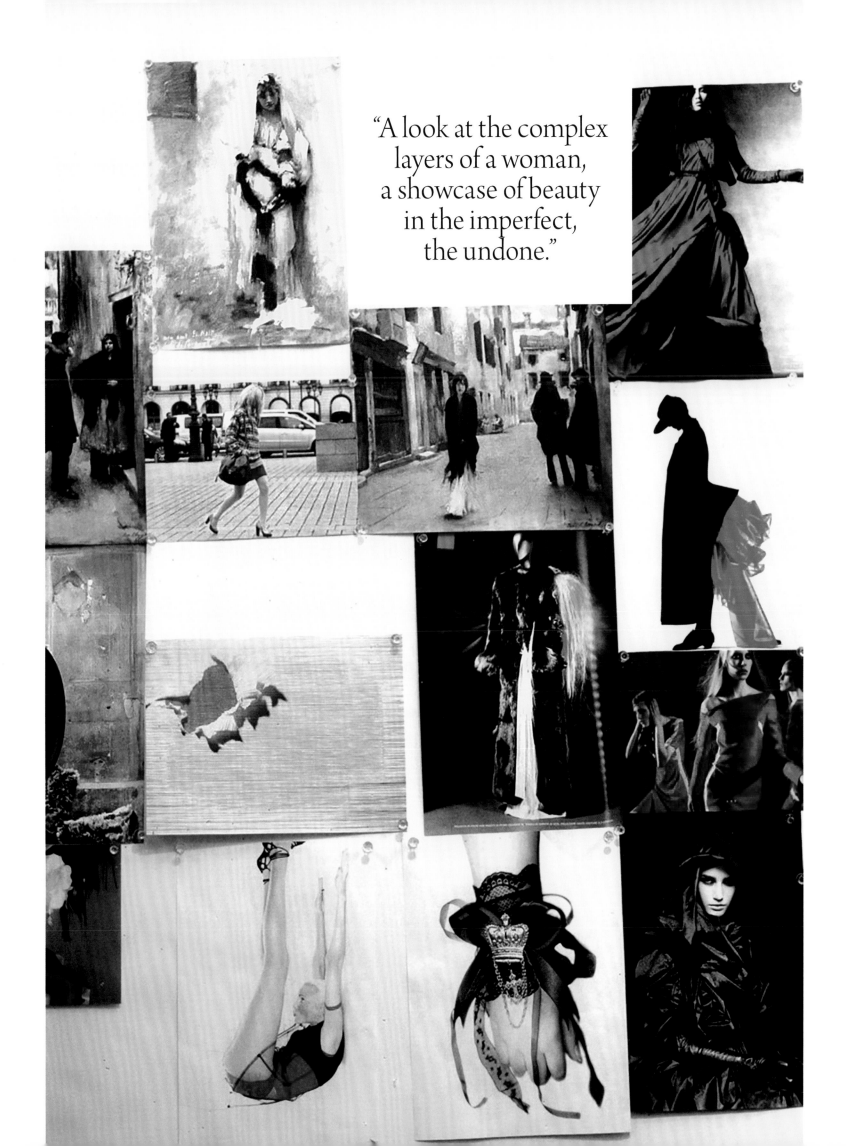

"A look at the complex
layers of a woman,
a showcase of beauty
in the imperfect,
the undone."

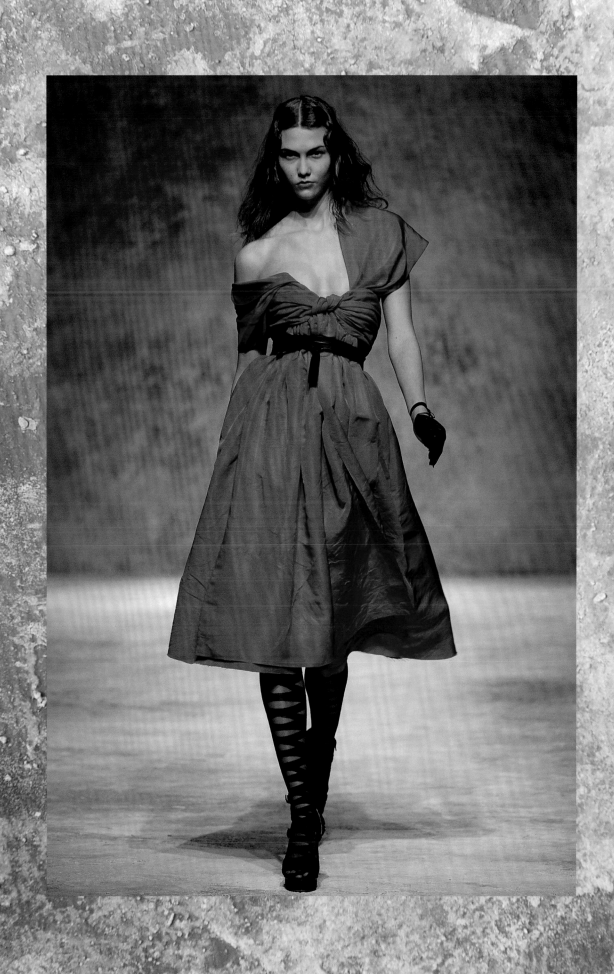

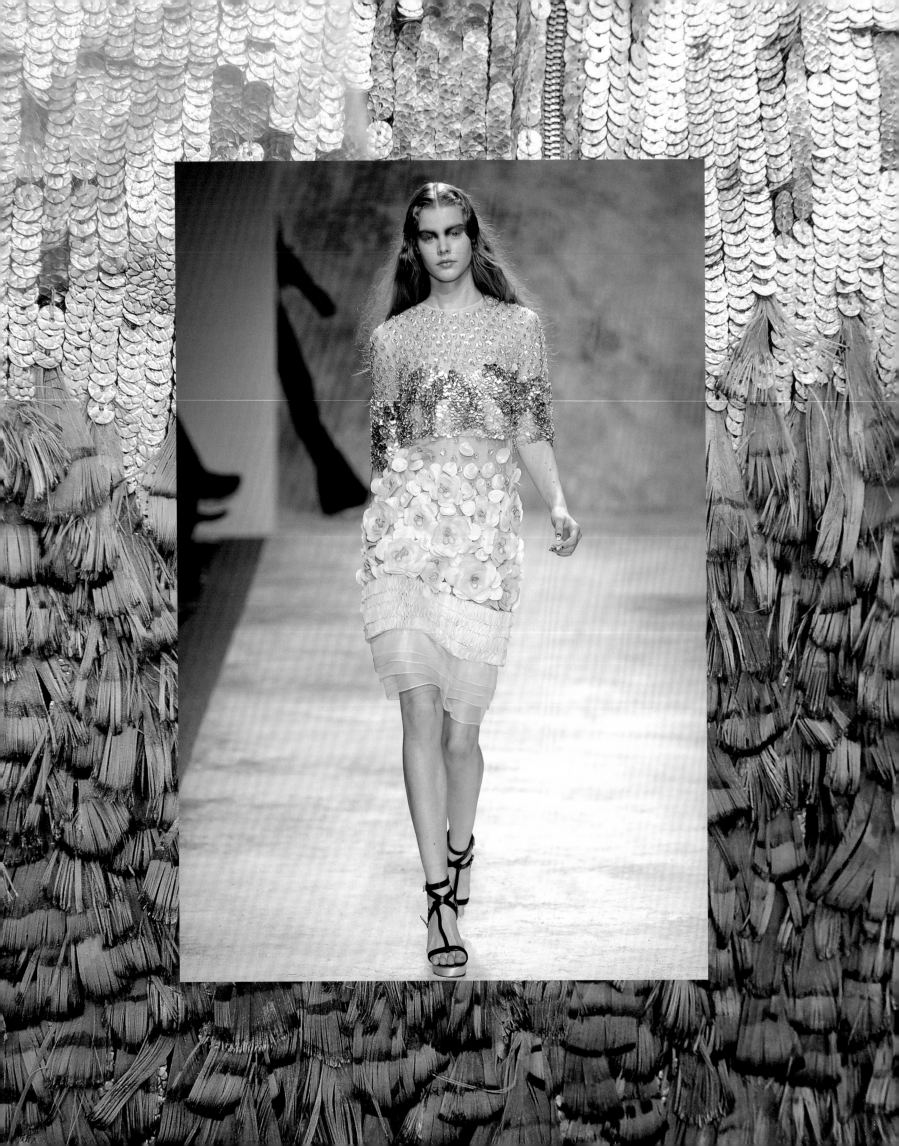

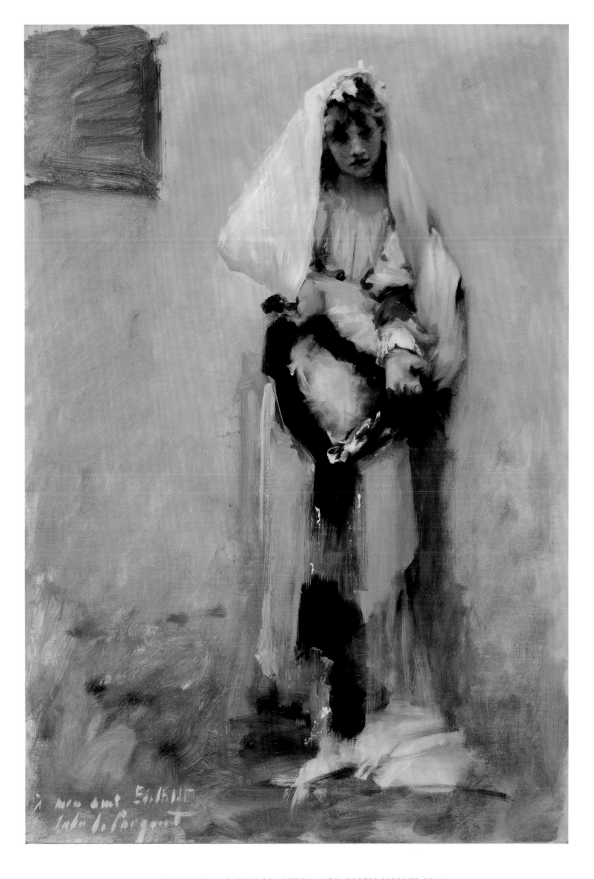

DESIGNS THROUGHOUT THE COLLECTION, LIKE THE DRESS OPPOSITE, DRAW
ON THE ROMANCE AND BEAUTIFUL IMPERFECTION INHERENT IN JOHN SINGER
SARGENT'S *A PARISIAN BEGGAR GIRL*.

ABOVE: JOHN SINGER SARGENT, *A PARISIAN BEGGAR GIRL*, C. 1880, OIL ON CANVAS,
25 3/8 X 17 3/16 IN (64.5 X 43.5 CM), TERRA FOUNDATION FOR AMERICAN
ART, DANIEL J. TERRA COLLECTION, 1994.14.

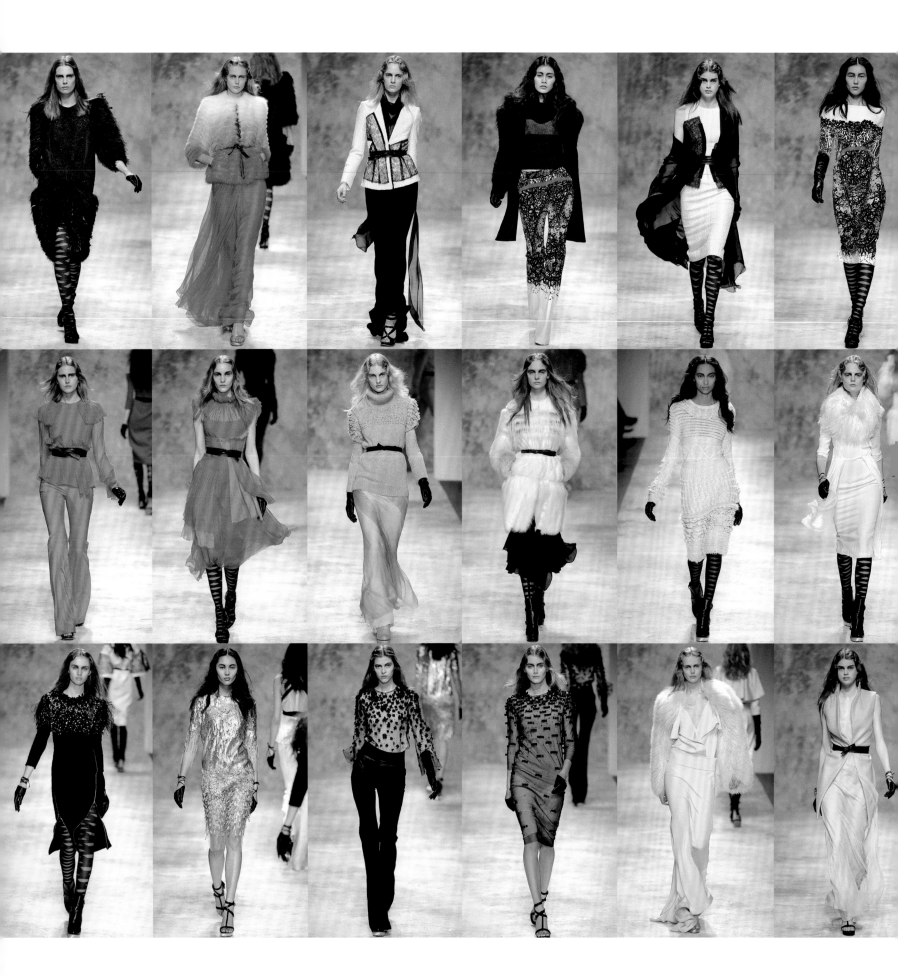

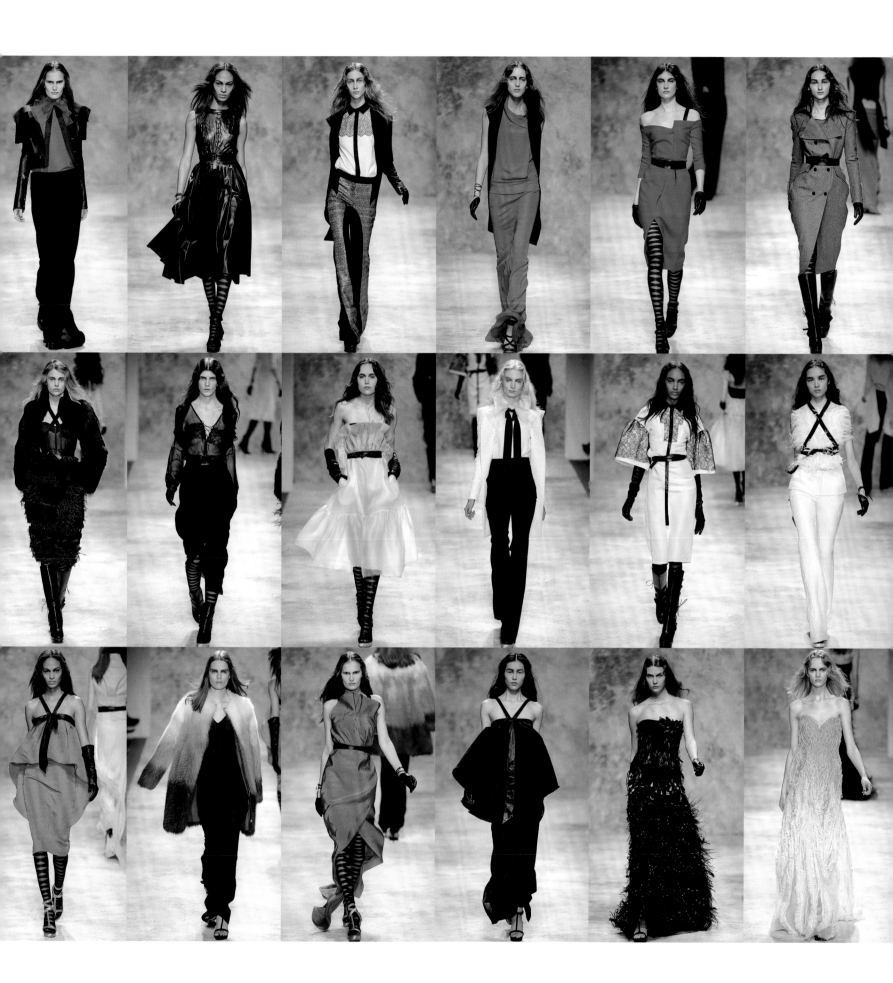

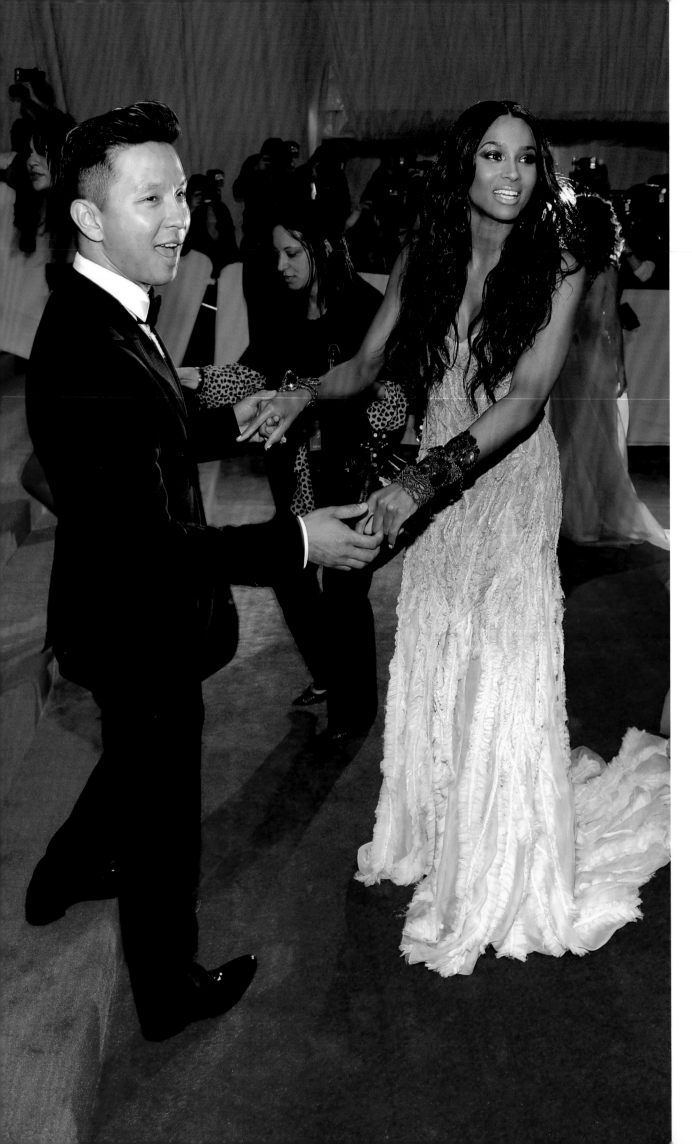

FOR MY FIRST EVER MET GALA IN
MAY 2011, I BROUGHT CIARA AND
DEMI MOORE AS MY DATES.
THEY BOTH WORE LOOKS FROM
THE FALL 2011 COLLECTION.

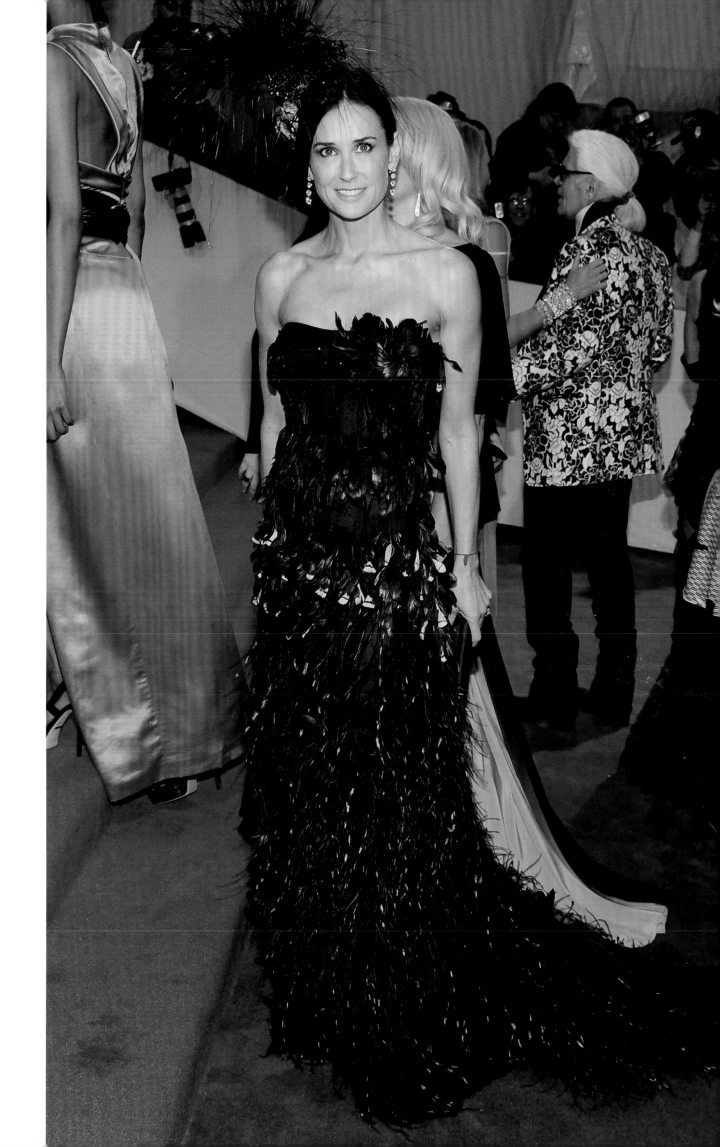

Spring 2012 "The Bonds of Duality"

The inspiration for Spring 2012 began with the Japanese artist Nobuyoshi Araki's photographic series *Sensual Flowers.* These flowers are beautifully subversive, layered, and nuanced with a feminist twist and perverse undertones. I became quickly fascinated by the innate eroticism of the flowers and revered the fine arts lens. It was a trailblazing approach, breaking down convention, especially coming from an artist born in traditional mannered Japan. As we are both of Asian heritage, I instantly connected with Araki's work and desire to reclaim sexuality in a society that keeps it covert.

Like the provocative work of Araki, we delved into imagery of love, bondage, and unique visions of sexuality, offering a tongue-in-cheek play with our collection. We wanted to question who is the one being objectified—the subject or the voyeur?

It is this duality—the opposition of soft and hard melding together—that created the Spring 2012 collection. We juxtaposed the soft beauty of an orchid against the Japanese Shibari (rope bondage) tradition found in Araki's work. Translated on our runway through nylons, meshes, latex, and leather harness finishings that evoke the strength of S&M, we gave these often fetishized materials a couture treatment by wrapping them around boldly elegant, digitally printed silk and chiffon florals. Vivid hues of white, violet, lilac, and turquoise come to life in an unexpected, somewhat shocking manner when set against strategically placed cutouts highlighting the beautiful curves of the female form.

This notion of unlocking beauty in the most surprising of places is how we view the world. Through our lens, the gradations, complexities, and contradictions of femininity are revered, the normative behavior of what it means to be a woman challenged, and the obscure elements celebrated. This is our world, where women are free to be themselves, to defy tradition, and to destigmatize what might be perceived as dissident. We live and act in favor of a place where a woman's most powerful tool is embracing the very femininity that makes her unique.

OPPOSITE: THE MOOD BOARD WITH INSPIRATION FOR THE SPRING 2012 COLLECTION, DRAWING ON THE ARTIST NOBUYOSHI ARAKI'S ARRESTING PHOTOGRAPHS.

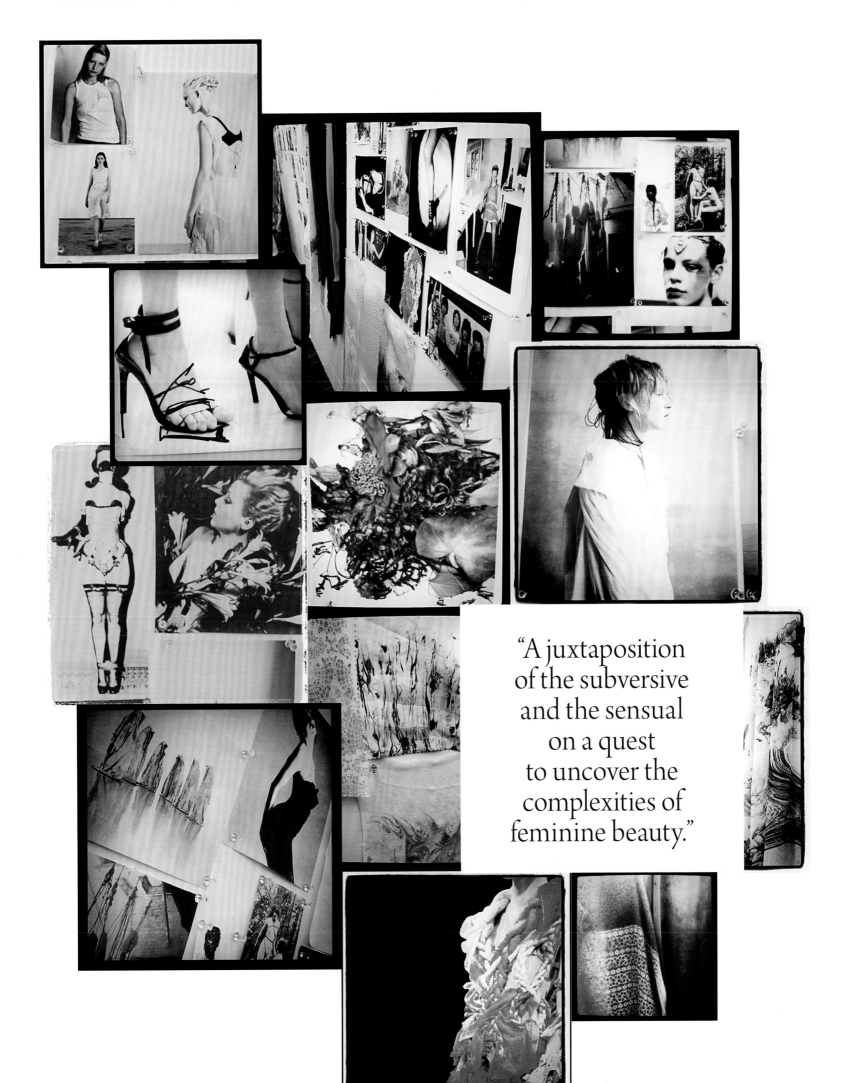

"A juxtaposition of the subversive and the sensual on a quest to uncover the complexities of feminine beauty."

GRAPHIC CUTOUTS, SEEN ABOVE, APPEAR THROUGHOUT THE SPRING 2012
COLLECTION, AND HAVE BECOME A SIGNATURE DETAIL.

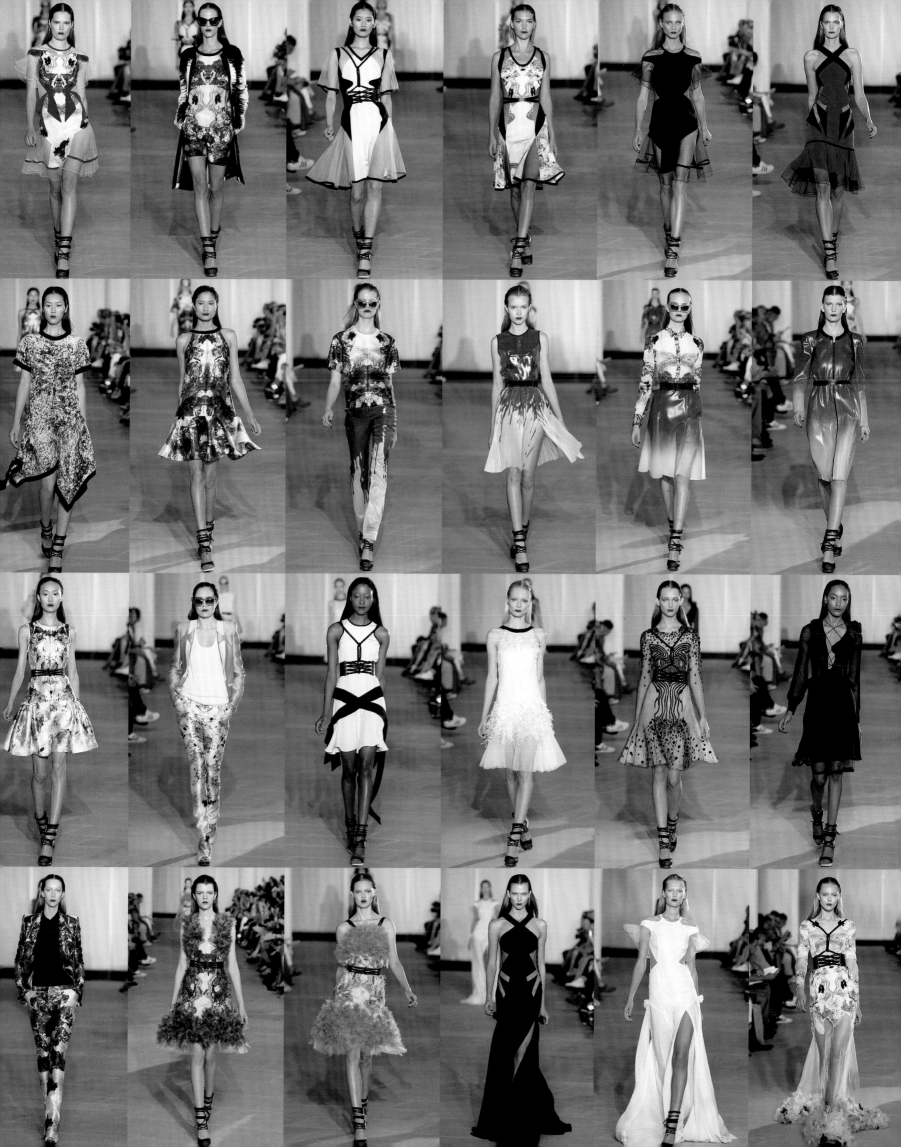

THE SPRING 2012
CAMPAIGN FEATURING
CANDICE SWANEPOEL.
PHOTOGRAPHED BY
DANIEL JACKSON.

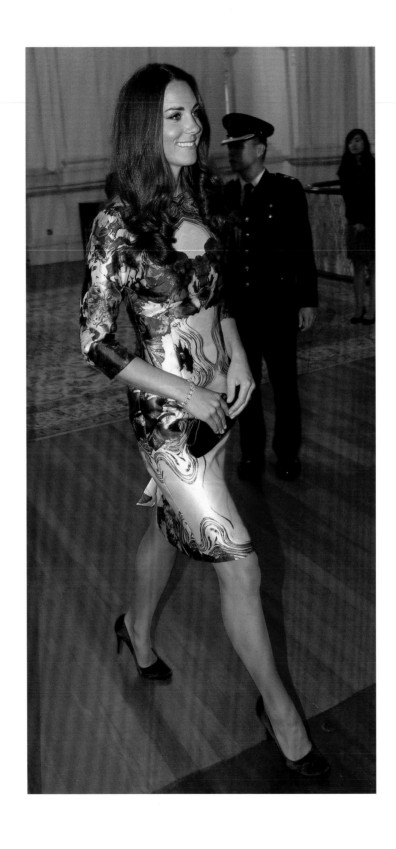

HER ROYAL HIGHNESS THE DUCHESS OF CAMBRIDGE, KATE MIDDLETON,
WORE MY DRESS IN SINGAPORE, MY PLACE OF BIRTH.

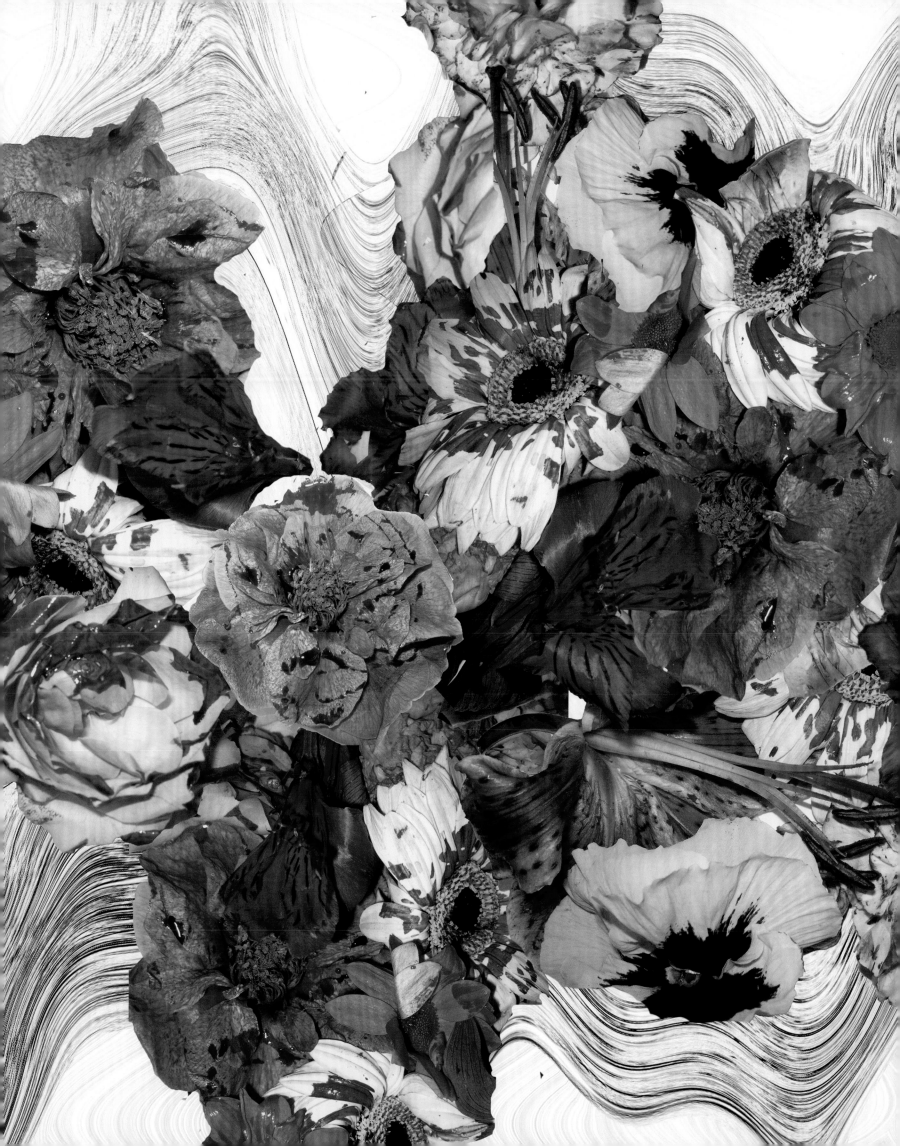

2012

THE YEAR OF MODERN GLAMOUR Two thousand twelve was the year I felt fully awakened. Our business had been growing over the past three years—we dressed incredible women with their own unique sartorial perspectives and empowered positions including our dear friend Sarah Jessica Parker, the fearless Nicki Minaj, the inspiring Duchess of Cambridge, Kate Middleton, the talented and hilarious Jennifer Lawrence, the soulful Lana Del Rey, the darling Diane Kruger, who told Style.com she wanted our entire collection, and many more. The brilliant Grace Coddington, then the creative director and absolute visionary of *Vogue*, attended our Spring 2012 runway show. I was exploding with emotions and felt the sky was the limit. During this time, I wanted to experiment and step outside of my comfort zone to explore and celebrate our muse's sensual side, showcasing the complex layers of a woman. I was so consumed with fashion, bursting with ideas, and on an absolute high, humbled by our achievements and envisioning our future.

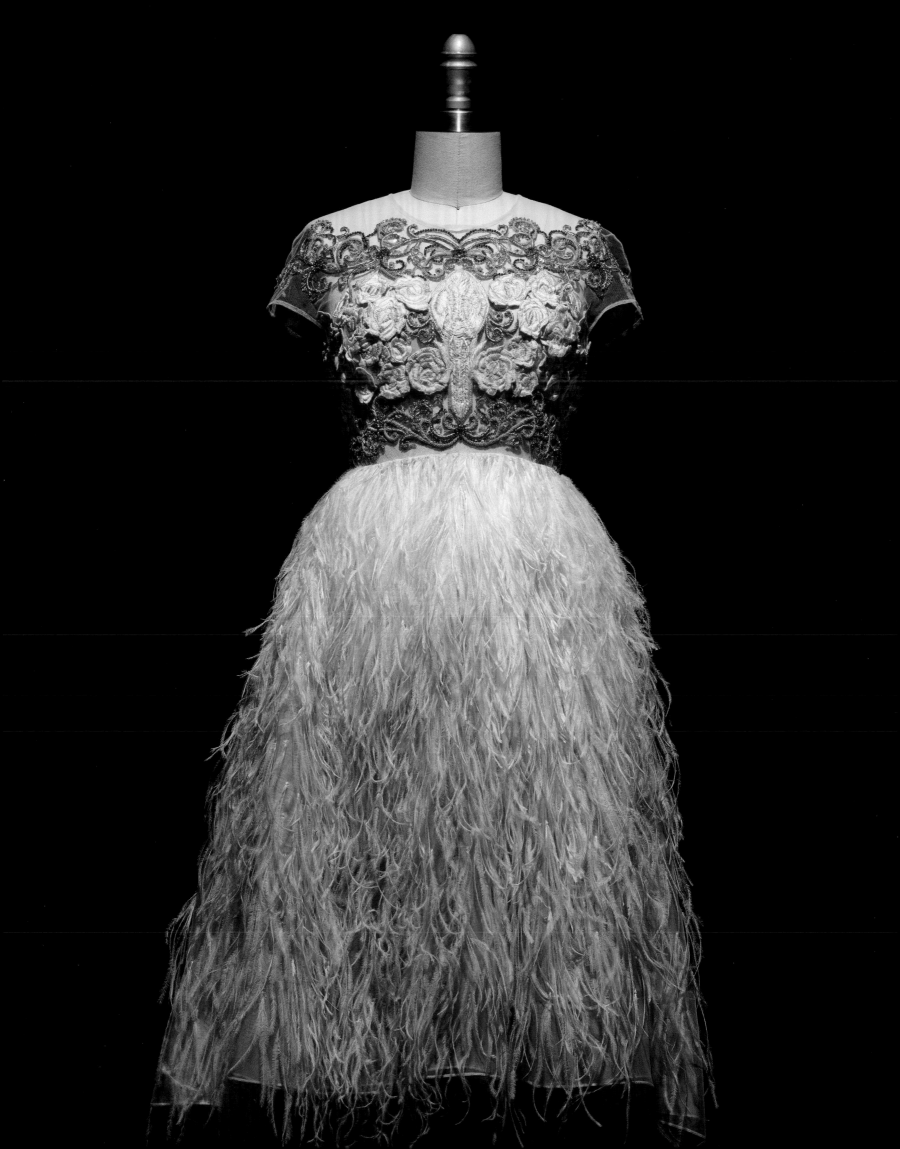

Fall 2012 "A Journey from Heaven to Hell"

The Fall 2012 collection was a journey from heaven to hell, an exploration into the depths of humanity as we seek to understand soulful creations and pursuits that have no bounds.

The inspiration began with the late, great Georgia O'Keeffe's *Cow Skull*, which pays homage to the imperfect yet enduring beauty and strength of the American spirit. I had been familiar with O'Keeffe's work for quite some time and was struck by it again when I began researching American women artists. I designed this collection during a presidential reelection year, and while I myself was not yet a citizen and able to vote, I felt transfixed by the idea of digging into the archive of America and understanding those who will forever be ingrained in our country's collective memory. I wanted to use this collection and my platform to highlight the work of a brilliant trailblazer. O'Keeffe's painting spoke to me at a moment when we were advocating to preserve the vigorous changes our country had experienced in the last four years. As we continued our fight for inclusion, representation, equality, and our livelihoods, I was faced with the concept of impermanence, and understood how we must act to create impact during our fleeting time on this earth.

While the collection was rooted in the work of an American artist, the spirituality of it transported me back home to Asia. I felt a sense of calm, a cleansing, which was represented by Japanese blue roses that were carefully embedded into the fabric of our story. Symbolizing prosperity and hope, these unnatural yet striking flowers carried us to another realm. It is this pursuit of perfection, of creating a new type of beauty that drove our journey.

Delicately designed with couture ideals, the collection moved from dark to light as we searched for a renewed future on our unending voyage. Jet-hued leathers and raglan furs faded into metallic neoprene, followed by vivid ultramarine intarsia knits and digitally printed skulls in shades of Sistine blue. The collection finished with angelic ivories and doré gold gowns that were artisanally embroidered with paillettes and feathers.

Our muse, as always, is conscious, imaginative, and alluring, embodying the concept of "femininity with a bite" so prevalent in our Prabal Gurung world. In this show, she fluidly transcended the depths of time and space, leaving her impact with spirit, soul, and love.

OPPOSITE: THE MOOD BOARD WITH INSPIRATION FOR THE FALL 2012 COLLECTION,
JUXTAPOSING THE CONCEPTS OF DARK AND LIGHT.

74

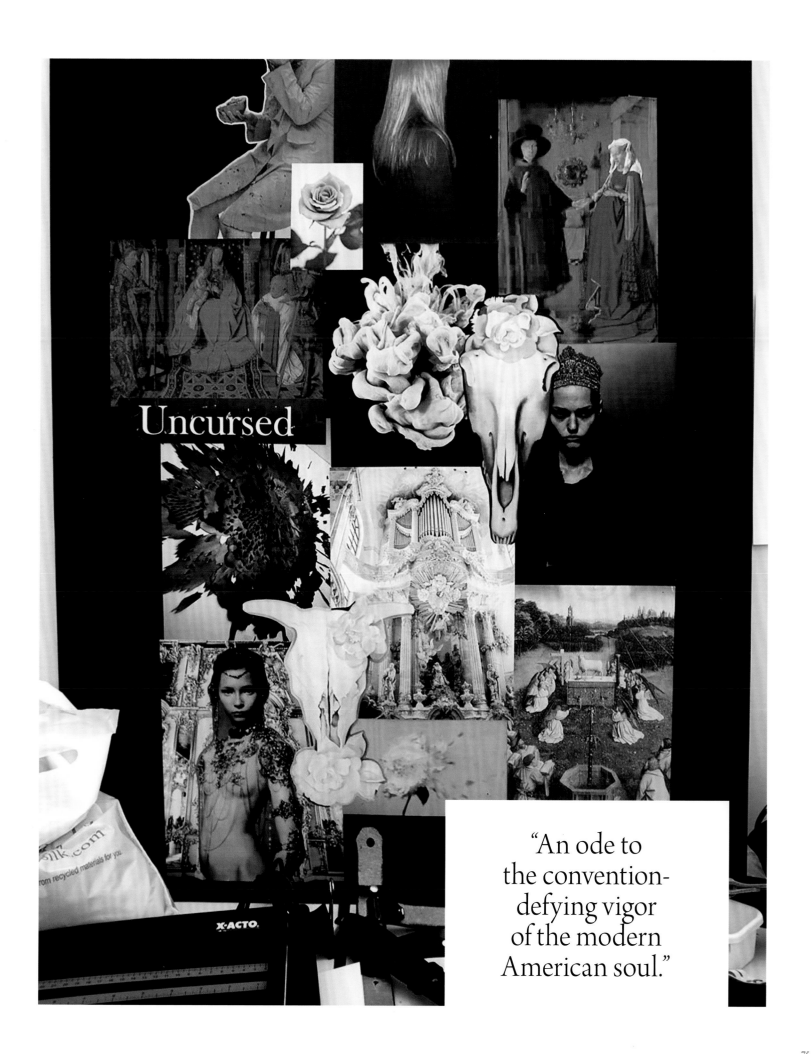

Uncursed

"An ode to
the convention-
defying vigor
of the modern
American soul."

DIGITAL PRINTS ON THE FALL 2012 TEXTILES, AN ABSTRACT TAKE ON
GEORGIA O'KEEFFE'S *COW SKULL* MIXED WITH A FLORAL MOTIF.

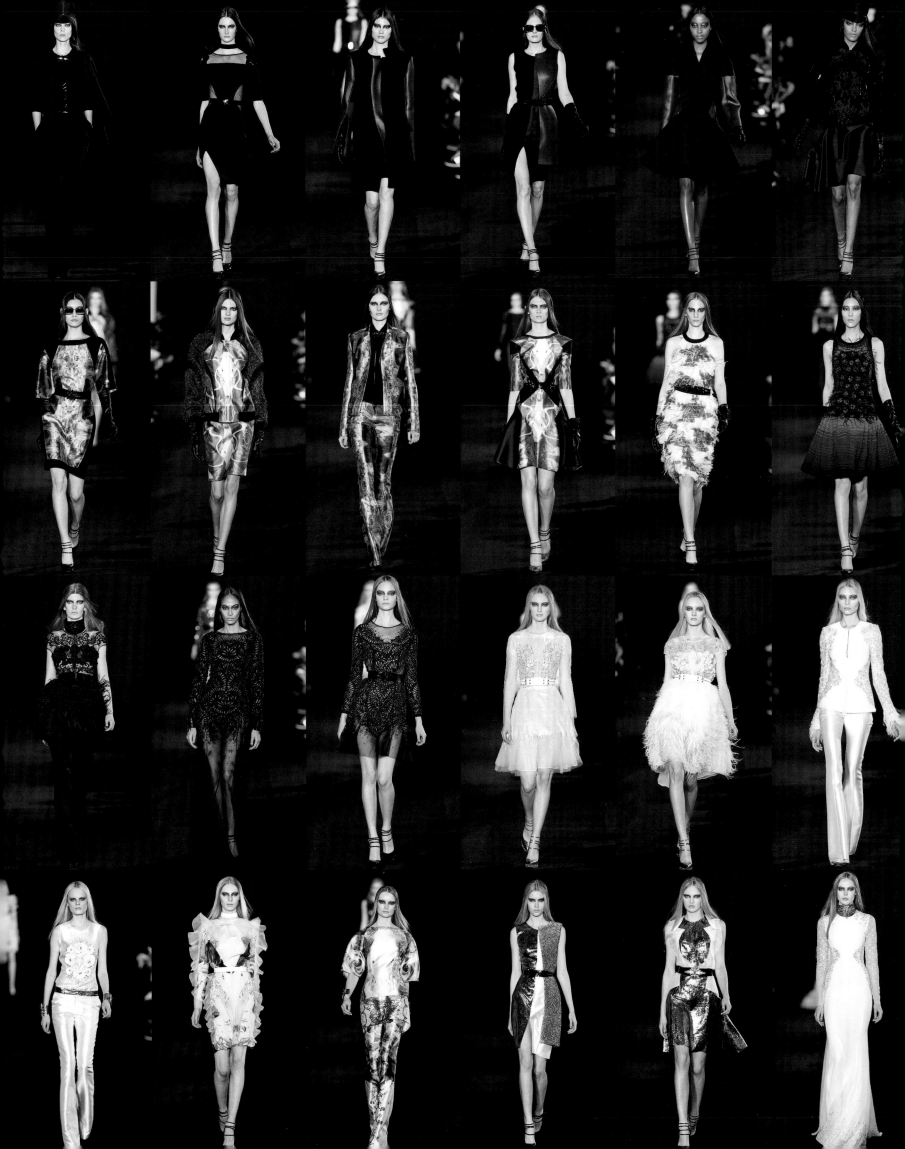

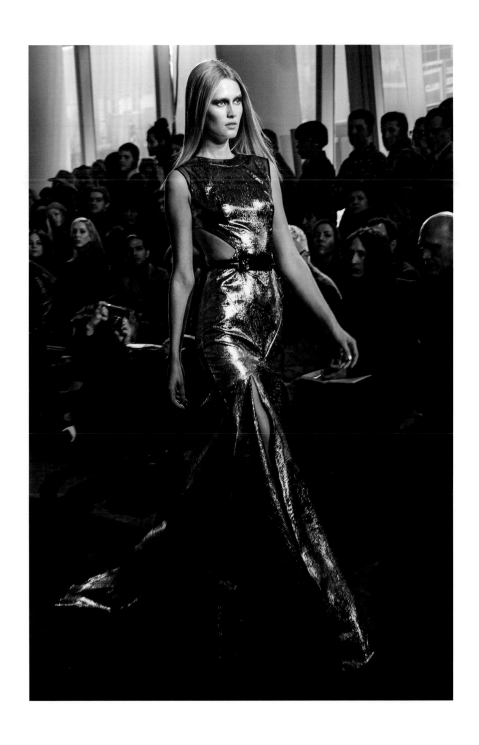

ABOVE: TONI GARRN WALKS THE FALL 2012 RUNWAY.

FOLLOWING SPREAD: BACKSTAGE AND RUNWAY MOMENTS FROM THE FALL 2012
SHOW WITH ANNA WINTOUR, BILL CUNNINGHAM, AND MY LOYAL FRIEND AND
MUSE ZOE SALDANA ALL IN ATTENDANCE.

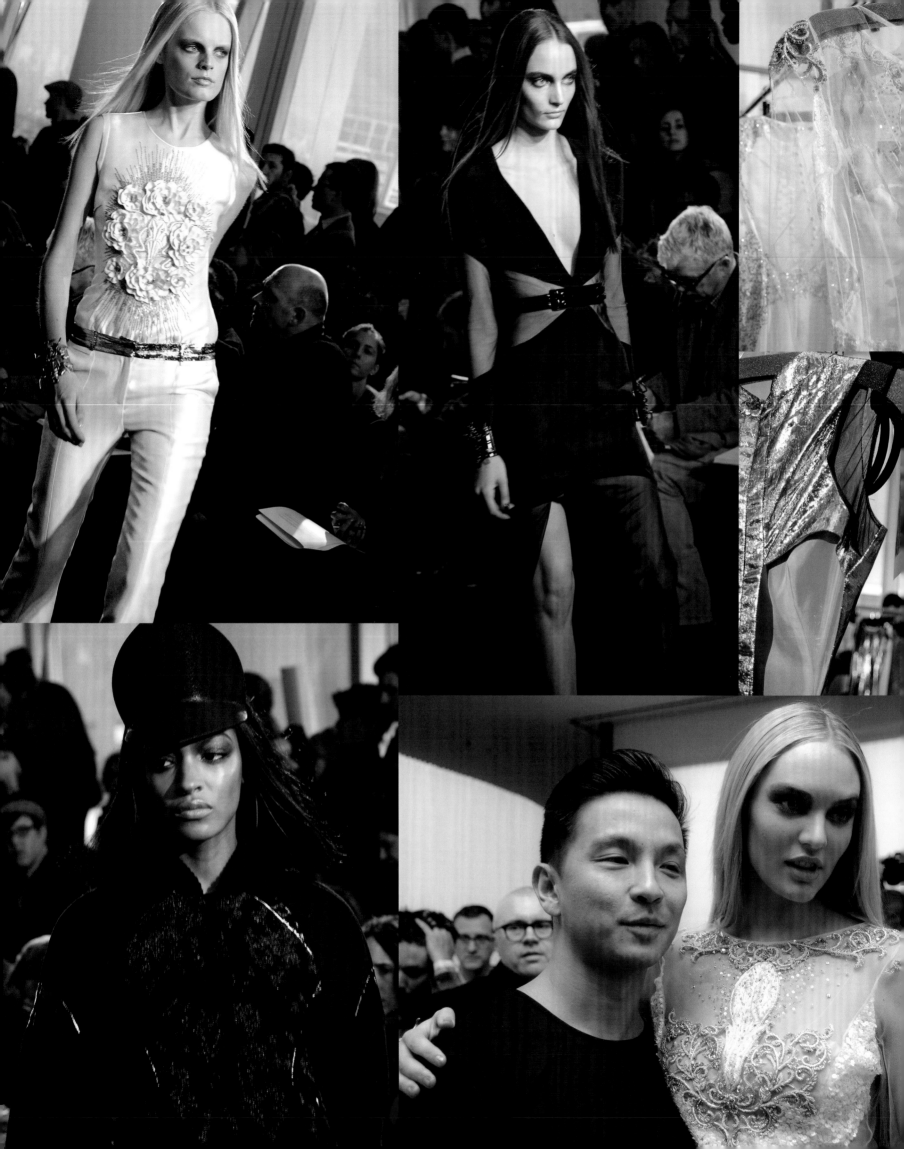

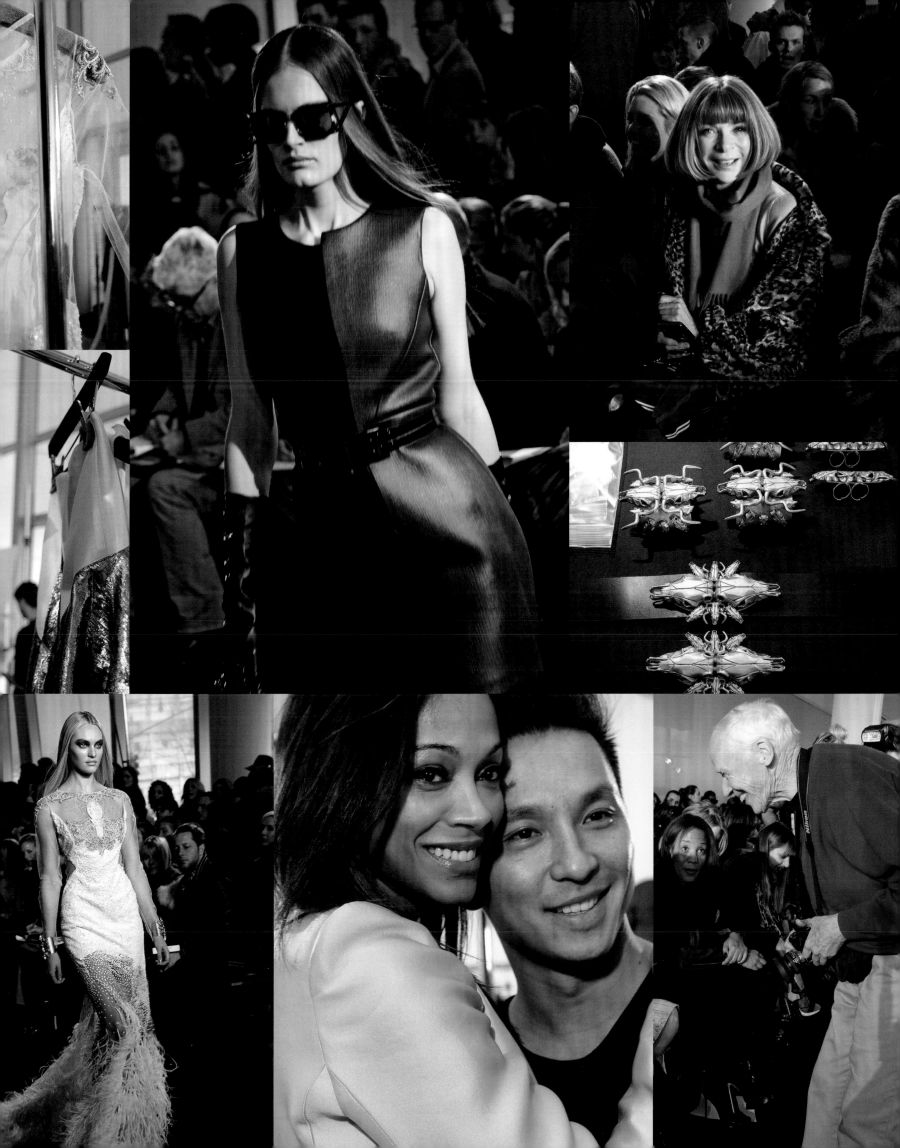

Kristen's Bite

Kristen Stewart is one of my favorite actresses. I love her fearlessness, her spirit, her uncanny ability to be true to herself. She doesn't conform to society or pop culture's conventions, rather, through her defiance, she creates a space for a new ideal to form. She brings to life an idea I like to call "femininity with a bite"—she embraces the power of her femininity as a tool while maintaining a cool and effortless edge. For the June 2012 issue of *Elle*, Kristen was photographed by Tom Munro in our black long-sleeve tulle gown embroidered with filigree cutwork, jet beads, and onyx crystals.

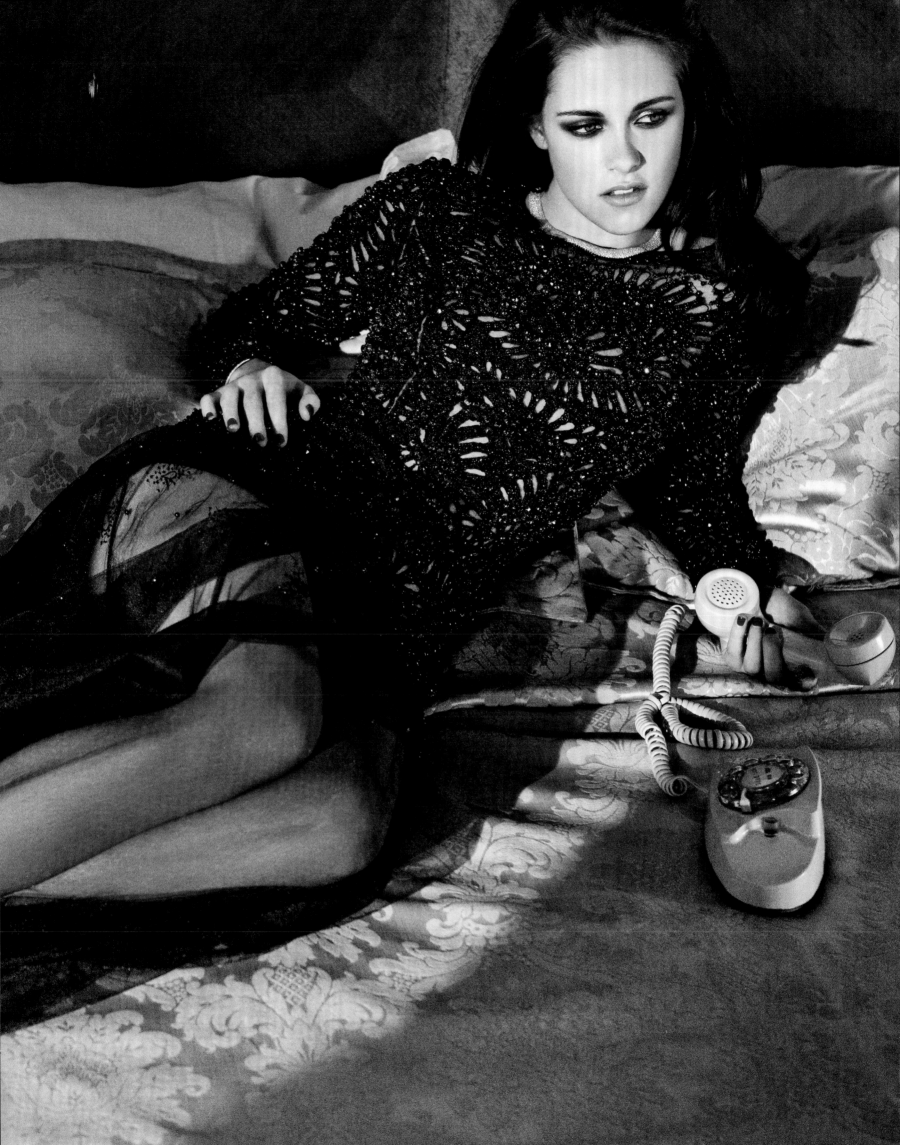

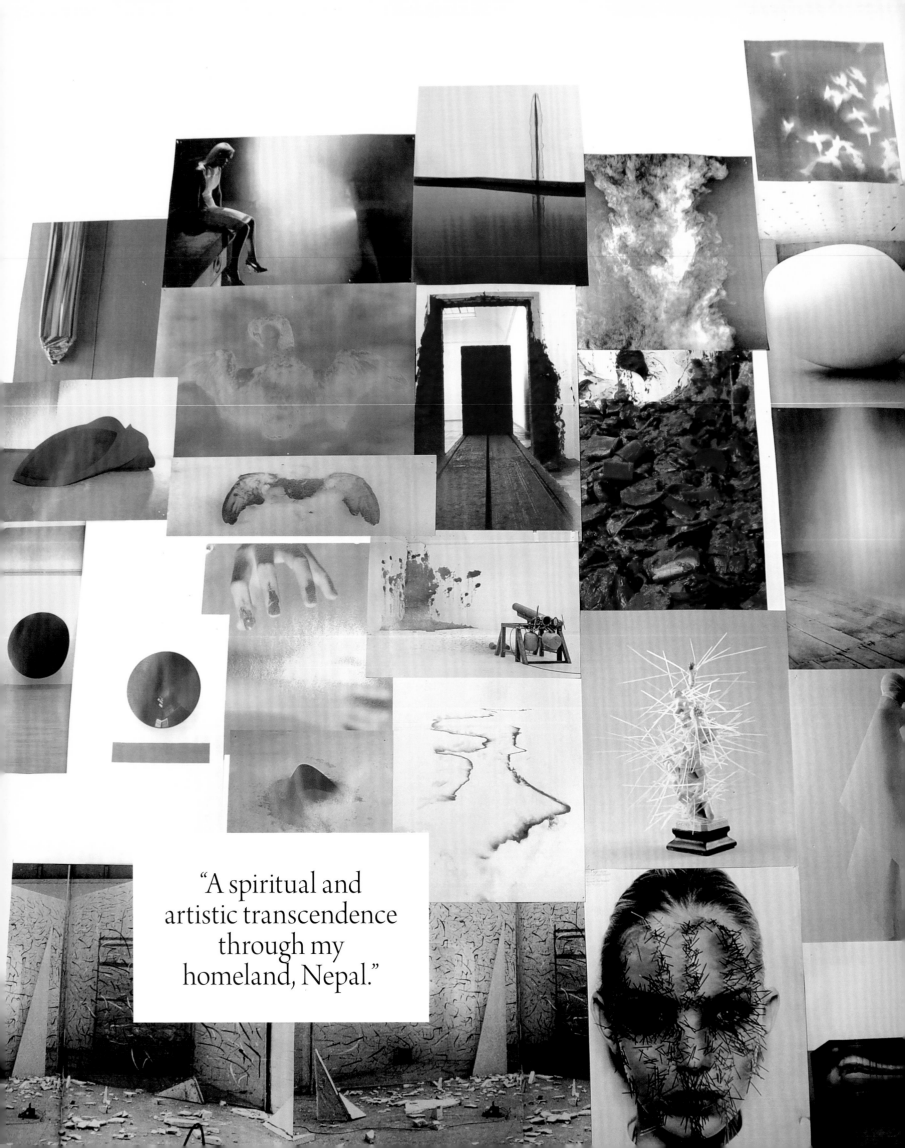

"A spiritual and artistic transcendence through my homeland, Nepal."

Spring 2013 "Passion Unleashed"

A spiritual yearning, a kindred reconnection. It had been quite some time since I had been able to travel back home to Nepal, so Spring 2013 was a season of introspection, a pining for family, love, and roots.

I embarked on a sacred journey of the heart, longing for my home in Nepal. Along the way, I encountered the work of the artist Anish Kapoor, a kindred soul who transcends place, with an energy and message that span the globe. Provoked by the monument and aura of his geometric sculptural work utilizing bold and breathtaking pigments, I engaged in a subcontinental dialogue with Kapoor, speaking with fabric and color as my language of choice.

It was on this voyage that I reflected on my life, holding a mirror to who I am and what I can be. Born in Singapore, growing up throughout Nepal, India, London, and Australia, and based now in New York, I felt provoked by the dual idea of being grounded yet taking flight.

This concept was translated in the clothing through the meeting of white feminine fluid organza gazars, silver metallic liquid lurex, and hand-stitched feather embroidery with the bones of our couture ideals—garments created by hand with precision and love by local artisans in New York and Nepal. It also appeared with digitally printed fabrics in crimson and violet, shades used to represent the spiritual and passionate nature of the collection and my journey birthing it, and figuratively in the structure of precise tailoring and sharp suiting. The juxtaposition of building roots with the freedom of movement is at the very core of our continued exploration of religion, spirit, and soul.

This collection was a play on the idea of hard and soft, celebrating the tough core of the woman who inspires, by presenting her in light and airy silhouettes, breaking down the façades of strength and suggesting that the greatest power a woman has is her ability to embrace her inner femininity.

OPPOSITE: THE MOOD BOARD WITH INSPIRATION FOR THE SPRING 2013 COLLECTION, DRAWING ON THE WORK OF ANISH KAPOOR.

85

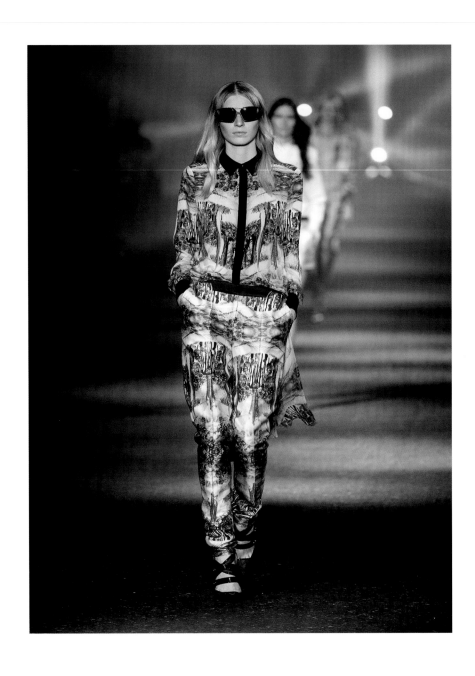

JULIA NOBIS WALKS THE SPRING 2013 RUNWAY IN A STORM BLUE SATI PRINTED ENSEMBLE.
THE PRINT WAS INSPIRED BY THE HIMALAYAN MOUNTAINS BACK HOME IN NEPAL.

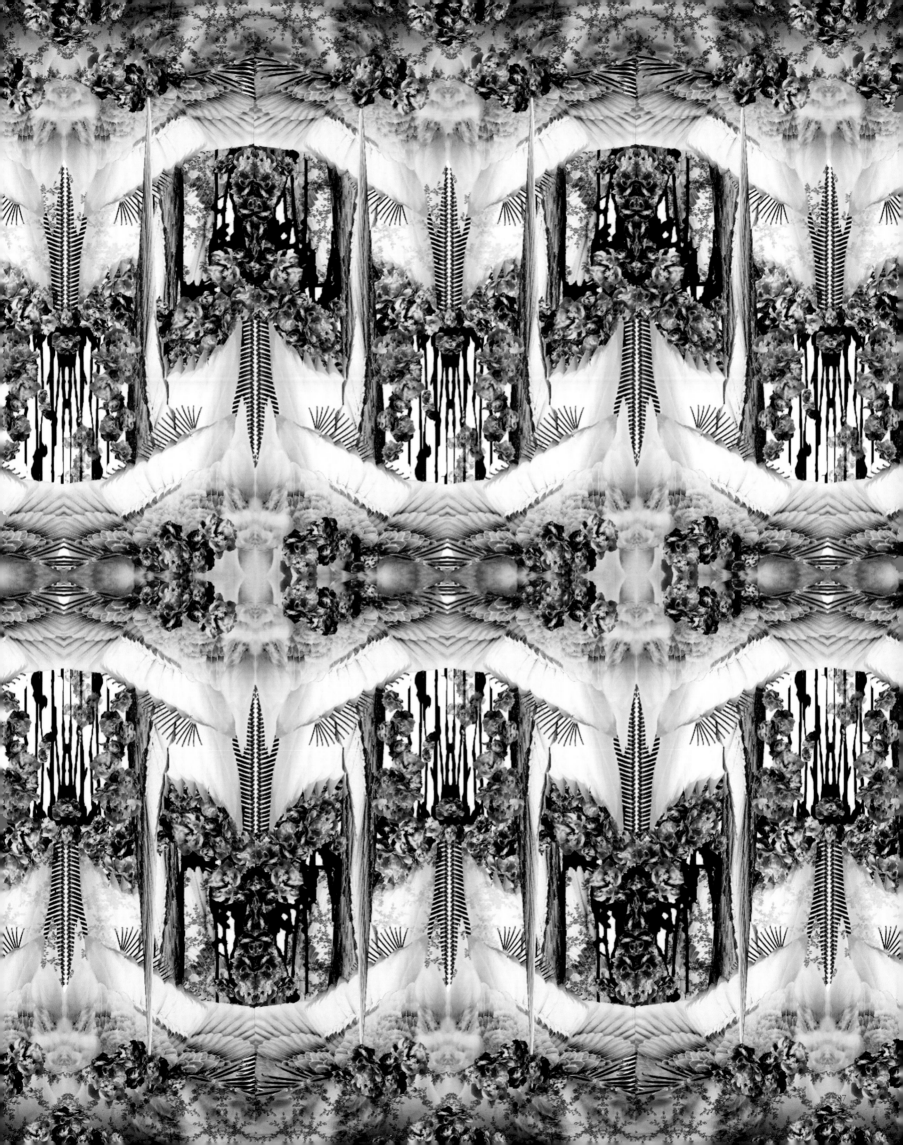

RIGHT: SUPERMODEL AND FRIEND JOAN SMALLS LEADS THE
PACK FOR THE SPRING 2013 FINALE.

PAGES 92–93: THE SPRING 2013 CAMPAIGN, FEATURING JOAN.
PHOTOGRAPHED BY DANIEL JACKSON.

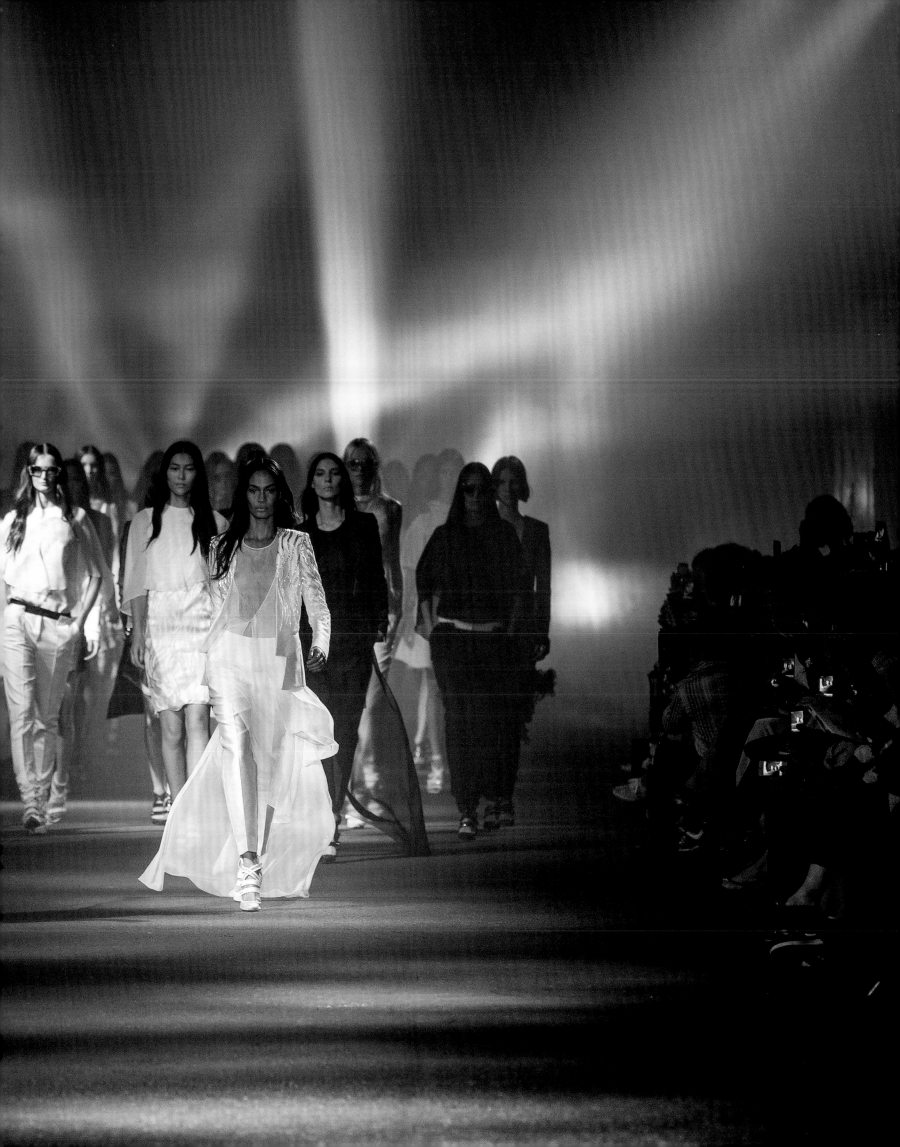

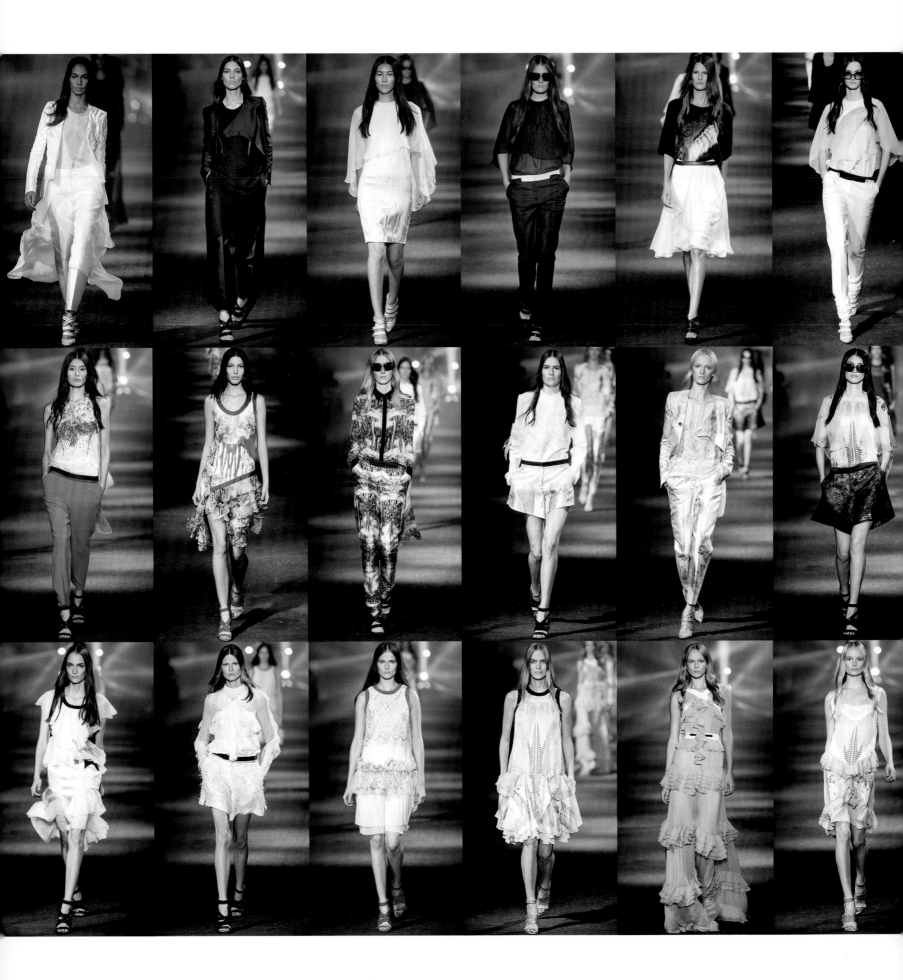

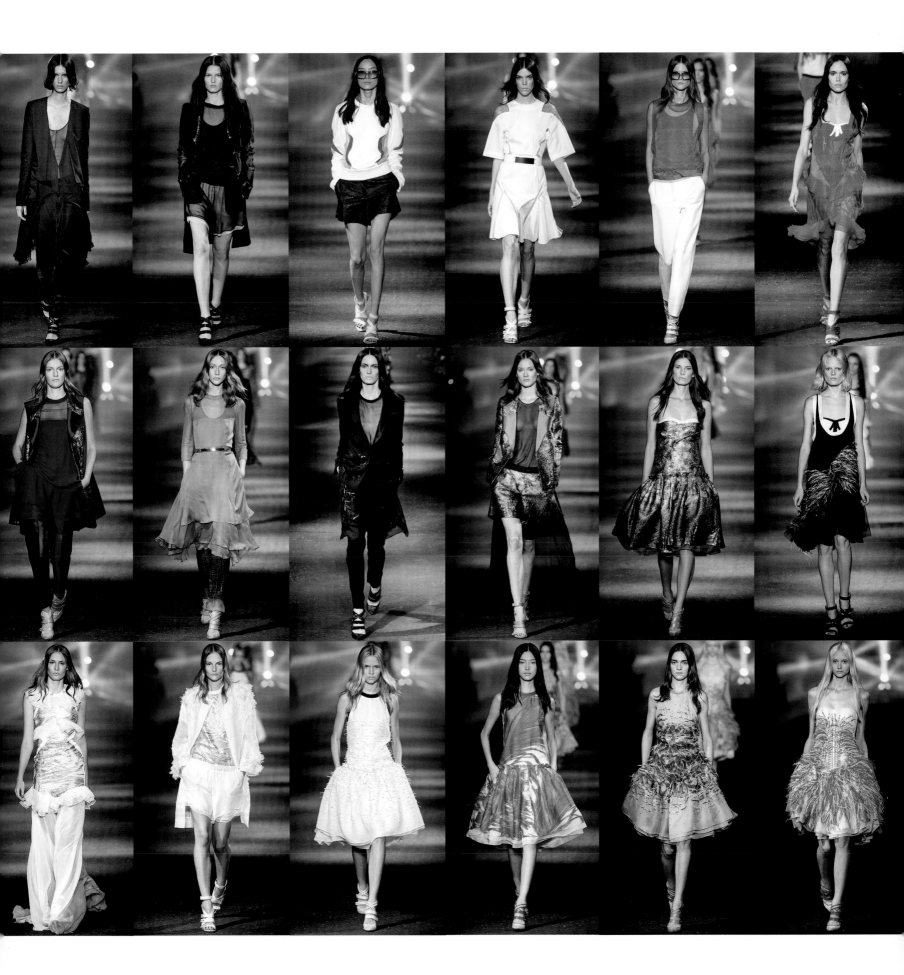

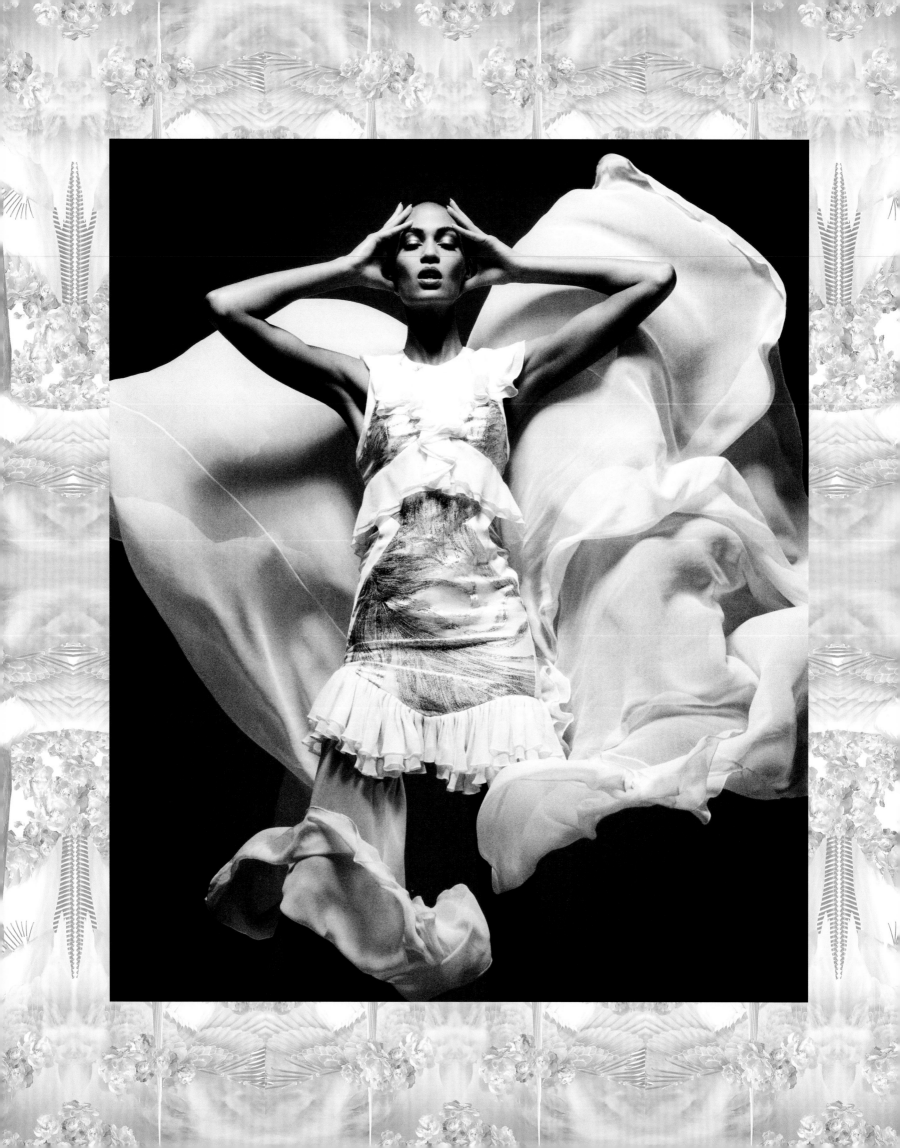

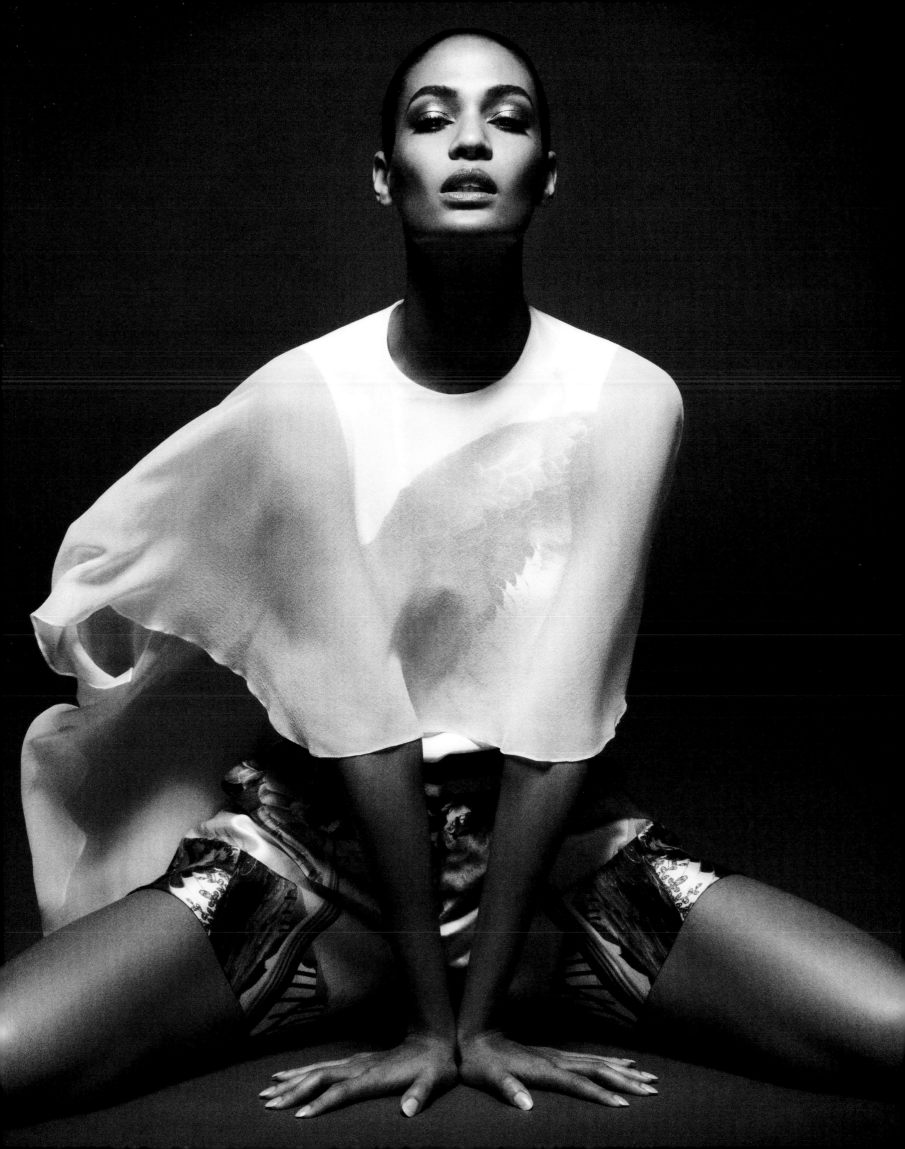

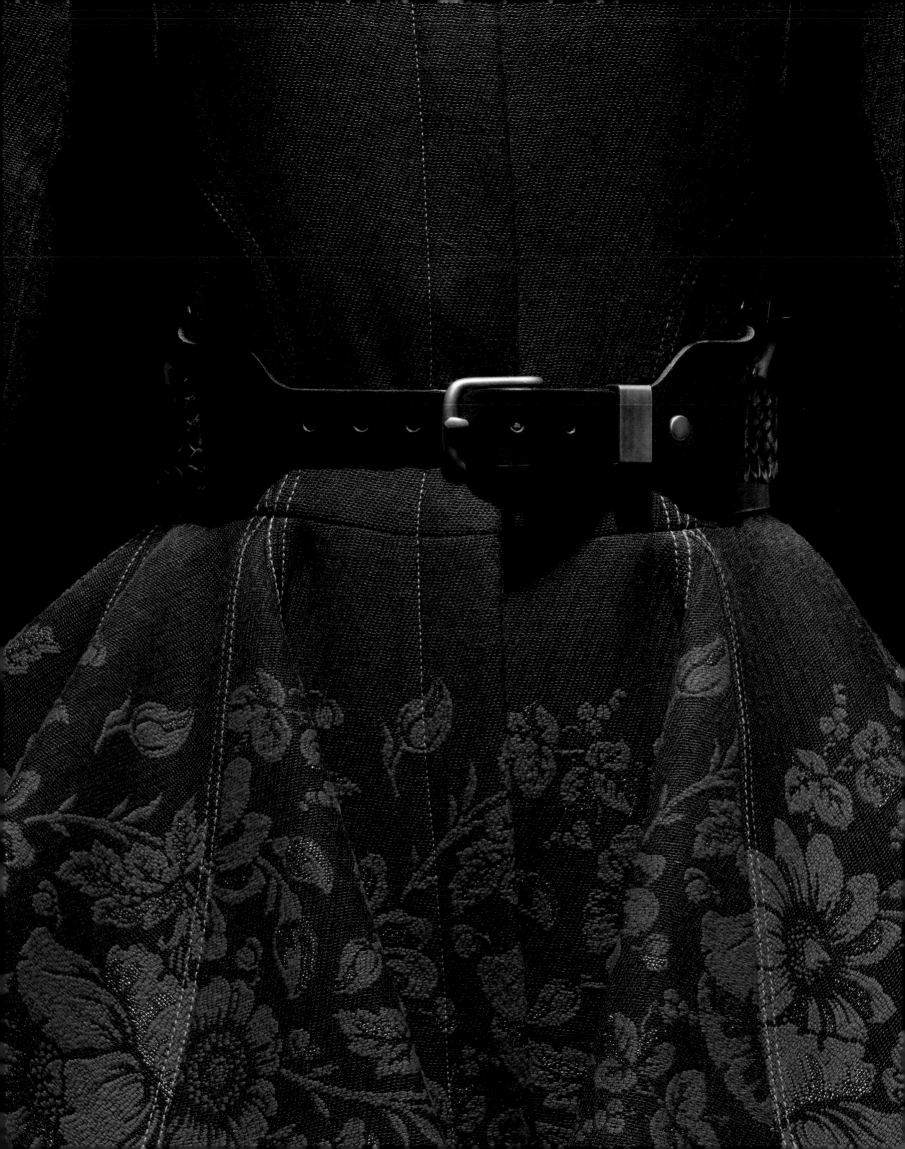

THE FEMININE DICHOTOMY In 2013, I wanted to reveal the side of women unseen by the world. We took two very different approaches in our runway collections this year, yet both explored this theme. Our first focused on women in the military, our unsung heroines. Later in the year, our Spring show delved into the nonpublic side of the great Marilyn Monroe. Through these collections, I wanted to continue to unravel the deep complexities of women and create a space to shift ownership of the female gaze back from the voyeur to the subject. During this time, I also started seeing the rise in street culture, an intriguing moment in fashion as traditional authorities began breaking down, paving the way for new voices and powerful forces. We explored the tough essence of a woman while remaining true to our glamorous roots, most notably in our collaboration with the New York City Ballet. It was a year of culture, exploration, and imagination.

2013

Fall 2013 "Armored Elegance"

This collection was dedicated to evolution, to revolution, and to the strength, vigor, and conviction of the modern women who so beautifully and bravely represent our country. In 2012, *Time* magazine named body armor for women as one of the "Best Inventions of the Year." When I first saw this feature I was inspired and decided to design a collection as a gesture of gratitude and a celebration of the empowerment of women.

While this innovation was overdue, I wanted to acknowledge the military's progress and focus on developing armor fit for a female figure, thus allowing women to be victorious as they champion equal opportunity across borders with grace, integrity, and stamina. This very perseverance is what I so admire in the women who dedicate themselves to defend freedom for all.

I simultaneously stumbled upon the story of the Asgarda tribe, a female enclave in the Ukraine where women are trained in martial arts to build self-confidence. They're empowered to combat a culture of gender inequality and trafficking. I was struck by the story of female strength being passed on through generations. I wanted to bring light to this story, to inspire us all to apply it to our own lives.

The silhouettes seen throughout the designs offered narrow shoulders and nipped waistlines, informed by the innovative, newly developed uniforms. The collection also included strong, clean silhouettes in metallic imperial brocades, rich crepe back satin, and utilitarian cotton twill. Harness belts and details convey the invigorating story of women in control, empowered. With ivory baroque-printed silk charmeuse, we are reminded of the history of our fight and the dedication to the cause, celebrating strength, bravery, grit, and femininity. Crystal hand-embroidery added light and glamour, evoking the joyous nature of a triumph that had been such a long time coming. With underwater floral and fauna digital prints, we presented the woman of today as found treasures, highlighting the radiant within a form of beauty that often is overlooked.

From the start, I built the brand on the ethos of telling multifaceted stories about varied women, and this collection did just that. Fall 2013 was a gift, a smile, a glimmer of hope to inspire momentum for a revolution that has no bounds.

OPPOSITE: THE MOOD BOARD WITH INSPIRATION FOR THE FALL 2013 COLLECTION,
CELEBRATING THE HEROISM OF OUR FEMALE SOLDIERS.

FOLLOWING SPREAD: THE FINALE FROM THE FALL 2013 SHOW. A MOMENT OF SOLIDARITY
TO HONOR THE COURAGEOUS, BRAVE, AND VIGILANT WOMEN WHO PROVIDE PROTECTION.

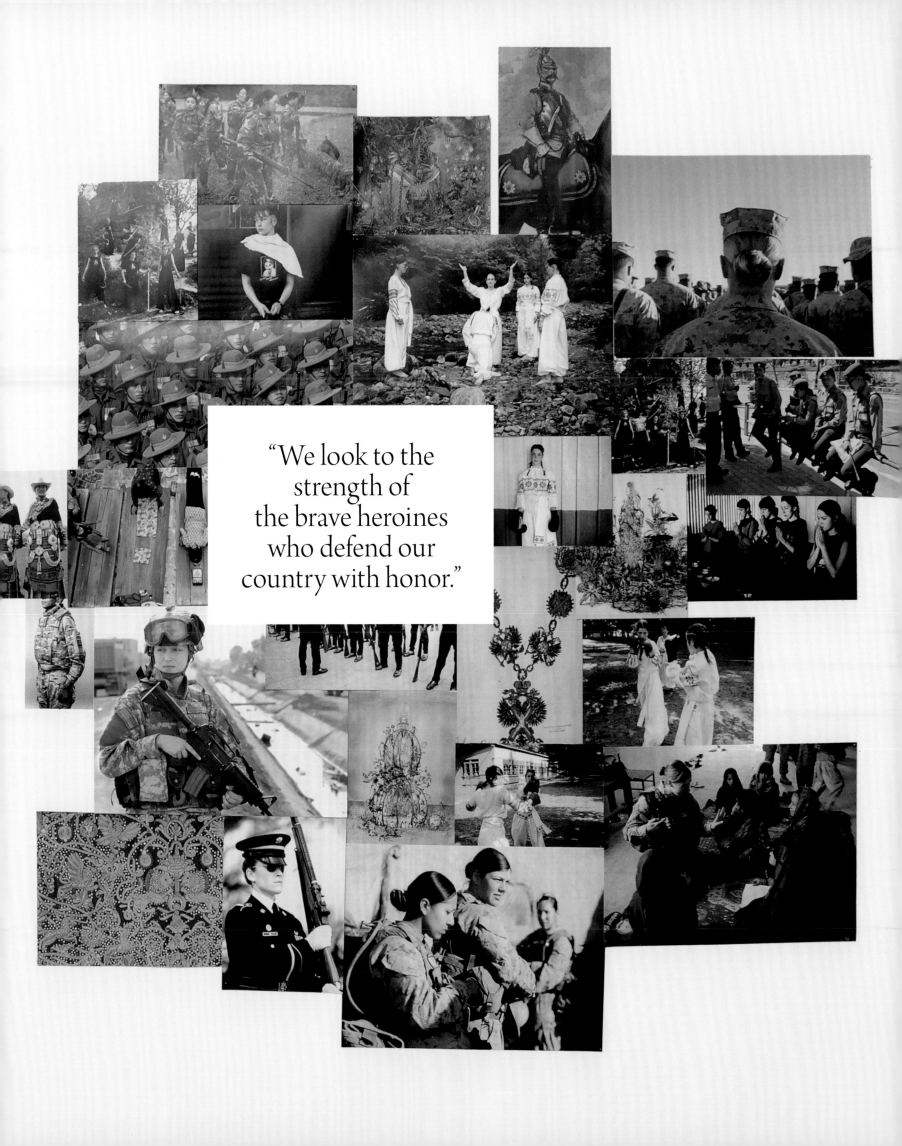

"We look to the
strength of
the brave heroines
who defend our
country with honor."

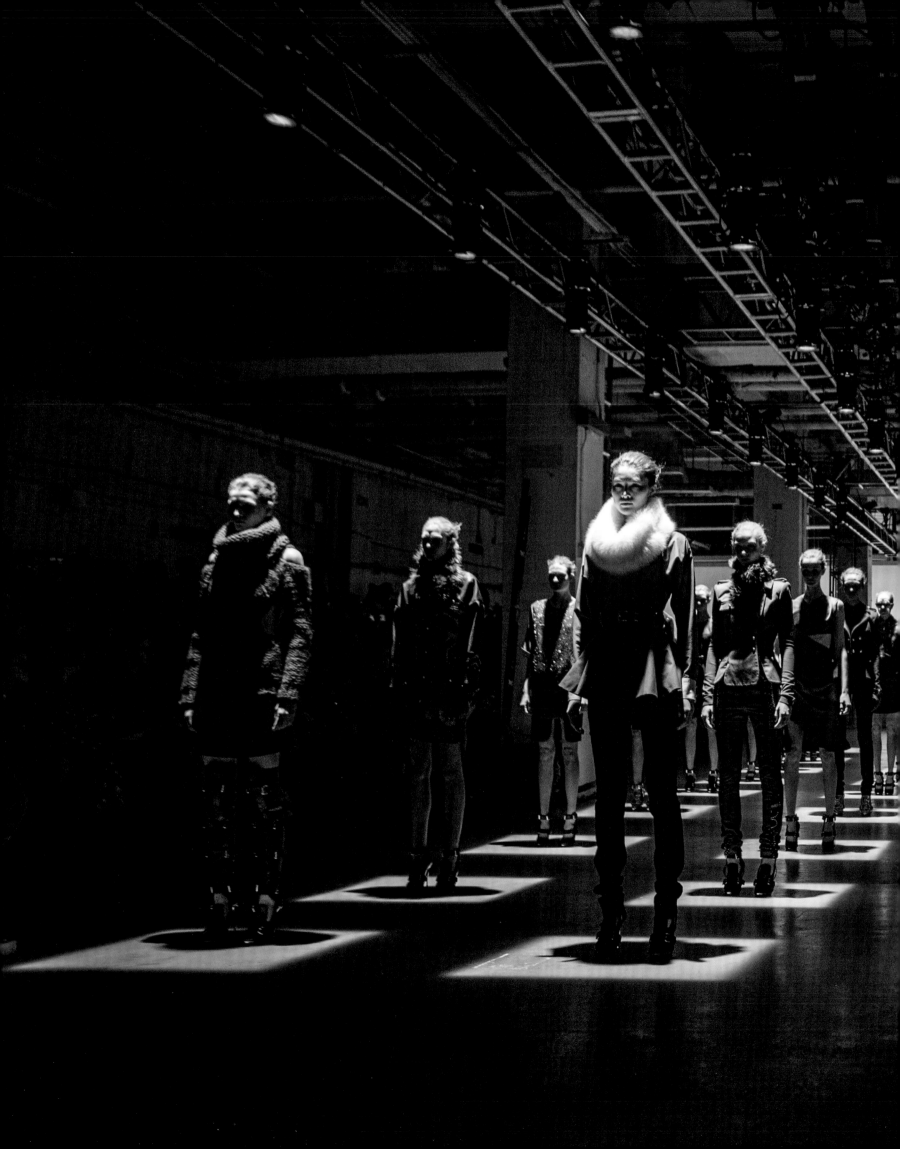

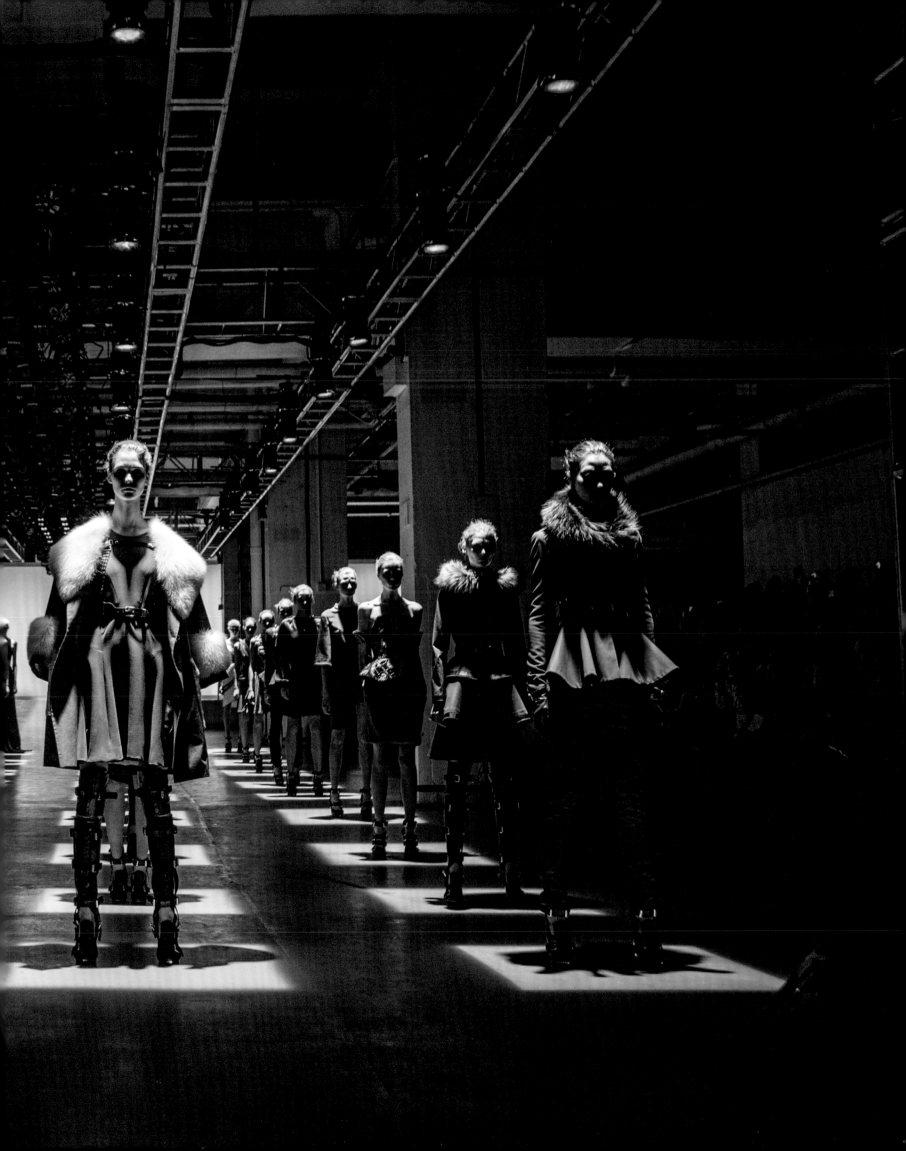

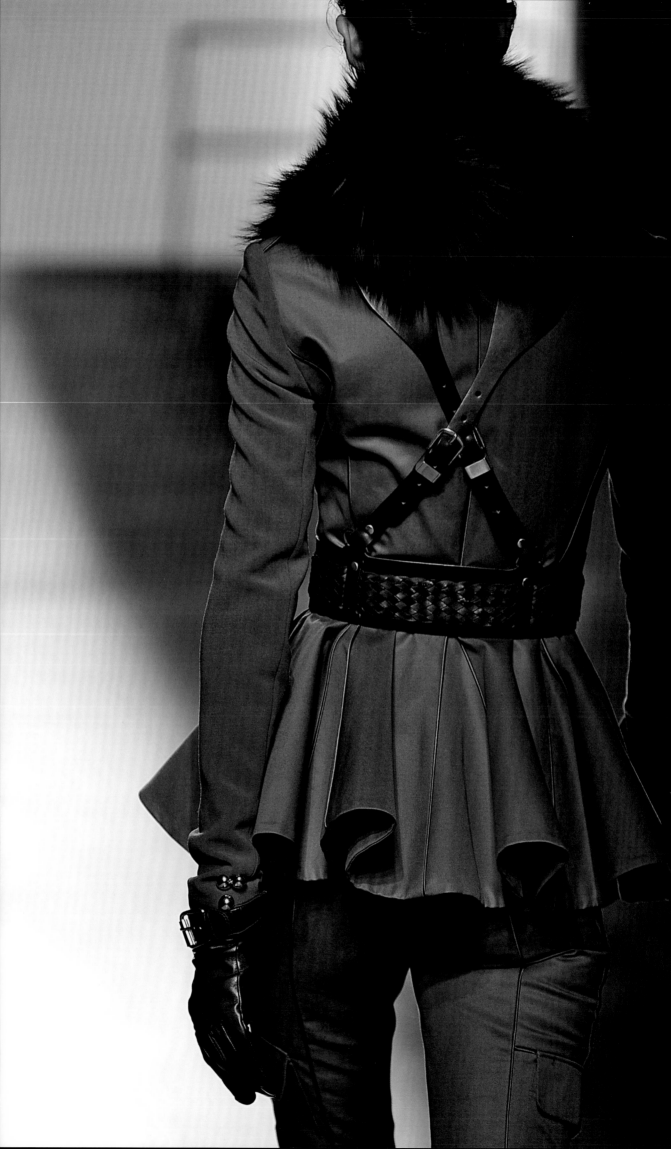

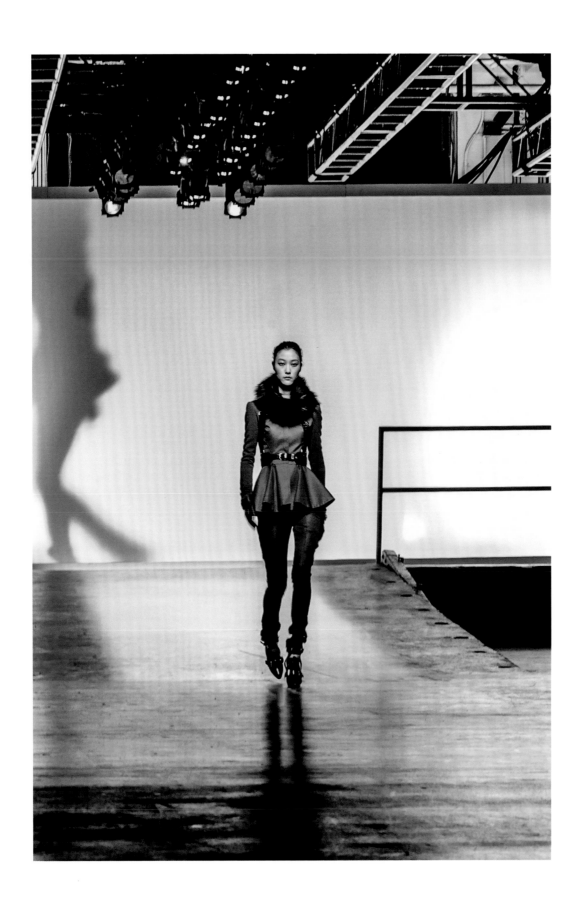

JI HYE PARK OPENS THE FALL 2013 SHOW, WEARING A LODEN GREEN COTTON POPLIN PEPLUM JACKET AND
CARGO PANTS WITH A ZANA BAYNE X PRABAL GURUNG HARNESS BELT (OPPOSITE) LAYERED ON TOP.

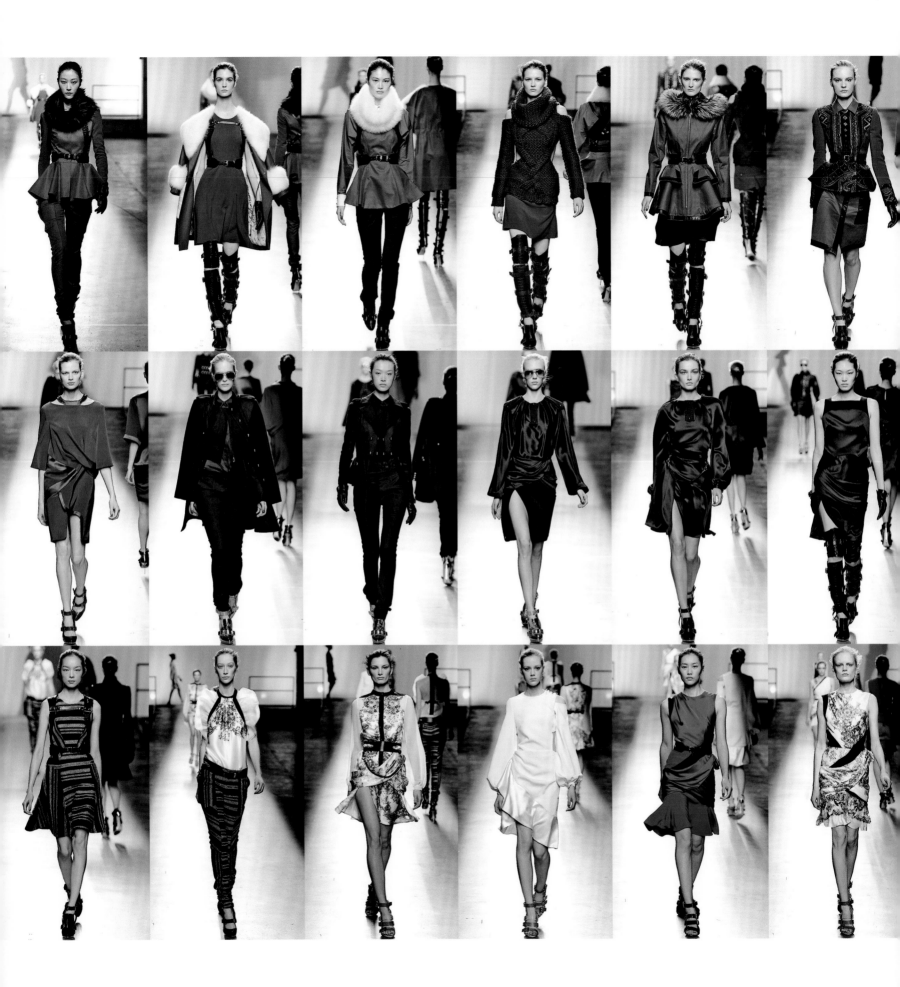

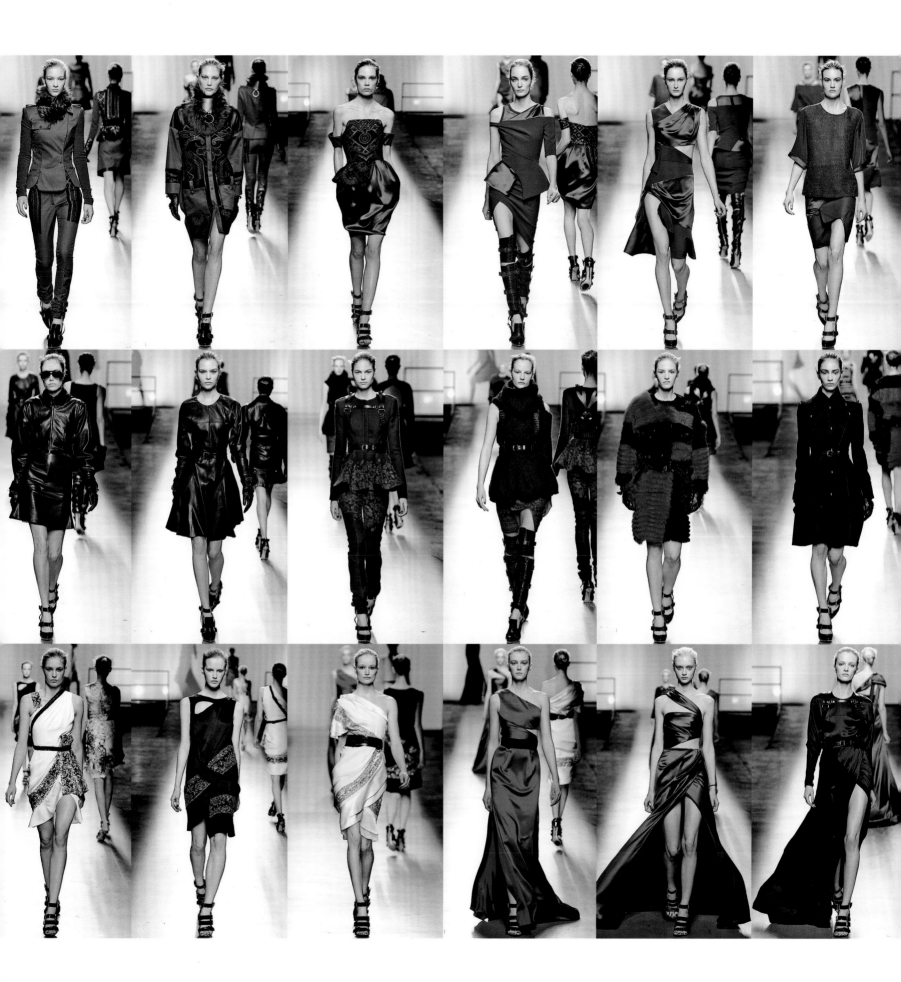

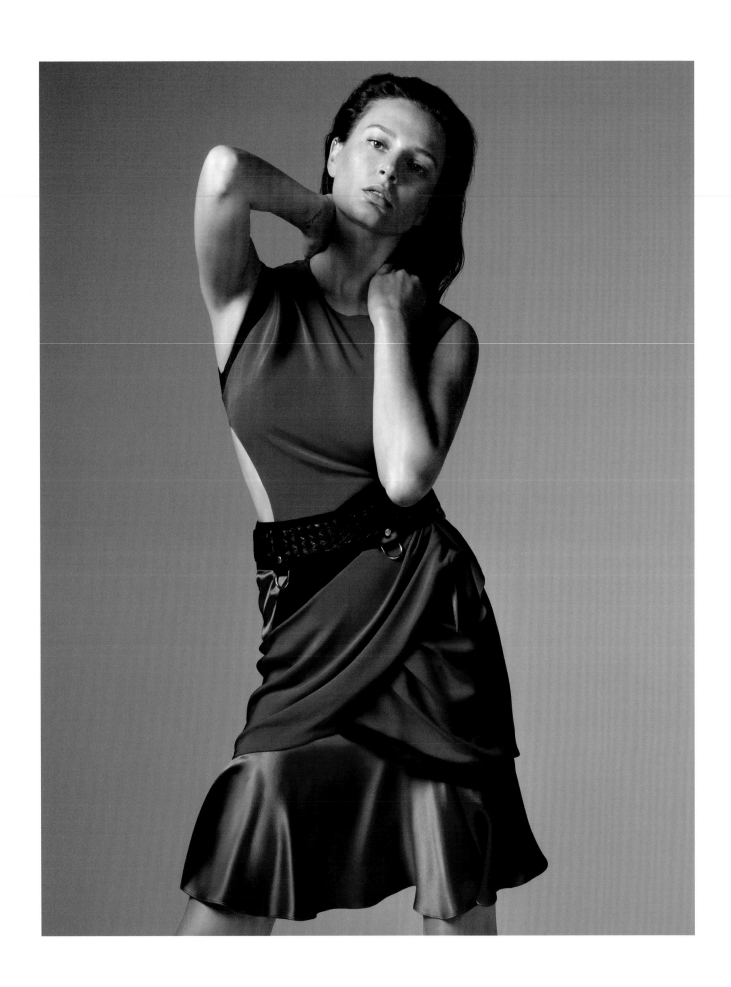

THE FALL 2013 CAMPAIGN FEATURING BRIDGET HALL. PHOTOGRAPHED BY DANIEL JACKSON.

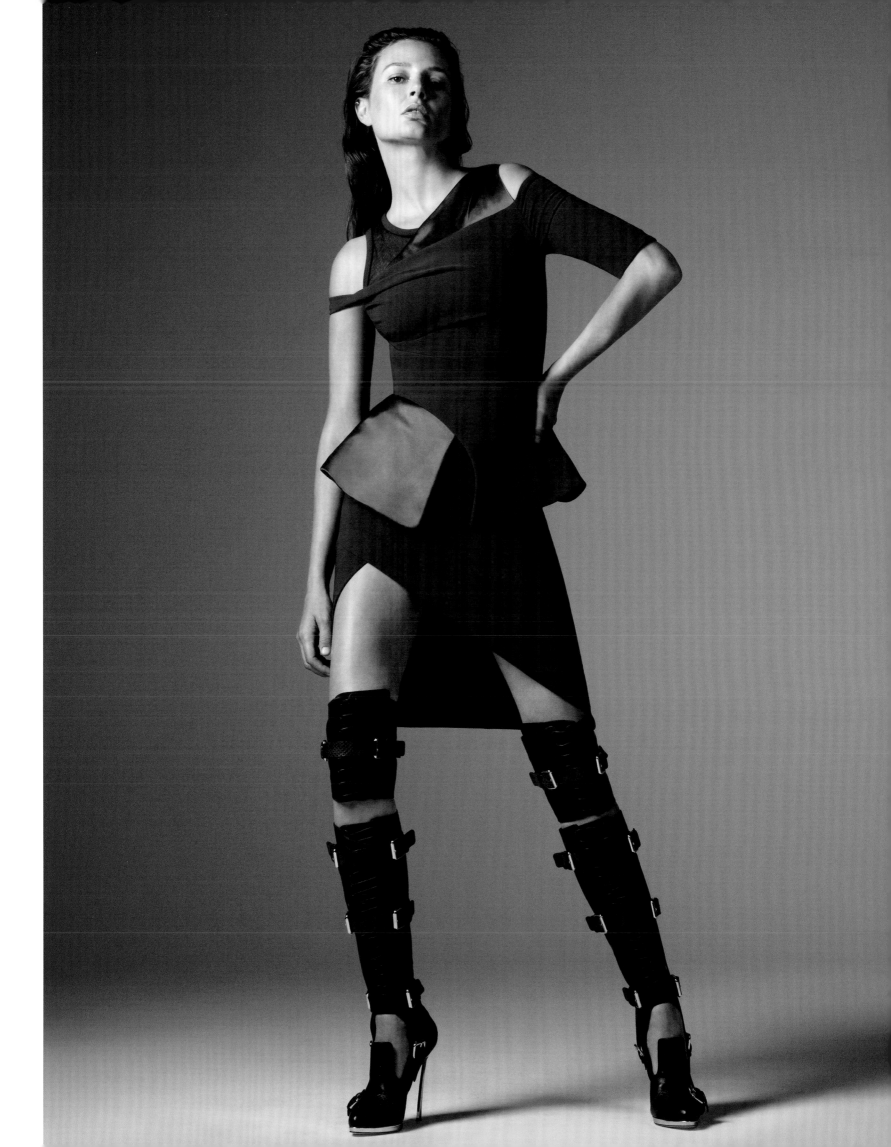

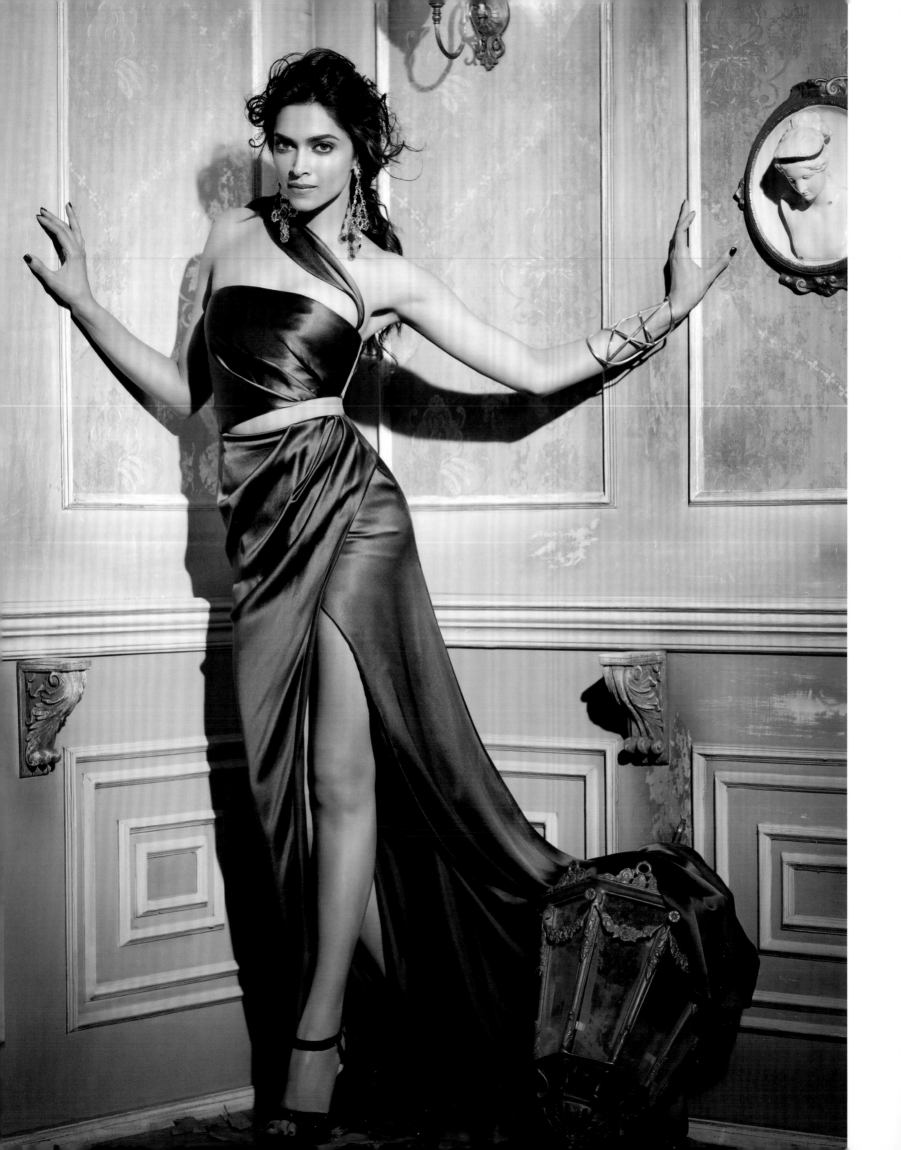

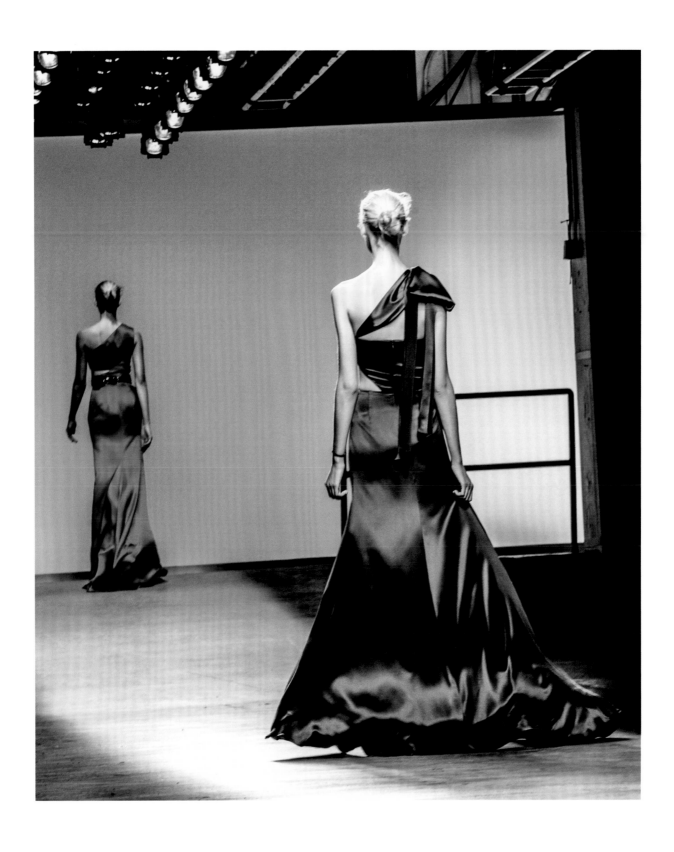

OPPOSITE: BOLLYWOOD STAR DEEPIKA PADUKONE, PHOTOGRAPHED FOR THE SEPTEMBER 2013
ISSUE OF *VOGUE* INDIA. SHE WEARS A LODEN GREEN SILK CREPE BACK SATIN HAND-DRAPED
GOWN, WHICH WAS THE CLOSING LOOK (ABOVE) FOR THE FALL 2013 SHOW.

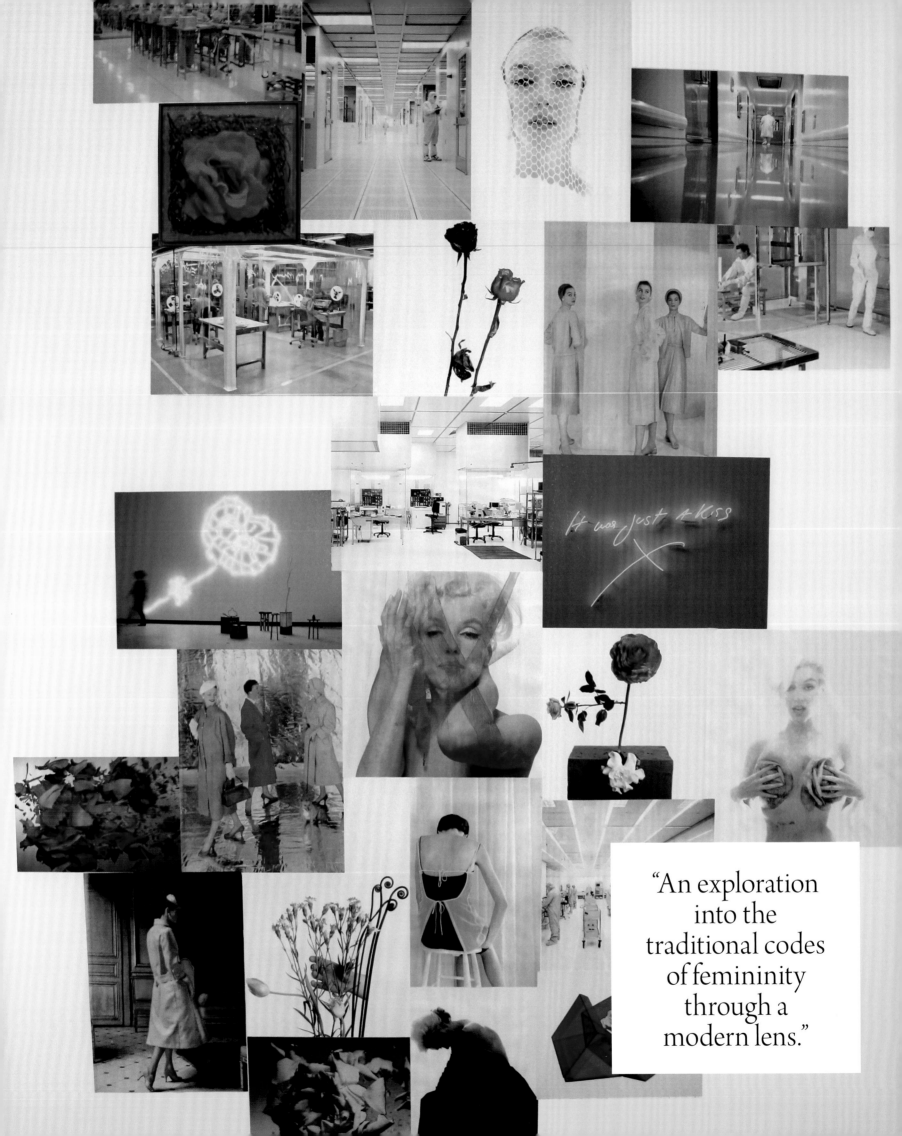

"An exploration
into the
traditional codes
of femininity
through a
modern lens."

Spring 2014 "The Nature of Voyeurism"

The Spring 2014 collection celebrated the elegant woman who has always been a source of intrigue and inspiration. I noticed that the refined sensuality of old world poise and grace was becoming an endangered species, so, for this season, we preserved the concept and added a modern twist.

It had been five years since I launched my brand, and in this time, I had been fortunate enough to dress so many inspiring muses—actresses, musicians, artists, and models. Through this process, I became fascinated with understanding the nuances and trappings of celebrity and fame.

The inspiration began with the concept of the idealized woman—a hyperfeminine pinup who is bold, colorful, and sultry with a hint of danger or bite. With this image in mind, we looked to photographer Bert Stern's *The Last Sitting* with Marilyn Monroe. Stern's arresting photographs play with curves, transparency, and skin, representing one of the most beautiful yet melancholic expressions of the female form. Looked at through a contemporary lens, this collection of imagery raises a few questions about voyeurism. Who has control? Whose gaze is presented? Does the male gaze objectify, or does the female gaze self-preserve, aware of her body, her mind, and the power of embracing her femininity? As the last images taken before her death, this series also calls on the concept of impermanence, a thought that is consistently on my mind. Amid darkness, I wanted to preserve the impression of beauty, even if for a fleeting moment in time.

The answers were translated on the runway through the collection and the set build. Our models emerged on the runway after being enclosed in plastic packages. While safeguarding their beauty and image, we also pondered the manner in which a person is looked at and objectified. During this time, the digital world was exploding. Our culture had a new level of access to dissect the lives and presentations of the celebrities we were surrounded by. The plastic boxes represented the dual intention of a showcase and a protector.

In the designs, we presented acidic pastels, grand opera coats, and frocks that form to every curve met with laminated French laces and silks, lush crepe de chine bonded cotton poplin, and digitally printed plastic and tweed weaves. We imagined a strong woman who is unafraid to celebrate the very essence of her being. The rose motif found throughout the collection illustrates expressions of layered beauty, with the danger of a thorn represented by harness detailing.

This jarring juxtaposition created the effects of the gaze when imposed by the objectifying eye. We wanted to provoke this conversation in an effort to create a space for a woman's ownership, vulnerability, and complex beauty, where her last sitting is a mirror to the way she chooses to portray herself.

OPPOSITE: THE MOOD BOARD WITH INSPIRATION FOR THE SPRING 2014 COLLECTION, FEATURING PHOTOS OF MARILYN MONROE AND TRACEY EMIN'S ICONIC NEONS.

109

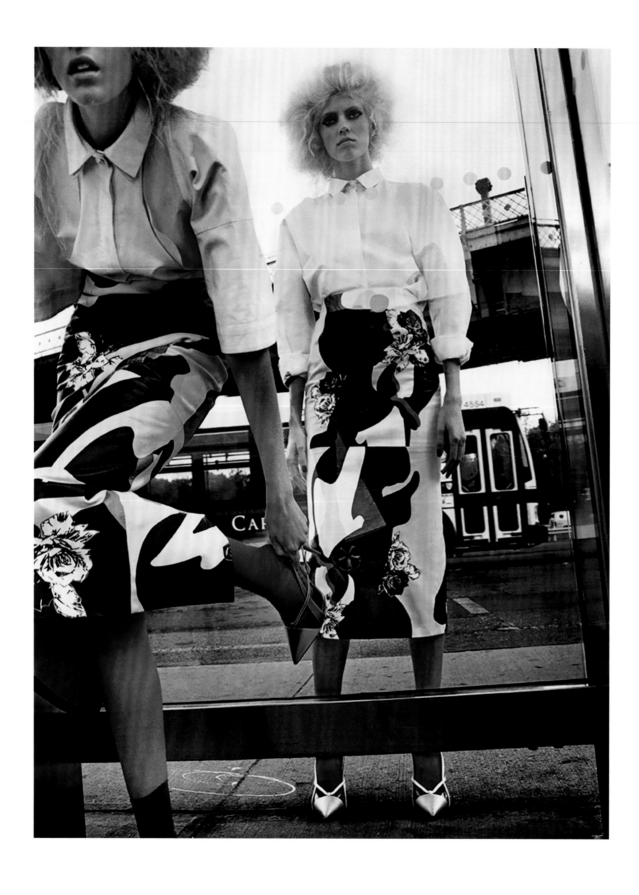

ABOVE: LOUISE PARKER AND DEV WINDSOR, PHOTOGRAPHED BY CHRISTIAN
MACDONALD FOR THE DECEMBER 2013 ISSUE OF *INTERVIEW* MAGAZINE.

OPPOSITE: A BOARD WITH THE SPRING 2014 FABRIC SWATCHES—A MÉLANGE
OF PASTELS AND ACID TONES FEATURING A FLORAL MOTIF, A SIGNATURE DETAIL
SYMBOLIZING OUR CONCEPT OF "FEMININITY WITH A BITE."

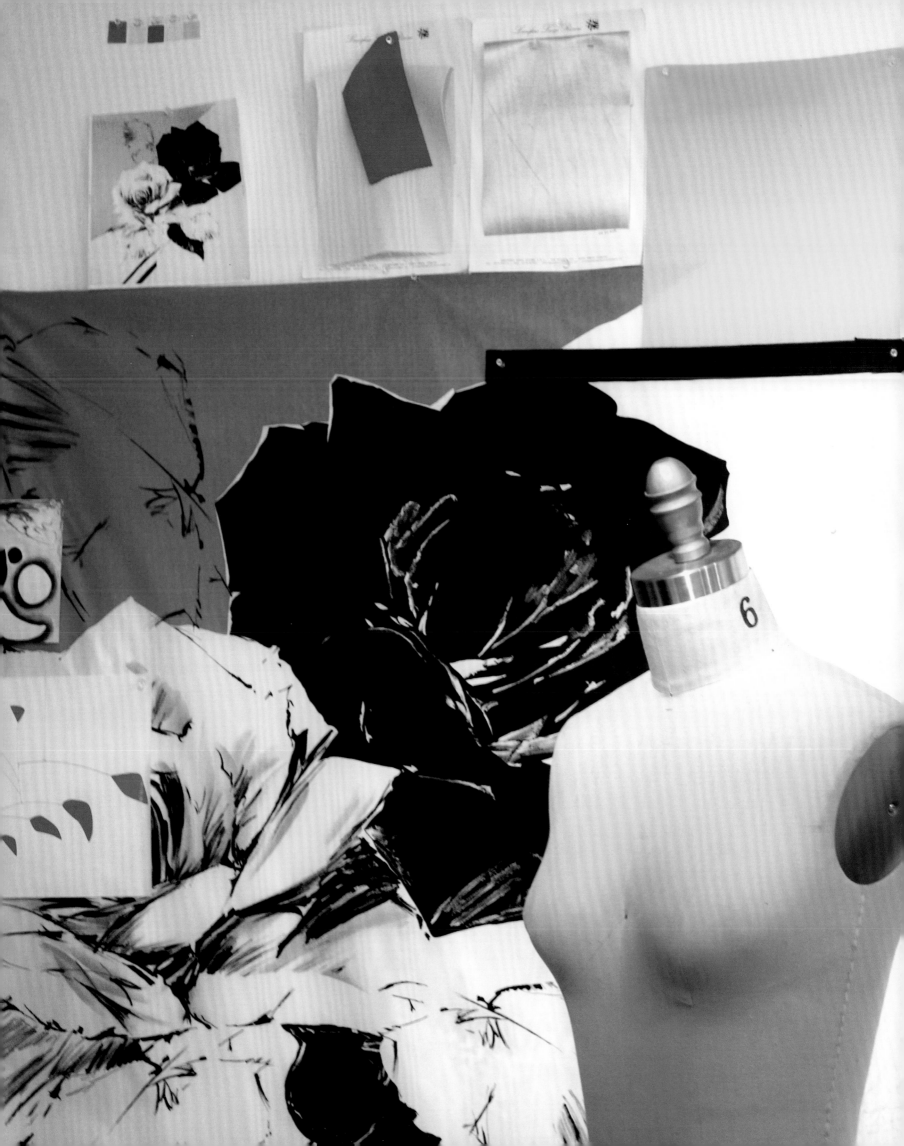

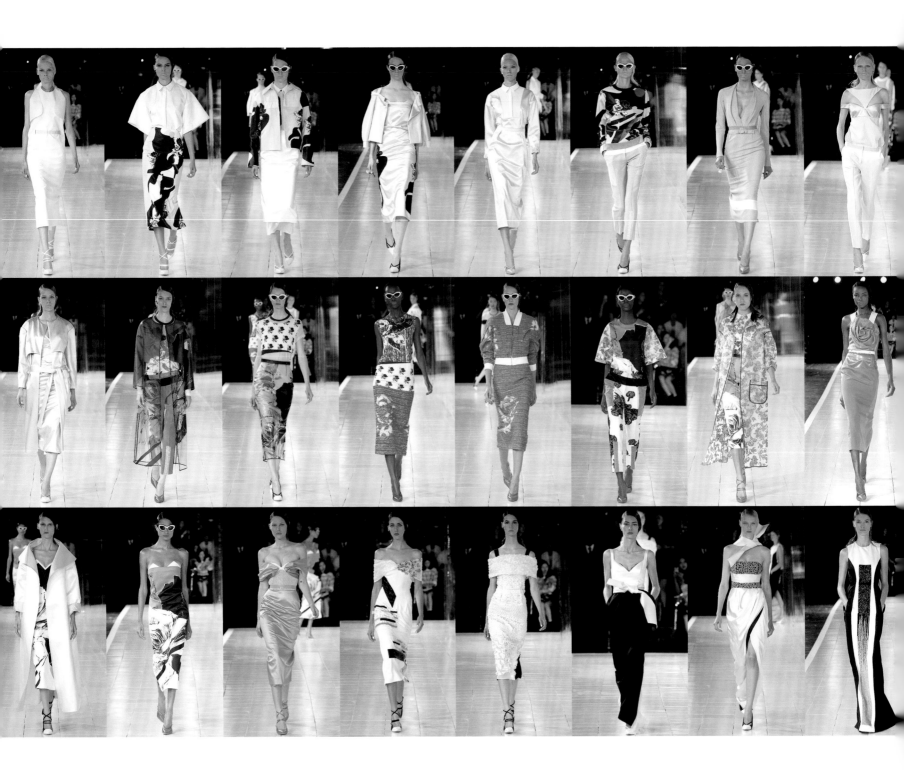

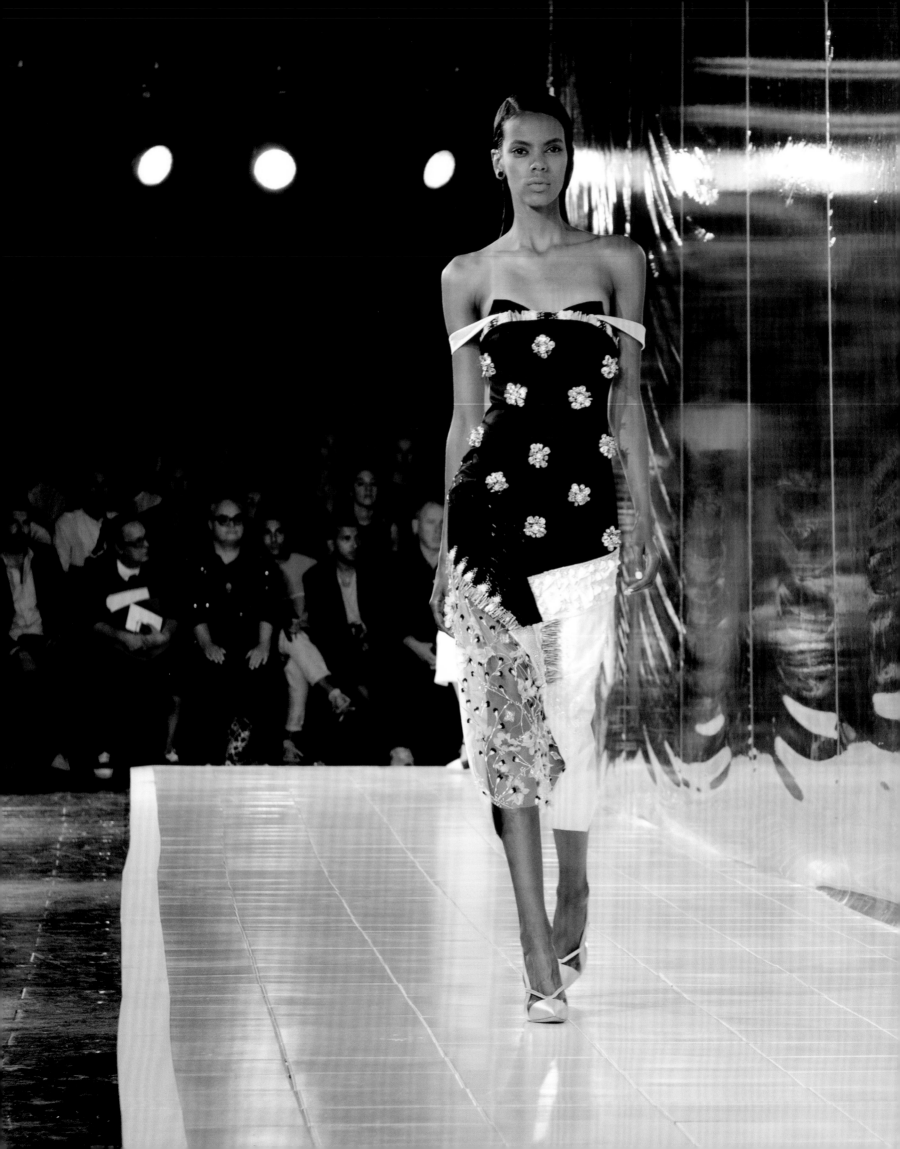

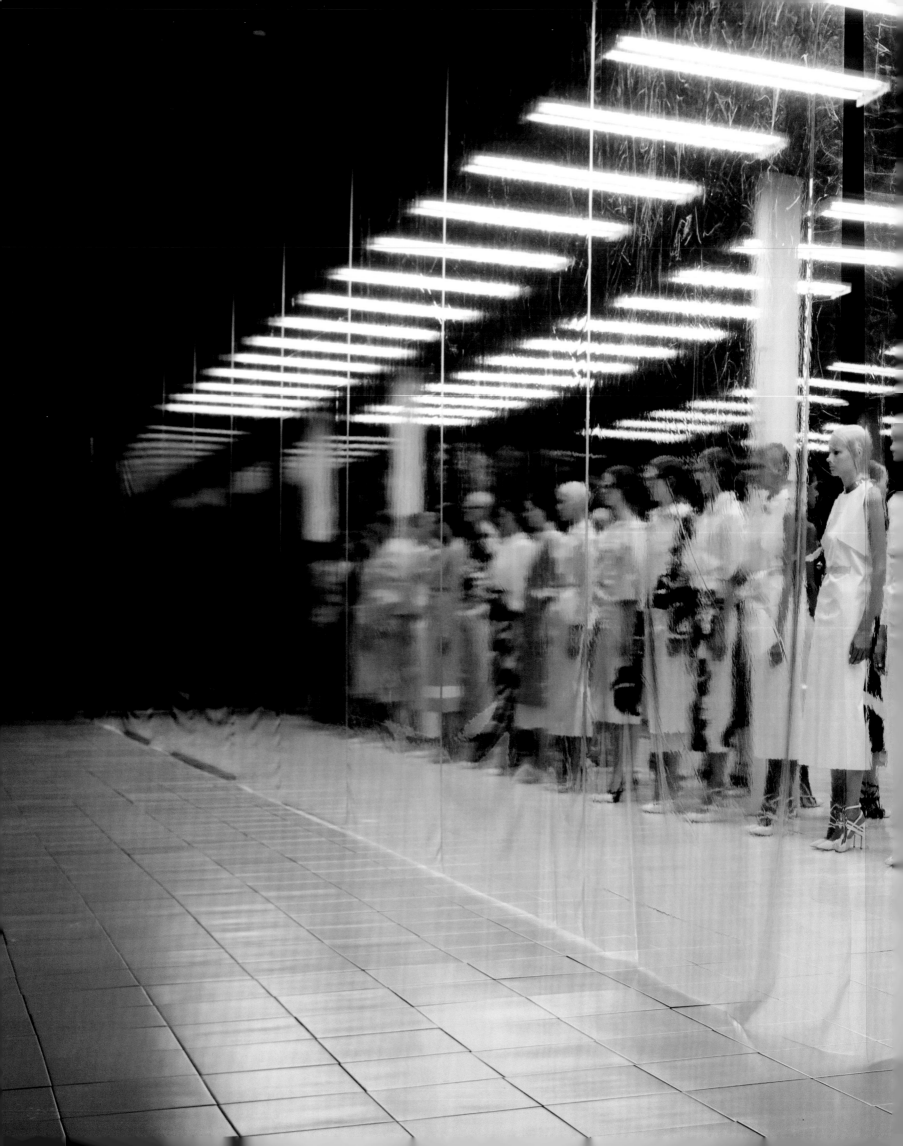

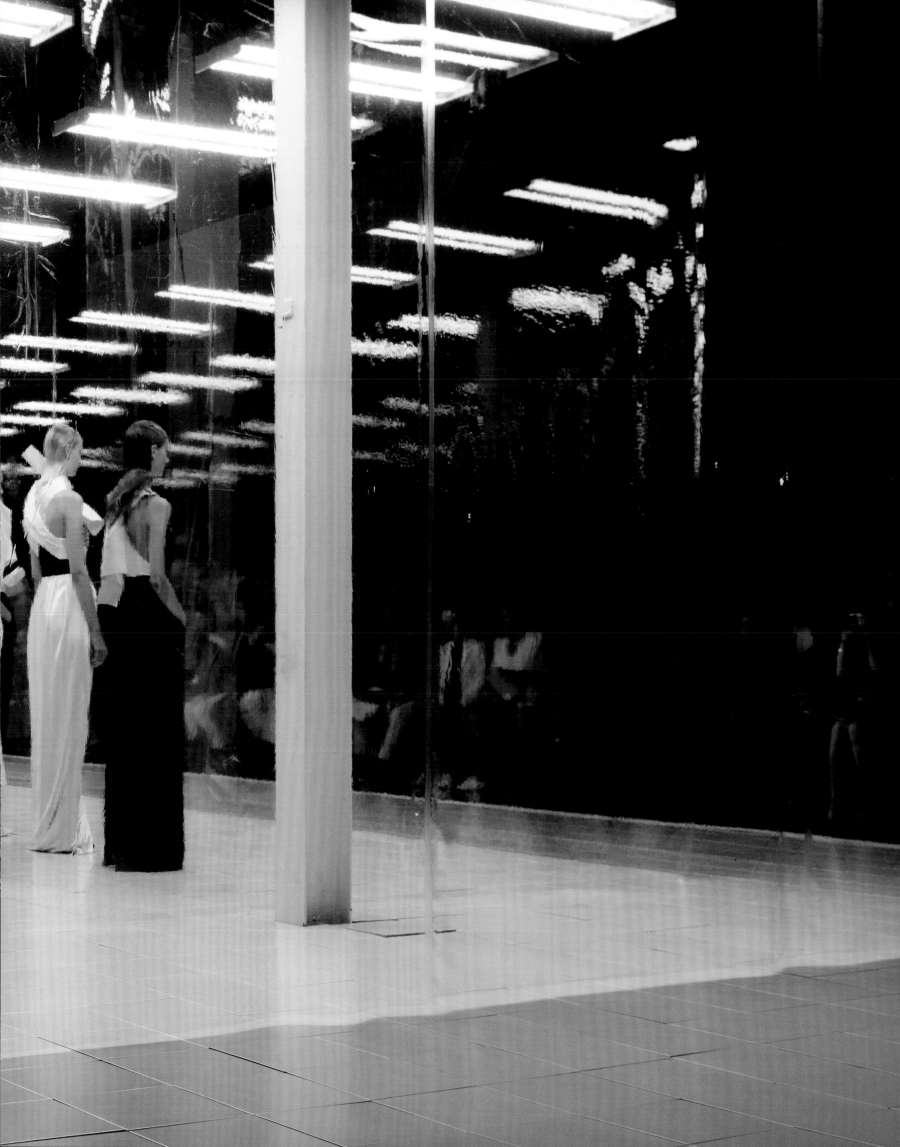

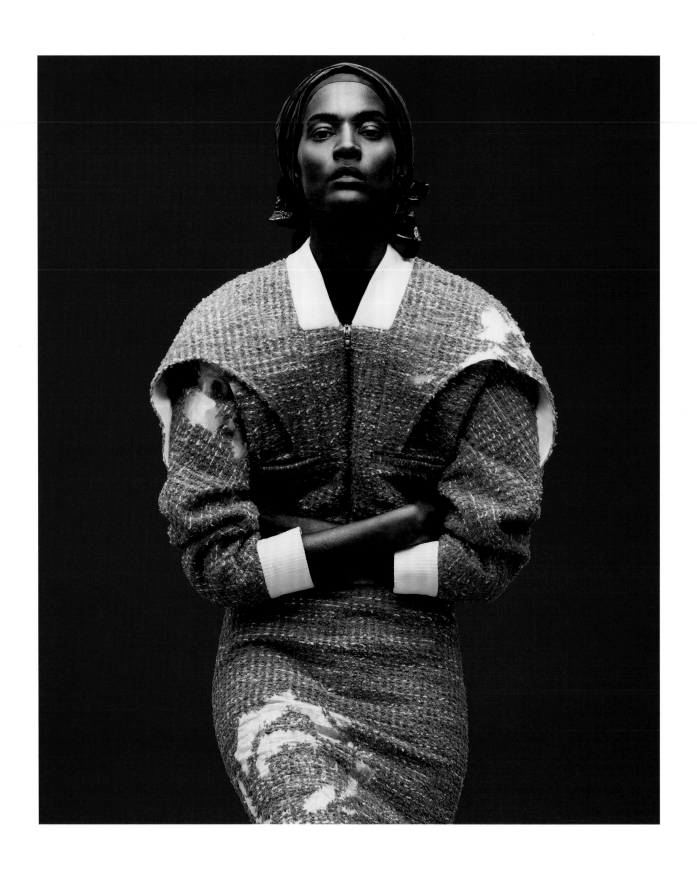

THE SPRING 2014 CAMPAIGN FEATURING LIYA KEBEDE.
PHOTOGRAPHED BY DANIEL JACKSON.

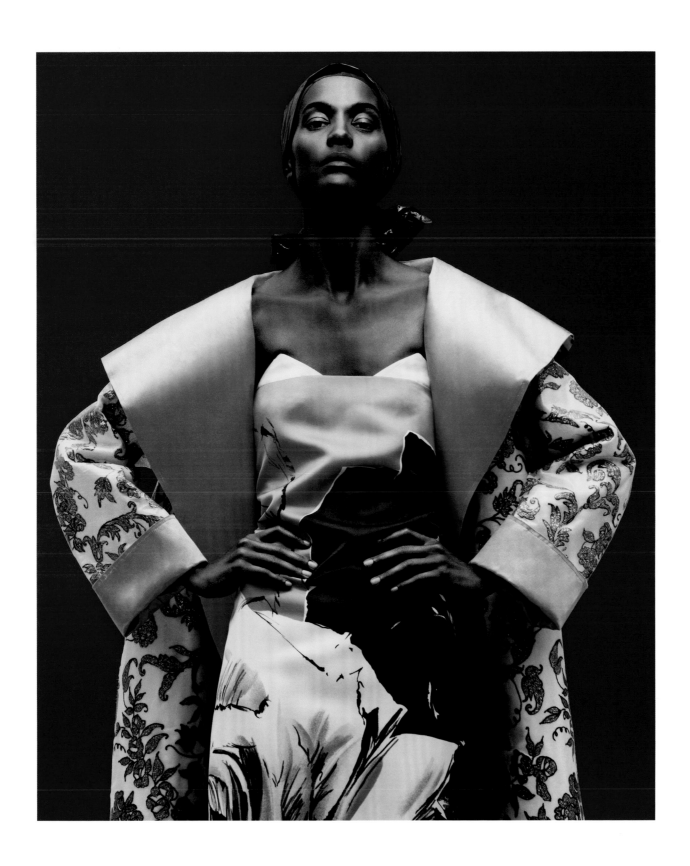

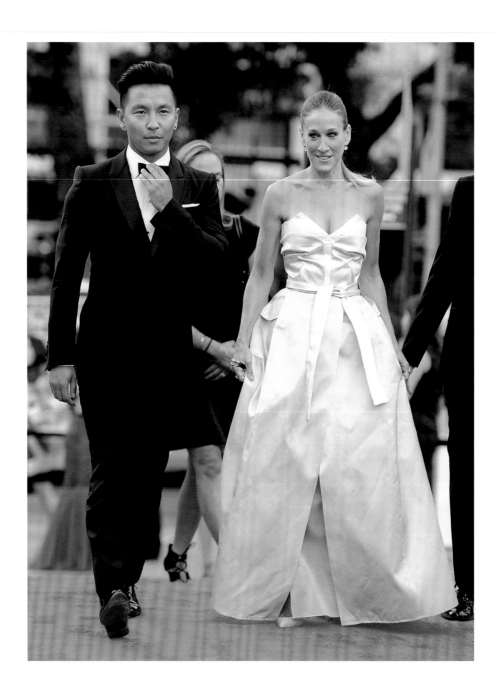

Save Us a Dance

In late 2013, I collaborated with choreographer Justin Peck for the New York City Ballet Fall 2013 Gala. My dear friend and incredible muse Sarah Jessica Parker, for whom I created a custom look in our New York Atelier, hosted the Gala. This was such a special project—one of creativity, passion, artistic beauty, and love. I am so grateful that Sarah Jessica brought me on board to design the costumes (sketch opposite) for such an iconic performance. This is one of those moments that will forever be weaved into the heritage of New York, and it truly feels surreal.

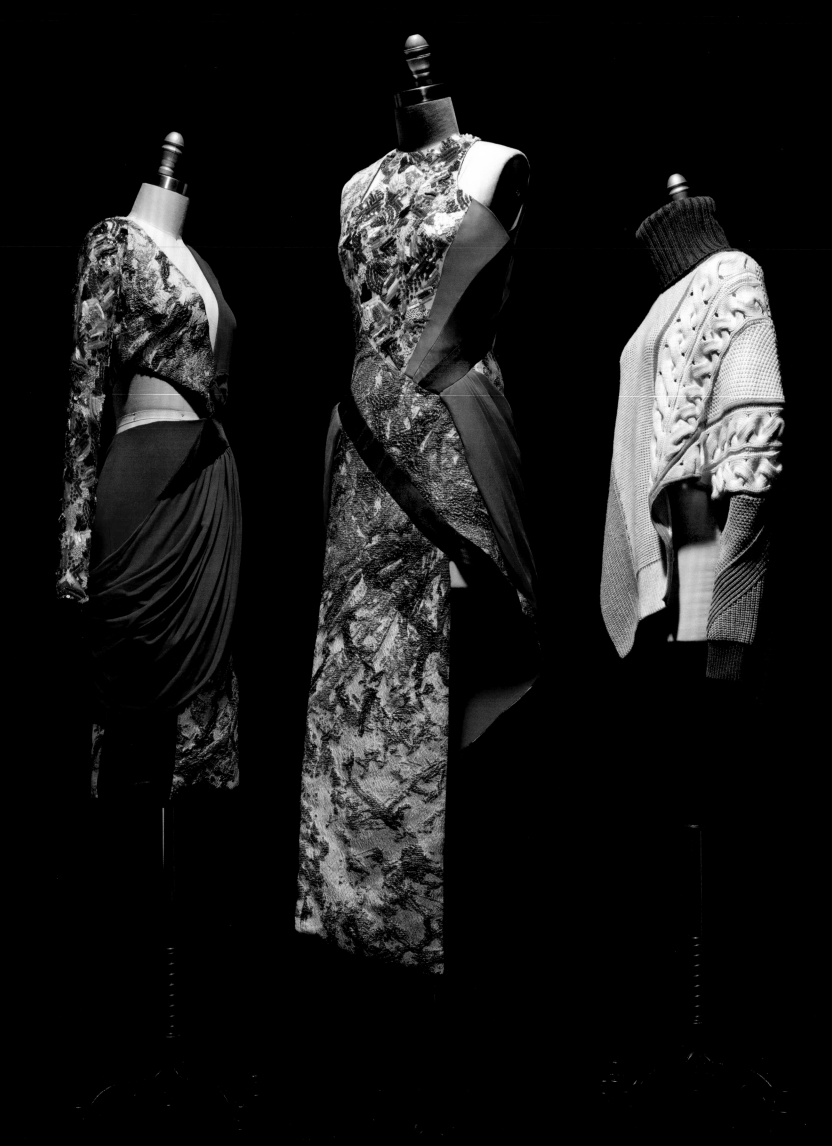

2014

HOMECOMING Two thousand fourteen was the top of the crescendo in the way we celebrated the spirit of my homeland. While the soul of our brand has always been rooted in my heritage, my voice and dedication to the place that so defines me were at their highest at our halfway mark. I returned to Nepal prior to designing the Fall 2014 collection and my trip reinvigorated my love, admiration, and appreciation for the Eastern world. I was so enamored with the colors and textures I experienced on my journey, and I wanted to share my story in a more overt and defined scale. In that collection, we blended my love for couture evening wear—translated into hand-embroidered beadwork and feathers and hand-draped chiffon dresses—with modern knitwear that was hand-sewn by female artisans in Nepal. It is and always has been important to me to create with artisans in Nepal; I feel a strong responsibility to highlight the craft of my country and to also create employment opportunities for women who wouldn't otherwise have access to equal pay and ethical standards. Fashion design is my vehicle to communicate who I am and what I stand for, and my connection to India and Nepal will always be deeply embedded in my work.

Fall 2014 "Transfixed by the Shangri-La"

We began our journey in the Mustang region of the Himalayan Mountains, nestled in my homeland of Nepal. I returned home to Nepal the year prior, and was able to reconnect with the land in a deeply spiritual way. One of my biggest thrills has always been trekking and hiking the Himalayas—the magnificence of the land enables me to dream that anything imaginable is achievable, to dream the impossible. However, the magnitude of the natural space is also quite humbling.

This recent journey reinvigorated my love, admiration, and appreciation for the Eastern world that so defines my upbringing and experience. Our show was a celebration of the soul of my home, a world unknown to so many. I wanted to share our story and culture with a new audience. We set the stage with mystical golden gongs, a sound and image that invoke memories from my childhood. I wanted to bring the magic of my unique experience to my fashion community, to transport them on a transcendental level.

The Fall 2014 inspiration was rooted in the history of the last remaining Shangri-La, a spiritual discovery I've always dreamt about. We blended my love for couture evening wear, translated into organza tweeds, hand-embroidered beadwork, feathers, and hand-draped chiffon dresses, with modern knitwear hand-sewn by female artisans in Nepal. We juxtaposed this historic place with textiles inspired by contemporary artist Cecily Brown's vivid abstract brushwork paintings, creating a tapestry that pays homage to the artisanal spirit. Cecily's body of work and her overall persona have an unburdening quality. We had a conversation about how she creates by designing her own fresh slate and removing modern-day demands and critical noise. She carves out a clean and renewed space to be able to paint freely, with passion. Hues of ivory, midnight, bordeaux, crimson, rhododendron, and cantaloupe signify the strength and passion innate to our muse who inspires us. We also introduced luxe knitwear through tonal cashmere shawls—handmade in Nepal with love and soul—and hand-braided sweaters that speak to our curious global explorer.

OPPOSITE: THE MOOD BOARDS WITH INSPIRATION FOR THE FALL 2014 COLLECTION, MIXING THE
STORY OF THE HISTORIC SHANGRI-LA WITH THE WORK OF CONTEMPORARY ARTIST CECILY BROWN.

124

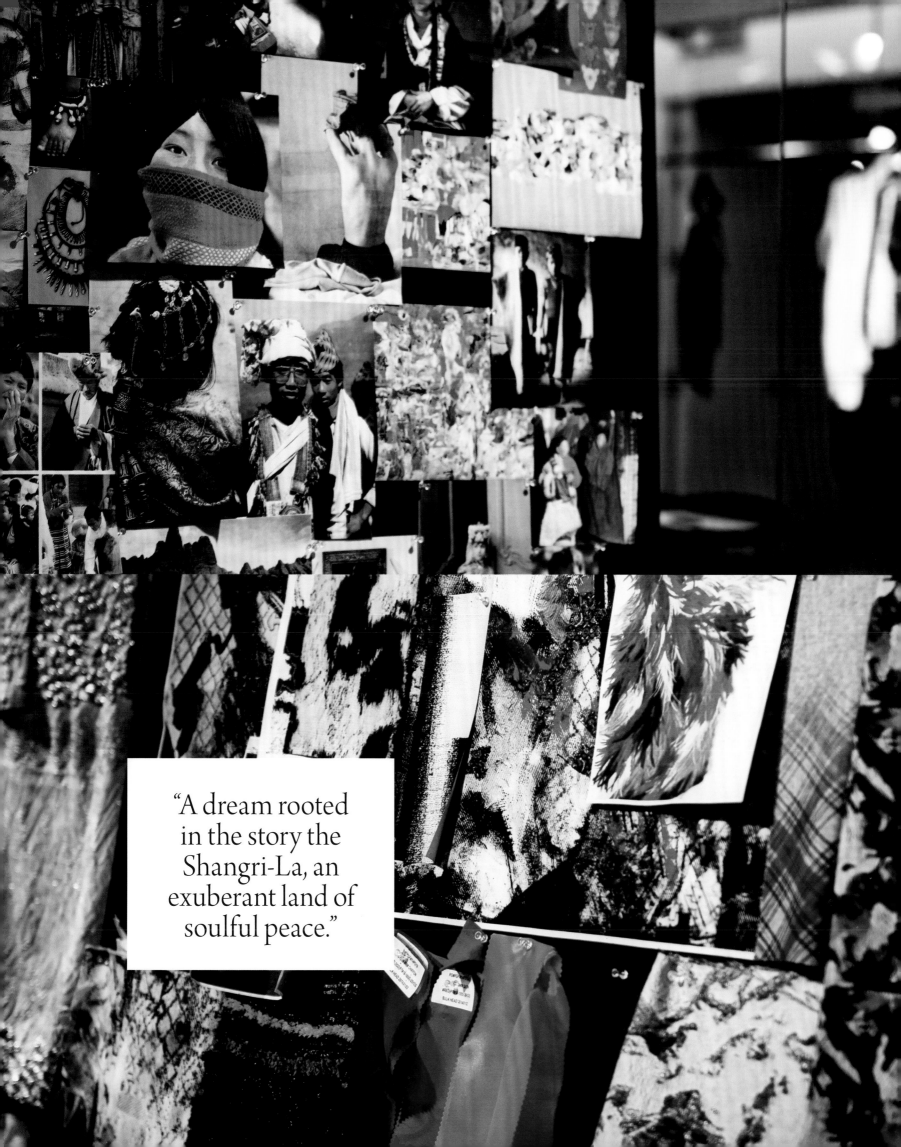

"A dream rooted in the story the Shangri-La, an exuberant land of soulful peace."

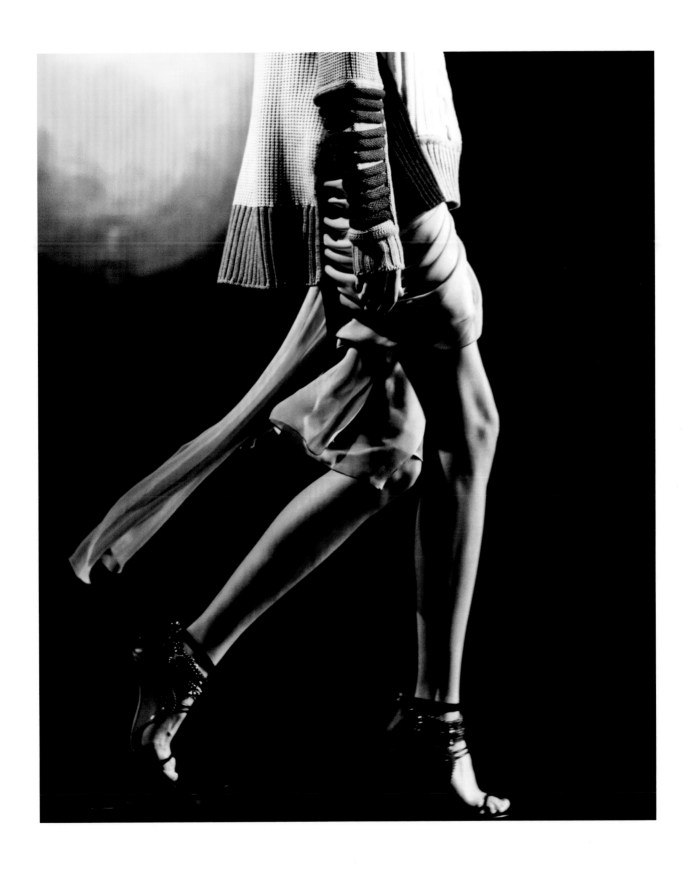

ABOVE: THE SHOW FEATURED KNITS HANDMADE IN NEPAL AND A RUNWAY
ACCENTED BY SPIRITUAL GONGS.

OPPOSITE: THE PAINTED BRUSHSTROKE TEXTILES SEEN THROUGHOUT THE
COLLECTION WERE INSPIRED BY THE ARTIST CECILY BROWN.

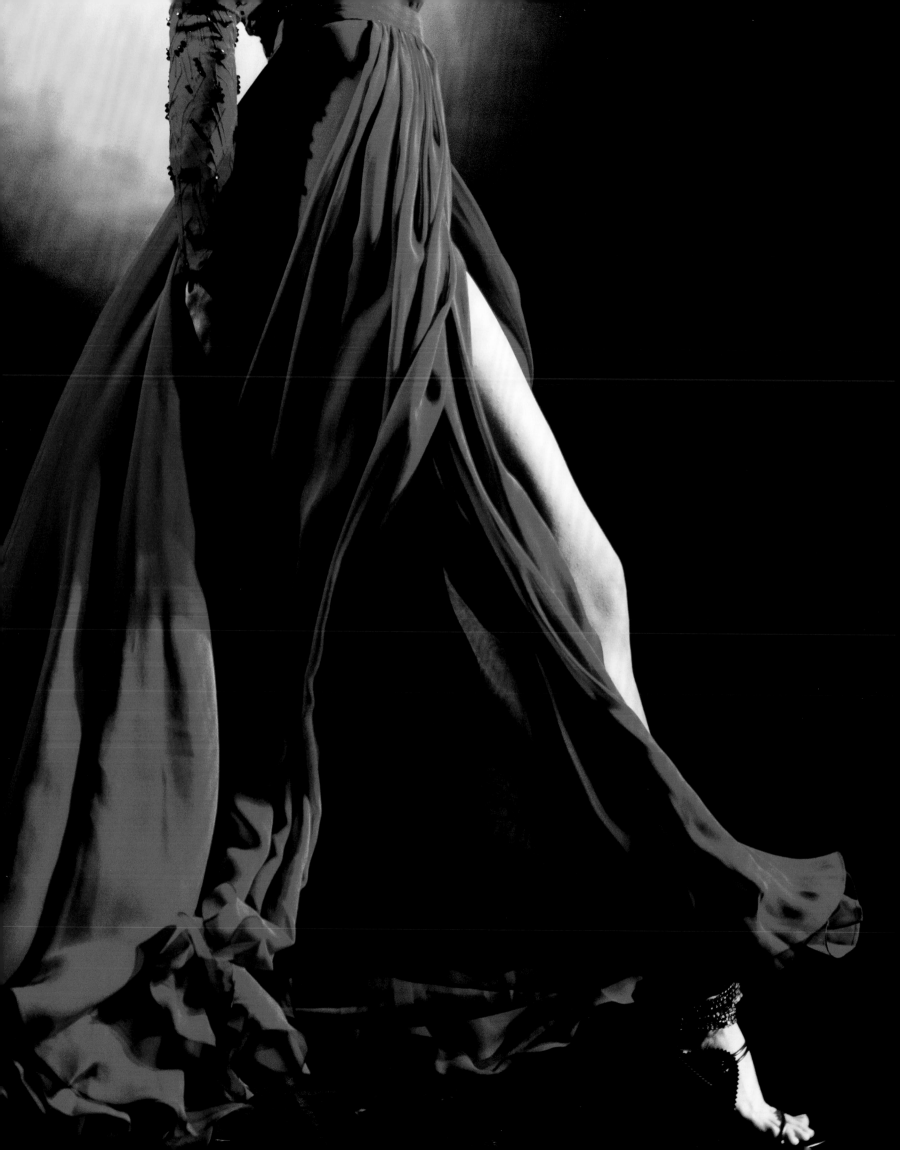

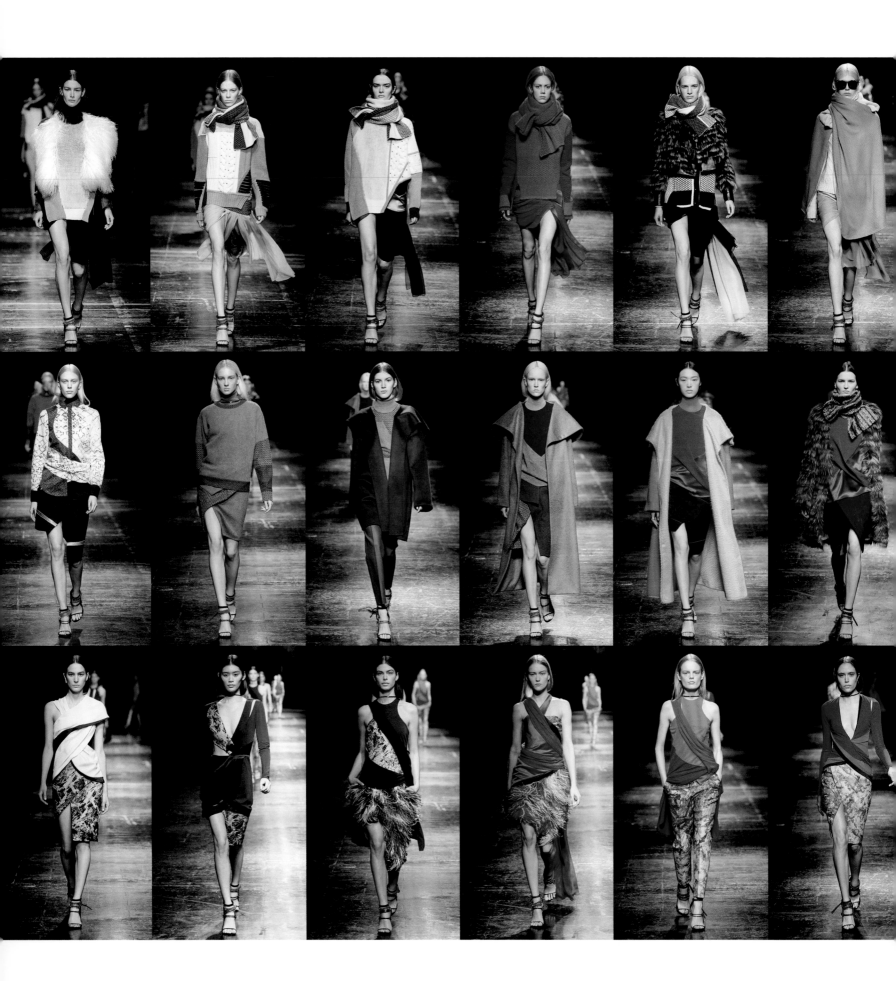

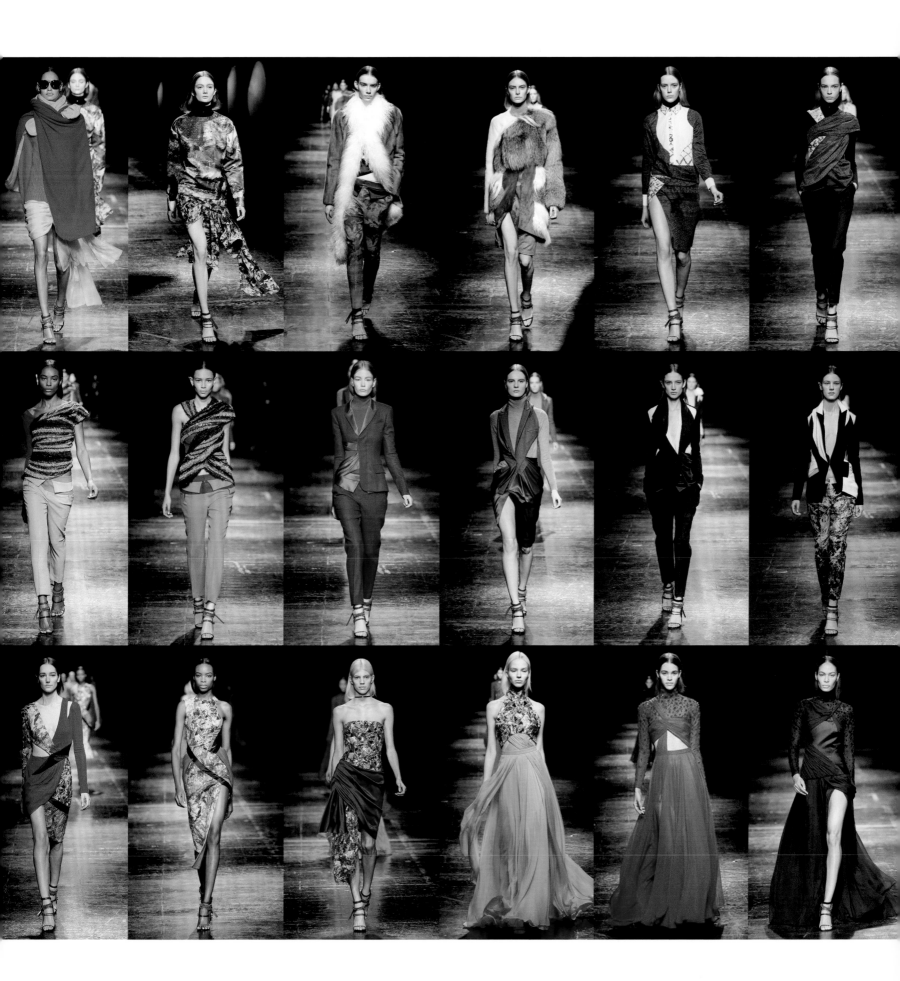

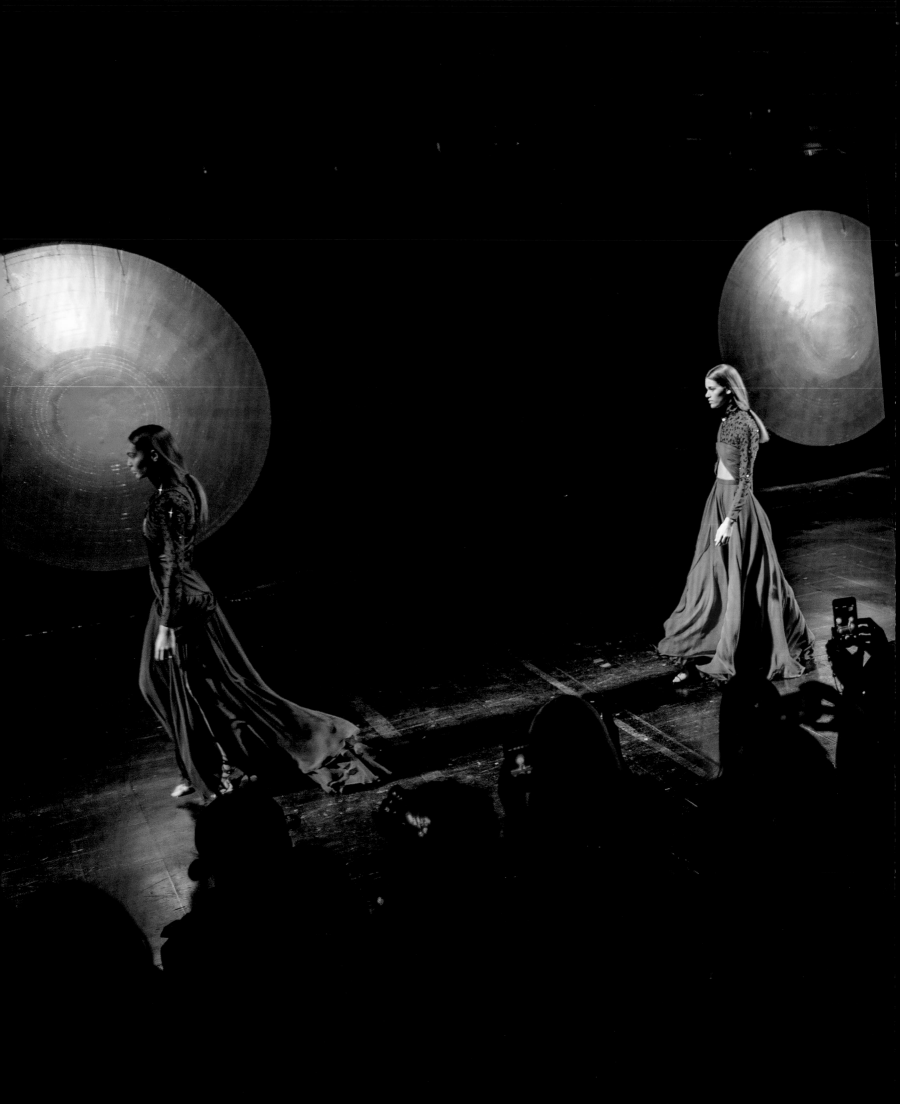

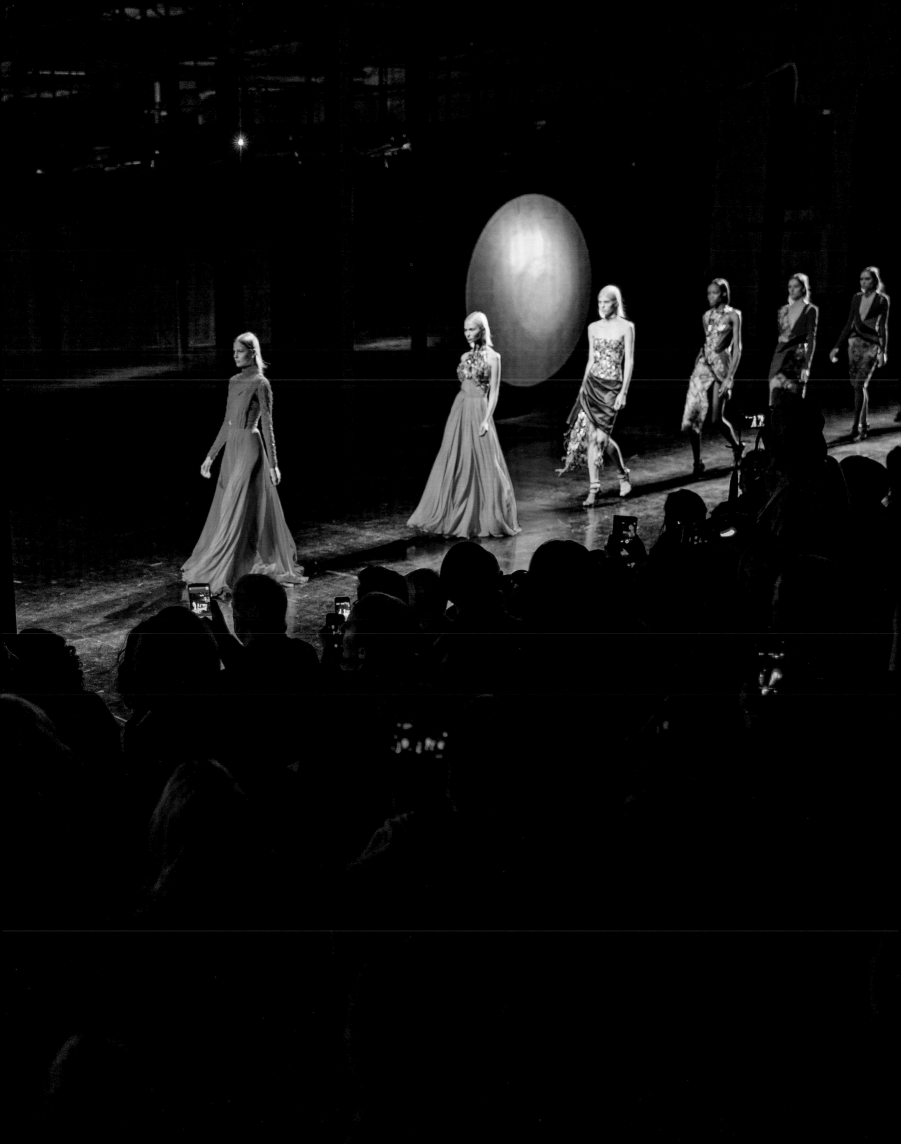

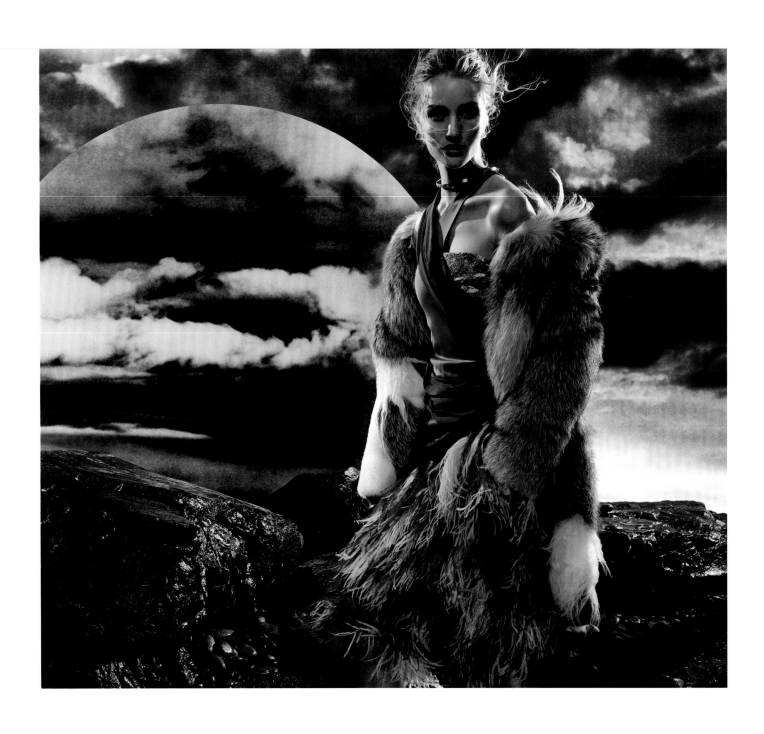

THE FALL 2014 CAMPAIGN FEATURING ROSIE HUNTINGTON-WHITELEY.
PHOTOGRAPHED BY DANIEL JACKSON.

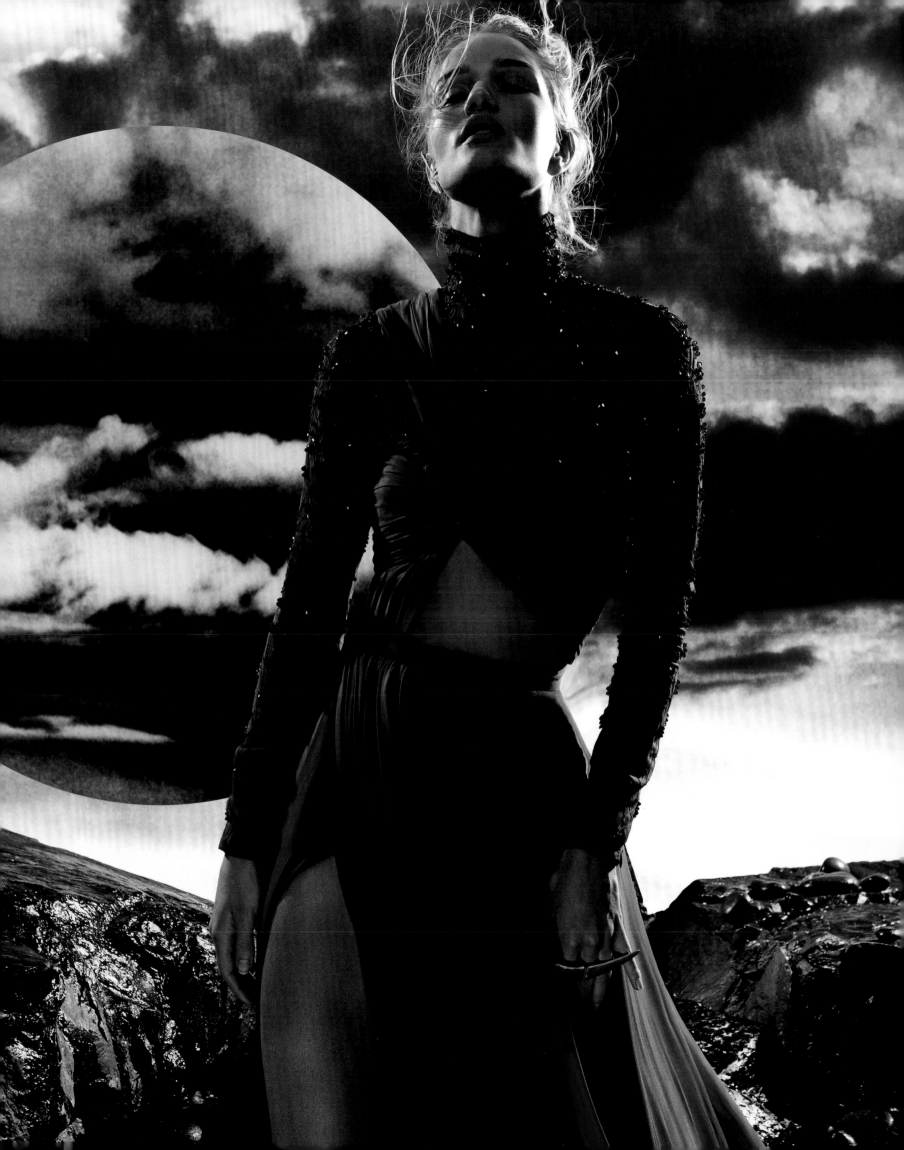

OUR GRAY, CRIMSON, AND BORDEAUX PAINT-STAINED LUREX JACQUARD DRESS—WITH HAND-DRAPED
DETAIL AND SWAROVSKI CRYSTAL EMBROIDERY—BRINGS TOGETHER CECILY BROWN'S SIGNATURE
BRUSHSTROKE WITH THE COLORS OF NEPAL. IT SHINED ON BOTH THE RUNWAY AND FEI FEI SONG,
WHO WAS PHOTOGRAPHED BY MIKAEL JANSSON FOR THE AUGUST 2014 ISSUE OF *VOGUE*.

FOLLOWING SPREAD: KATY PERRY, PHOTOGRAPHED BY CAMILLA AKRANS FOR THE OCTOBER 2014
ISSUE OF *HARPER'S BAZAAR*.

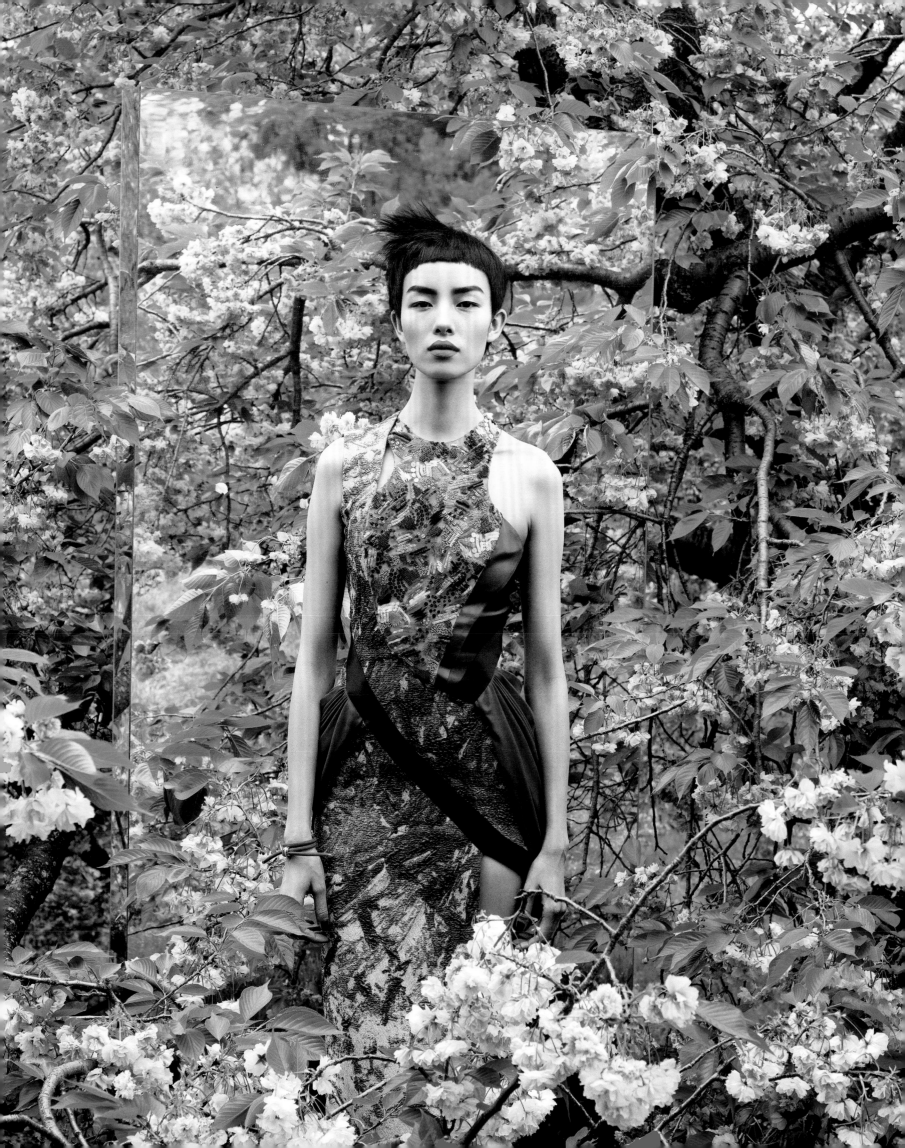

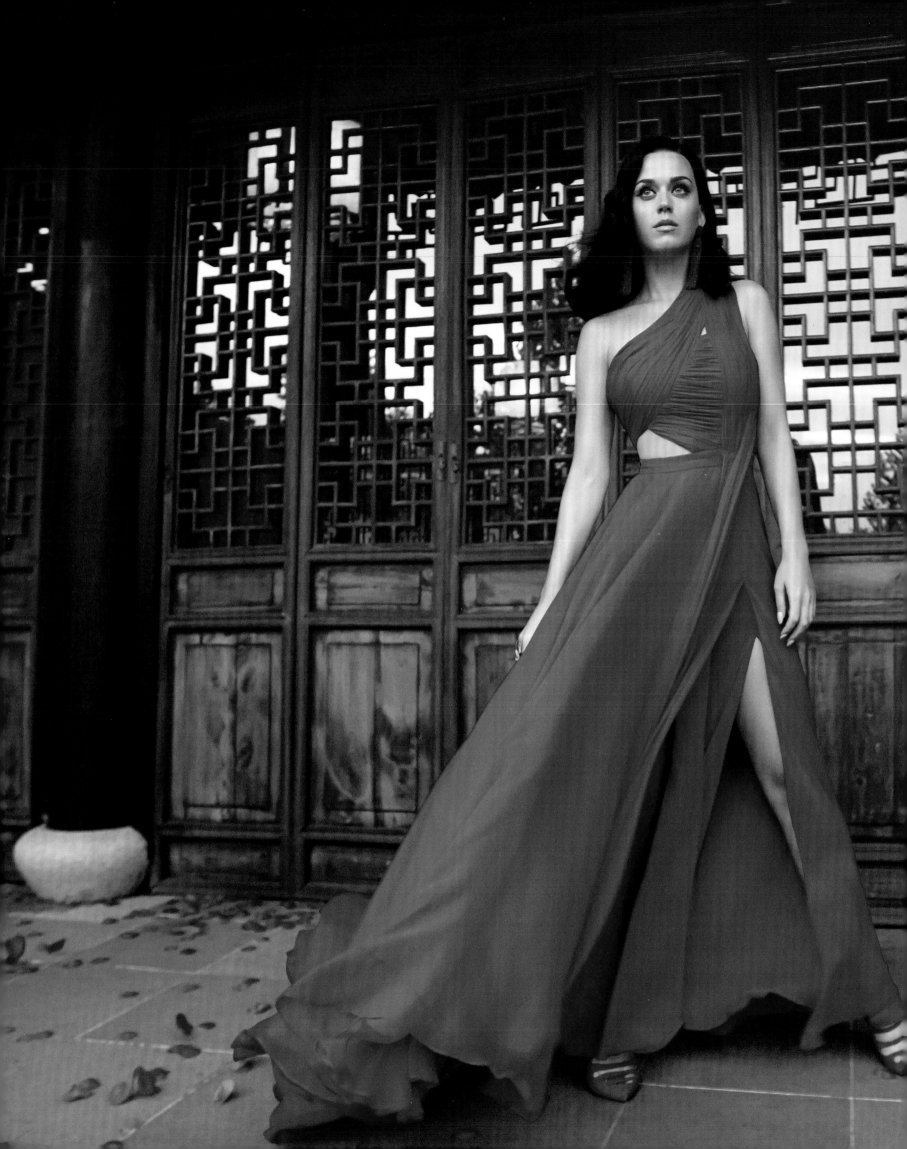

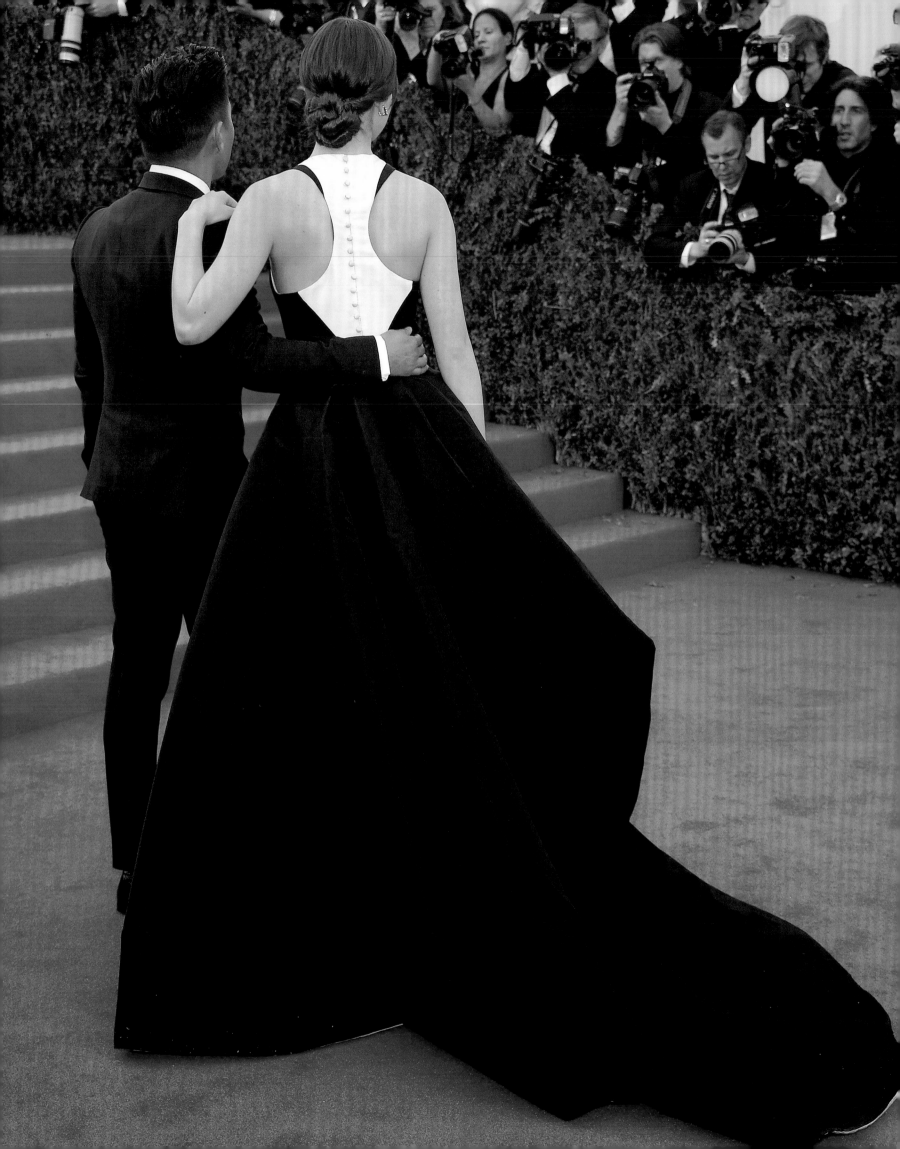

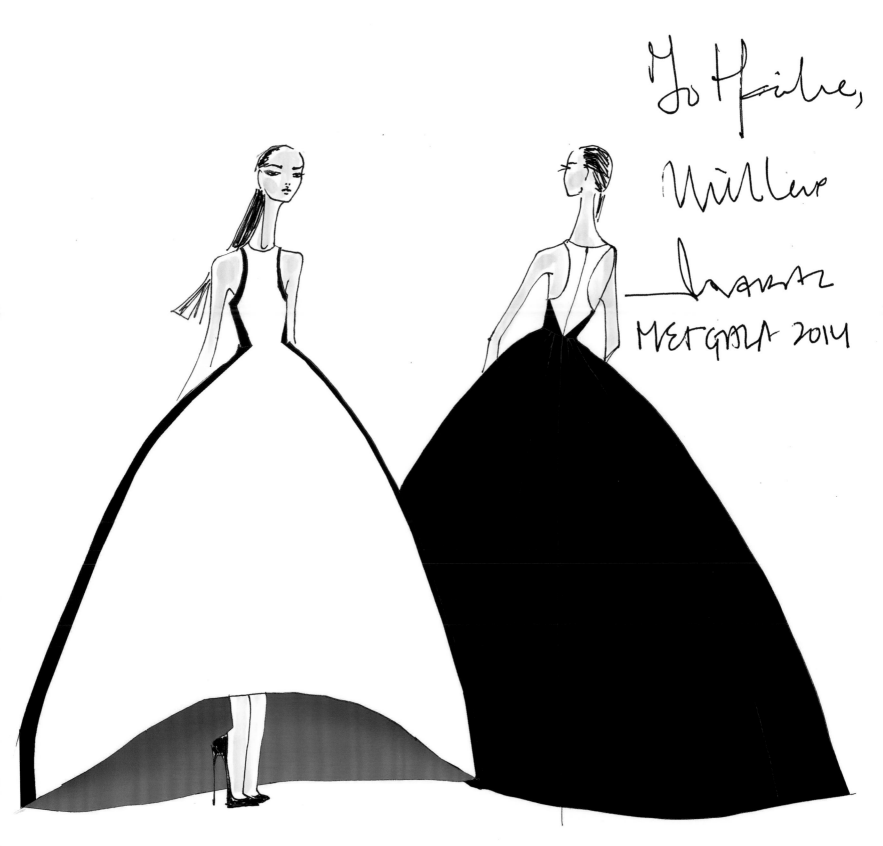

Recalling How We Met

I brought the talented Hailee Steinfeld as my date for the 2014 Met Gala celebrating "Charles James: Beyond Fashion." I was introduced to Hailee in 2011—she wore my dress to the Golden Globes. It was a first for us both! For this special night, I created a gown for her that evokes the grandeur and Old World glamour so inherent to Charles James, but finished the look with modern details that highlighted Hailee's youthful exuberance. This was such a full circle moment of friendship to attend the glamorous Met together.

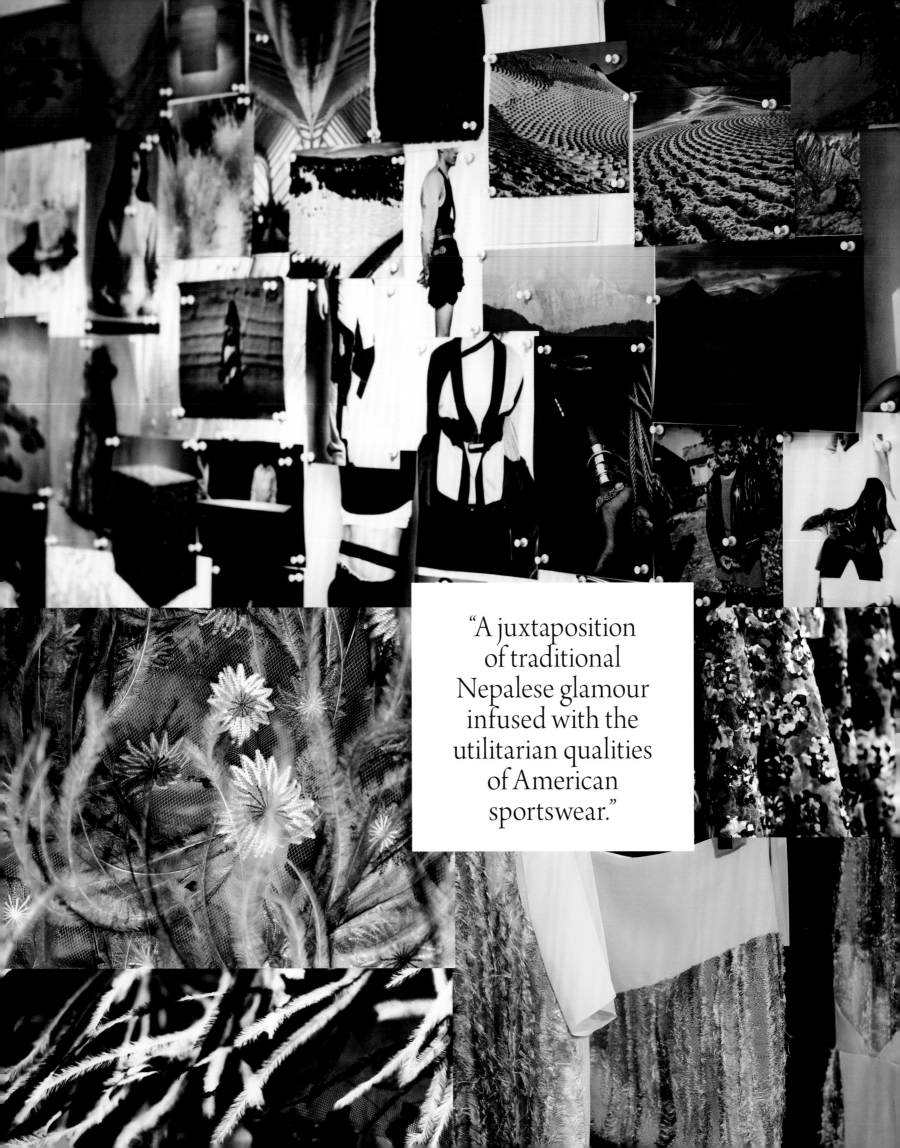

"A juxtaposition of traditional Nepalese glamour infused with the utilitarian qualities of American sportswear."

Spring 2015 "A Himalayan Trek"

My earliest memories of Nepal are vastly visual ones: snowcapped mountains, fiery skies, and vibrant lush hillsides dotted with wild roses and rhododendrons. The country offers a perfect balance of intoxicatingly natural beauty and serene spirituality. Spring 2015 marked a continuation of Fall 2014's celebration of Mustang—a Shangri-La so enlightening that this season the Prabal Gurung woman's path continued onward, leading her deep into the Himalayas.

This arduous trek inspired a collection reflecting a nomadic journey. The clothes were visual nods to a lived-in treatment, utilizing patchwork, weathered footwear, and worn sweaters, telling the story of an exchange, a passing down, and an immersive adventure.

We introduced new fabric innovations including cloque jacquard (a nod to the mountain ranges), three-dimensional rhododendron and carabiner prints with petal-like ruffles, raw bleached denim, and mossy *dégradé*, as well as sculptural ostrich hand-embroidery flattened to mimic topographical maps. The color palette was designed to emulate the vibrant Nepalese sky from dusk to dawn: white, turquoise, lilac, amethyst, navy, and sunset coral.

The collection played on the juxtaposition of traditional Nepalese dressing and androgynous American sportswear through layered blouses under mountain jackets, expedition vests over skirts draped with chiffon, and feminine dresses spliced with graphic details. Architectural layering added modernity to the opulent evening wear. Cut-out motifs represented the physical aspects of the exploration, as did utilitarian hardware details, playing on the rustic fasteners found on the hike.

This season also marked the launch of our footwear collection. The six styles embodied elegant "femininity with a bite" and refinement with modern appeal. All were named after artists who inspire season after season—Tracey (Emin), Zaha (Hadid), Cecily (Brown), Georgia (O'Keeffe), Cindy (Sherman), and Frida (Kahlo). The range included textural and color-blocked details with graphic straps and rhodium-plated hardware echoed in buckles of technical nylon belts.

OPPOSITE: THE MOOD BOARD (ABOVE) WITH INSPIRATION FOR THE SPRING 2015 COLLECTION, EMBRACING
THE FEMININE GLAMOUR OF THE EASTERN WORLD. THE TEXTILES (BELOW) JUXTAPOSE THE UTILITARIAN
ASPECTS OF TREKKING WITH THE CRAFTSMANSHIP AND FEMININITY INHERENT TO OUR BRAND ETHOS.

FOLLOWING SPREAD: THE LINEUP BACKSTAGE AT THE SPRING 2015 SHOW. OUR SIGNATURE STRATEGICALLY
PLACED CUTOUT DETAIL WAS FEATURED PROMINENTLY THROUGHOUT THIS COLLECTION.

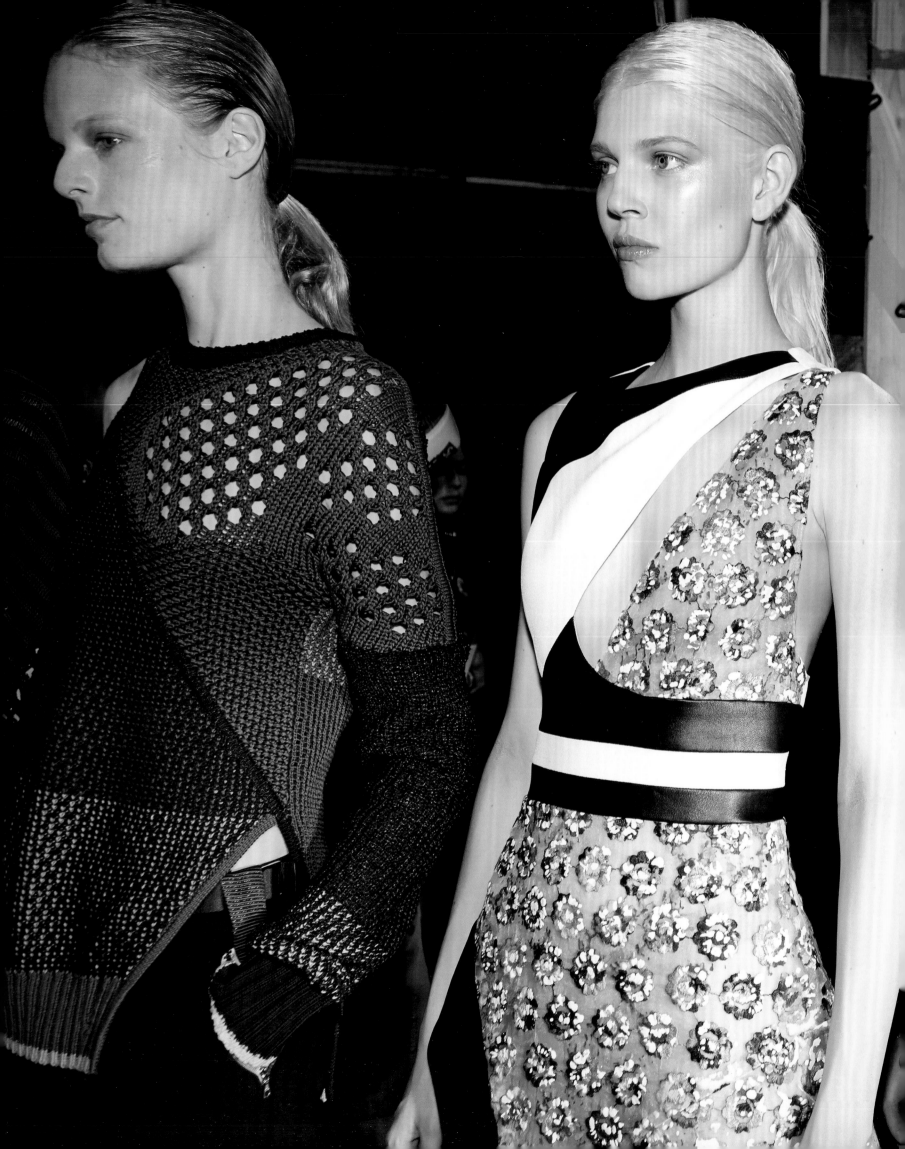

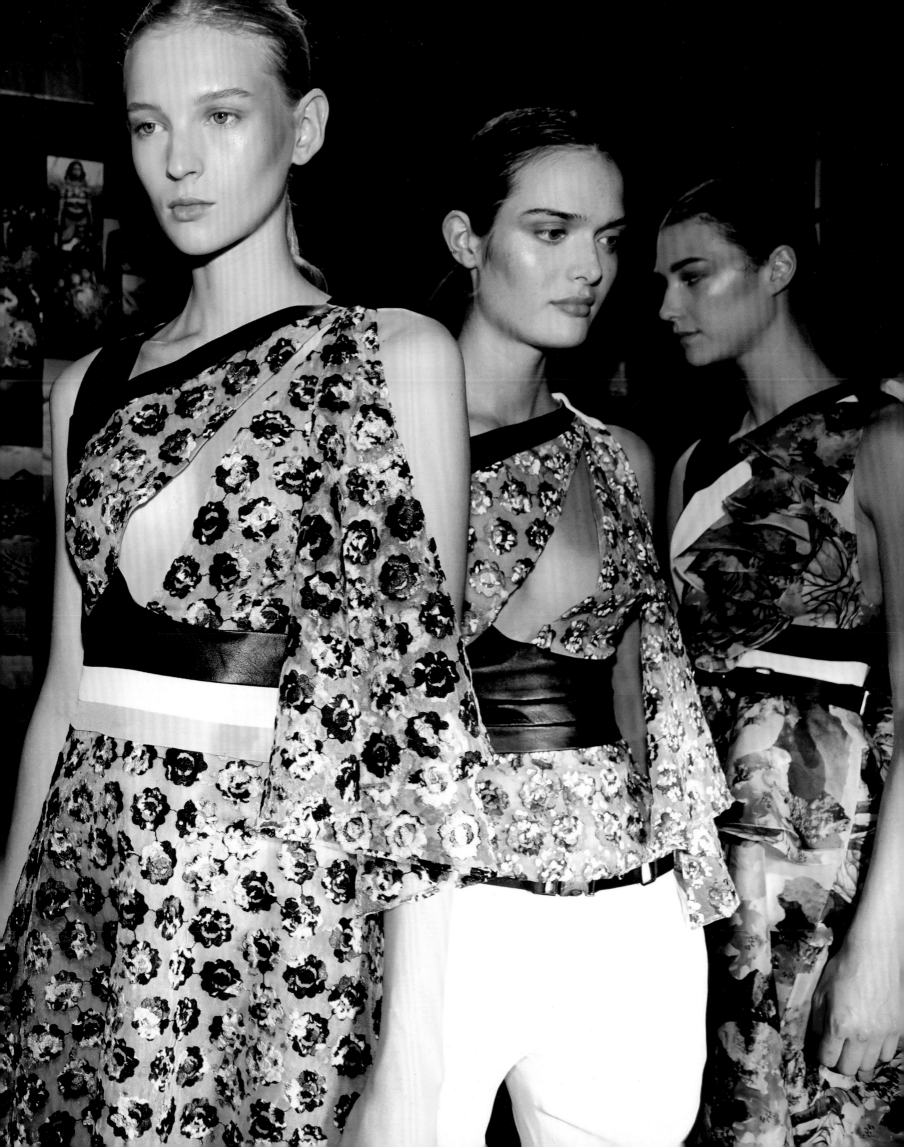

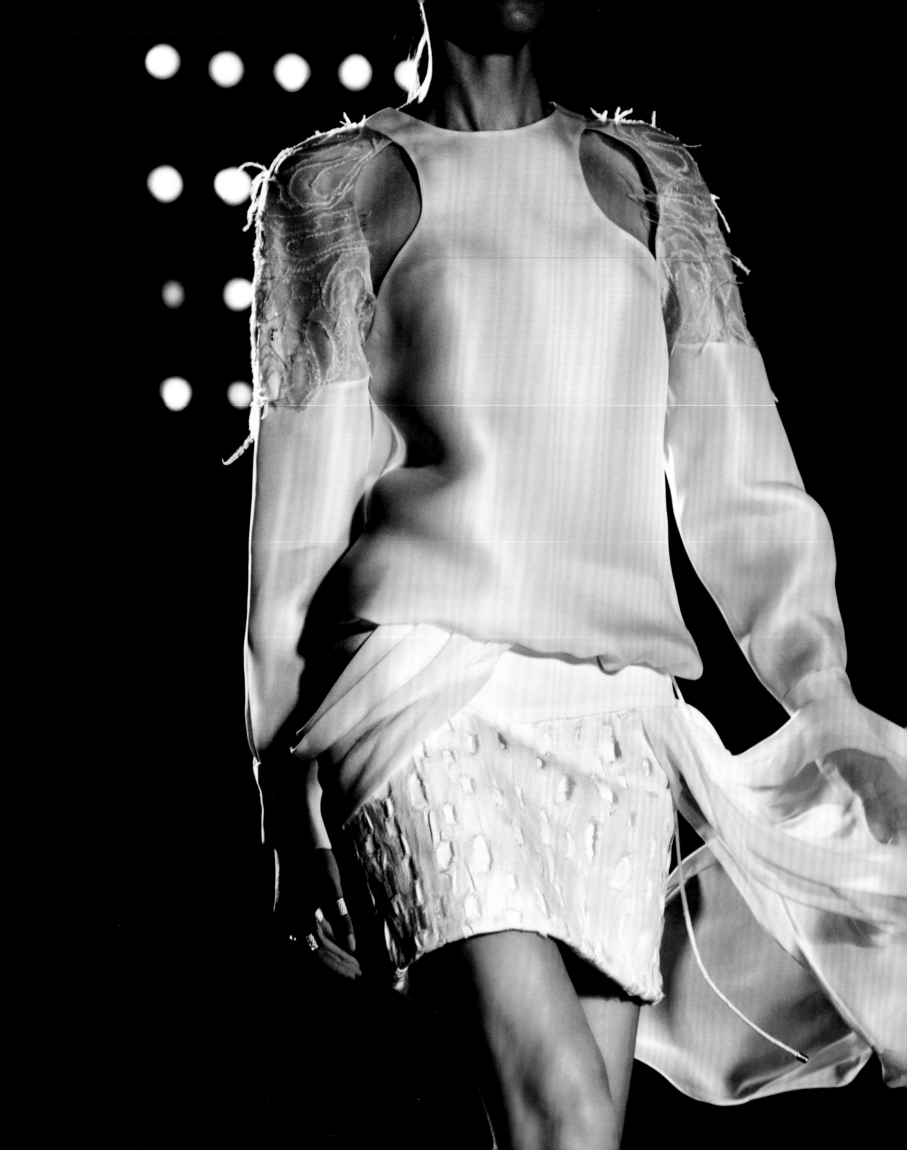

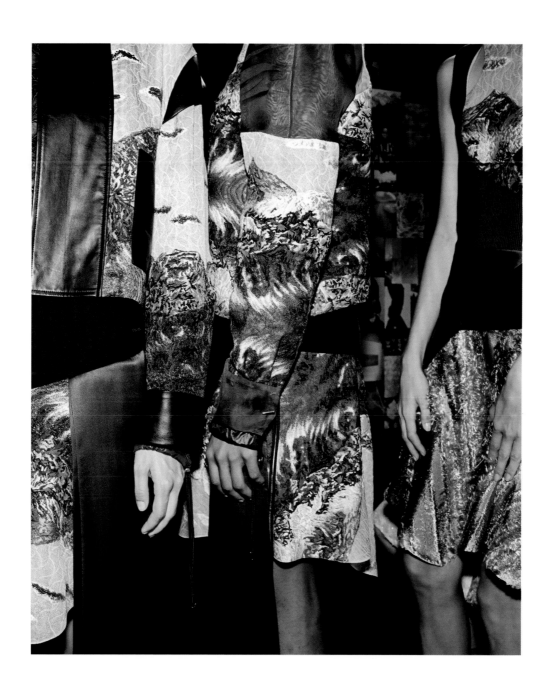

ABOVE: BACKSTAGE AT THE SPRING 2015 SHOW.

OPPOSITE: SPRING 2015 IN MOTION ON THE RUNWAY.

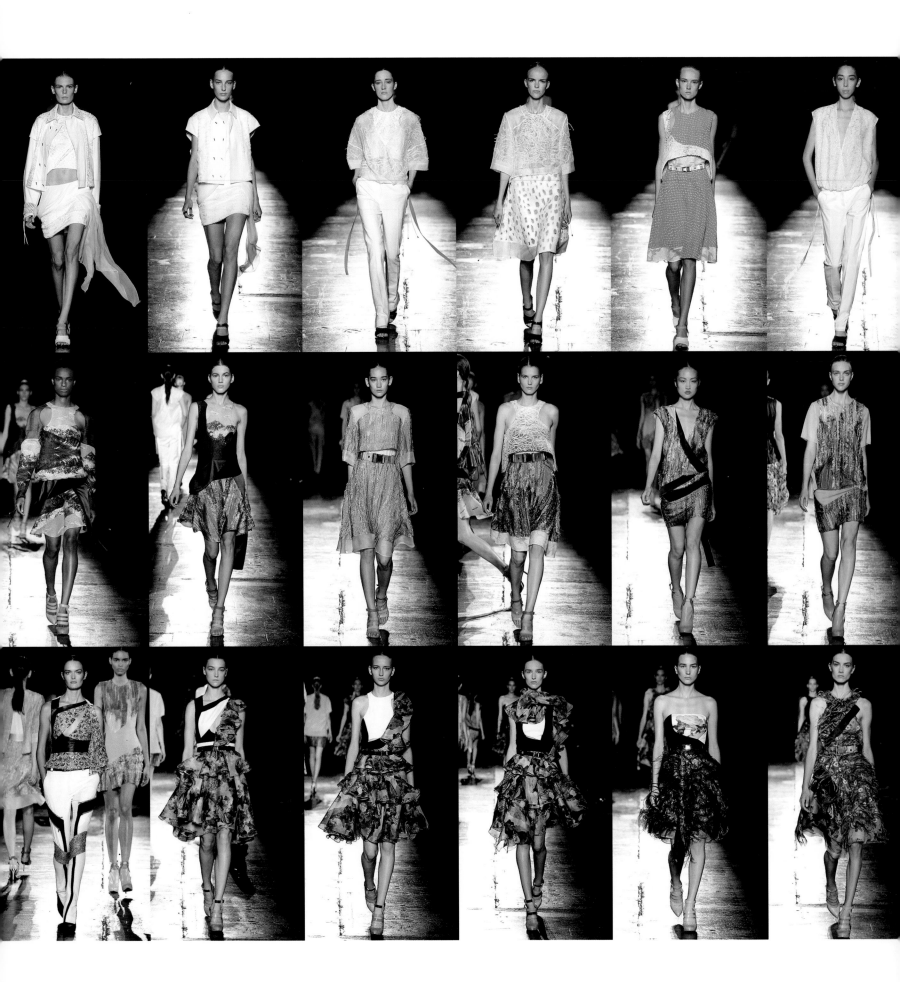

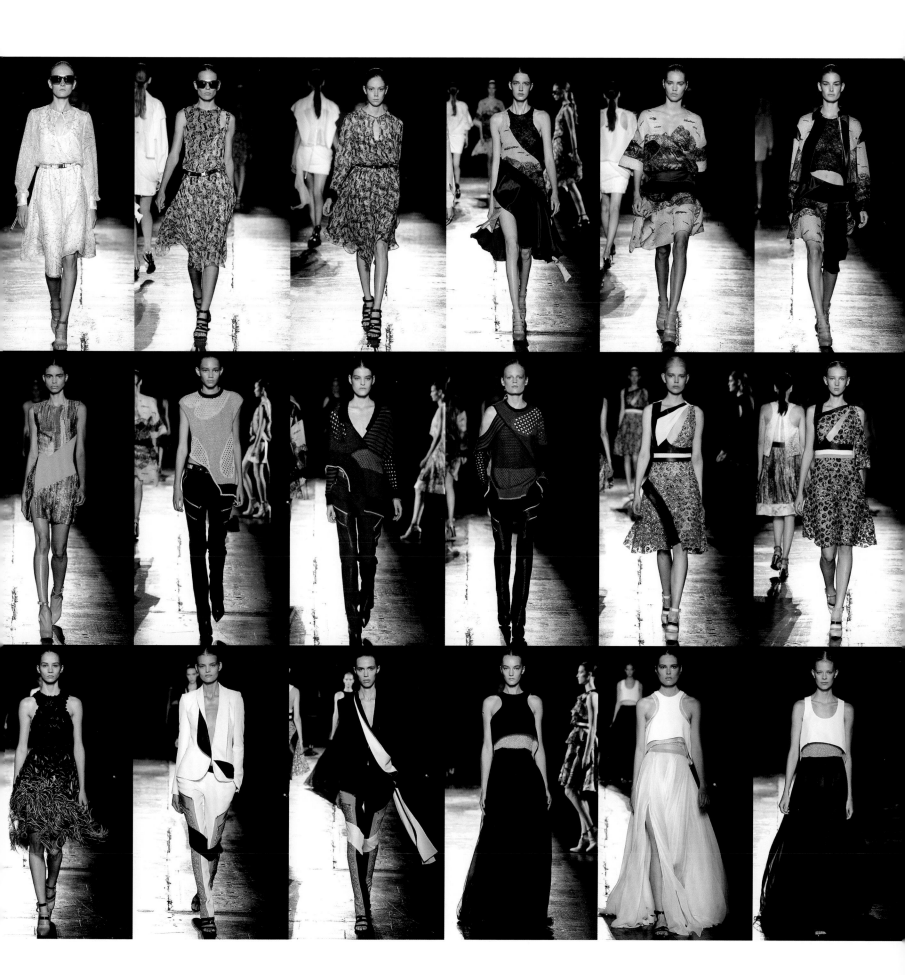

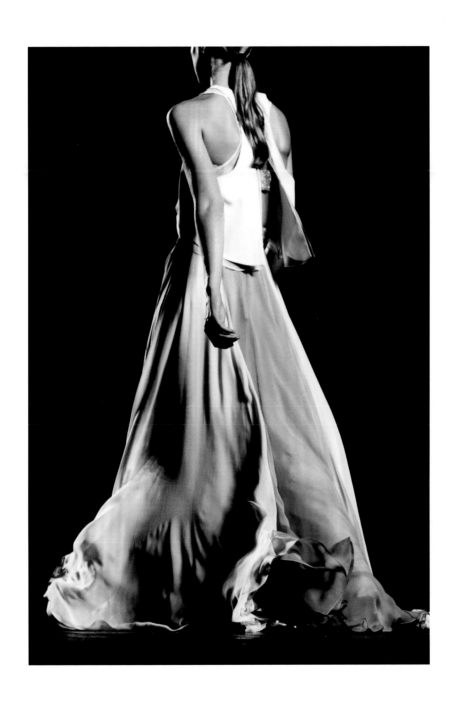

THE LILAC AND LEMON HUES ARE INSPIRED BY THE SUNRISE AND FLOWER FIELDS
I GREW UP WITH IN NEPAL, TRANSLATED ON THE RUNWAY INTO HAND-PAINTED
TEXTILES AND ETHEREAL FLOWING CHIFFON GOWNS.

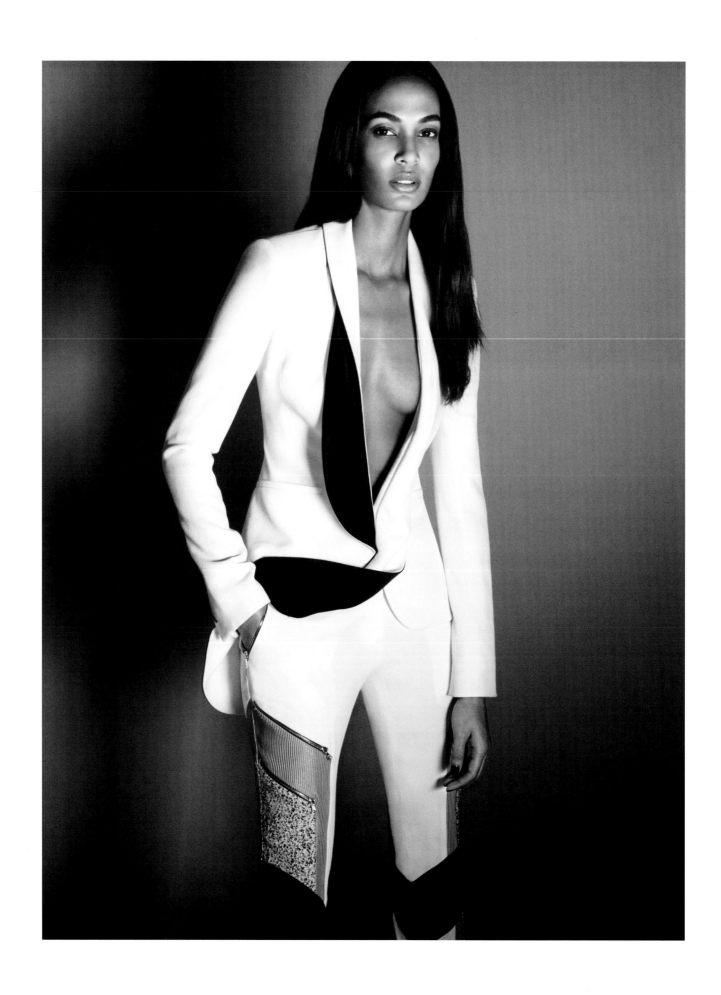

THE SPRING 2015 CAMPAIGN FEATURING JOAN SMALLS.
PHOTOGRAPHED BY DANIEL JACKSON.

REBUILDING MY HOME. REDISCOVERING MY IDENTITY.

Two thousand fifteen was an earth-shattering year. It was the year that the devastating earthquake struck my homeland in Nepal. I so vividly recall hearing my phone ring in the early morning, to be told the news by a dear friend in Nepal. I was transfixed, unable to move myself from my laptop screen, diving deeper and further into the gut-wrenching images. I felt as if the world I knew was crumbling. I was living in despair, confusion, and hopelessness. But I knew I had to get up and find a way ahead, despite feeling so far away from my home and the self-identity I once knew. I re-found my home in my fashion community—in their outpouring of support, their open arms, and their positive energy toward creating a collective effort to rebuild. With the incredible support of my mentors, peers, colleagues, and friends in the fashion industry and Hollywood, we raised more than one million dollars to build shelters and restore damaged artwork. I felt humbled. I felt gratitude. I felt a new invigoration of hope and optimism as I rediscovered myself and my place in this world. I was provoked, awakened, and inspired to use the platform I developed in a bigger way, to become an advocate and activist to drive tangible reform.

2015

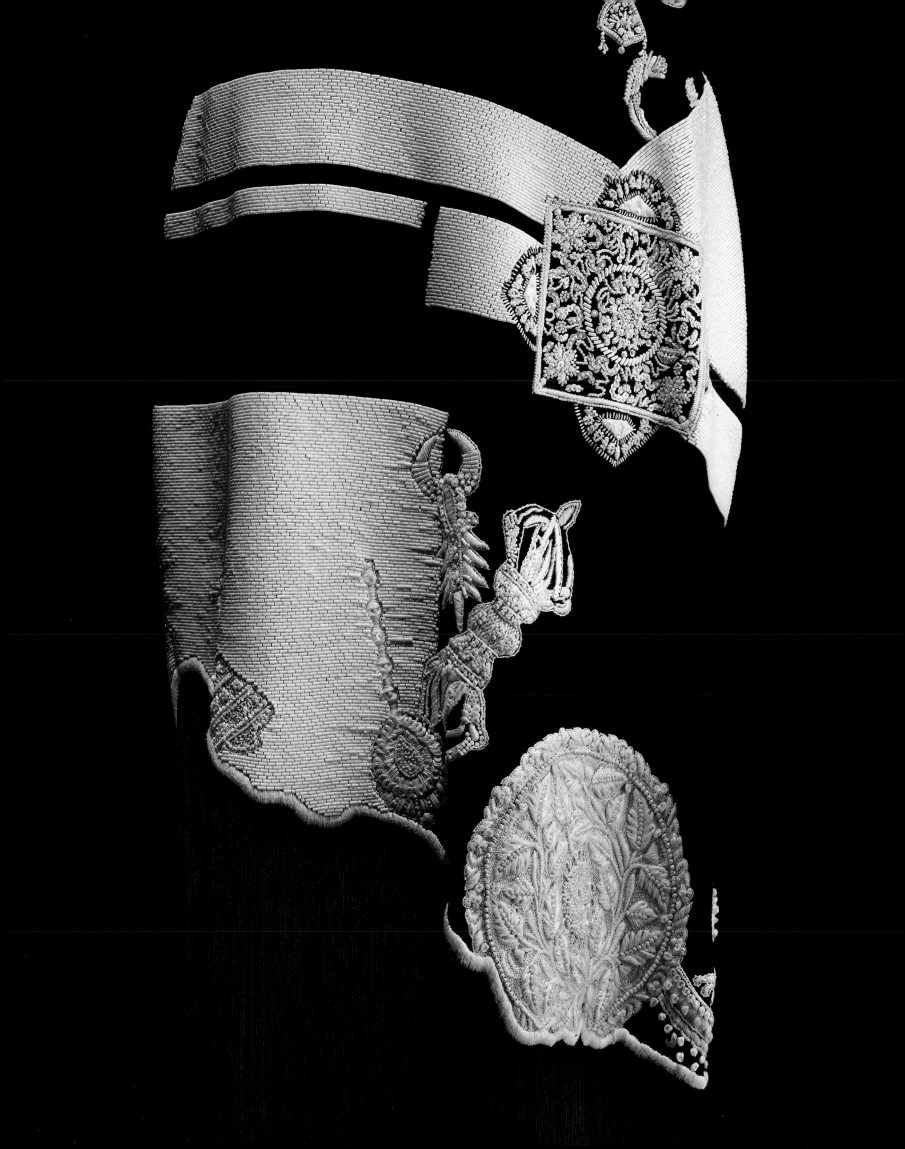

Fall 2015 "Majestically Idyllic"

I had recently fallen in love with my wonderful partner. He gave me the most safe, comfortable feeling I can recall ever having. He brought me serenity, a beautiful calm. Together, we visited his home in the heights of the Adirondacks, where Mother Nature's meditative, majestic beauty, soft color palette, and exquisite textures served as the central point of inspiration for the season. I learned to understand the depths of simple beauty, to appreciate understated glamour. This idyllic essence informed color tones of alabaster, navy, crimson, claret, and vermillion, along with innovative fabrications including hand-knit Nepalese cashmeres, snow-leopard-printed calf hair and embossed astrakhan velveteen, tonal jacquards, deconstructed Fair Isle knits, Lesage-embroidered tweed, hooded cashmere duffel, and sumptuous fox- and astrakhan-embossed velveteen coats.

Drawing on a newfound appreciation for Americana, this season was an embrace of sportswear in its stylistically celebrated attributes—luxurious layers, rich textures, and silhouettes with ease and sensuality—all with the vision of glamour echoed throughout. We approached the collection with the couture ideals I developed during my time at Bill Blass, but placed them within the understated ease nature invokes. The designs honored the skill of artisanal craft both traditional and modern from the precisely cut little black dress in double-faced cashmere to the hand-embroidering of tonal evening gowns.

As always, strong women served as inspiration. Watching my personal heroines, from the Old Hollywood sirens to my mother and sister—all assured, intelligent, multifaceted, and radiant women—evolve challenged me to redefine the notion of "what it means to feel beautiful." To wit, this season offered more relaxed silhouettes allowing for movement away from the body while still embracing the female form. This sense of effortless ease is never without a sensual, glamorous edge.

The interesting mix of materials used for our footwear—brushed calf, matte and metallic snake, suede, lizard, specchio leather, and patent—brought modern appeal to the refined and feminine silhouettes of this season. A signature spike detail—seen throughout the collection—echoes our philosophy of "femininity with a bite" and highlights the inspiring duality of the millennial woman.

OPPOSITE: LUCA GAJDUS WALKS THE FALL 2015 RUNWAY.

FOLLOWING SPREAD: CAROLINE TRENTINI CLOSES THE FALL 2015 SHOW
IN A TONAL HAND-EMBROIDERED SWAROVSKI CRYSTAL GOWN.

156

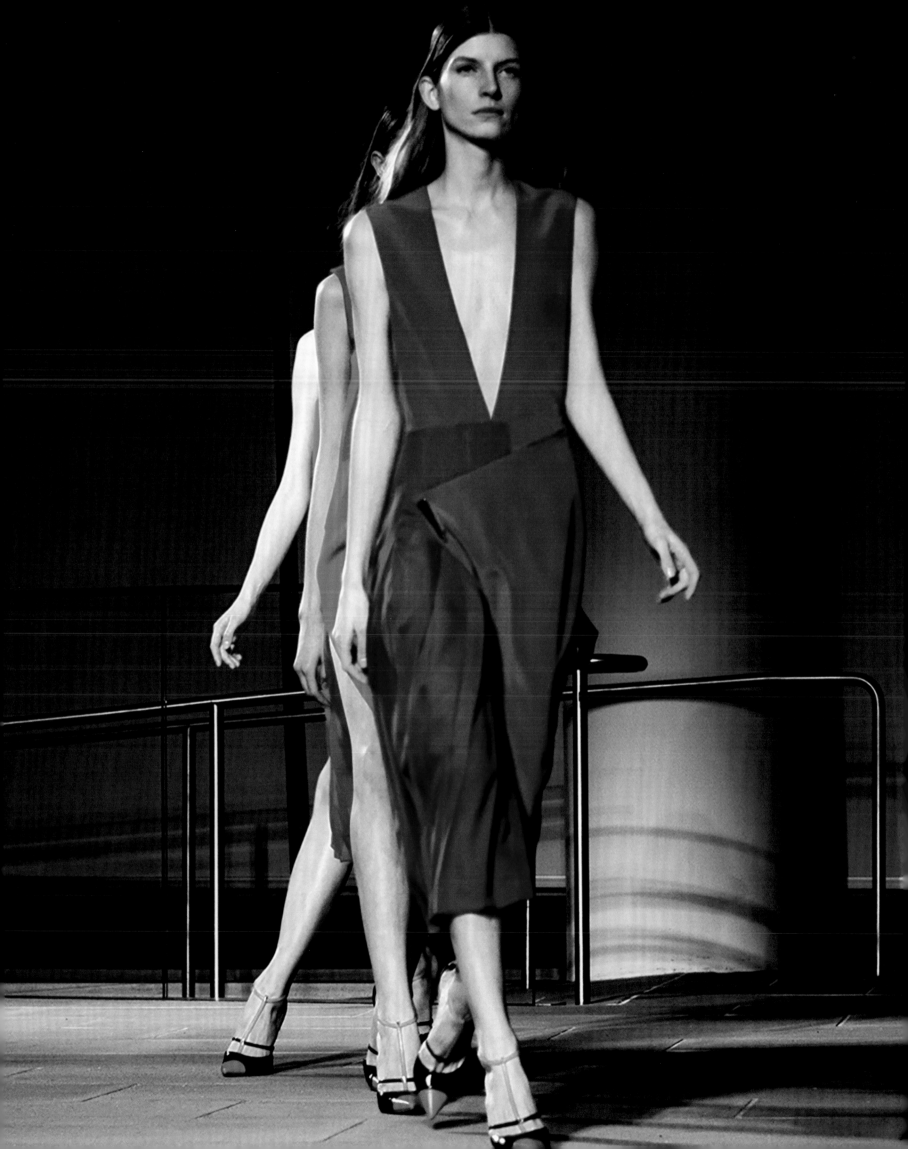

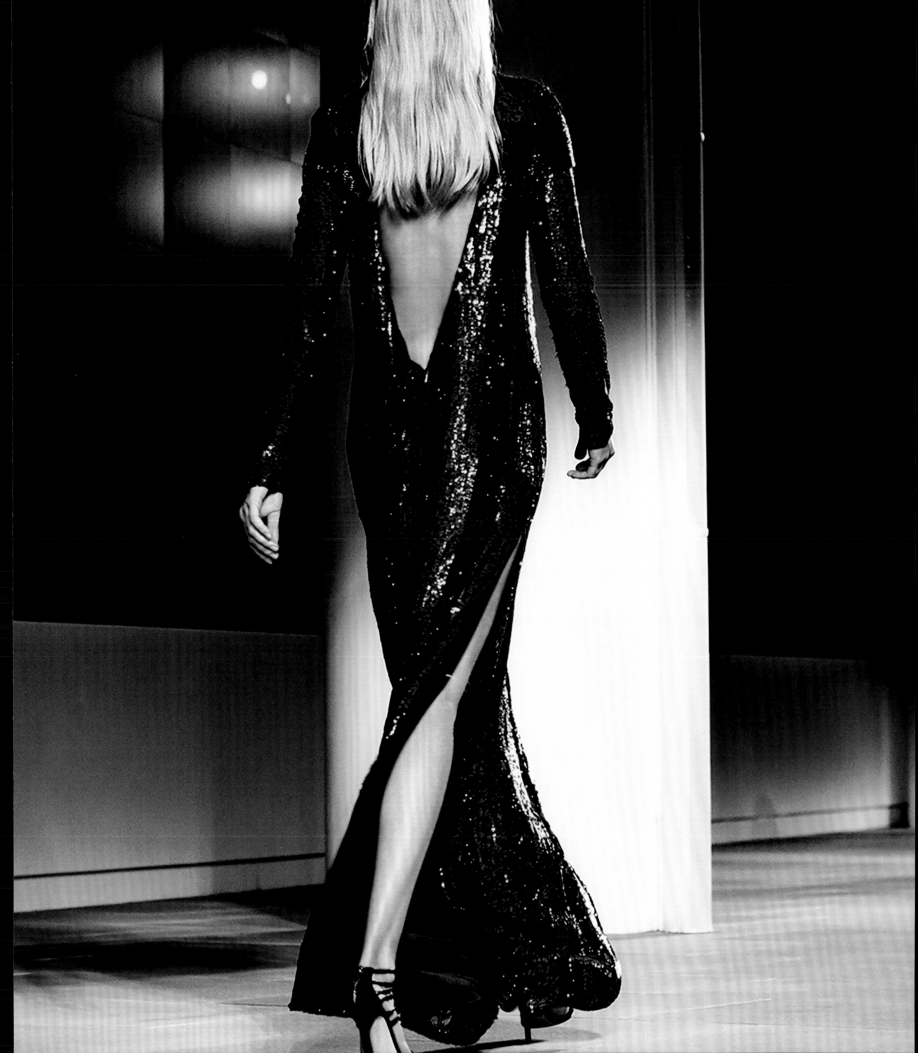

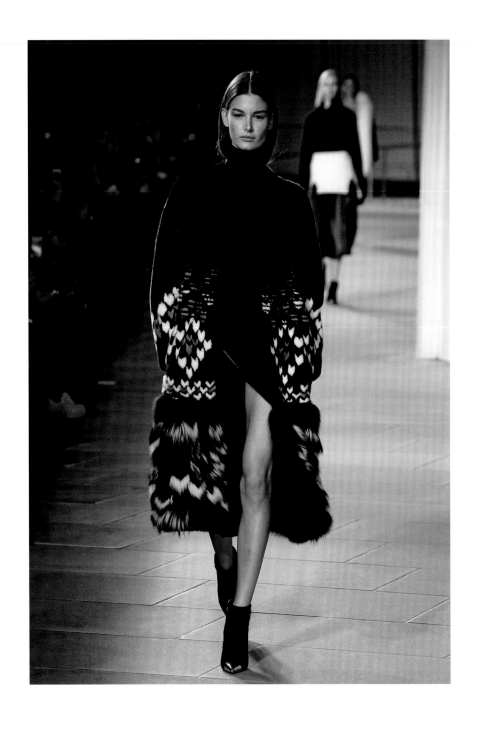

OPHELIE GUILLERMAND (ABOVE) WALKS THE FALL 2015 RUNWAY, WEARING
A FAIR ISLE INTARSIA COAT. WE USED DIGITAL FAIR ISLE PRINTS (OPPOSITE)
ON TEXTILES THROUGHOUT THE COLLECTION.

PAGES 164–165: THE FALL 2015 CAMPAIGN FEATURING CAROLINA TRENTINI.
PHOTOGRAPHED BY DANIEL JACKSON.

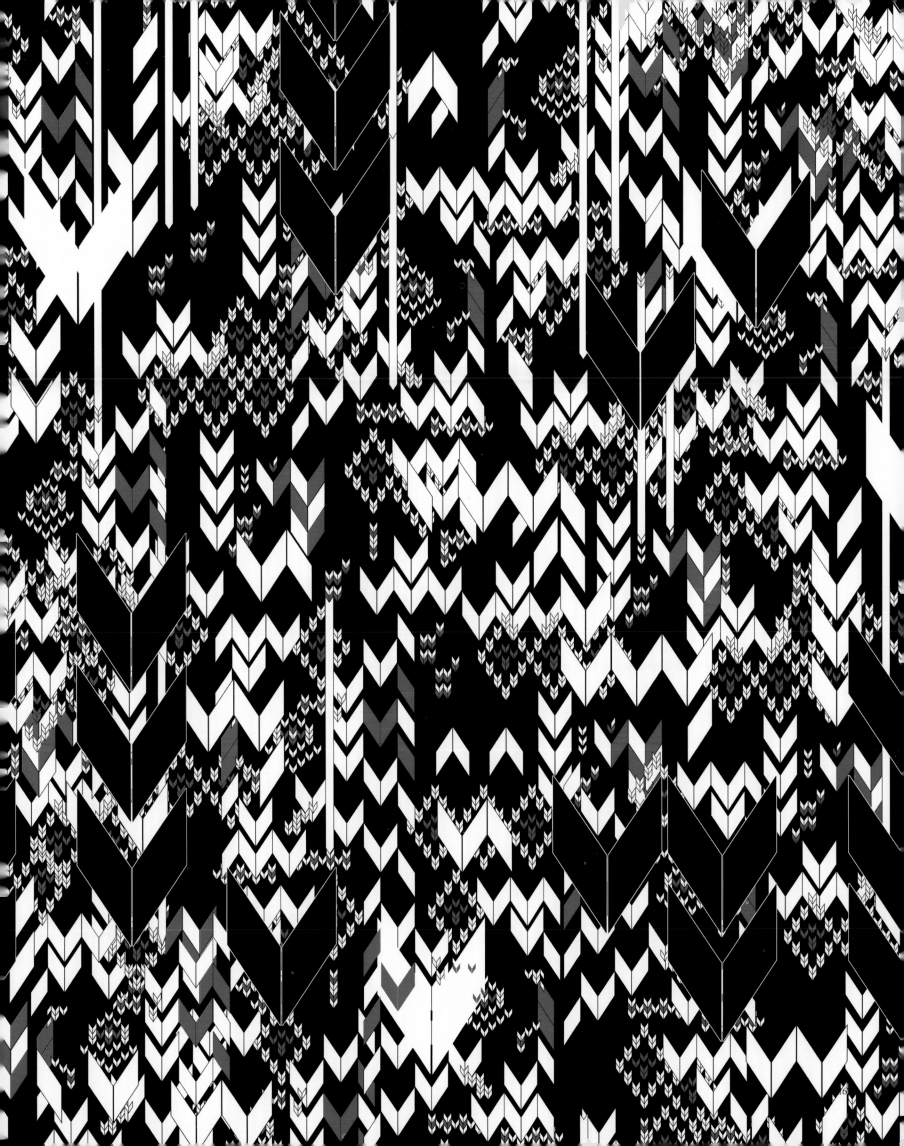

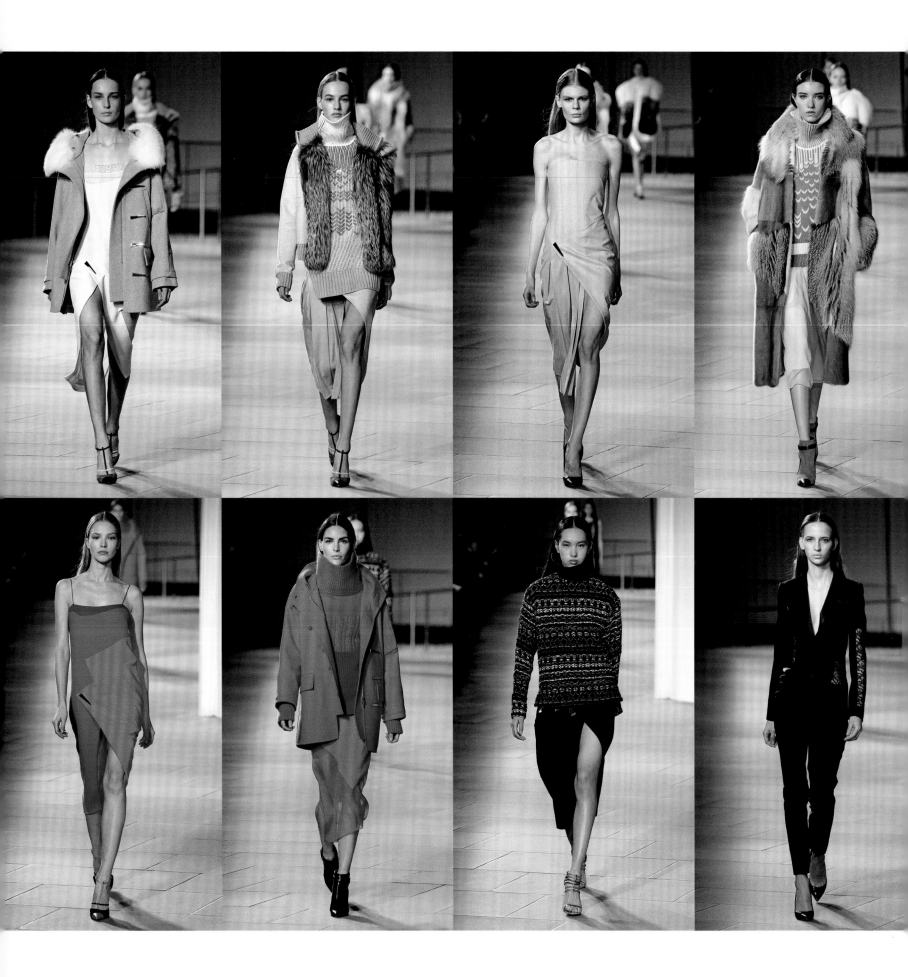

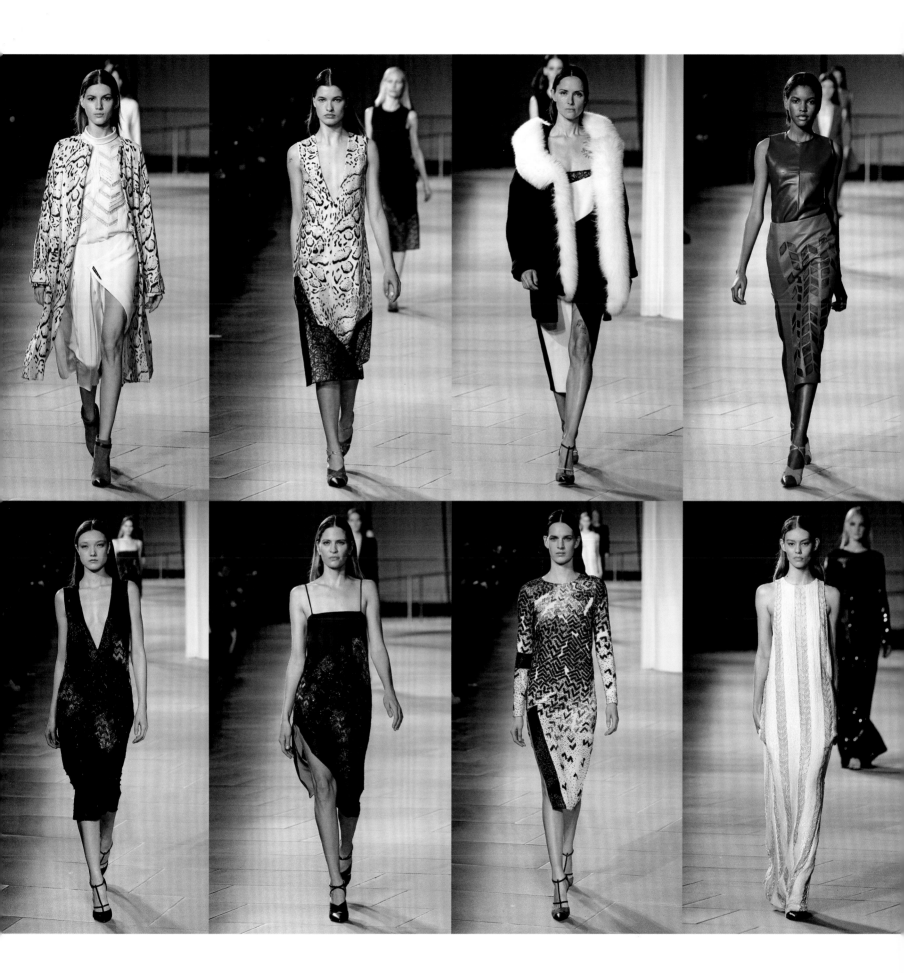

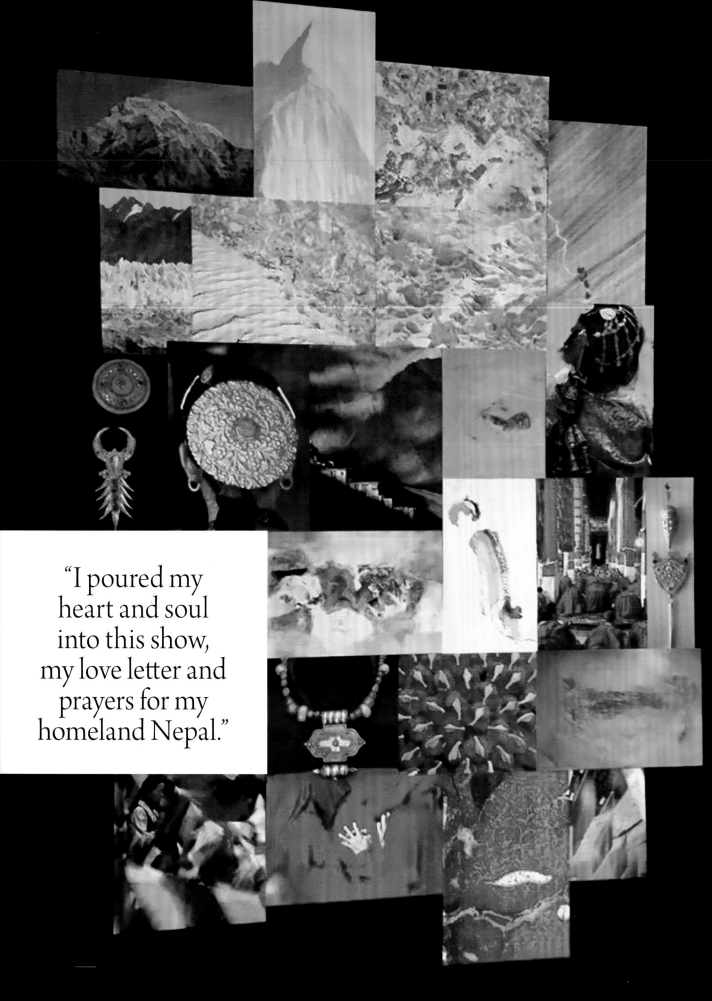

"I poured my heart and soul into this show, my love letter and prayers for my homeland Nepal."

Spring 2016 "The Day My Earth Was Shattered"

Saturday, April 25, 2015, changed my life forever.

With visuals of destruction and despair flooding in after Nepal's devastating earthquake, I could not help but feel that the world in which I grew up had crumbled. It seemed as though part of my identity was unraveling with it. I felt helpless halfway around the world, and I was compelled to do something beyond raising money for my foundation. I wanted the world to experience a glimpse of what Nepal meant to me:

People sharing stories while sitting on a hand-carved window seat overlooking the fifteenth-century Palace Square. Monks chanting in the juniper-incense-filled monastery, which I unfailingly visit to seek refuge every time I return home. Trails of self-discovery leading to the majestic mountains through which I have trekked. These are a few of the images that raced through my mind as I sat down to sketch my Spring collection— a collage of my memories gathered.

Fashion has been my savior many times in my life, but when I presented this collection, I was reminded of two very special moments. The first time—when I felt my creativity and passion being stifled in Nepal—it gave me the courage to follow my dreams and an opportunity to explore the world. It allowed me to flourish and discover myself. The second time—when the devastating earthquake hit Nepal and I felt part of my identity dissolving— the support that the fashion world extended to me and thousands of Nepalis back home gave us the strength to regain a sense of self, hope, and optimism. My friends and colleagues in the fashion industry were the first people to rise and support me, and the continuous outpouring of generosity was extremely humbling. I am still forever grateful.

My heritage is my identity, and I wanted to share a piece of myself with our community. We began the show with monks who joined together in harmony and sang a spiritual prayer. On the runway, I spoke with billowing hues of crimson, lemon, saffron, and blush—the colors of Nepal—unearthing my vulnerability and soul in an effort to build a community of kindred spirits.

At the runway show, I shared these words with my guests:

Today is about gratitude for all the kindness. Today is about renewed faith in the goodness of humanity. Today is about celebration of the empathy exhibited. Today is about prayer and blessings for each of us here to follow our passion and make a difference.

My collection was a very personal gesture of gratitude. I showed my world who I am, and fully understood the gravity my platform carries. We all have an ability to do good and make a change within us. This devastating experience was a rebirth, a shedding of a layer to step into a new role, paving the way for even greater advocacy, social responsibility, and activism.

OPPOSITE: THE MOOD BOARD WITH INSPIRATION FOR THE SPRING 2016 COLLECTION, AN ODE
TO THE STRENGTH AND VIGOR OF NEPAL JUST MONTHS AFTER THE DEVASTATING EARTHQUAKE.

167

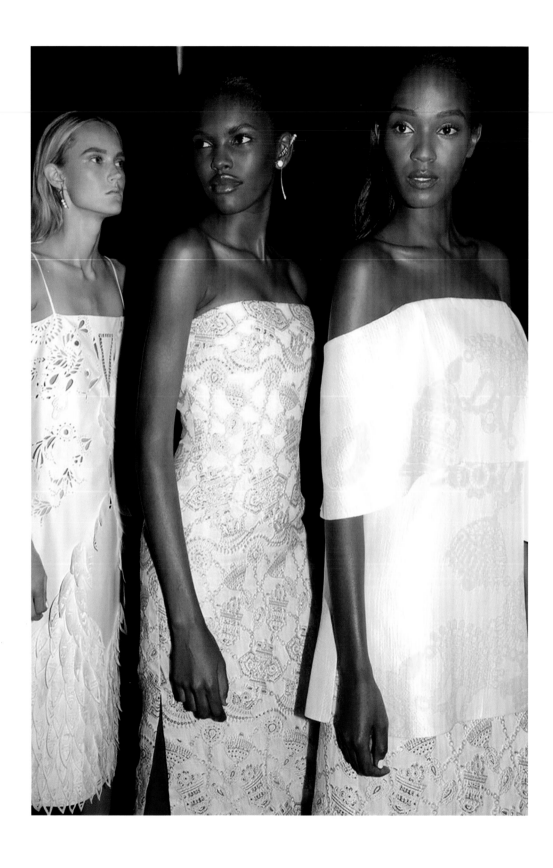

THIS SPREAD AND FOLLOWING: EMBROIDERIES, TEXTURES, AND COLORS
EVOKE NEPAL THROUGHOUT THE COLLECTION.

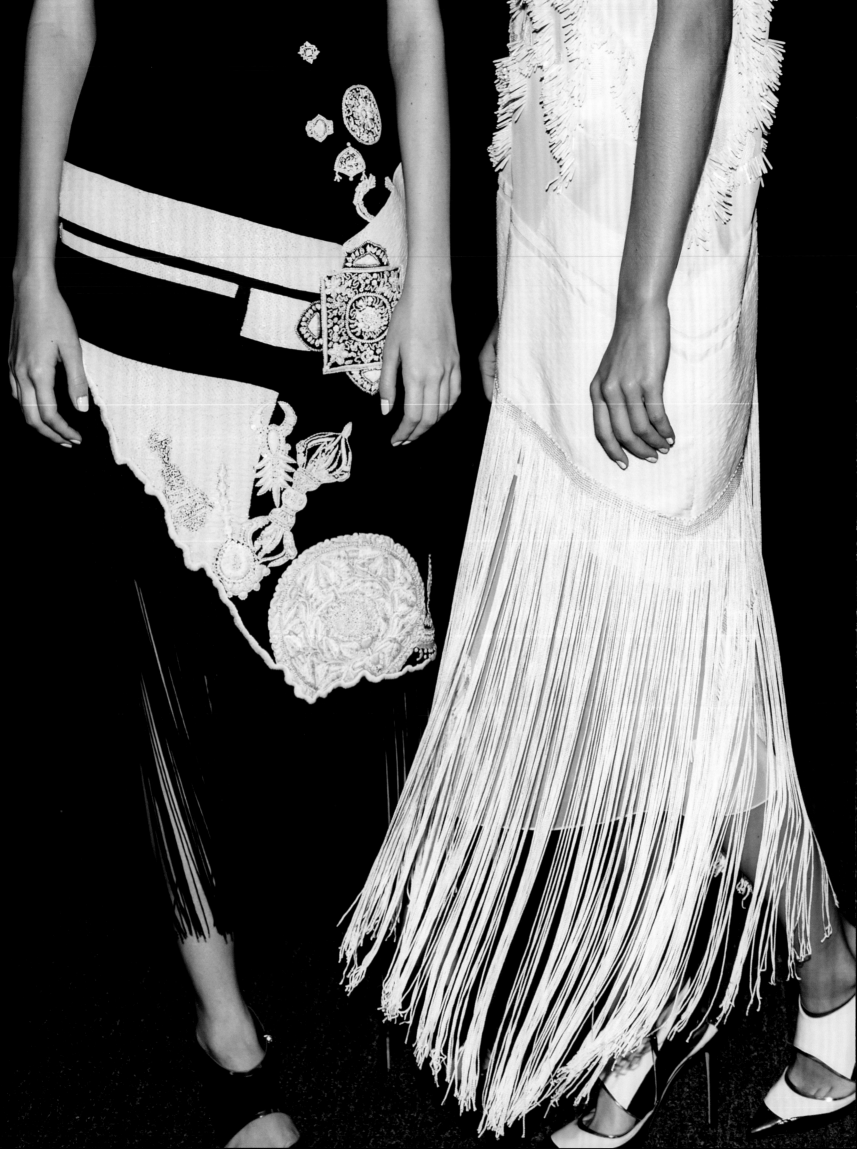

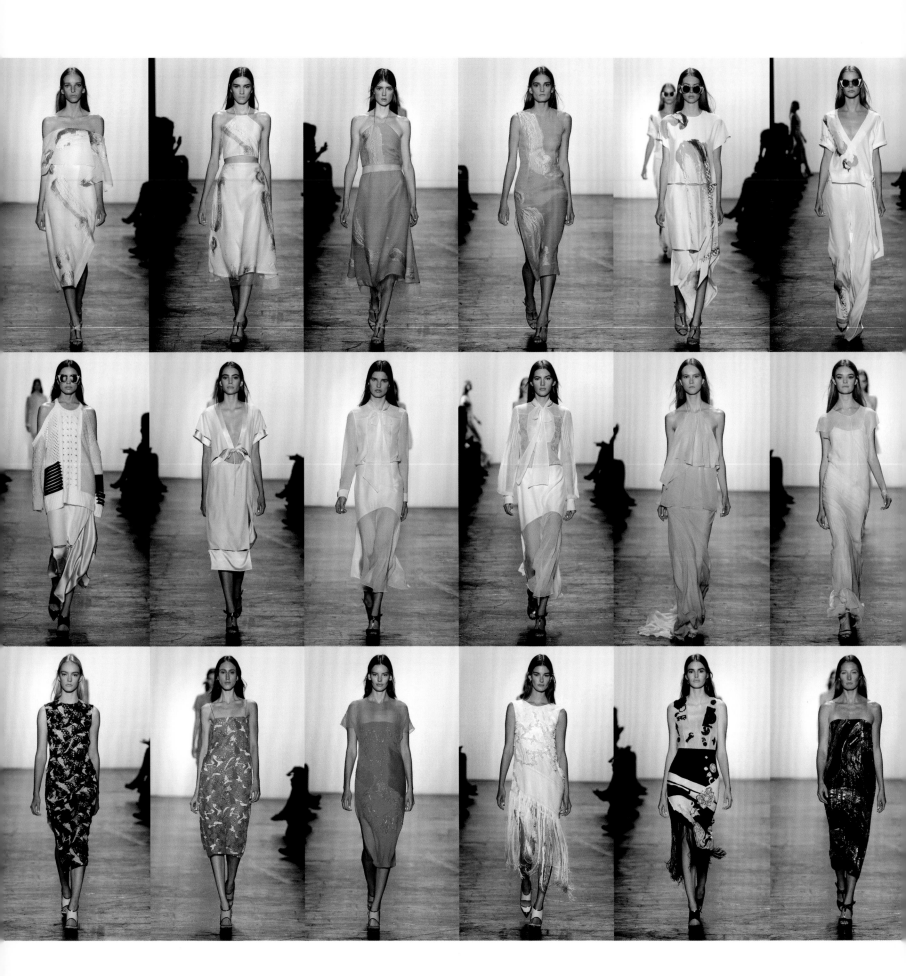

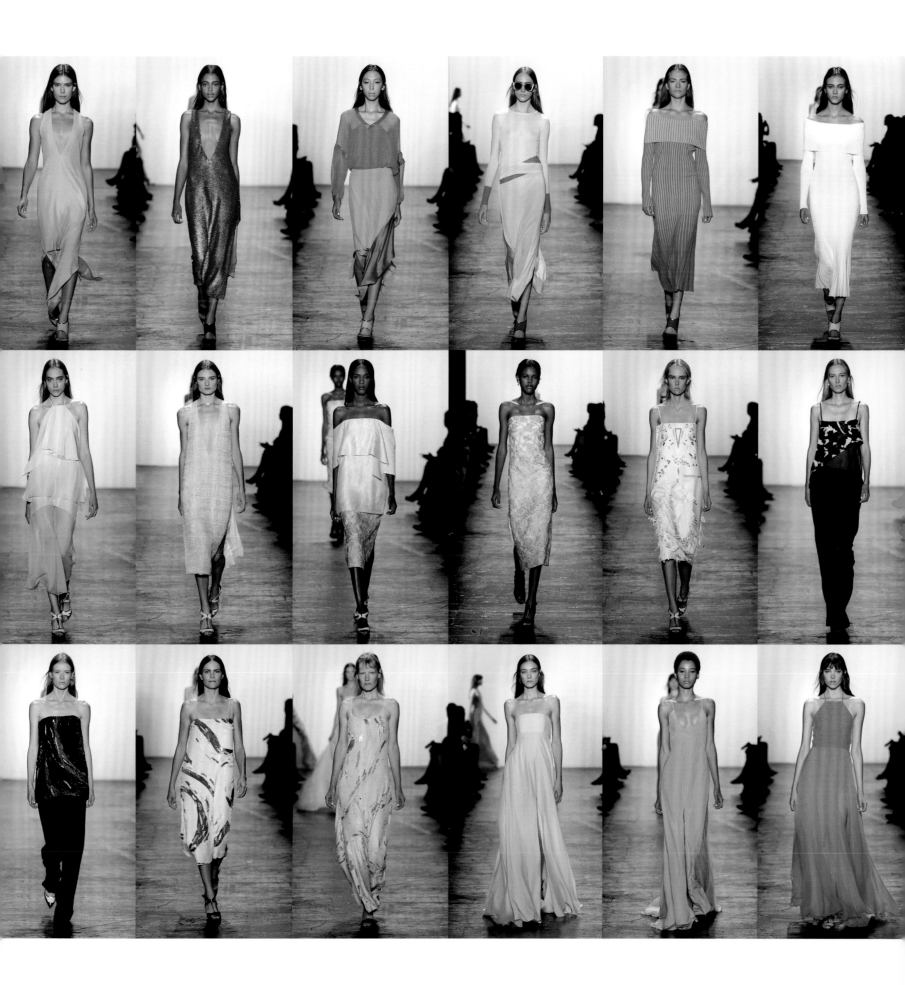

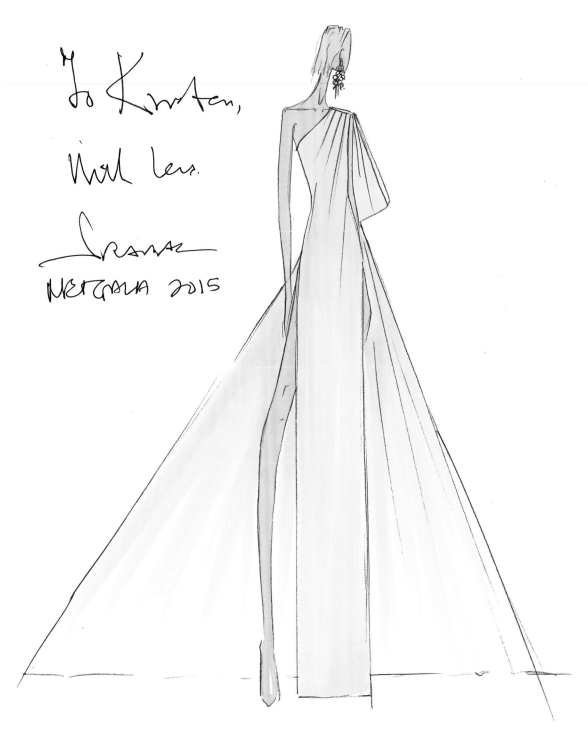

To Kristen,
With Love.

Prabal
MET GALA 2015

Through the Looking Glass

I attended the 2015 Met Gala celebrating "China: Through the Looking Glass"
with the hilarious, witty, and beautiful Kristen Wiig. I absolutely love the bril-
liance of Kristen—she is creative, sharp, and really embraces fashion in all of
its glory. We chose to make her Atelier Prabal Gurung gown in a light shade
of yellow, which, in China, symbolizes heroism and beauty. It was a celebration
of the imperial spirit of the Chinese culture and of our muse Kristen. We had
such a fun night, and the exhibit was truly exceptional.

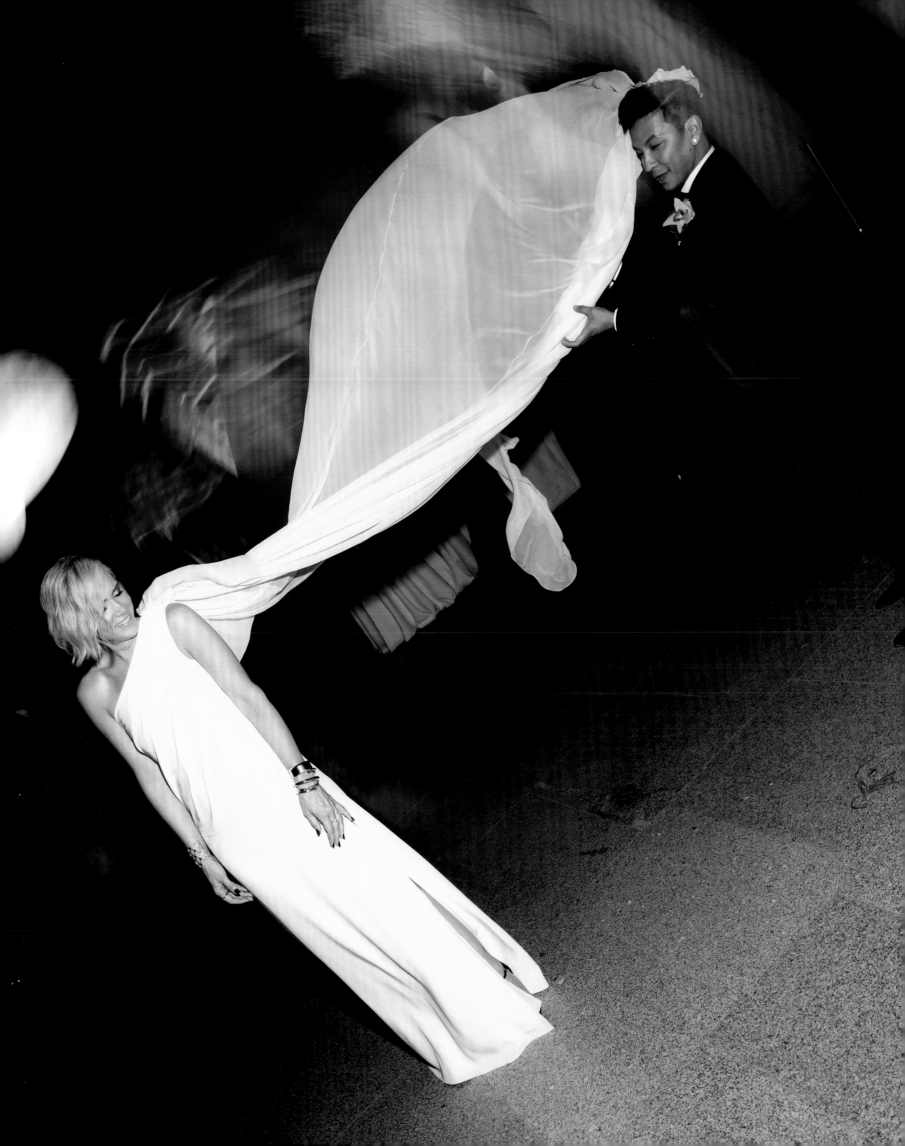

2016

EMBRACING MY VOICE I've always been a proponent of feminism, minority inclusion, and equality. While I've never been one to shy away from speaking openly about my ideals, 2016 was the year I learned to really embrace my voice, and when society leaned into our ideals as well, whether through championing for who I hoped would become our first female president, advocating for size inclusivity, or supporting women on their pursuit to be free from constraints of the male gaze. In November, we launched our Lane Bryant capsule collection, which featured size-inclusive options at an accessible price point for women. From day one, our brand was founded on the ideals of celebrating diversity and fostering an inclusive world, and while we've always offered a size-inclusive range, it brought me such happiness to be able to build a community and engage with inspiring women on a broader scale. It was also a rewarding year of personal growth. I returned home to Nepal in the spring to see my beloved niece Vaidehi's coming-of-age ceremony, a beautiful tradition where we celebrated her womanhood. I am so proud and amazed at the people she and my nephew are both becoming—they challenge and inspire me every day and give me hope for what our future can become. They are the reason I want to break down barriers, defy convention, and do my part to design a brighter world.

Fall 2016 "Magical Realism"

This season I took my audience to a place where magical realism reigns.

I was inspired by the brilliant Henri Rousseau's painting *Woman Walking in an Exotic Forest* and the powerful prose of Lord Byron's "She Walks in Beauty," and designed a collection filled with a romantic collage of ideas. The Fall 2016 woman embarked on a fantastical journey in an attempt to connect with the divinity of the natural world and experienced her new surroundings through an idyllic lens—curious, intrigued, and slightly undone.

The essence of her surroundings informed the color tones of snow, pewter, midnight, ivory, cherry, blackberry, and sky, which were complemented by rich fabrications and textures including hand-knit Nepalese cashmere, fawn-printed leather, feather and leaf hand-embroidered guipure lace, astrakhan-textured velveteen, and ginko leaf–printed knits. The inspirations also lent themselves to the softening of silhouettes and an ease in shape with oversized coats and effortless knits, allowing the Prabal Gurung woman to explore freely as she discovers that which is extraordinary in an otherwise mundane world. Beginning with utilitarian coats, heavy knits, rich guipure laces, and luxe layers, as her journey continues, she sheds her skin, leaving behind the weight of the world she once knew, embracing her sensuality, as shown on the runway through the buttons coming undone. The collection concludes with an ethereal escape, depicted by a duo of chiffon gowns elegantly hand embroidered with enchanting crystals.

Our shoes were designed with an eclectic mix of materials—joining pony, suede, matte and metallic snake, and specchio leather together to bring a modern and unexpected appeal to this season's relaxed silhouettes. As always, they were finished with the signature spike detail, also seen throughout the ready-to-wear collection, visually symbolizing the brand's philosophy of "femininity with a bite," celebrating the multifaceted nature of our modern muse.

While this journey through the mystical world was fleeting, the experience forever grants us all the perspective to respect the land and our roots, inspiring us to live with purpose and become extraordinary.

OPPOSITE: THE MOOD BOARD WITH INSPIRATION FOR THE FALL 2016 COLLECTION,
A JOURNEY THROUGH A MAGICAL FOREST.

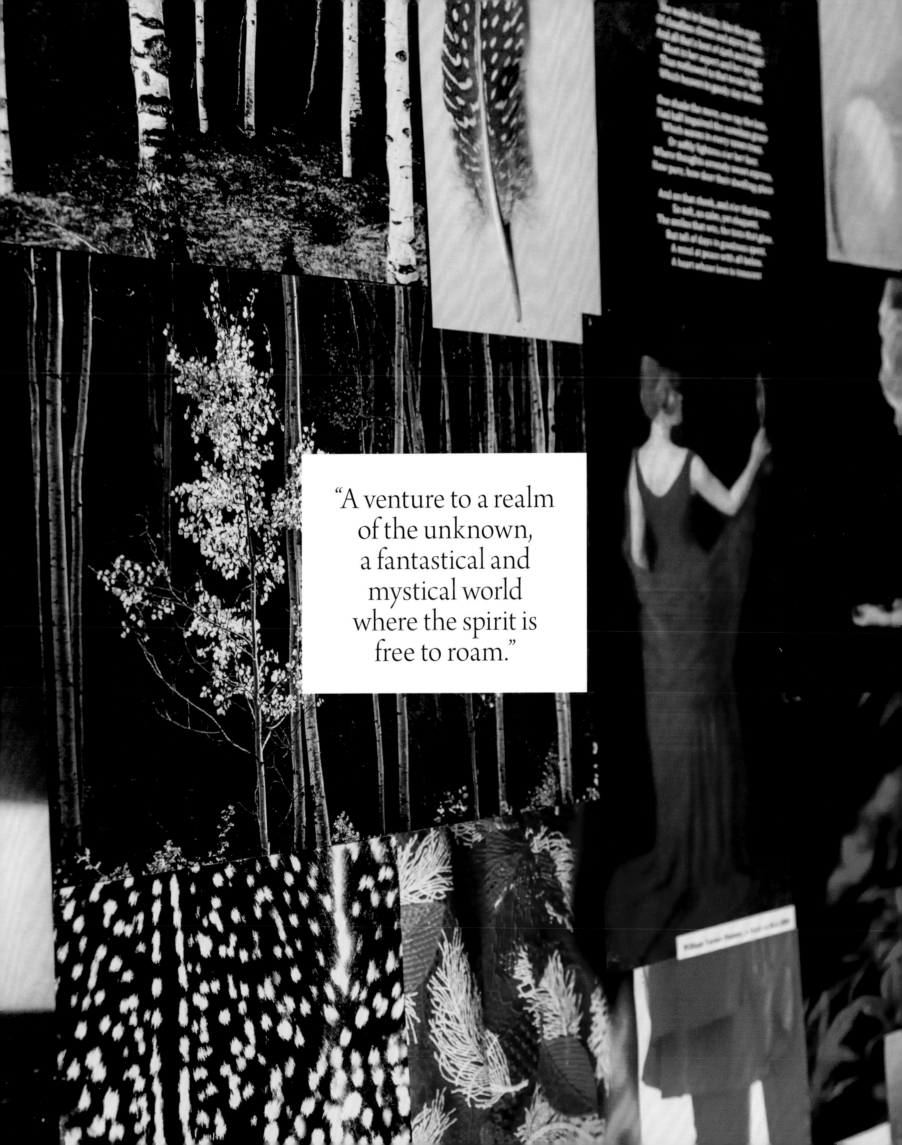

"A venture to a realm of the unknown, a fantastical and mystical world where the spirit is free to roam."

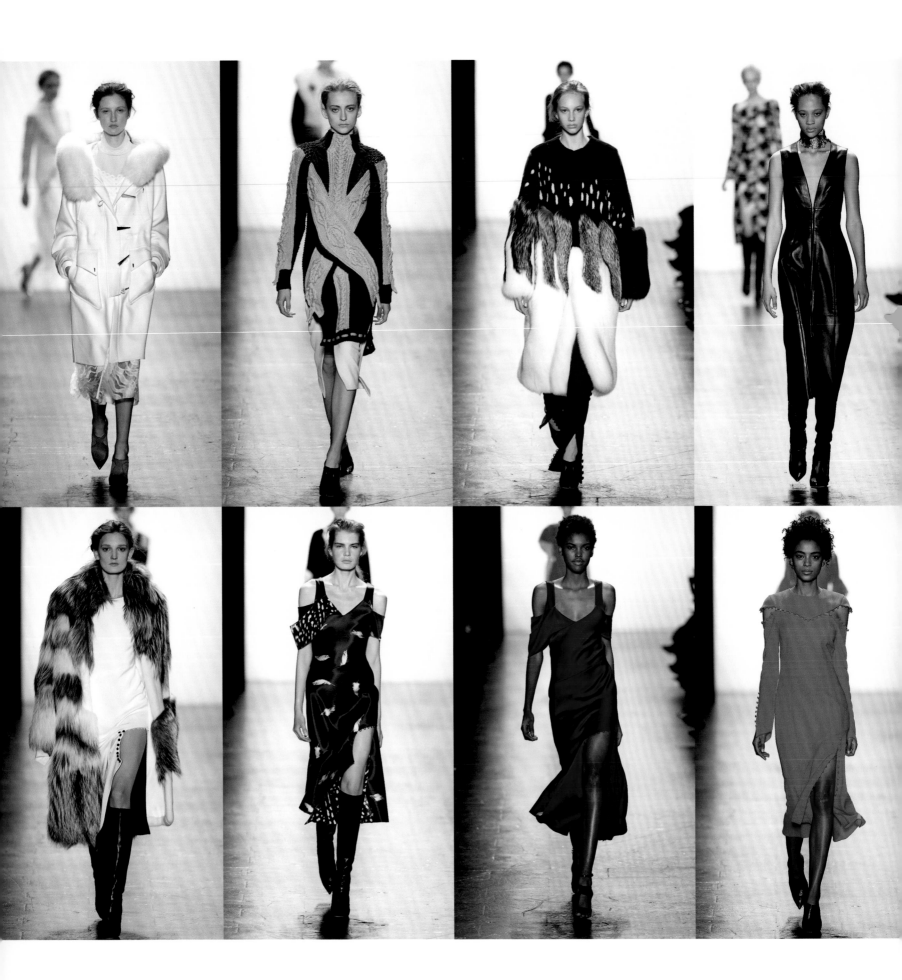

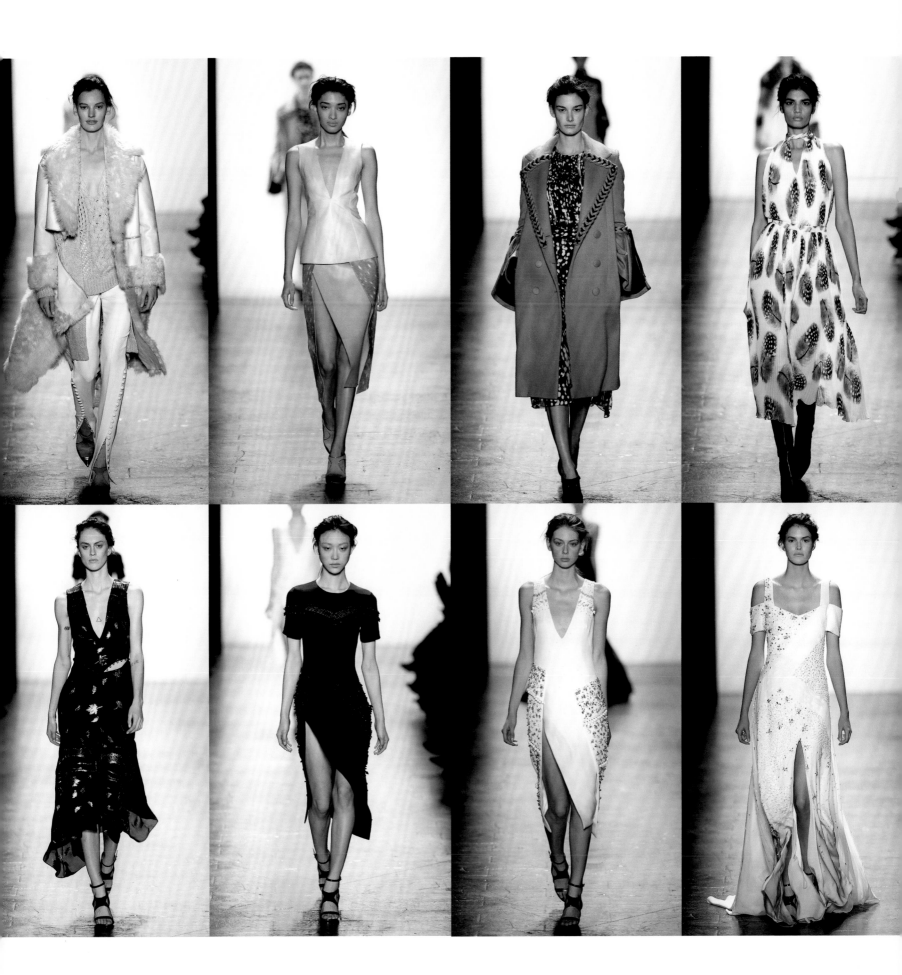

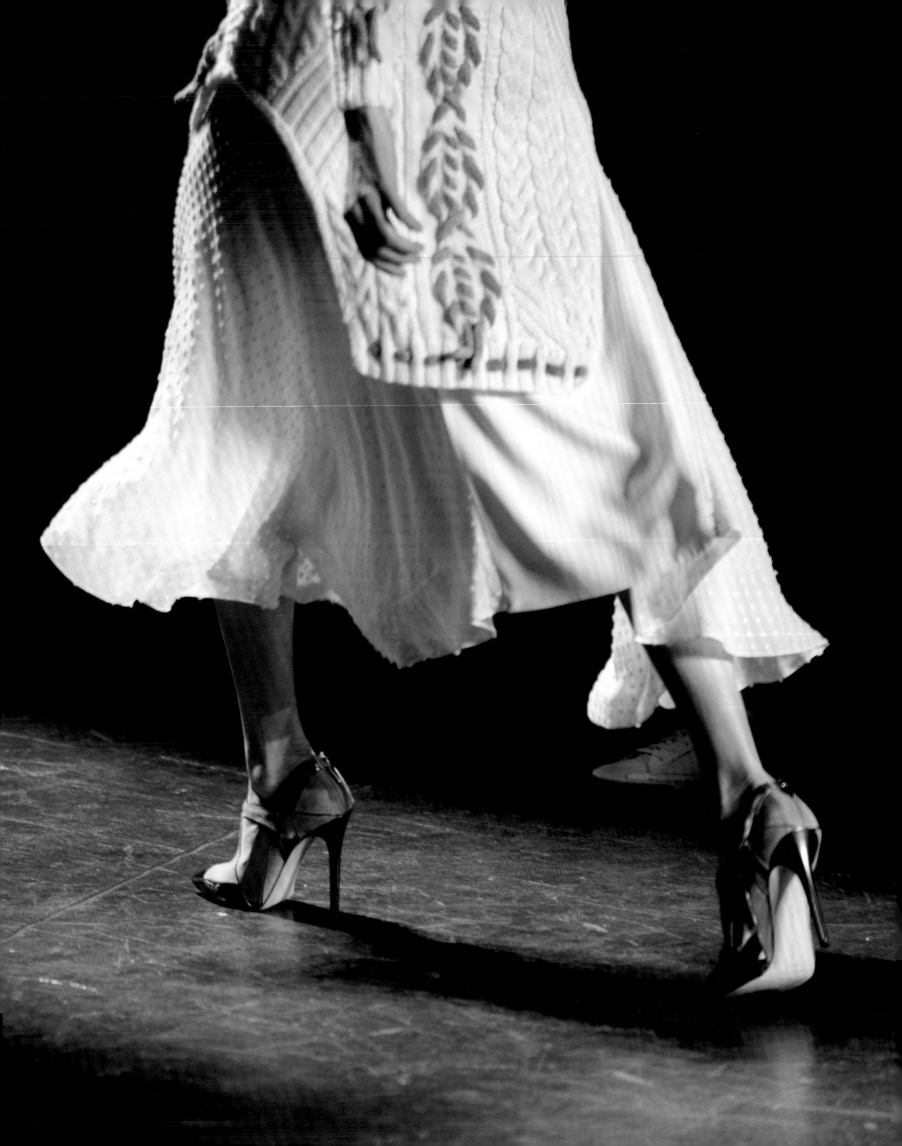

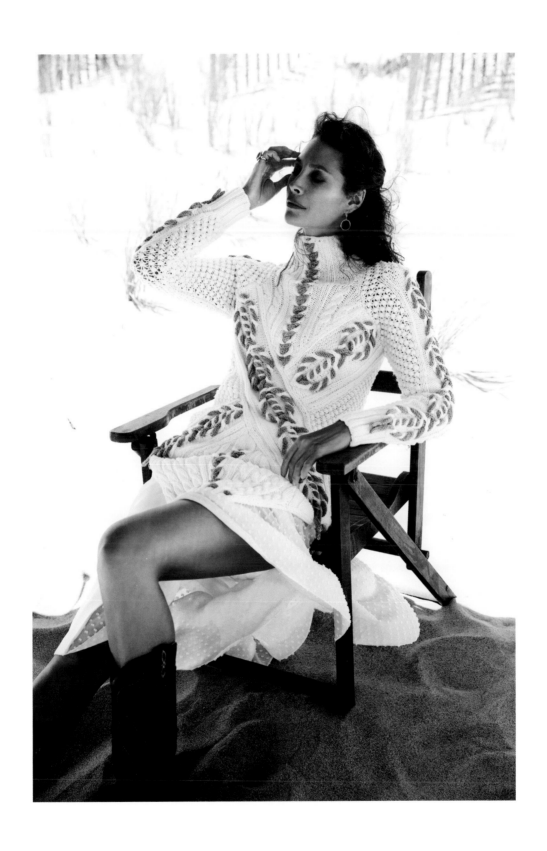

ABOVE: CHRISTY TURLINGTON, PHOTOGRAPHED BY SILJA MAAG
FOR THE AUGUST 2016 ISSUE OF *GLAMOUR* ICELAND.

OPPOSITE: THE HAND-EMBROIDERED KNIT, MADE IN NEPAL, WAS
STYLED WITH A CHIFFON SKIRT FOR THE FALL 2016 RUNWAY.

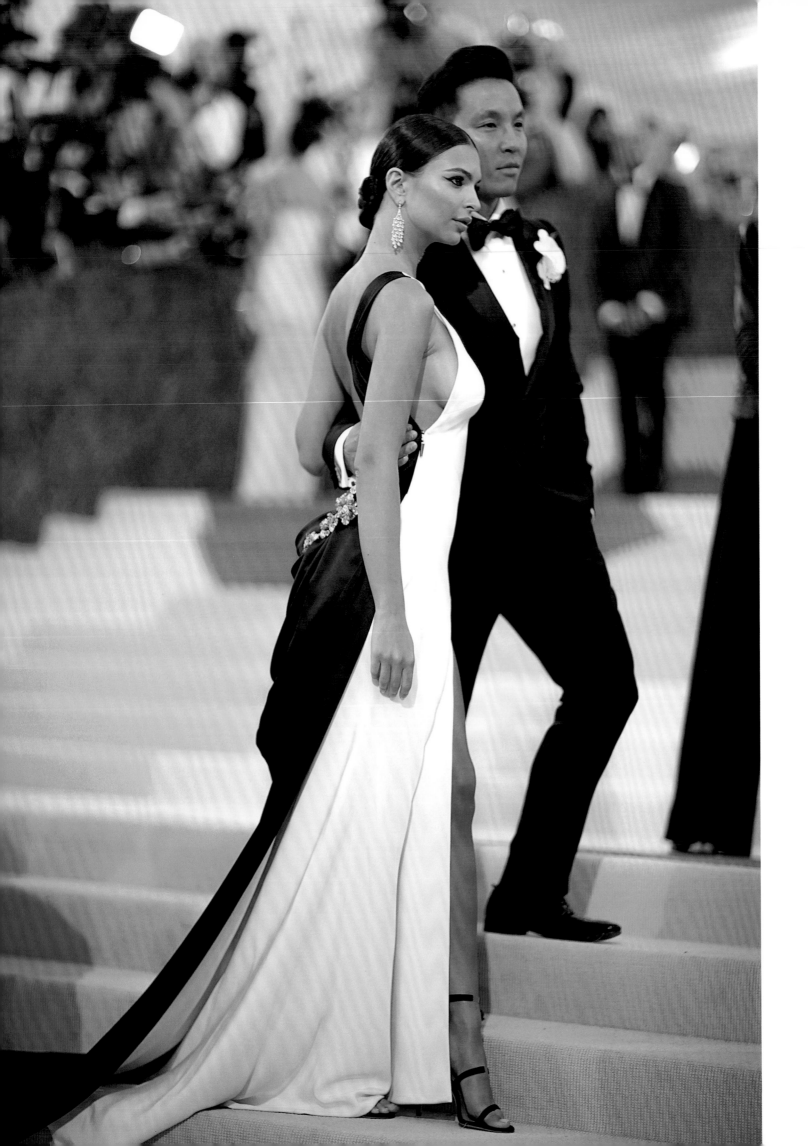

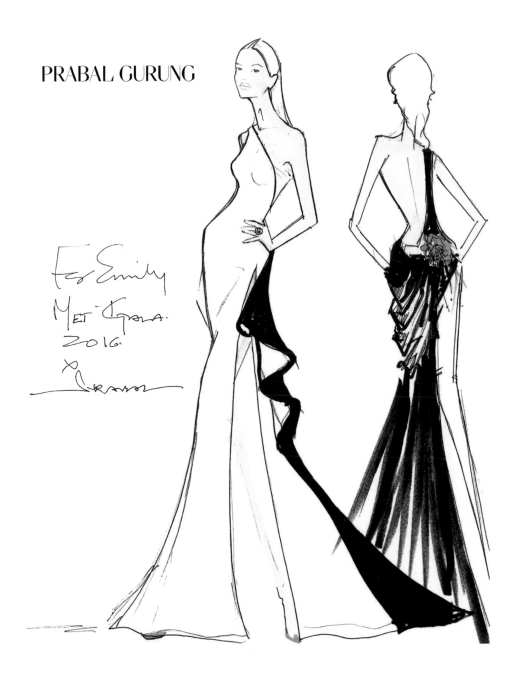

PRABAL GURUNG

For Emily
MET Gala.
2016.
x [signature]

Enchanted by Emily

Emily Ratajkowski was my date for the 2016 Met Gala celebrating "Manus x Machina: Fashion in the Age of Technology." When I first met Emily at our fitting, I was immediately struck by her presence—she is alluring, yes, but more seductive than her beauty is her brain. She is informed and eloquent. She is resolute in her desire to transform the cultural canon and what feminism means within it. Together, we chose to make her an Atelier Prabal Gurung gown that highlights her feminine form with empowerment, hand draped and sewn in our New York atelier.

Spring 2017 "Together We Rise"

I dedicated this collection to my mother, who always wanted to change the idea that the higher you go, the fewer women there are.

The inspiration for Spring 2017 began with Gloria Steinem, my forever heroine. I met Gloria at my dear friend Jennifer Hudson's Broadway opening for the play *The Color Purple*. Never had I been so nervous to meet a celebrity, but I felt calm in Gloria's presence. She immediately offered warmth and bravery. I had recently finished her poignant memoir *My Life on the Road*, and in designing this collection, her presence and influence sat at the forefront of my mind. With her strength and stark determination to fight for feminism without compromise, Steinem embodies our ideal of "femininity with a bite"—celebrating the complexity of a woman, layered far beneath surface beauty. Likewise, we also looked at art that offers a steep subtext, encouraging the viewer to look deep beneath the shell—the floral paintings by William Kentridge, photographs by Taryn Simon, and neon artwork by Tracey Emin.

This notion of modern feminism was reflected in a loosening of silhouettes—garments that drape around a woman's natural form are juxtaposed with refined tailoring, creating a fluid offering that gives the Prabal Gurung woman the power of choice. Carwash-style skirts and dresses equally reveal and conceal, leaving our wearer in control of her self-presentation. The option of femininity was exaggerated through a trio of hand-pleated sleeves, showcasing the power a woman possesses when she rises in all of her glory. Hand-engraved hardware details, made in Nepal, were used to remind us of our muse's journey and her vigor. This season's color palette provided a powerful amalgamation of practical and controlled American sportswear in hues of ivory and black with the exotic mysticism of a glamorous explorer in shades of citron, iris, and azure.

This collection waxes poetic, showing reverence for the inspiring women who impacted the fabric of our history. I paid homage to the exhilarating and moving words of Emily Dickinson, Maya Angelou, Susan B. Anthony, Gloria Steinem, Angela Davis, and my dear friend Rupi Kaur. We quite literally marked our collection with their impact, screenprinting and embroidering their heroic words into grosgrain ribbons, swinging dresses, and structural suits.

The curves and linear details of William Kentridge's and Taryn Simon's abstract florals inspired the silver-plated brass jewelry, handmade by artisans in Nepal. It has always been a core part of my ethos not only to highlight the craftsmanship of the country that I am from, but also to create economic opportunity for the women who reside there, ensuring they can build a sustainable future for themselves and our next generation. With a dedication to ethical and responsible production, we created jewelry out of recycled metals, minimizing our environmental impact while elevating the future of sustainable fashion.

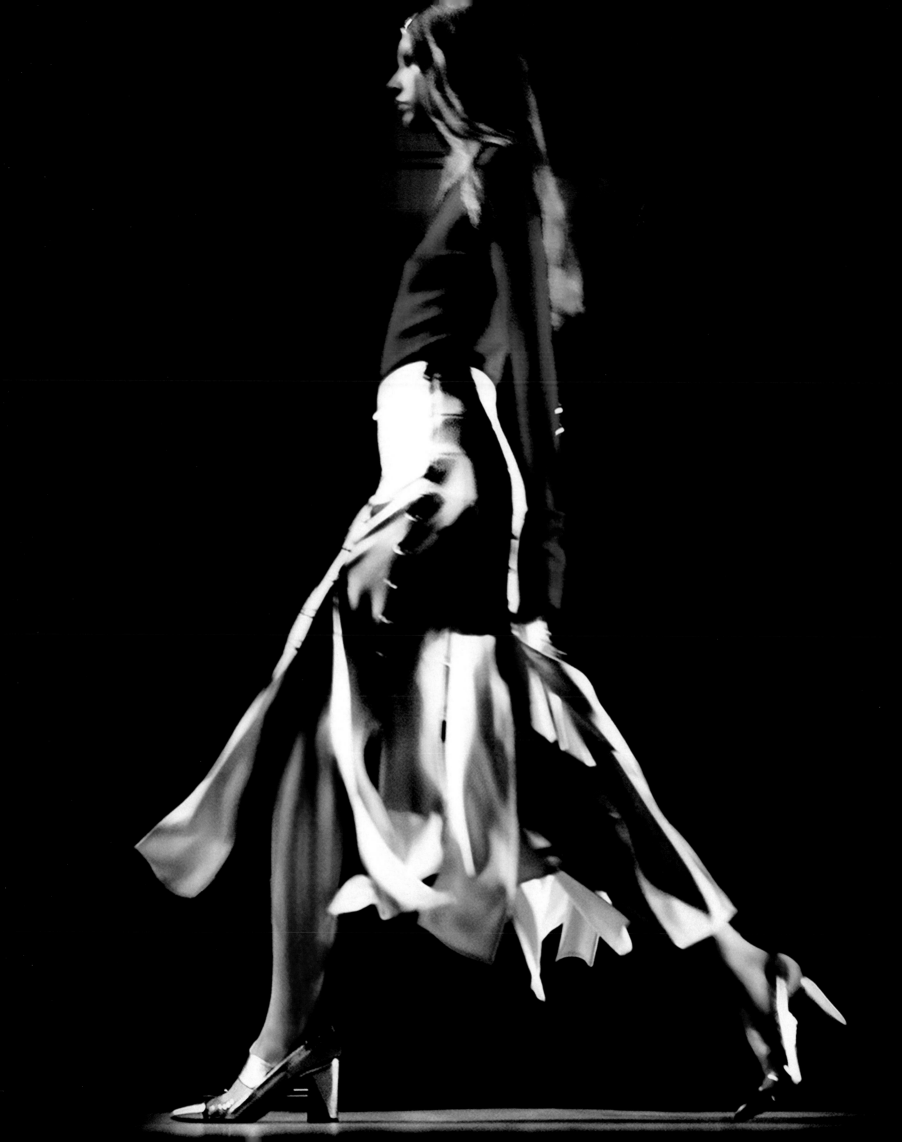

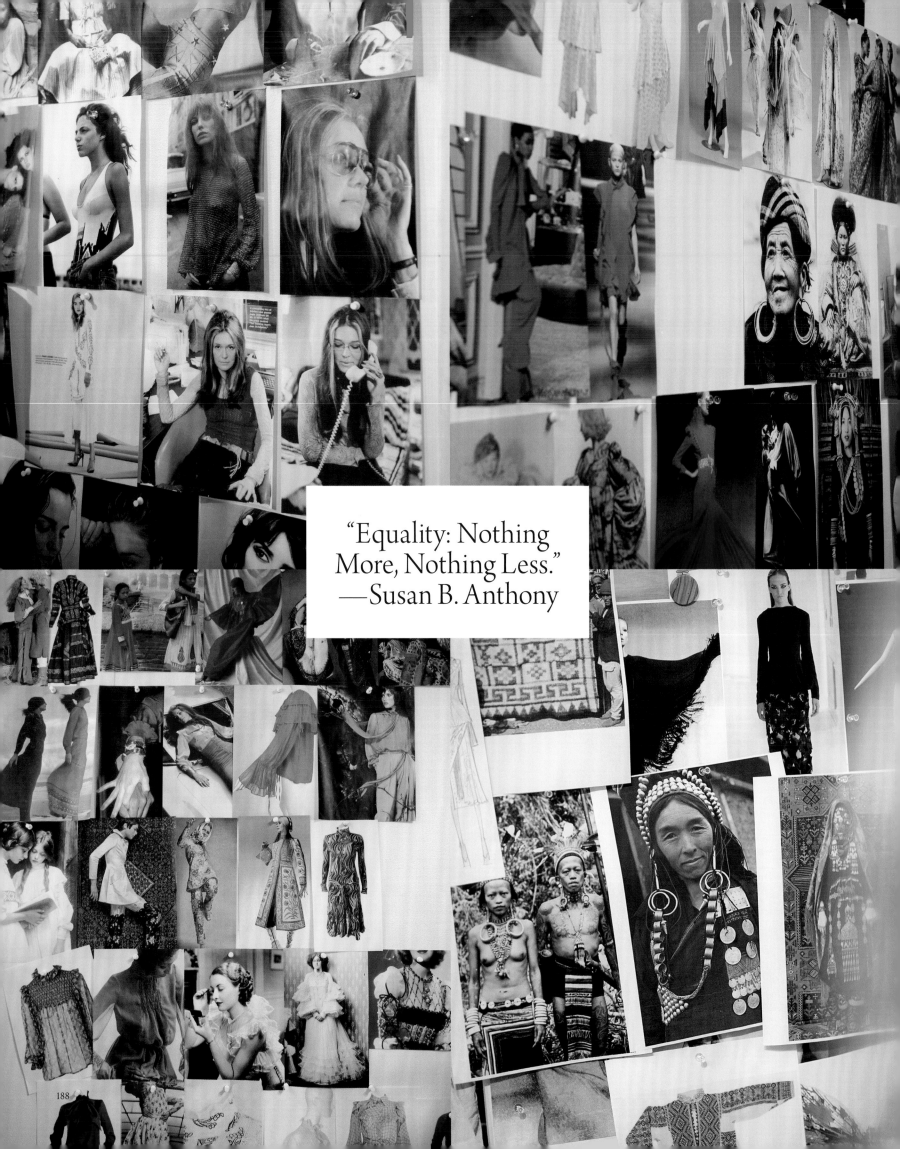

"Equality: Nothing More, Nothing Less."
—Susan B. Anthony

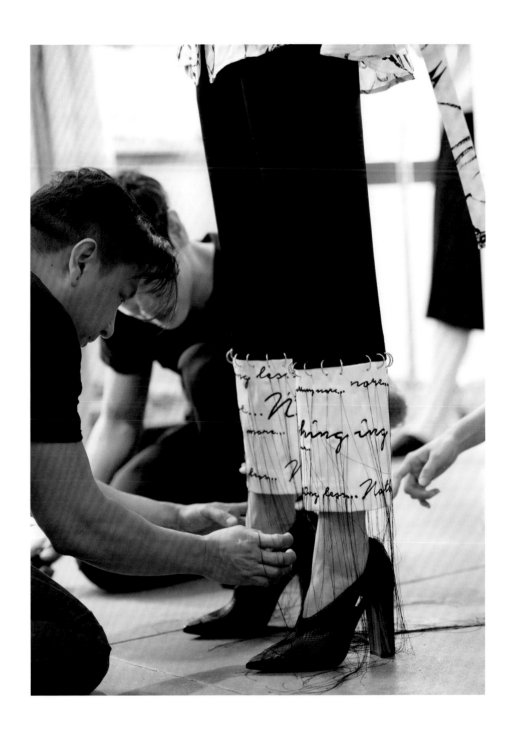

ABOVE: FITTINGS FOR THE SPRING 2017 SHOW.

OPPOSITE: THE MOOD BOARD WITH INSPIRATION FOR THE SPRING 2017 COLLECTION,
A CELEBRATION OF MY SUPER-HEROINES FROM FEMINIST GLORIA STEINEM TO THE
WOMEN AROUND THE WORLD WHO WORK WITH TENACITY, GRIT, LOVE, AND SOUL.

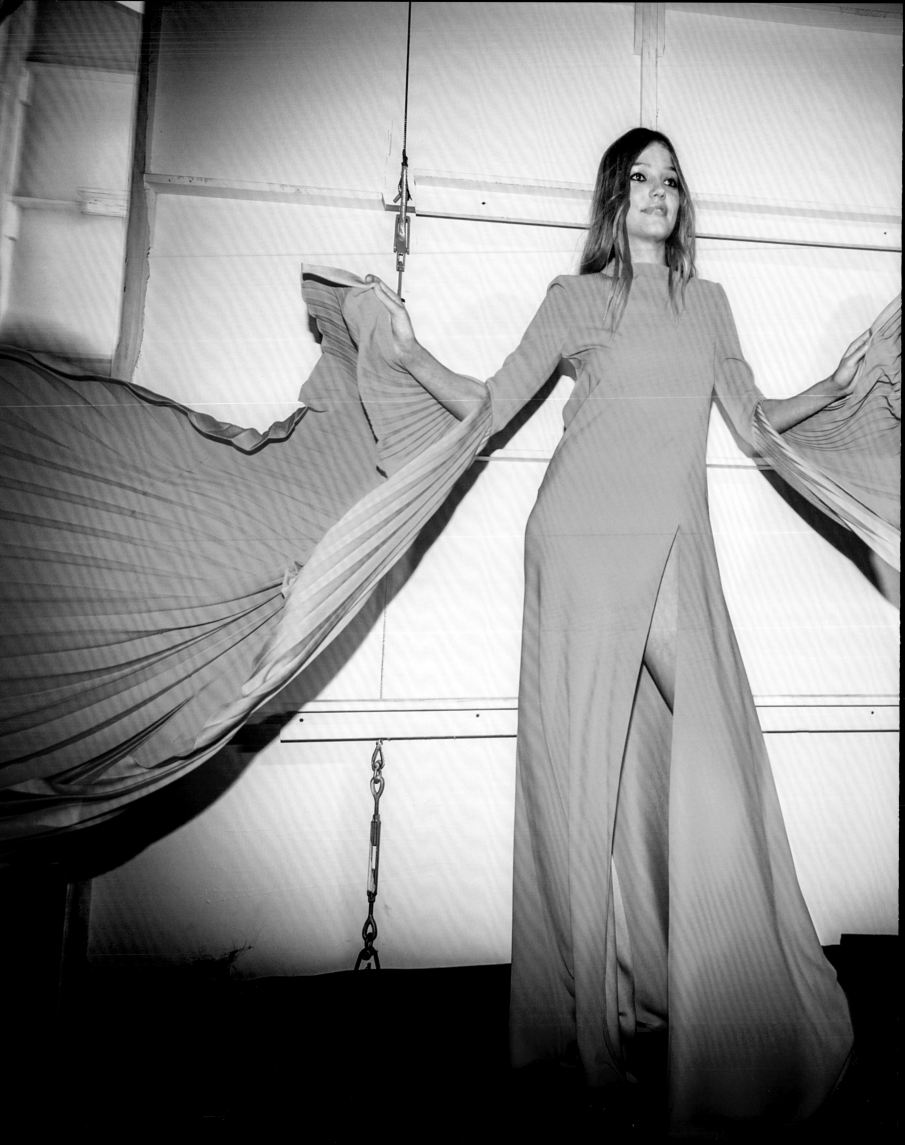

ROOS ABELS WEARS THE PEONY SILK CREPE GOWN WITH EXAGGERATED
PLEATED SLEEVE. THIS LOOK SHOWCASES THE POWER OF A WOMAN
DRESSED IN ALL OF HER FEMININE GLORY.

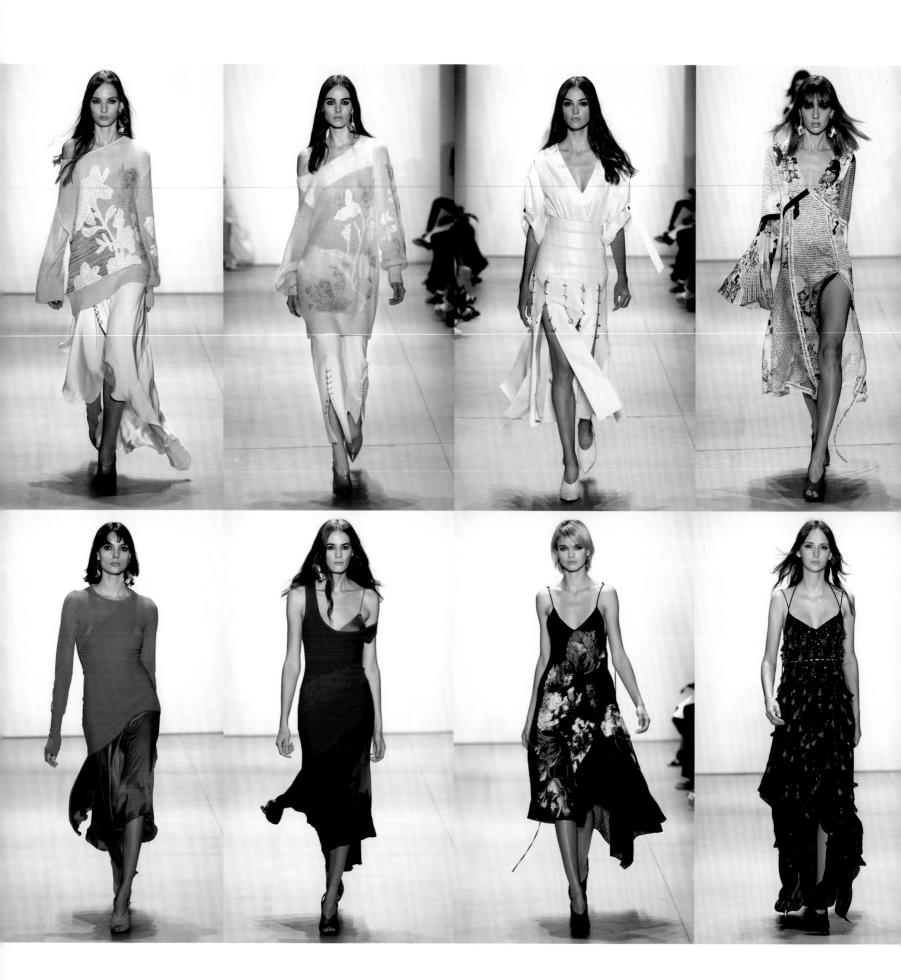

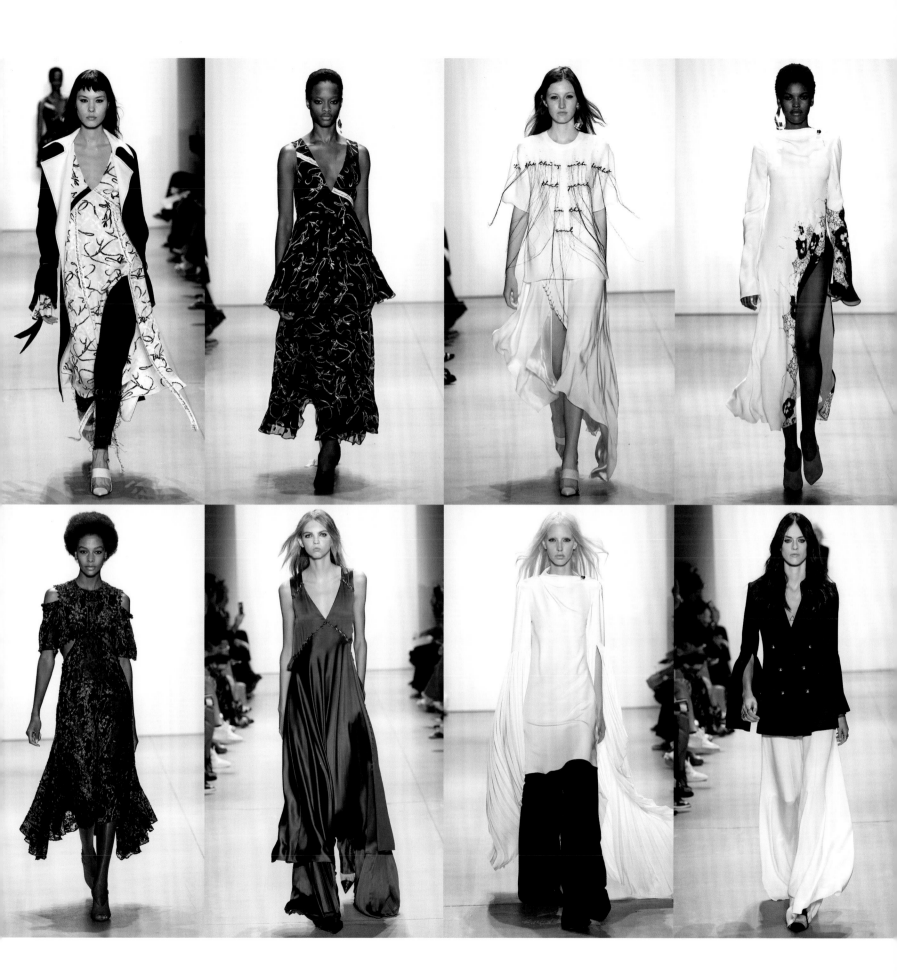

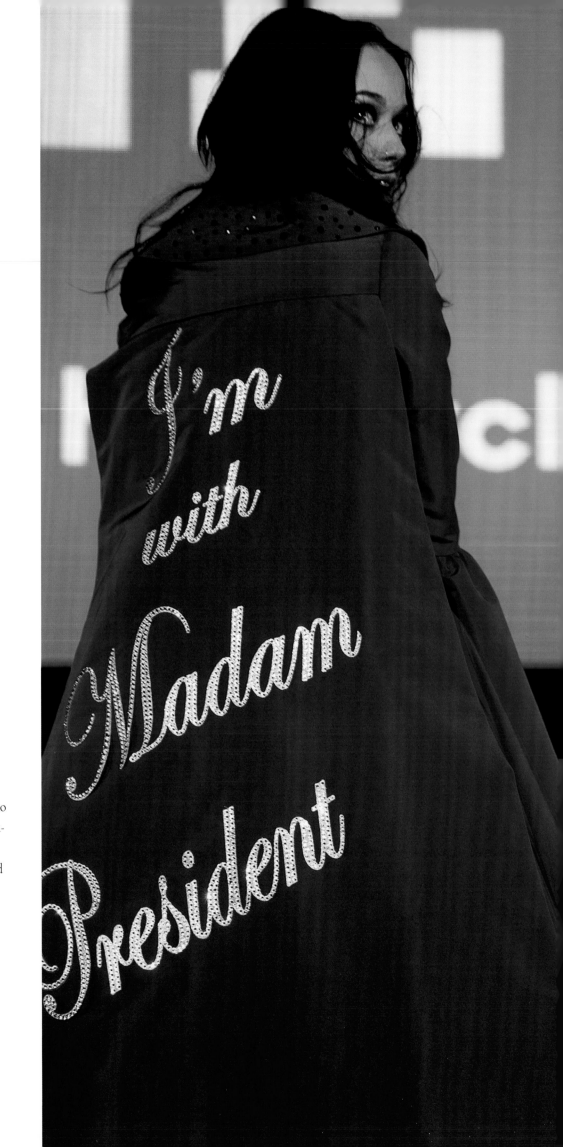

A Woman's Right to Reign

We worked with a loyal friend, super-stylist Karla Welch, to custom create a look for Katy Perry at the last Hillary Clinton rally before the election. I wanted to design a special piece made for the stage that mimicked Katy's empowered convictions, while also celebrating who I hoped would become our next president. Our goal was to ignite people across the country to get out and vote. Although the election didn't quite turn out as we hoped, I am still proud of this moment because I took a stand, and bravely stood up for what I believed in. Of course, I was devastated following the election, but looking back, I try to believe that it has only made some of us stronger, and more courageous, more active citizens.

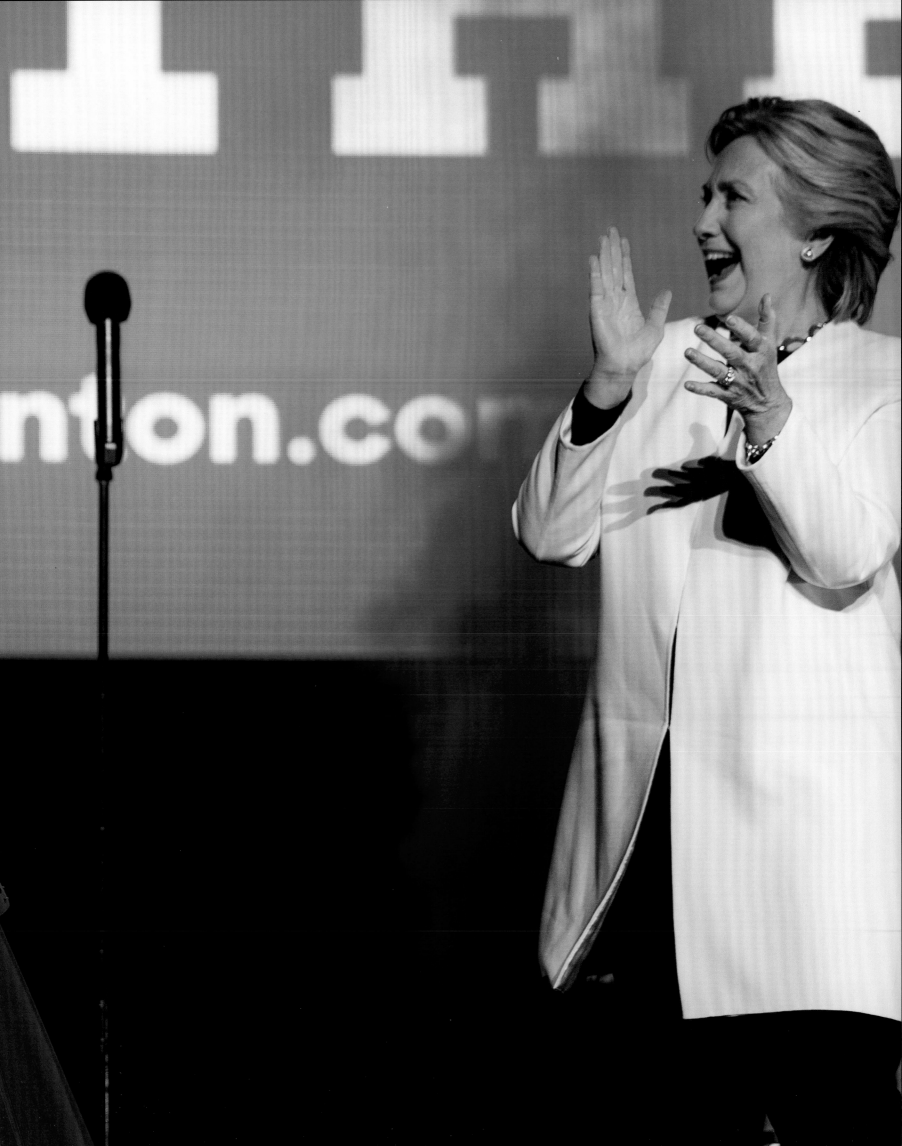

2017

THE YEAR OF SOCIAL ACTIVISM Two thousand seventeen was a year of awakening. My mantra: Together we are vigilant, we are active, we are armed to fight, peacefully and courageously. Collectively, we are living in a trying political climate, one where our freedoms are threatened, our souls unseen. Amid this chaos, I rediscovered my voice, strengthened my wits, and used fashion as a visual platform to communicate and provoke change. With Shikshya Foundation Nepal, we acted with social responsibility, aware of our impact and inspired to make things better for the next generation. We continued this momentum and gracefully stepped into higher power, learning to embrace the upside of the downside. Through it all, I wanted to build a community of like-minded and kindred spirits, who stand together in solidarity to advocate for our lives. Provoked by the vigilance of the Women's March, we staged a moment of solidarity at our Fall 2017 show, launching a diverse collection of T-shirts that spread our messages of feminism, equality, and inclusion. Following this powerful and impactful moment, the next season, my heroine Gloria Steinem joined us for her first-ever fashion show in our front row. It was a full-circle moment of pride, joy, and humility.

Fall 2017 "The Upside of the Downside"

The results of the 2016 presidential election were devastating, for our country, and for me personally as an immigrant, a gay man, and a feminist. Those of us who felt like I did faced a choice—we could choose to sit idle and wallow in our misery, or we could rise up with poise, action, inspiration, and courage, refusing to accept the new status quo. For me, and so many others, this became the time to speak with conviction and use our voices to invoke change. Amid a trying time following the election, we came together, armed to bring a peaceful revolution, one where minorities rise and normative society sees change. This is the upside of the downside.

For this collection, I presented the women who inspire me—those made of strength, inner beauty, graceful femininity, and vigilance. Femininity has more than one definition and this fall began with a question: What does it mean to say a woman should "dress like a woman"? From utilitarian overcoats and two-tone work gloves to Chantilly lace and hand-embroidered gowns with 220,000 delicately woven crystals to floral prints to hand-knit cable cashmere, we offered multiple ways to celebrate the exuberance of being a woman and to interpret her femininity as she sees it.

We looked back at the women in 1940s America and Nepal—the women who joined the workforce during World War II in factory lines and offices or rooted themselves in the fields, ready for manual labor that required strength and stamina. These women maintained grace under pressure and held a quiet power, a secret weapon during war. These women were workers, mothers, fighters, and sisters who understood that one minority's downfall is equivalent to the demise of all humanity.

This notion of modern feminine power was reflected in silhouettes that draw on military detailing with blurred camo prints juxtaposed with strategically placed ruching to showcase the female form. Oversized cashmere sweaters hand-sewn by artisans in Nepal were presented alongside sarong-style skirts in delicate chiffon. Sparkling lurex and bold brushed florals were printed on mock neck dresses with strategically placed cutouts accented by our signature covered button detail.

My collection was a celebration of women from all walks of life. It was a love letter to you, our women, who inspire us to present our unabashed and unapologetic definition of "femininity with a bite."

OPPOSITE: THE MOOD BOARD WITH INSPIRATION FOR THE FALL 2017 COLLECTION,
INSPIRED BY WORKING WOMEN AROUND THE GLOBE.

FOLLOWING SPREAD: A TRIO OF LOOKS BACKSTAGE AT THE FALL 2017 SHOW. THE
OVERSIZED CASHMERE KNITS WERE HANDMADE BY ARTISANS IN NEPAL.

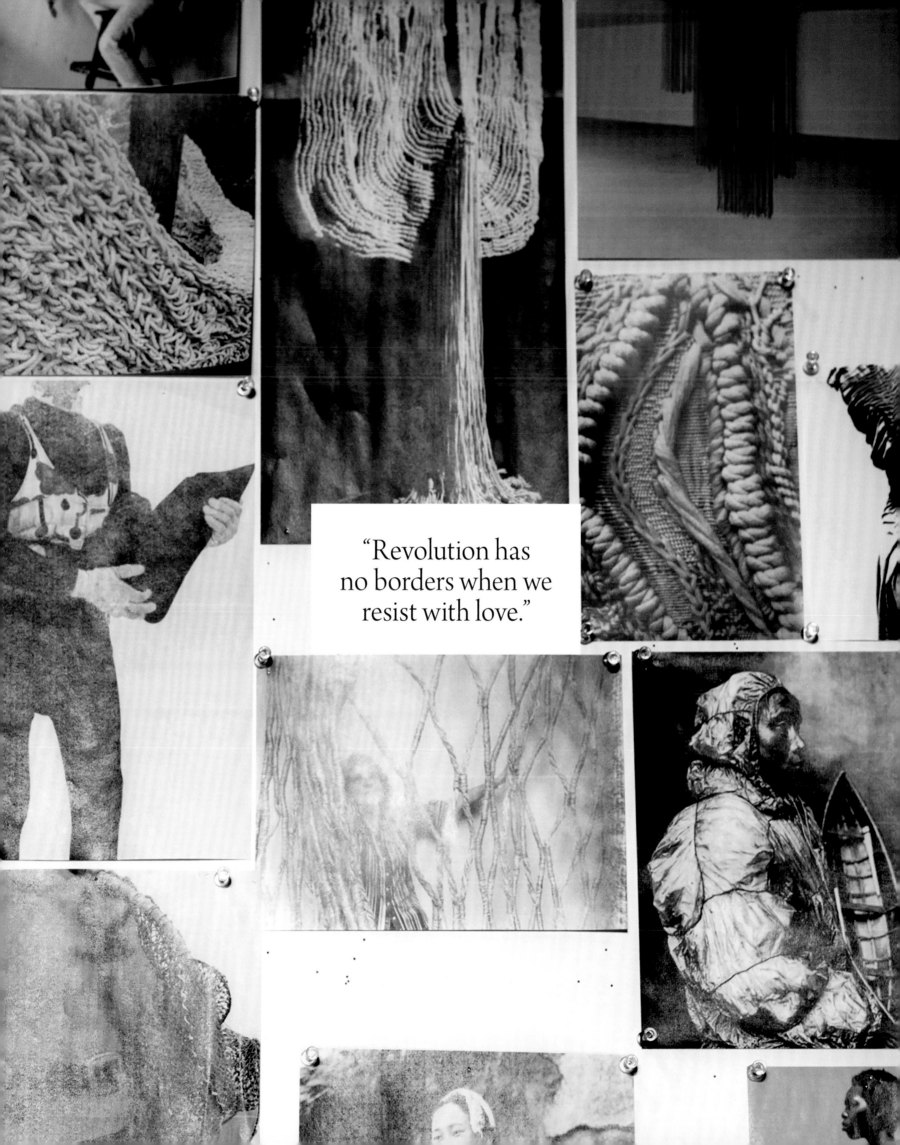

"Revolution has
no borders when we
resist with love."

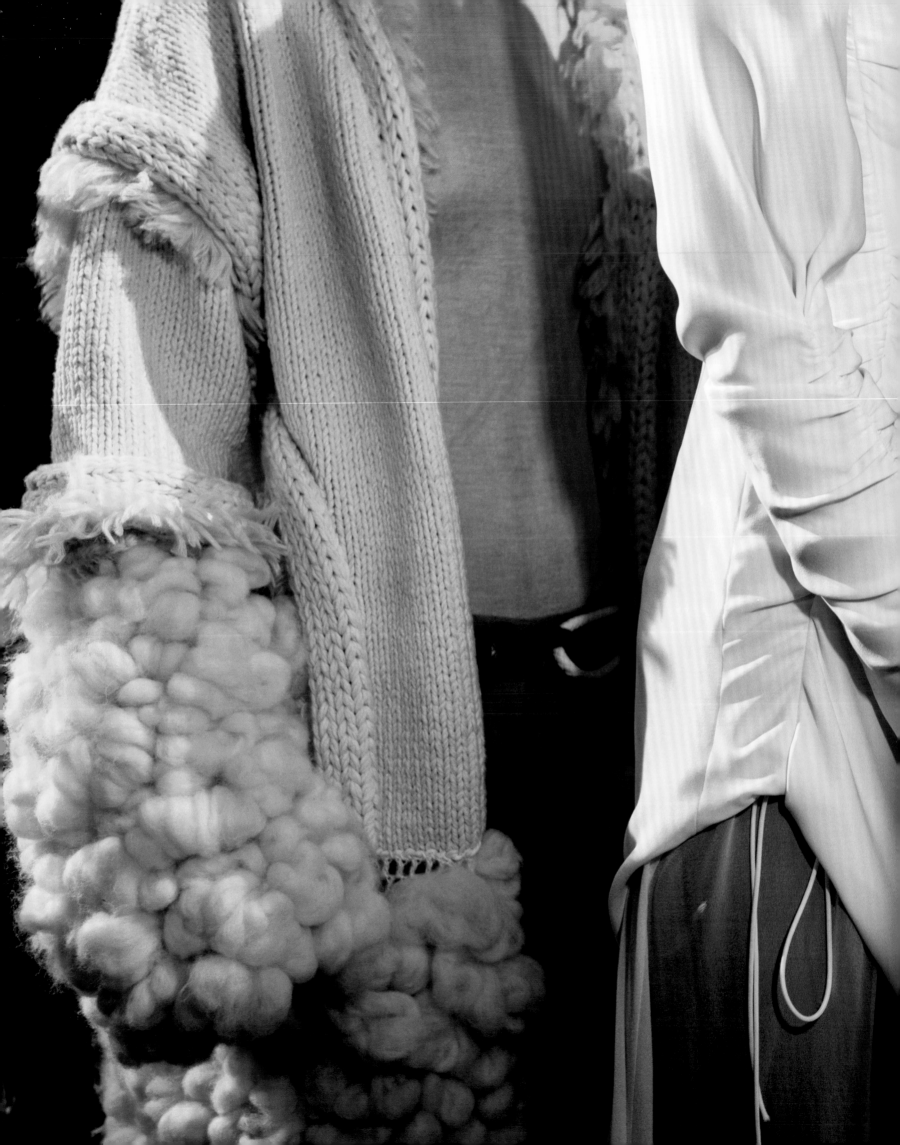

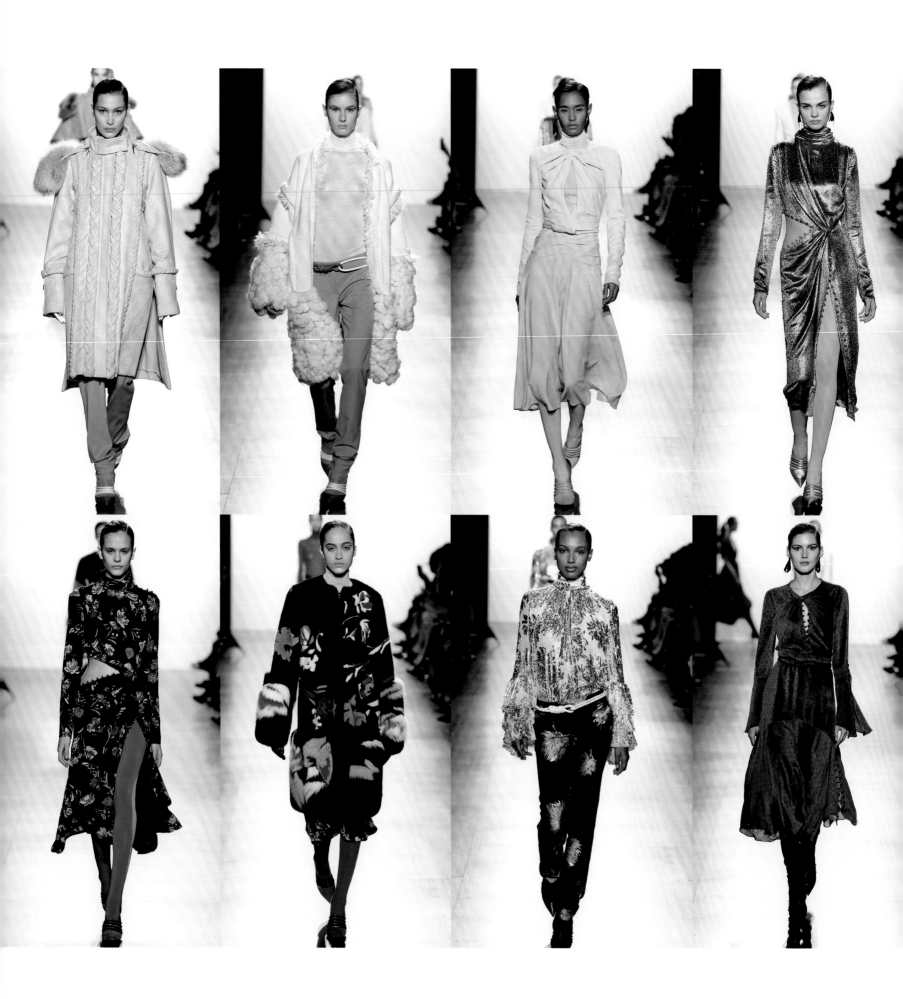

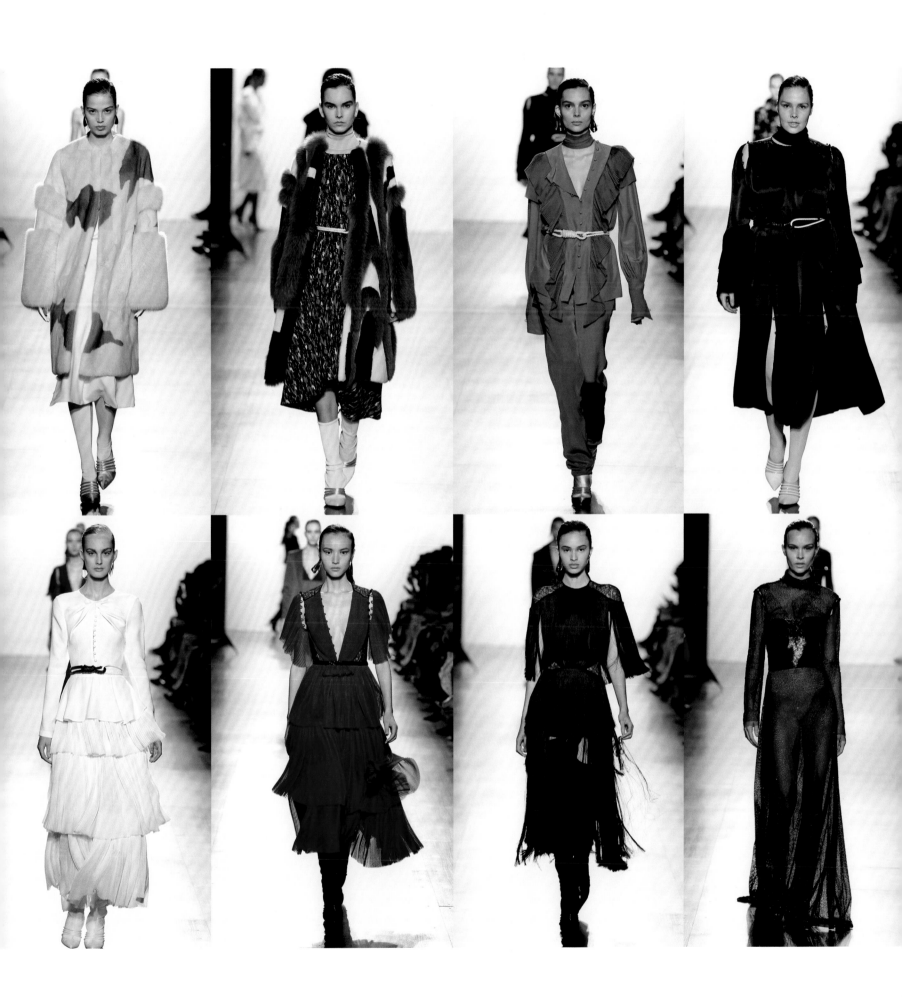

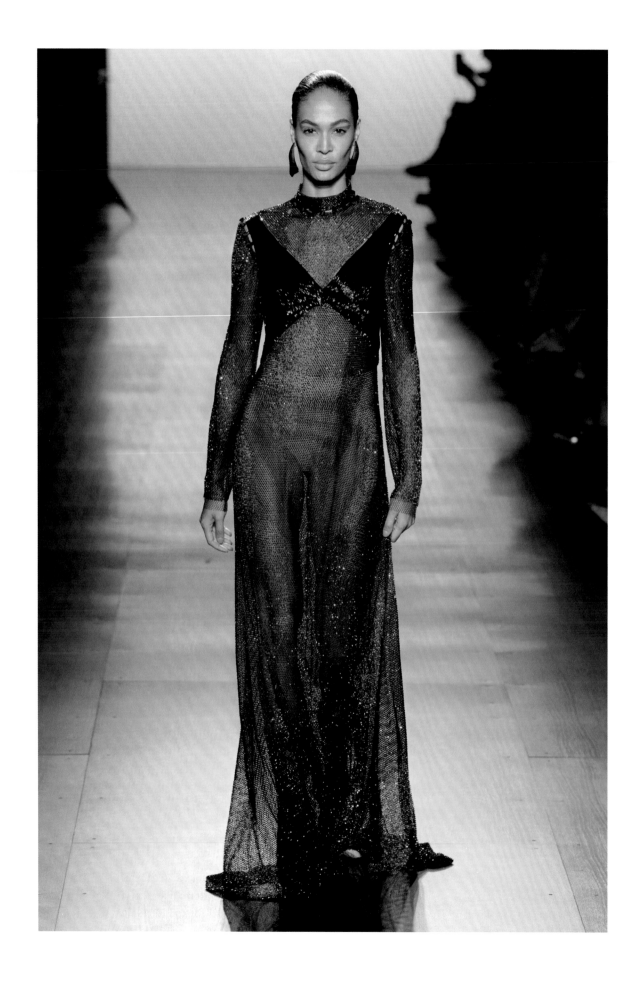

ABOVE: SUPERMODEL JOAN SMALLS CLOSES THE FALL 2017 SHOW.

OPPOSITE: A BACKSTAGE MOMENT WITH JOAN AND BLANCA PADILLA.

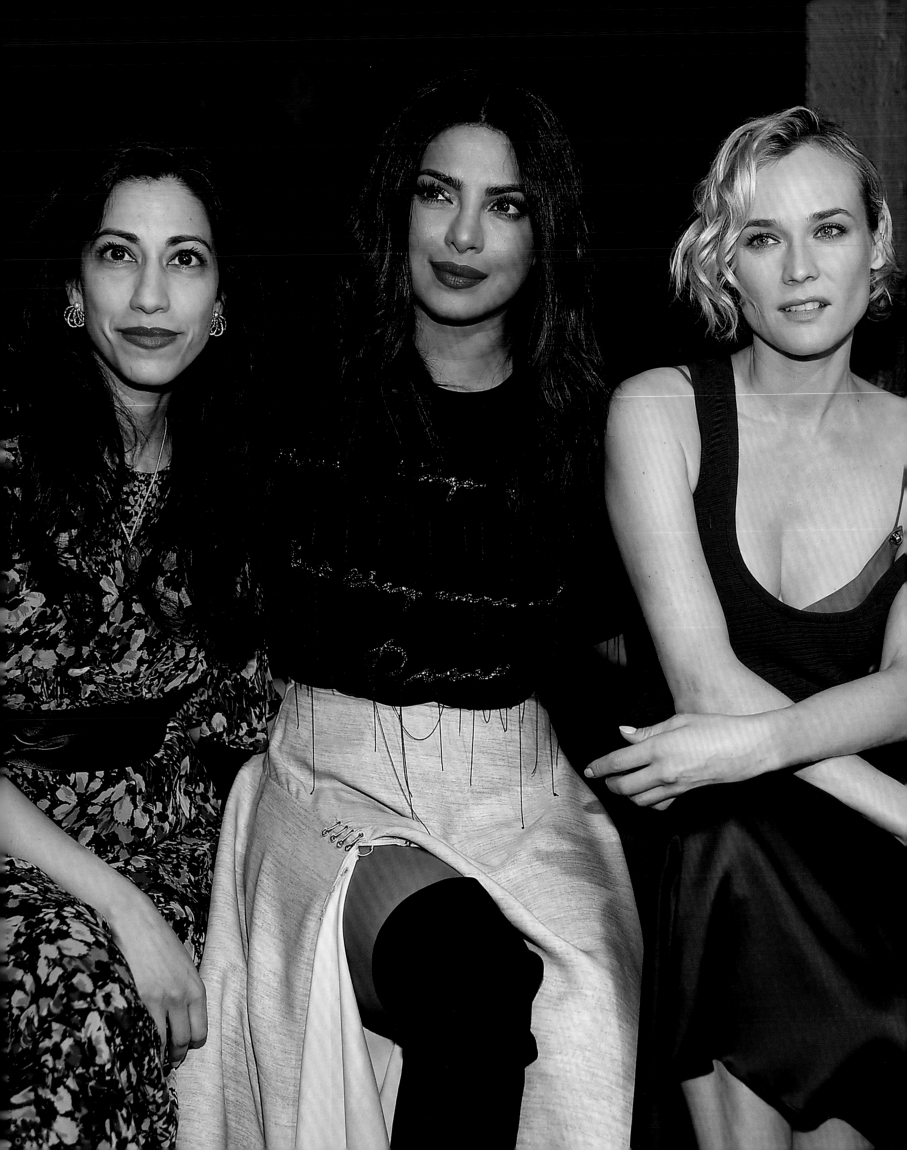

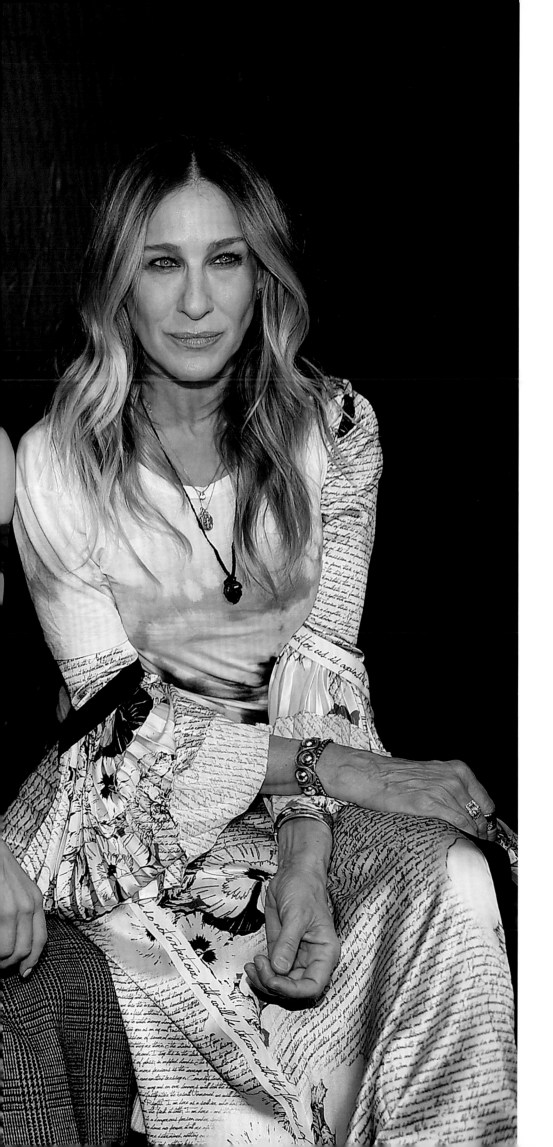

Together in Solidarity

My modern muses, my real-life superheroines, my incredible friends Huma Abedin, Priyanka Chopra, Diane Kruger, and Sarah Jessica Parker came together at our Fall 2017 show. Just as we use our runway as a vehicle of communication, so too is our front row. We want to celebrate the women who are trailblazers, change makers. The women who inspire. This was our first show after the election, and we staged an activists' march for our finale. It was so special and humbling to have these women supporting the brand and our ethos.

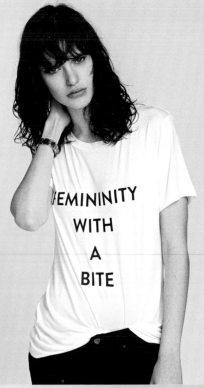

FEMININITY
WITH
A
BITE

R.E.S.P.E.C.T

NOW
MORE
THAN
EVER

YES,
WE SHOULD
ALL BE
FEMINISTS...

(THANK YOU,
CHIMAMANDA AND MARIA)

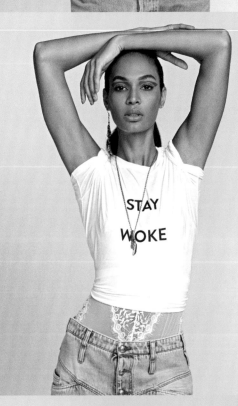

STAY
WOKE

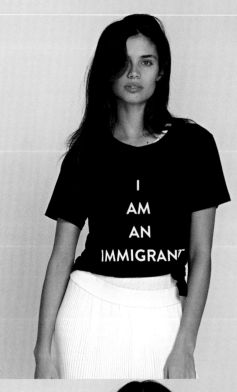

I
AM
AN
IMMIGRANT

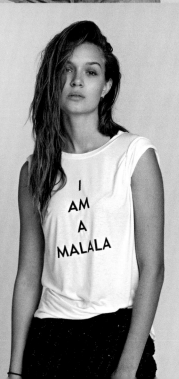

I
AM
A
MALALA

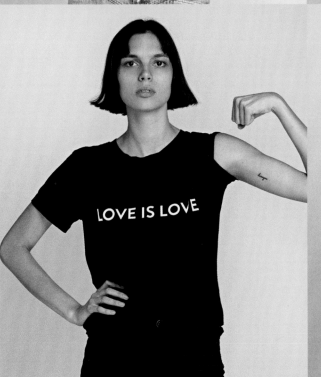

LOVE IS LOVE

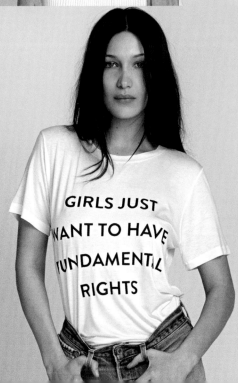

GIRLS JUST
WANT TO HAVE
FUNDAMENTAL
RIGHTS

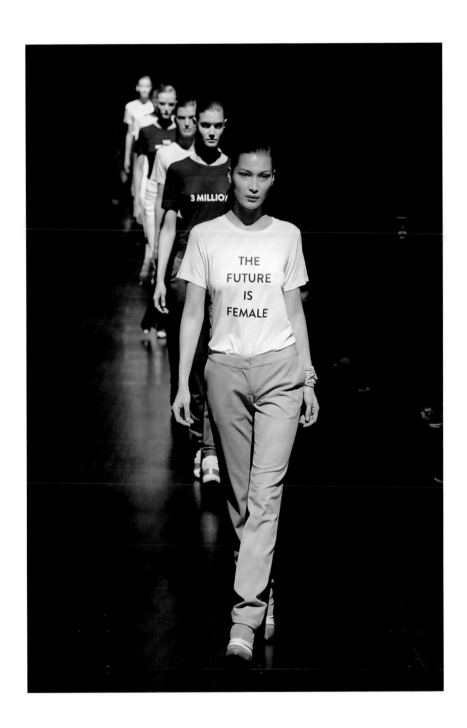

This Is What the PG World Looks Like

After attending the first women's march, I was inspired by the striking signs, powerful slogans, and overall solidarity of the women's movement. The emotion and strength behind it were soul stirring. When I returned to work on our Fall 2017 collection, I felt a responsibility and an urgency to use our runway as a platform to disseminate a larger message and create a global dialogue. We launched a series of T-shirts, thirty-eight to be exact, on our runway during the finale. Our models walked out with power, poise, and spirit to the moving sound of John Lennon's "Imagine," rethought by a beautiful female vocalist. I'm so proud that the T-shirts have raised money for Planned Parenthood, the ACLU, and our foundation, SFN.

Spring 2018 "Dreamers Awake"

What is a moment but an amalgam of memories? What is the present but a culmination of the past? What is the future but a mirrored reflection of history?

The inspiration for Spring 2018 began with a dream, yet we were wide awake. We were dreamers bringing a group of memories to life with our eyes and minds open. Prior to designing this collection, I visited the "Dreamers Awake" exhibition at the White Cube gallery in London, which showcased surrealist art from the female perspective by brilliant talents like Julie Curtiss, Caitlin Keogh, and Kiki Smith. I was immediately struck by the way these modern artists reclaimed the concept of the female gaze. By repossessing ownership over the fragmented body, their artwork has become a vehicle for irony, resistance, and self-creation, depicting a woman as a strong, sentient, and thinking being. I left thinking that now more than ever is a time for the woman to take ownership over her body to portray her own beauty as she sees fit.

Reveling in my own dreamlike state, I engaged in a spiritual memory, returning to my vibrant and colorful childhood in Nepal. I was reminded of the visual history of my country, rooted in prayer flags whispering in the wind as their messages and spiritual meaning soar. I continued on to another fantastic memory of a recent trip to the Tasaki pearl farm in Nagasaki, Japan, with a vision of the Ama, diving mermaids. With strength and determination, these mystical beings plunge into the depths, often clad in no more than fisherman-plaid bottoms, focused and breathless on their quest to unearth beauty. Reflecting on their depiction in history felt dreamlike—somewhere between the real and the hypnagogic.

In the surrealist world we presented on the runway, beauty takes on multiple meanings: It is soft, sensual, provocative, elegant, unsettling, foreign, discomforting, different. It is a Victorian corset through a modern lens, a chiffon dress that billows, leaving little to the imagination. The disheveled delicacy of threads as they come undone. It is the contradictory juxtaposition of the most feminine of florals beside the tough synthetic-coated trench. It is the de-genderization of color—be it pink, azul, lemon, or seagrass. It is recalling the fearlessness and strength of a woman despite a hyperfeminine appearance; here, the traditional codes of femininity are, as they ever were, powerful.

This season, we also debuted our Tasaki Atelier collection on the runway, as I had recently been named creative director of the Tokyo-based high-end jewelry brand. Handcrafted with unique organic curves and graphic lines rendered in white and sakura-gold and accented by effervescent diamonds and pearls brightened with hues of azul, citron, and coral sapphires, we take you on the journey of our inquisition for treasure through the mystical sea. Anchor and rope motifs that I saw at the pearl farm ground the collection back in tradition and reality, reminding us of our roots, our heritage, and the story of creation.

My collection painted a bright, colorful, and sometimes contradictory world that we hope to one day live in. It is a world that is free of bias, free of hate, free of prejudice. Simply put, it is a world where humanity reigns. We cannot dream of anything more beautiful.

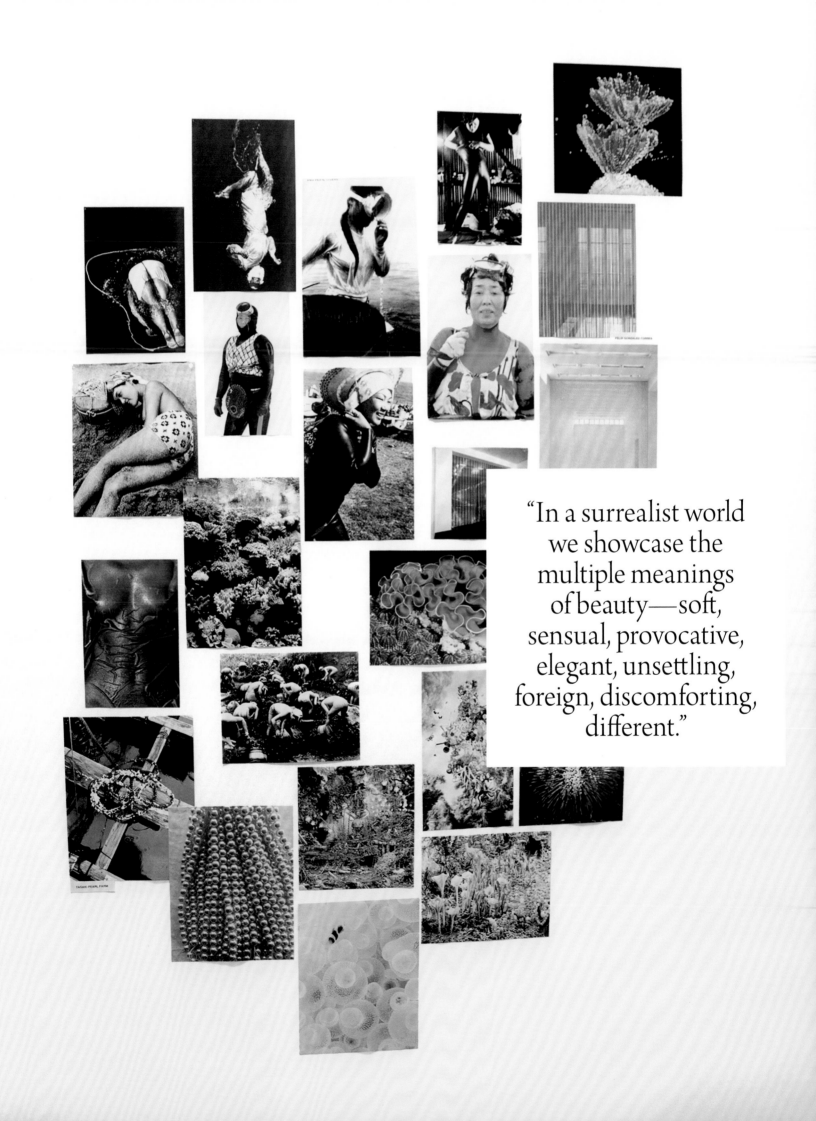

"In a surrealist world we showcase the multiple meanings of beauty—soft, sensual, provocative, elegant, unsettling, foreign, discomforting, different."

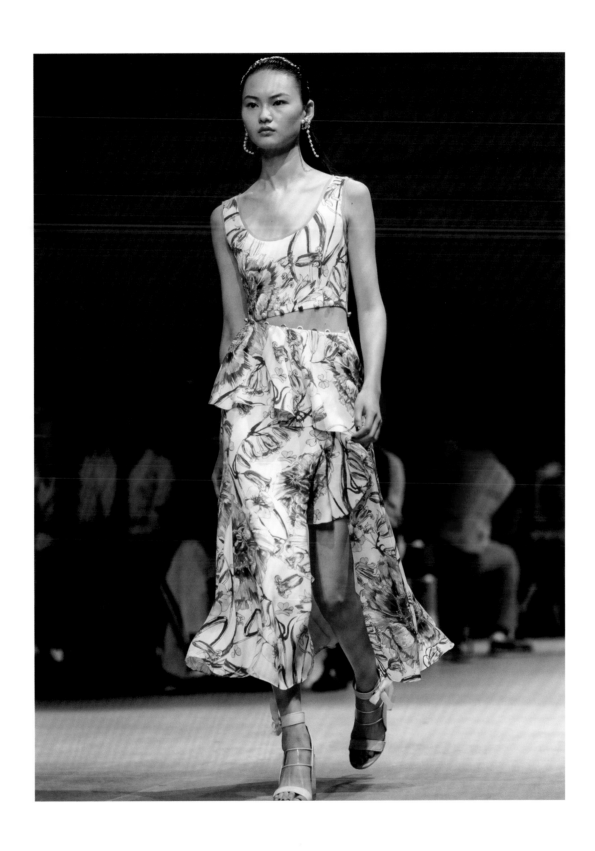

HE CONG WALKS THE SPRING 2018 RUNWAY, WEARING A SUBMERGED FLORAL SILK CADY PRINT DRESS
WITH OUR SIGNATURE COVERED BUTTON AND CUTOUT DETAIL. THIS PRINT IS INSPIRED BY THE FLORALS
FOUND IN THE DEPTHS OF THE OCEAN, AS EXPERIENCED BY OUR AMA MERMAIDS.

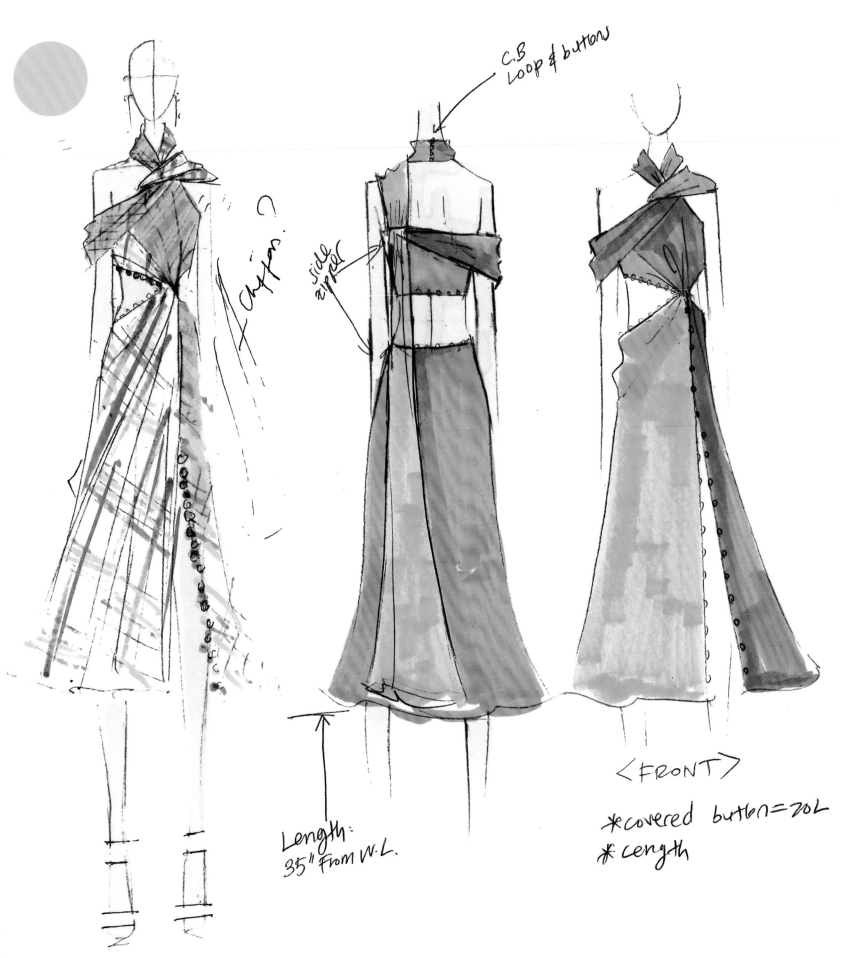

S18D21

C.B
Loop & button

Chiffon.

side zipper

Length:
35" From W.L.

<FRONT>

*covered button=20L
*Length

ABOVE: SKETCHES FROM THE SPRING 2018 COLLECTION.

OPPOSITE: A SPRING 2018 RUNWAY LOOK, INSPIRED BY THE PRAYER FLAGS IN NEPAL.

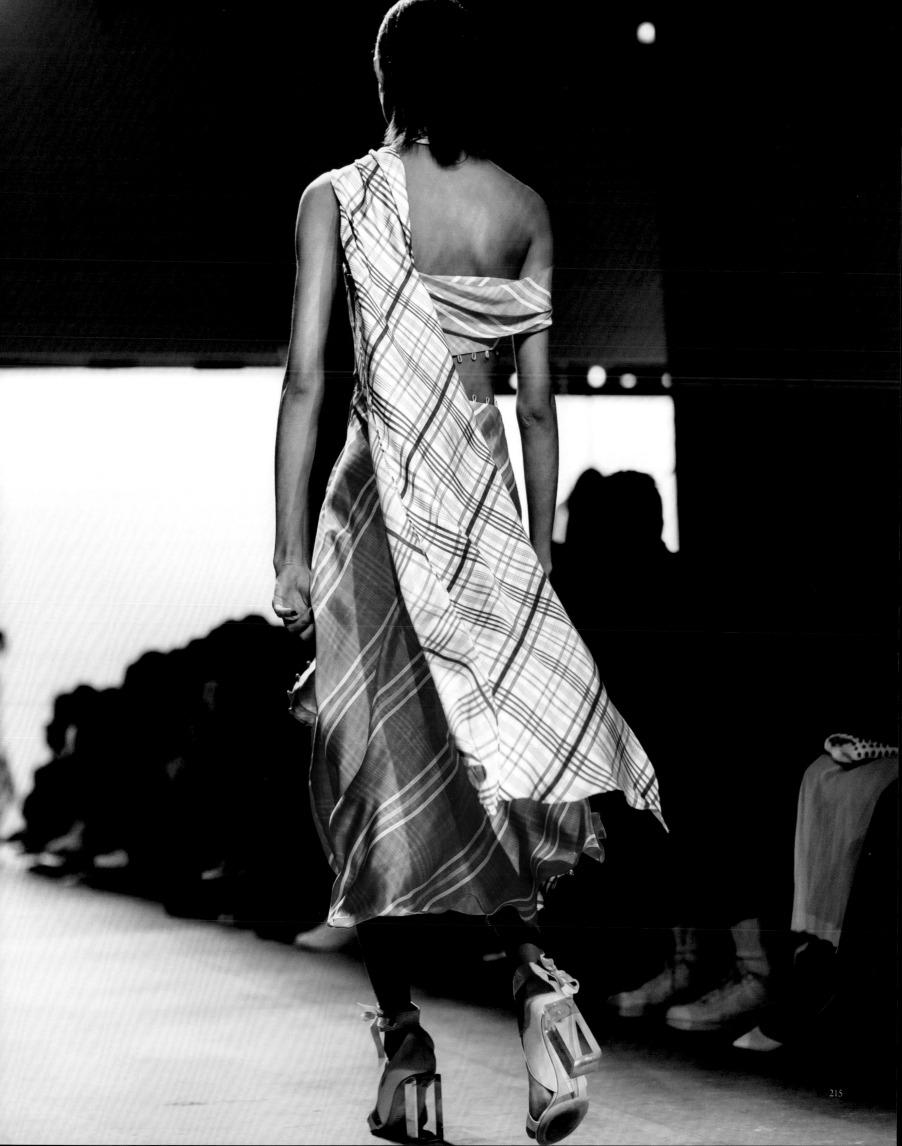

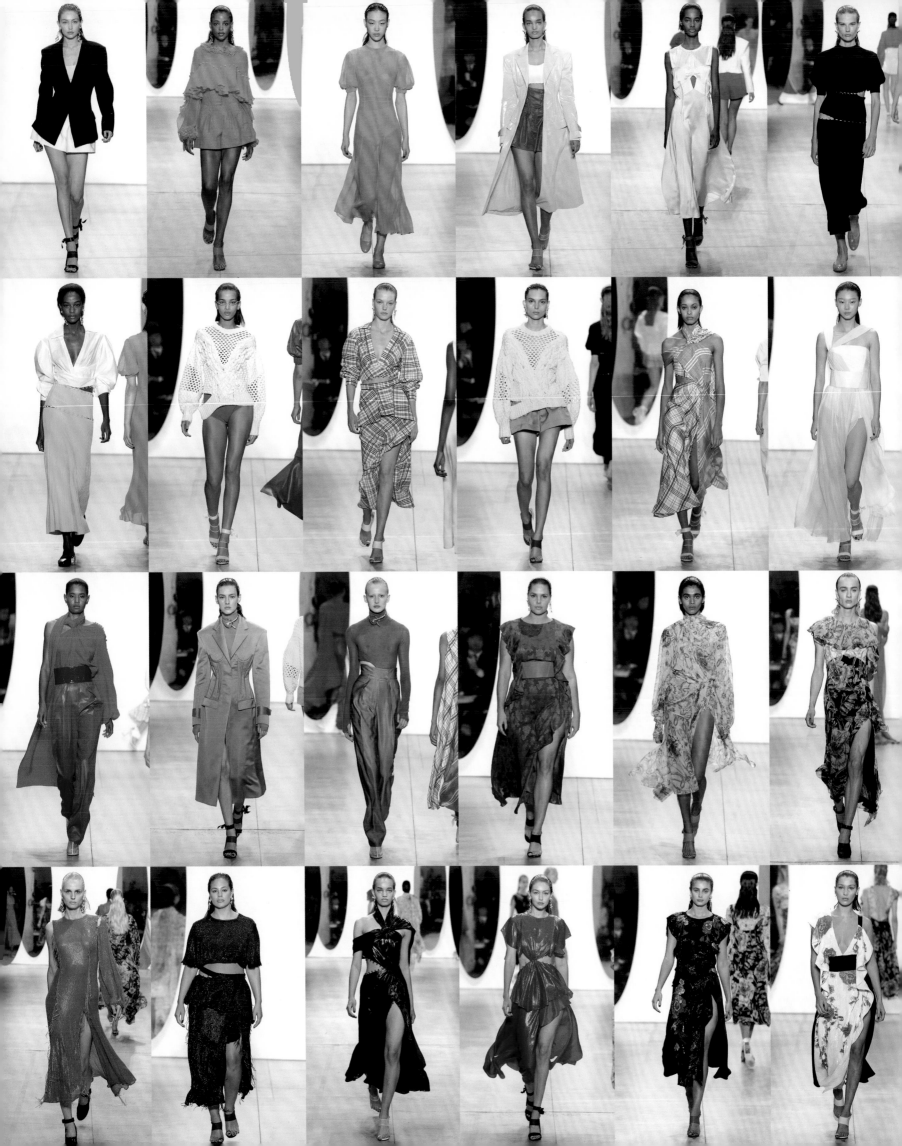

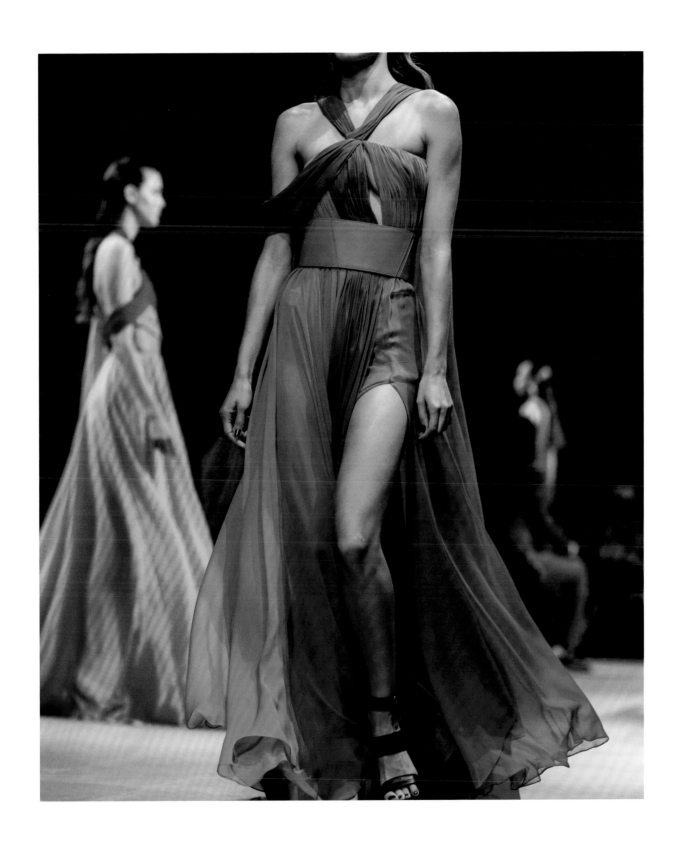

OUR SIGNATURE CHIFFON GOWNS ON THE SPRING 2018 RUNWAY IN BRILLIANT
SHADES OF PEONY, HIBISCUS, AZUL, AND SEAGRASS.

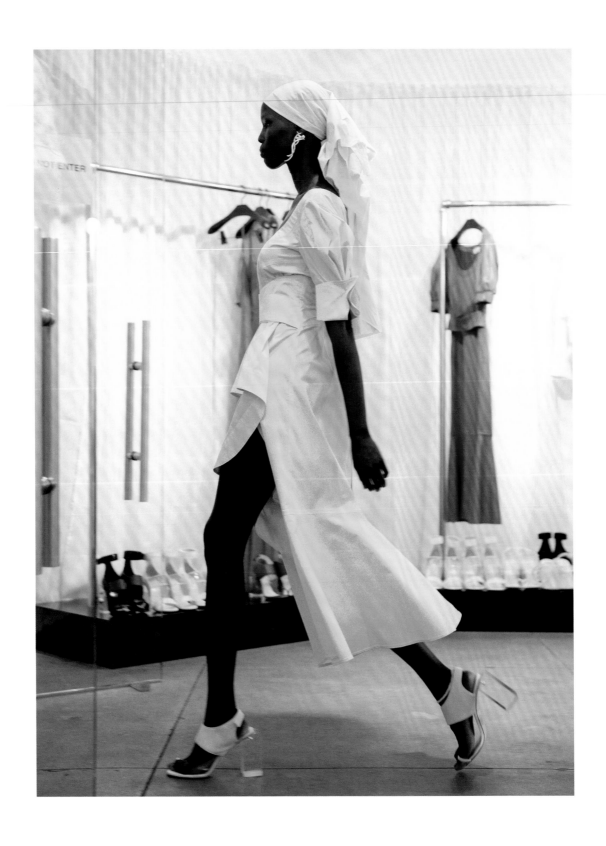

ABOVE: FITTINGS FOR THE SPRING 2018 SHOW.

OPPOSITE: FRIEND AND MUSE GIGI HADID WEARS A DRESS FROM THE SPRING 2018
COLLECTION IN NEW YORK CITY.

PAGES 222–223: A MOMENT OF LEVITY BACKSTAGE AT OUR RESORT 2018 SHOW, STAGED
DURING BERLIN FASHION WEEK. WE CELEBRATE DIVERSITY, FEMINISM, AND LOVE.

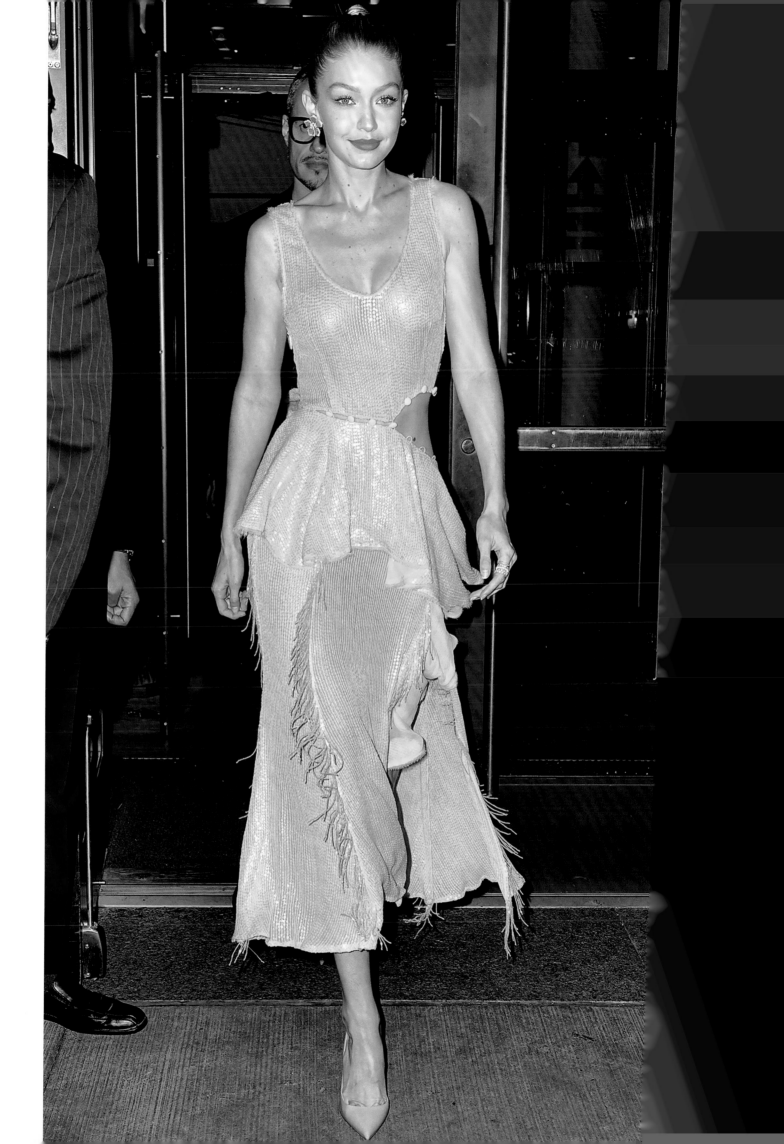

A Is for Alia

Bollywood star Alia Bhatt is undoubtedly one of the
great stars of this generation. She is an arresting actress,
a kindred soul, and what I believe is the future. I've been
inspired by her talents for quite some time, and am lucky to
call her a friend and muse. She was nominated for a Film-
fare Award, one of the highest levels of honor an actress can
attain. I immediately knew I wanted to dress her for this
special moment, to help her feel beautiful and empowered
on the red carpet. We worked together on her gown for
months, and her winning the Filmfare made the moment
all the more sweet. Not that I ever doubted her.

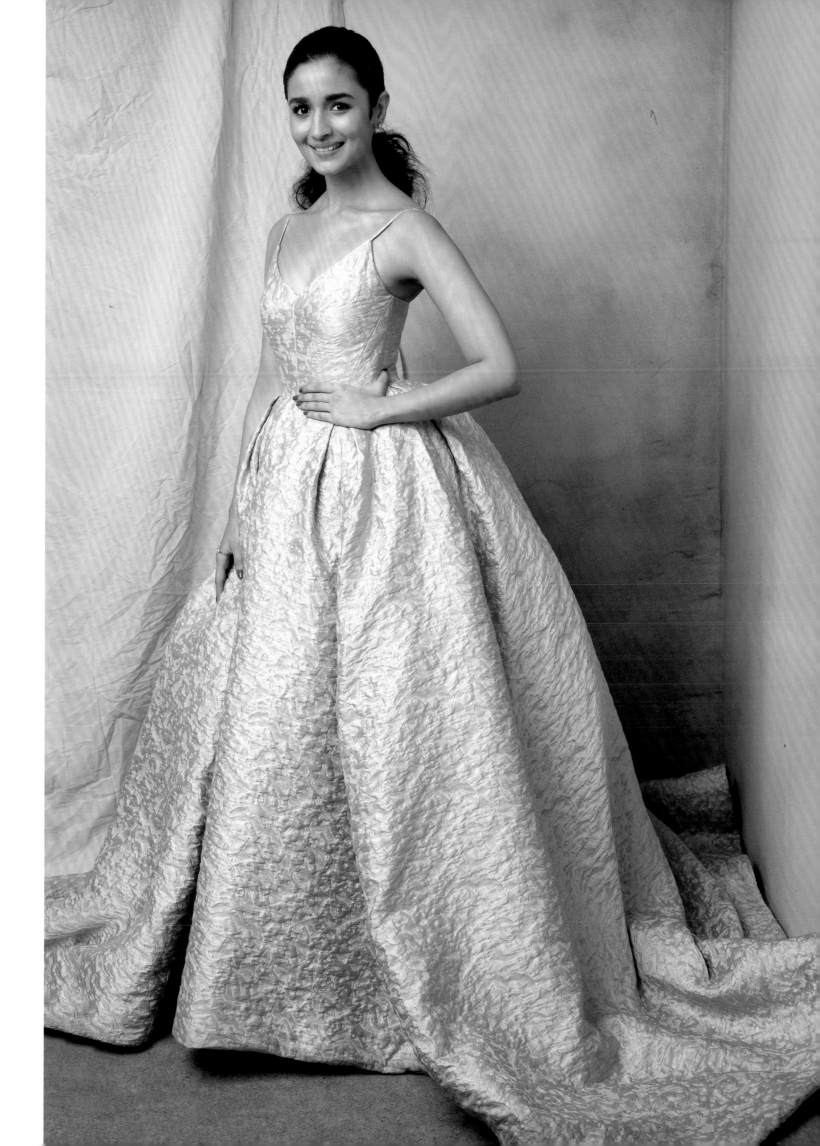

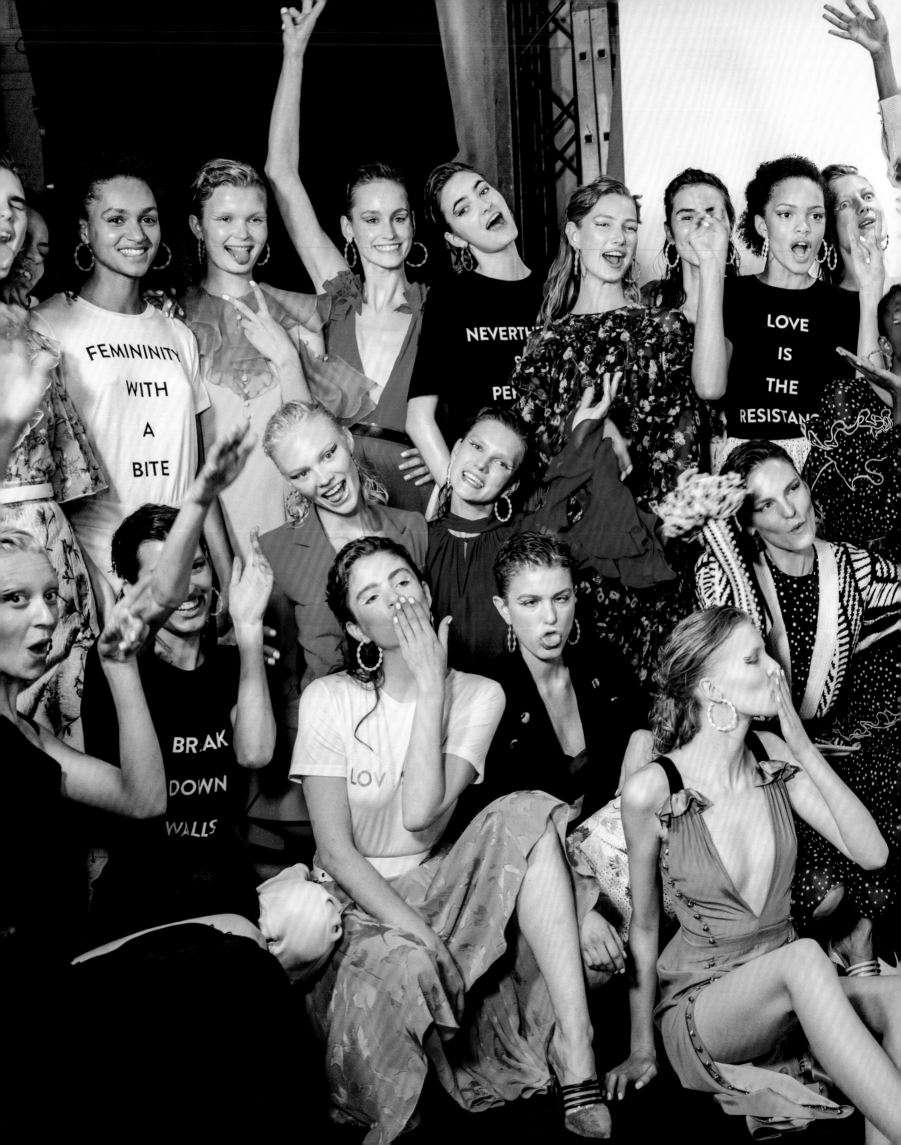

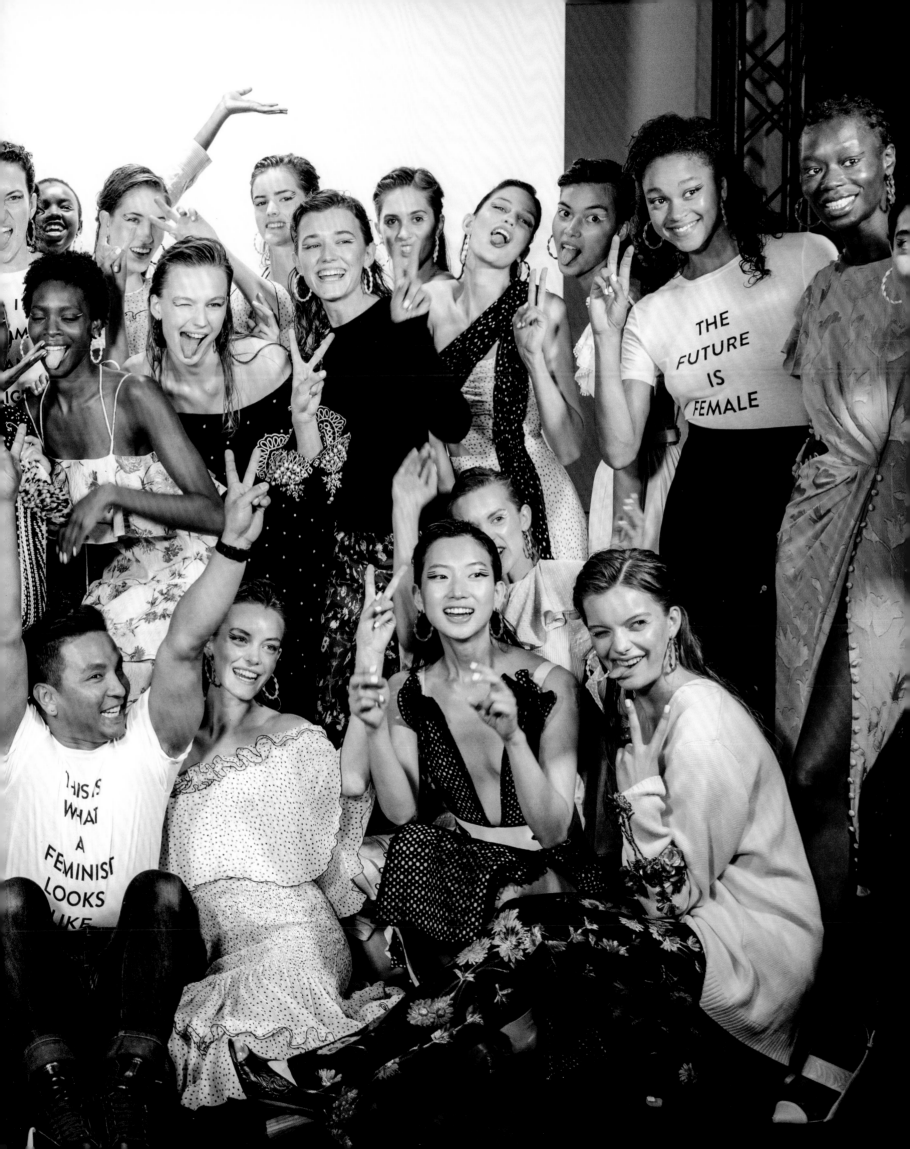

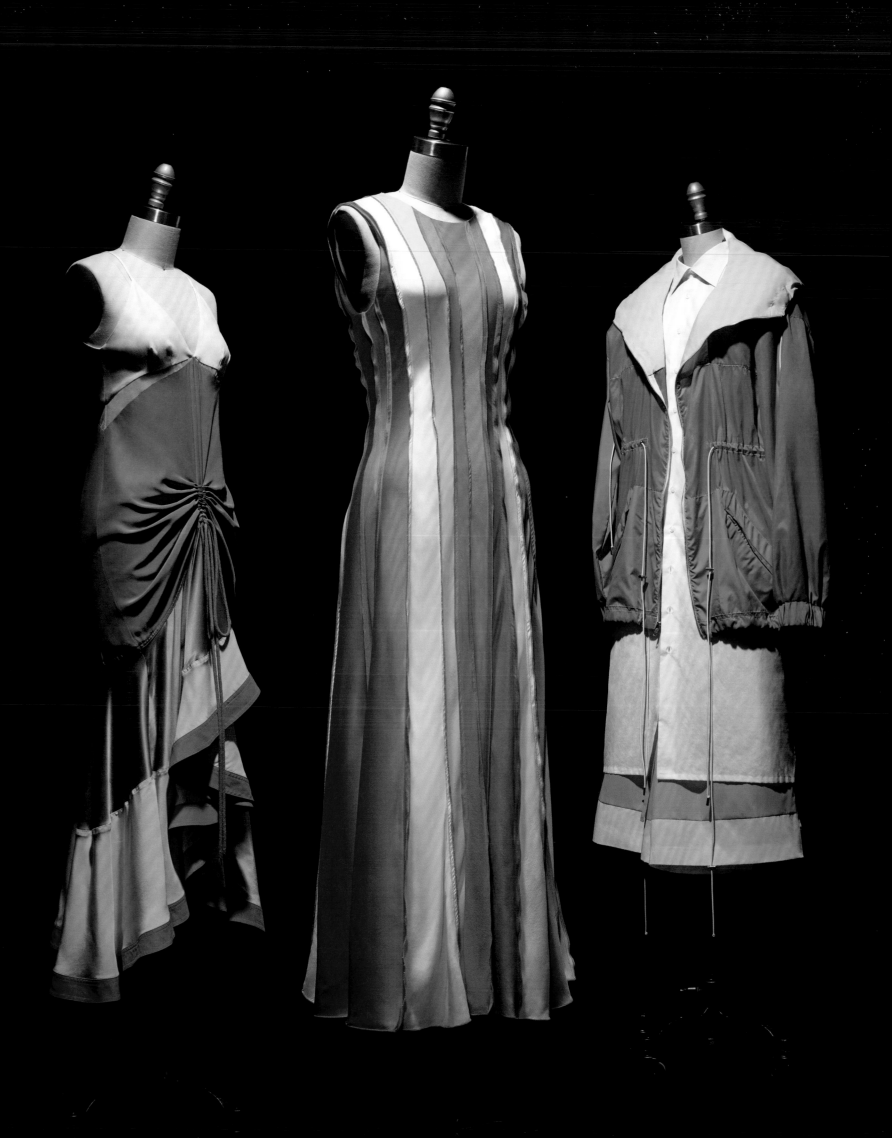

2018

STRONGER IN COLOR Two thousand eighteen was our year of celebrating beauty with substance and luxury with soul. We protested existing societal norms and advocated for stronger, more inclusive visual representation. It was a year of challenges—politically, personally, and socially—and a year of triumphs. In May, we launched our Atelier Prabal Gurung collection at the Met Gala on a group of diverse muses from around the globe. Four months later, we debuted our menswear collection in an effort to expand our offering to all people, regardless of gender identity, and to defy the traditional version of masculine dressing. We presented optimistic color and unique patterns. This was our way of taking a stand for inclusivity, or allowing our clients, followers, and friends to use their clothes as a visual language to represent who they are. Together, we found peace, compassion, understanding, and optimism. We celebrated the power of color. We let our spirit take the reins and led with our hearts.

Fall 2018 "The Power of Pink"

For my Fall 2018 collection, I shared a piece of my past, a part of my world, and a collage of my memories from my childhood. This story was a cross-cultural exploration, a journey from West to East as I discovered the various iterations of feminism and femininity.

I was raised by a single mother and surrounded by strong women. They were the ones who stood at the forefront, who came first. They were my superheroes.

On a quest to unearth these memories, I was inspired by the matrilineal world of the Mosuo tribe, which is situated in the Yunnan province of China. Reminiscent of the Sherpas that I so vividly recall from my childhood growing up in Asia, I was taken back to my native Nepal and ultimately reached the Bundelkhand region of India, home to the Gulabi Gang, a community of female activists who adorn themselves in pink saris symbolic of their self-proclaimed power and fearlessness.

What unites all of these places are the graceful women with quiet strength, resilience, and an unrelenting desire for independence. Full of determination and grace, these women tightly wrap themselves in yards of *patuka* cloth, readying for the field, to protect and to persevere. In all of their glory, these women work with purpose and with poise, unabashed in their approach.

The collection celebrated the melding of these beautiful cultures with the use of rich panne velvets, fluid feathers, hand-embroidered sequins, engineered patchwork, and tufted quilting. Mongolian accents represented the raw grittiness and savage beauty of these fearless women. The artisanal spirit seen throughout was an ode to Eastern practices, captured by the mandala-inspired and hand-drawn graphic prints, hand-cut fringe, hand-knit sweaters, and hand-embroidered feathers, paillettes, and pearls. The utilitarian quilting and cargo details hail from mountain treks through rough terrain.

We also presented Tasaki Atelier ear pieces that were meticulously crafted with couture ideals to mimic the graceful silhouettes of Eastern draping. Vivid gold wraps around the ear were highlighted by oversized pearls. They epitomize feminine luxury and demonstrate that power and femininity can live together in harmony.

As I designed this collection, I recognized that a new era of change was upon us, one where our modern world was beginning to see the cumulative power of female solidarity. It felt exciting and empowering to see the cultural zeitgeist catching up with the beliefs I've been so resolute about for as long as I could recall. This moment in time was historic and it continues to be exhilarating, and while unquestionably powerful, it is often communicated in a way that downplays what I believe to be one of the many strengths of a woman. This collection presented the colors that are the Eastern world, the colors of our future.

OPPOSITE: GIGI HADID OPENS THE FALL 2018 SHOW. SHE SHARES HER PLATFORM
TO HIGHLIGHT THE CRAFT OF THE FEMALE ARTISANS WE WORK WITH IN NEPAL,
SEEN HERE IN THE HAND-KNIT CASHMERE MANDALA PRINT SCARF.

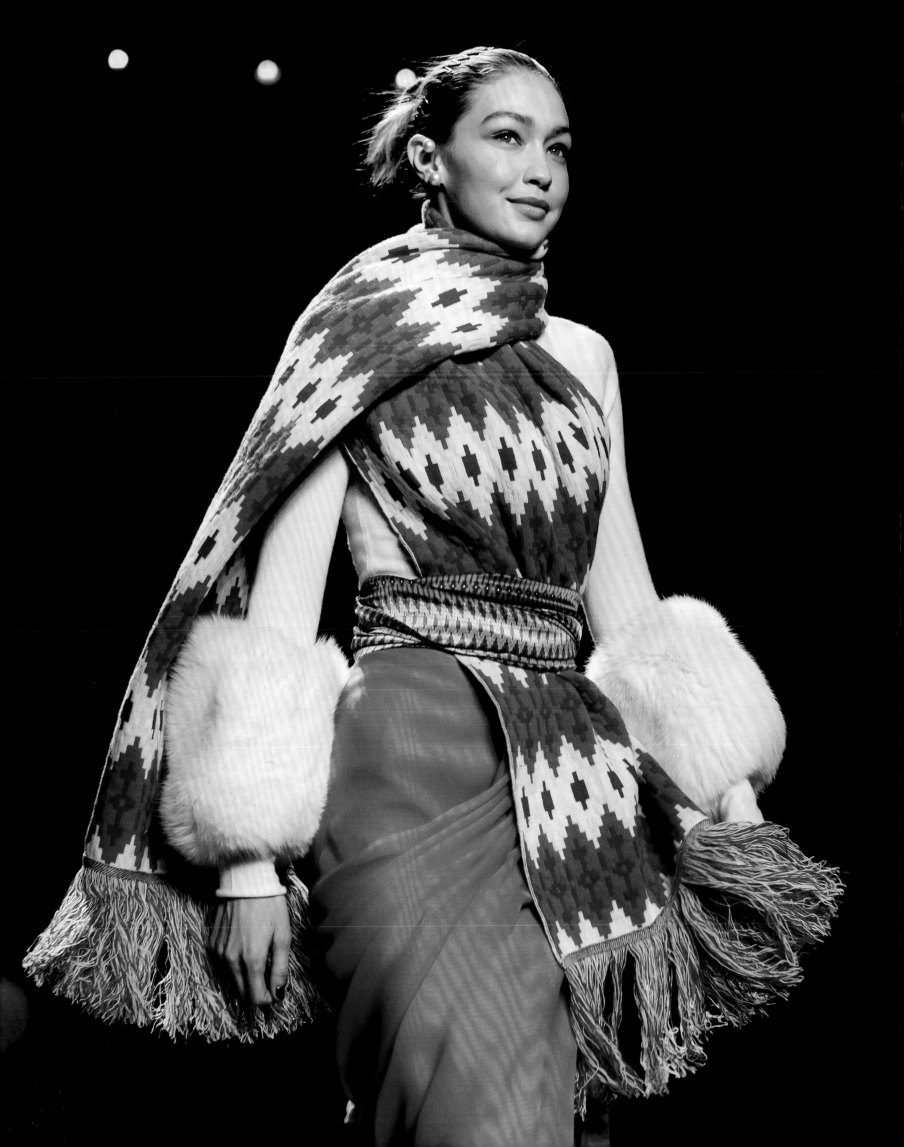

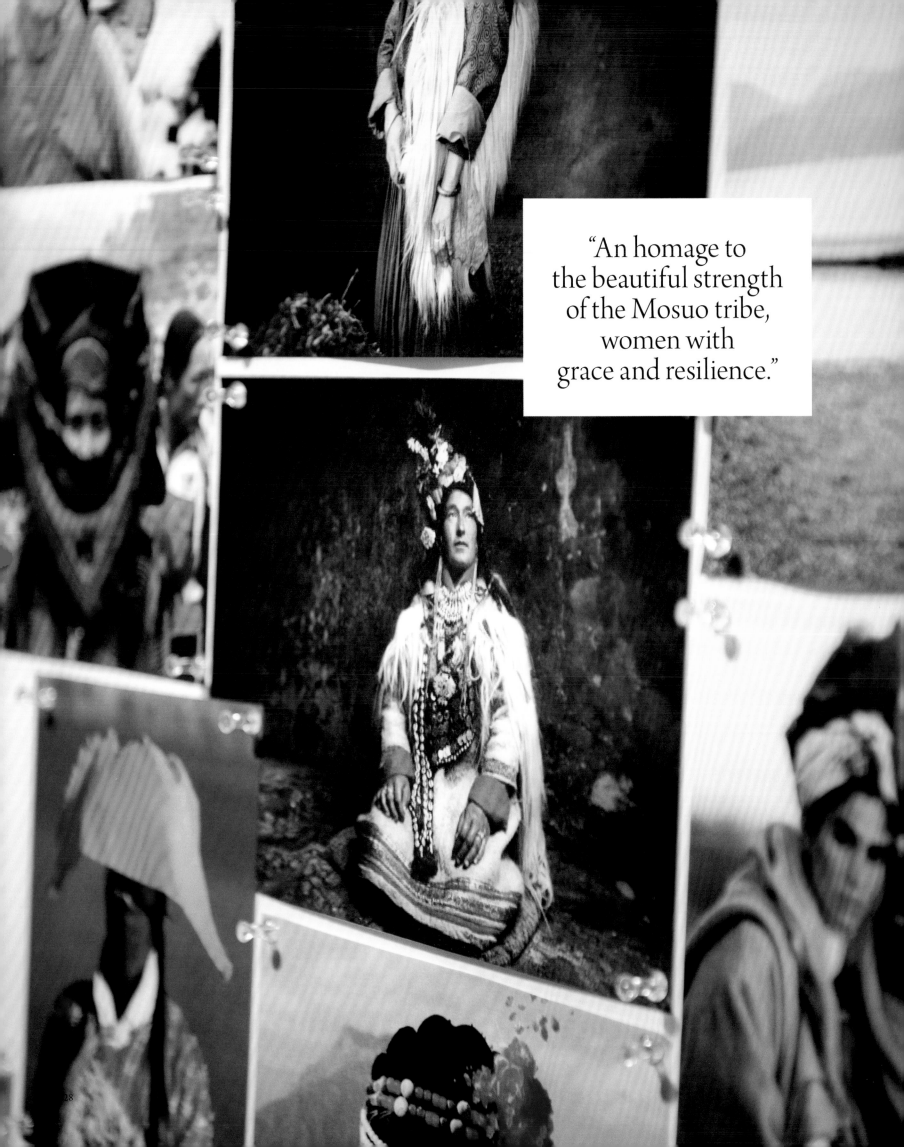

"An homage to the beautiful strength of the Mosuo tribe, women with grace and resilience."

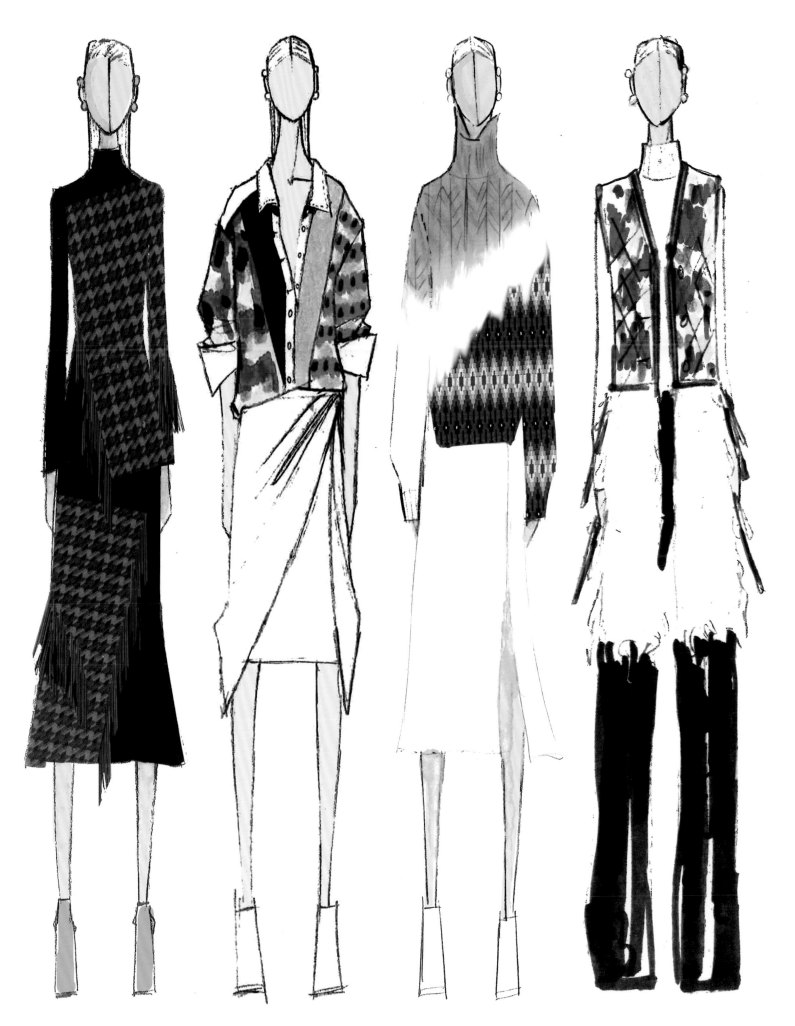

ABOVE: SKETCHES FROM THE FALL 2018 COLLECTION.

OPPOSITE: THE MOOD BOARD WITH INSPIRATION FOR THE FALL 2018 COLLECTION,
A CELEBRATION OF THE WOMEN OF THE MOSUO TRIBE.

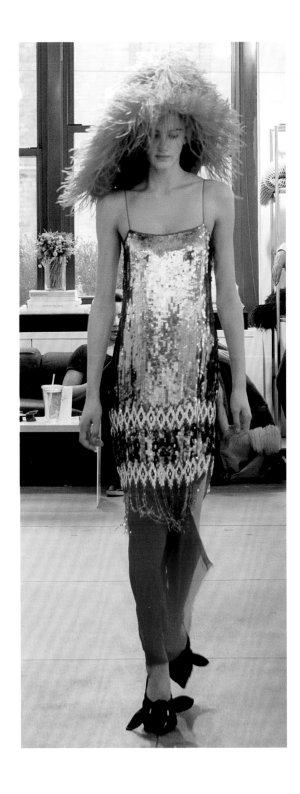

ABOVE: FITTINGS FOR THE FALL 2018 SHOW.

OPPOSITE: ADESUWA AIGHEWI WEARS THE HAND-EMBROIDERED MANDALA PRINTED DRESS
ON THE RUNWAY. THE MANDALA PRINT IS A SPIRITUAL SYMBOL FROM BACK HOME IN NEPAL.

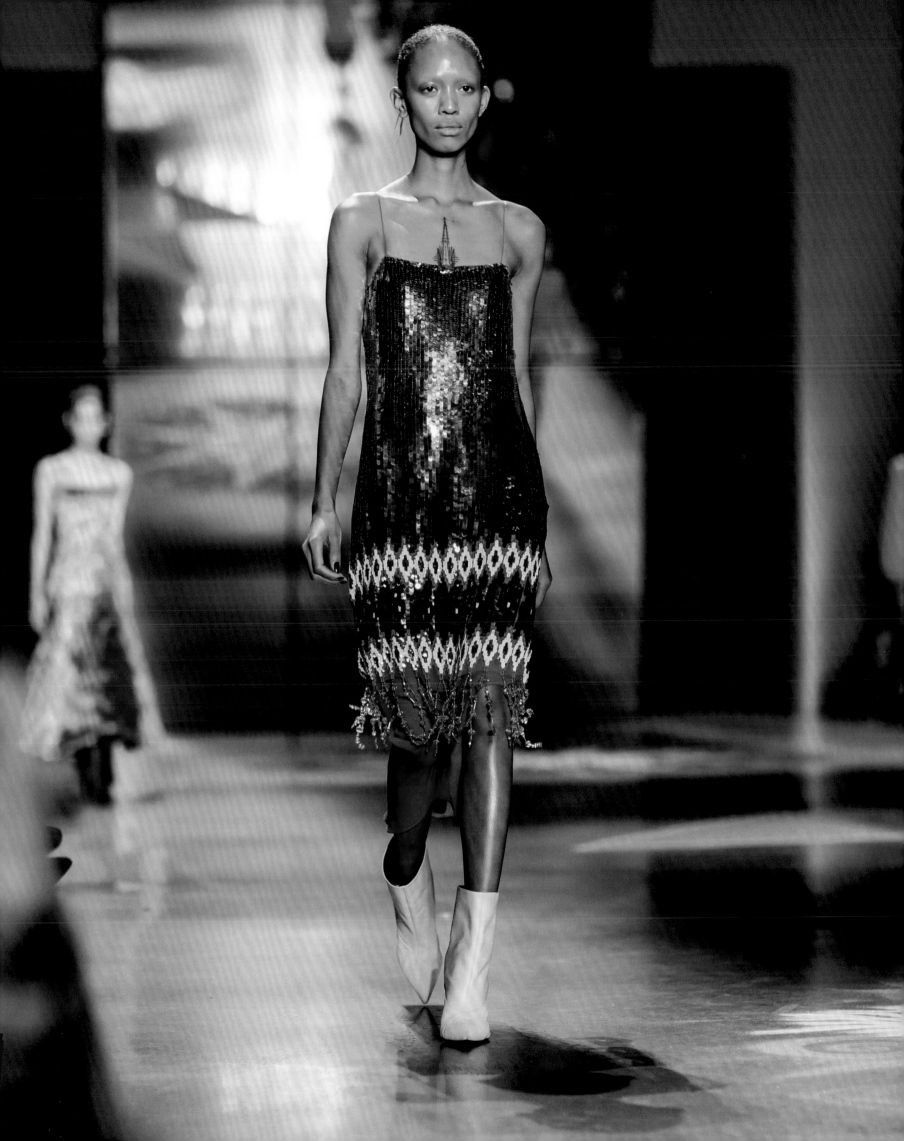

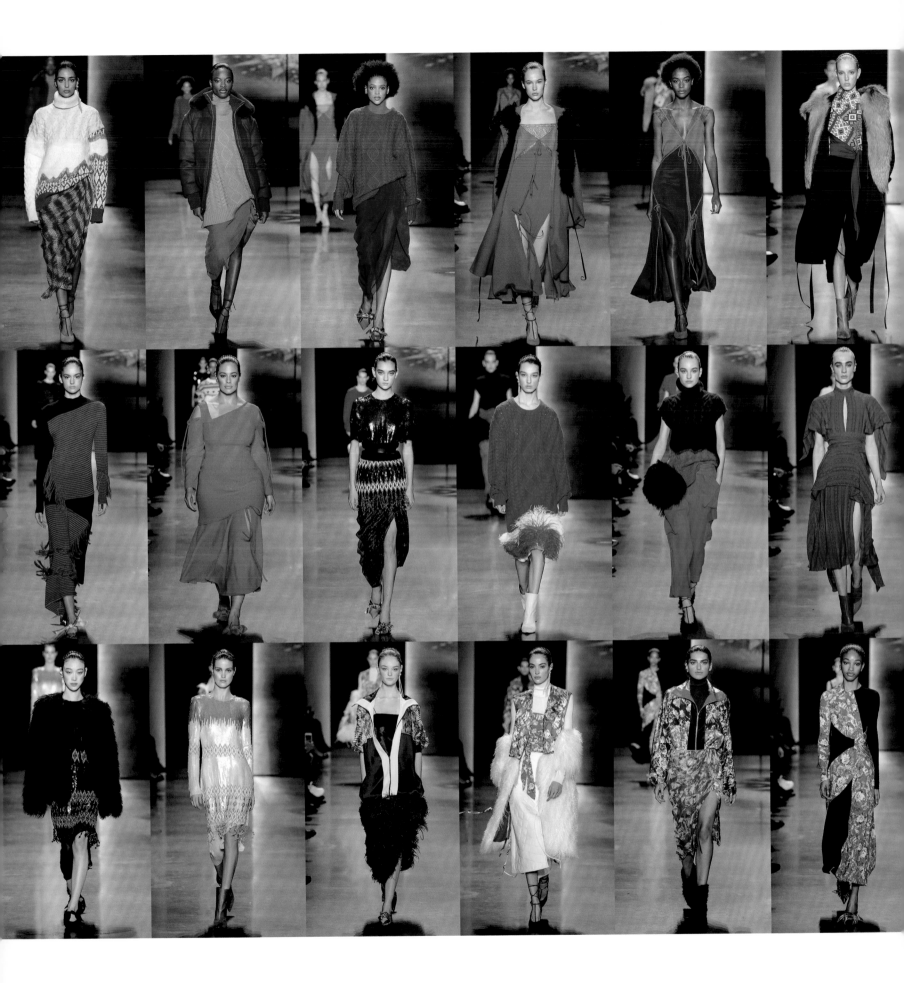

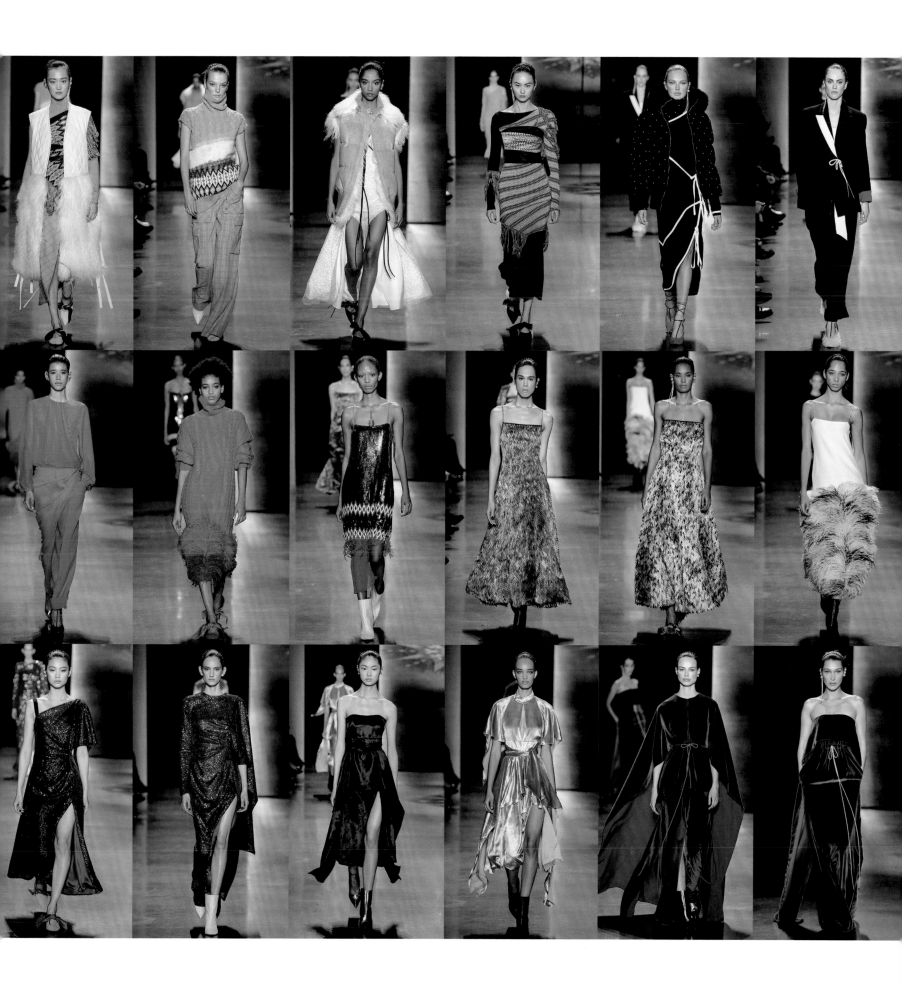

LEFT: HAND-EMBROIDERED FEATHERS IN MOTION ON THE FALL 2018 RUNWAY.

PAGES 236–239: THE FINALE, A BEAUTIFUL MOMENT OF RESILIENCE AND SOLIDARITY IN THE WAKE OF THE ME TOO MOVEMENT.

PAGES 240–241: ACTRESS DANAI GURIRA, PHOTOGRAPHED BY DENNIS LEUPOLD FOR THE MAY 2018 ISSUE OF *EBONY* MAGAZINE. SHE WEARS OUR PITAYA AND RASPBERRY EMBROIDERED SEQUIN DRESS.

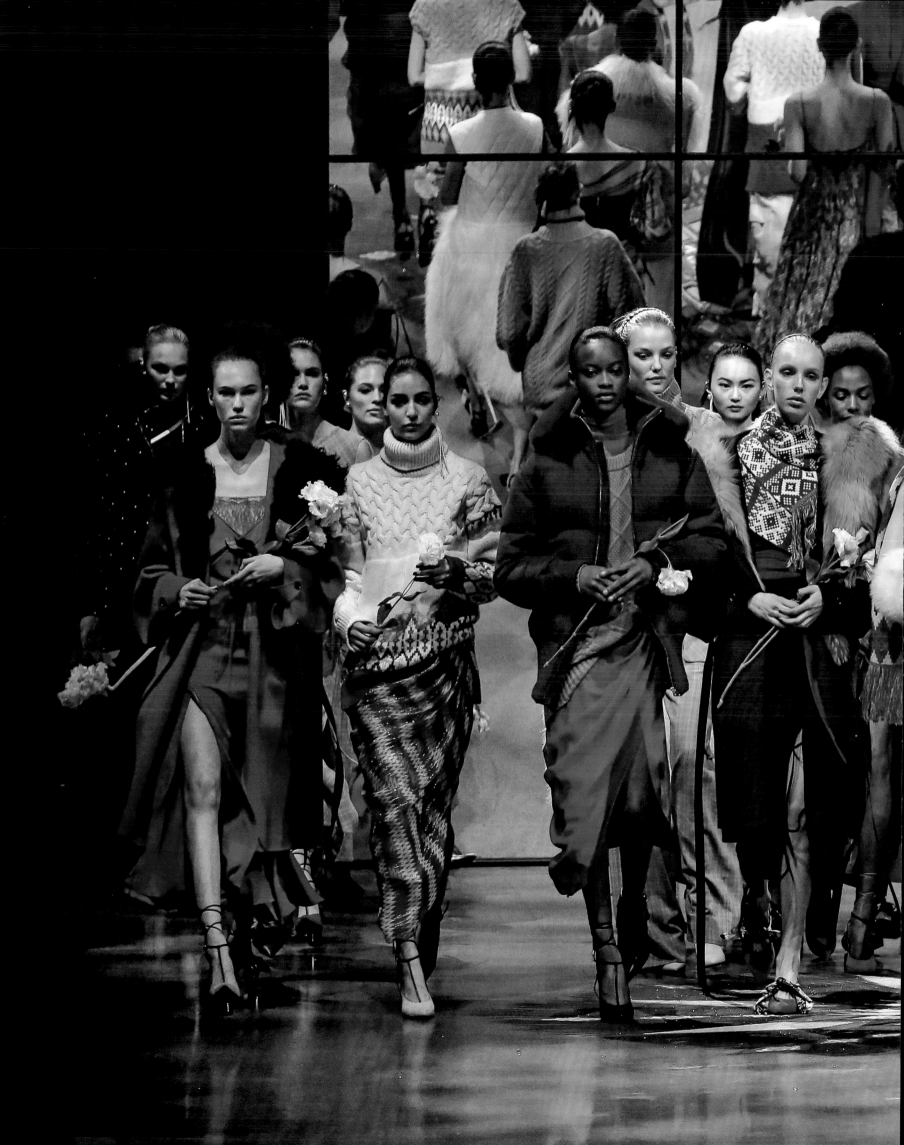

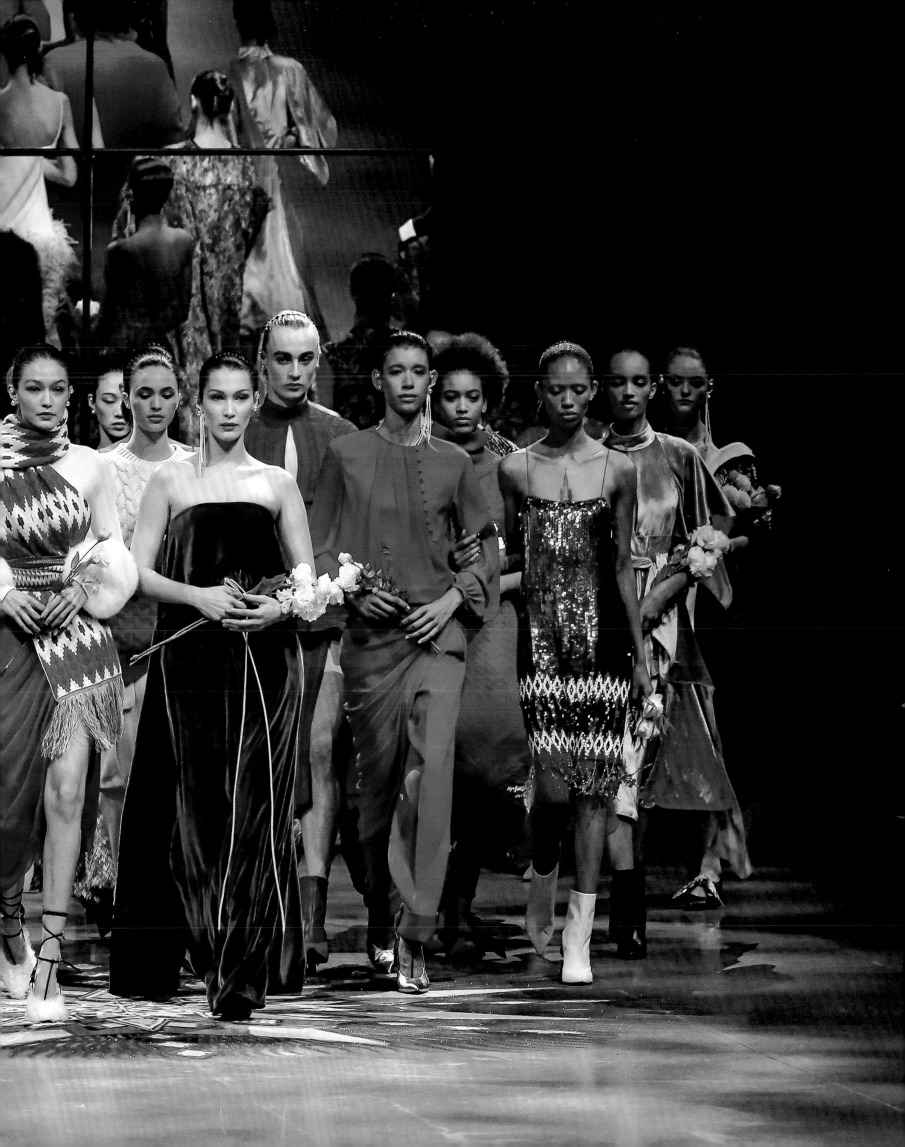

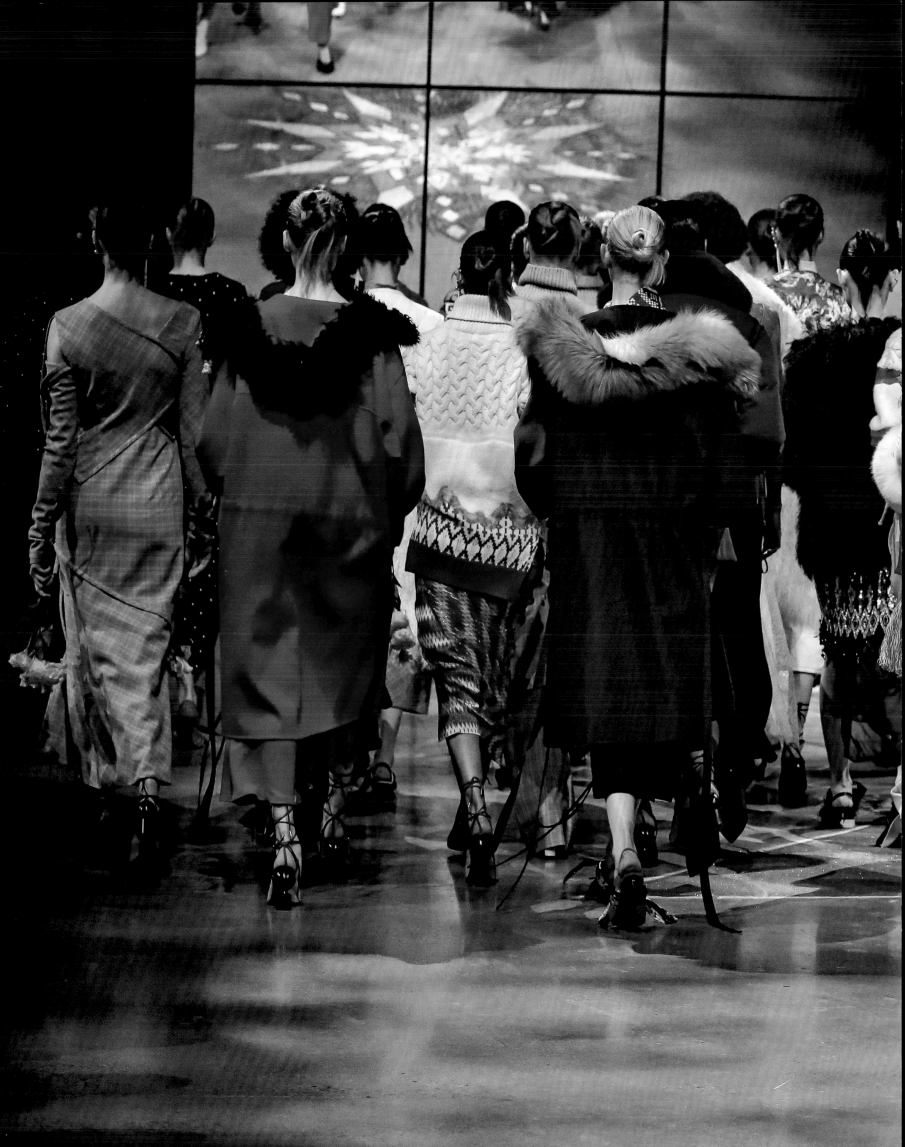

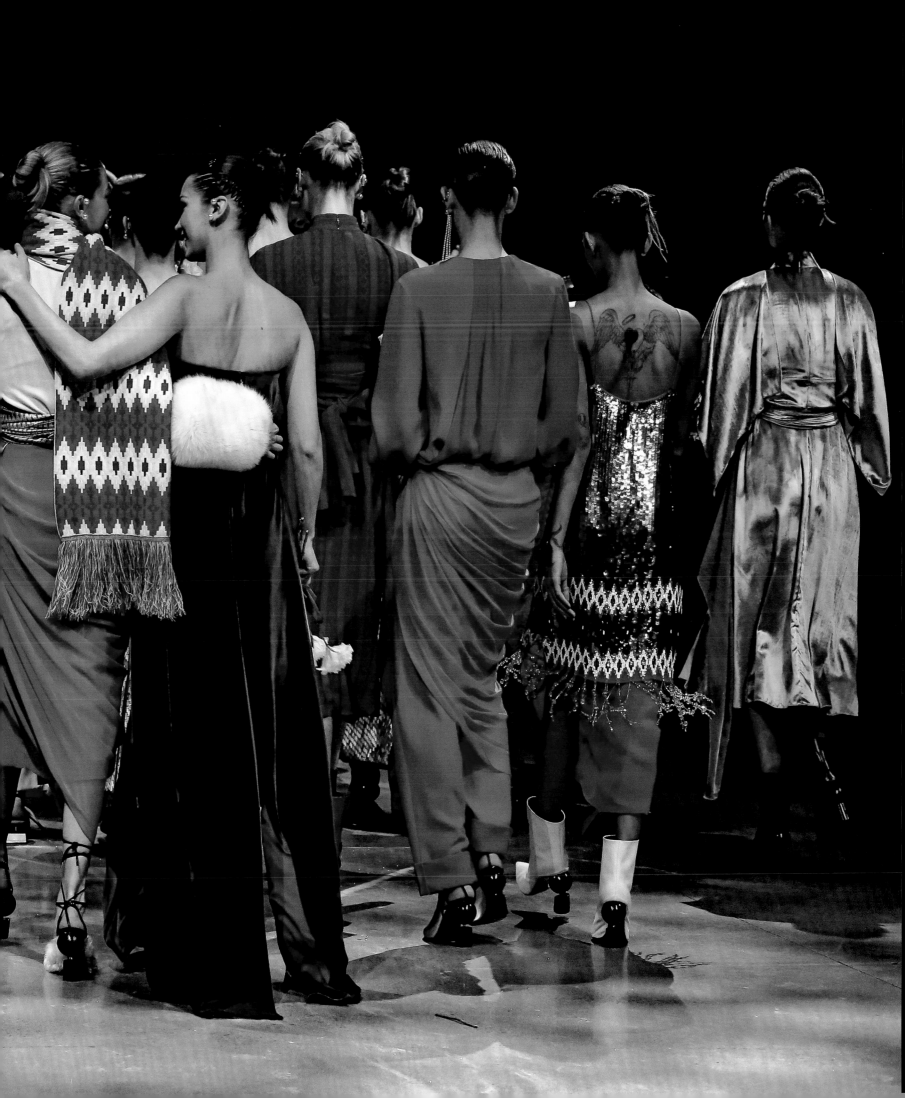

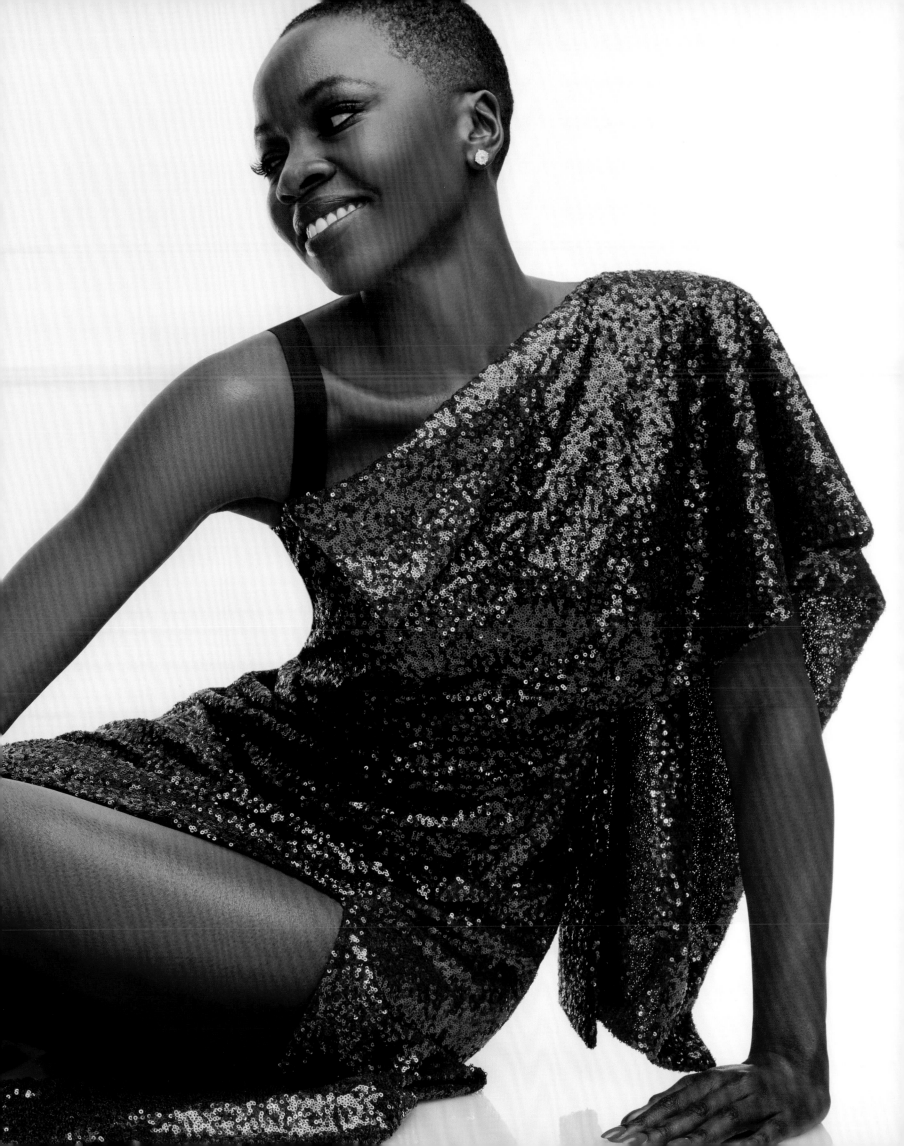

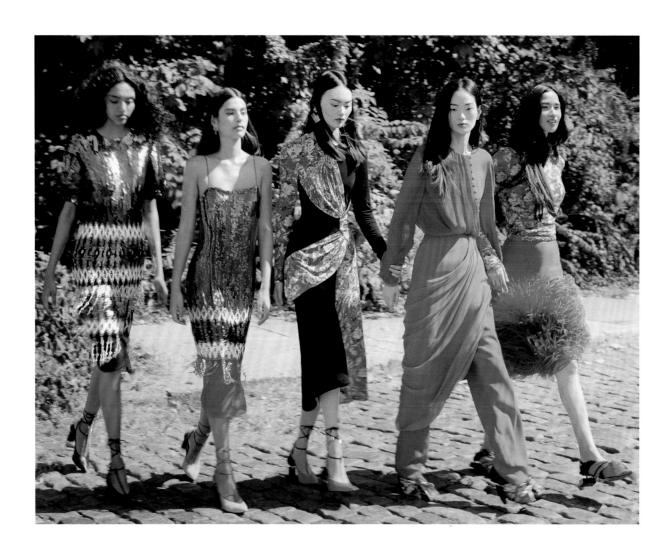

A Seat at the Table

The Fall 2018 collection was inspired by the strong, vigilant, and graceful women I was raised by back home in Nepal, and was an ode to the women of the Eastern world. Therefore, for this campaign, I wanted to cast talent that represents this part of the world. We featured models representing different countries across Asia—Singapore, India, Thailand, China, Korea, and Nepal—and also worked with a stylist and hair and makeup artist who were all women with Asian ethnicities. Amid a chaotic and challenging political and social climate, representation for minority groups is more important than ever, and it was essential for us to create a table where these groups have a seat to be heard, seen, and counted.

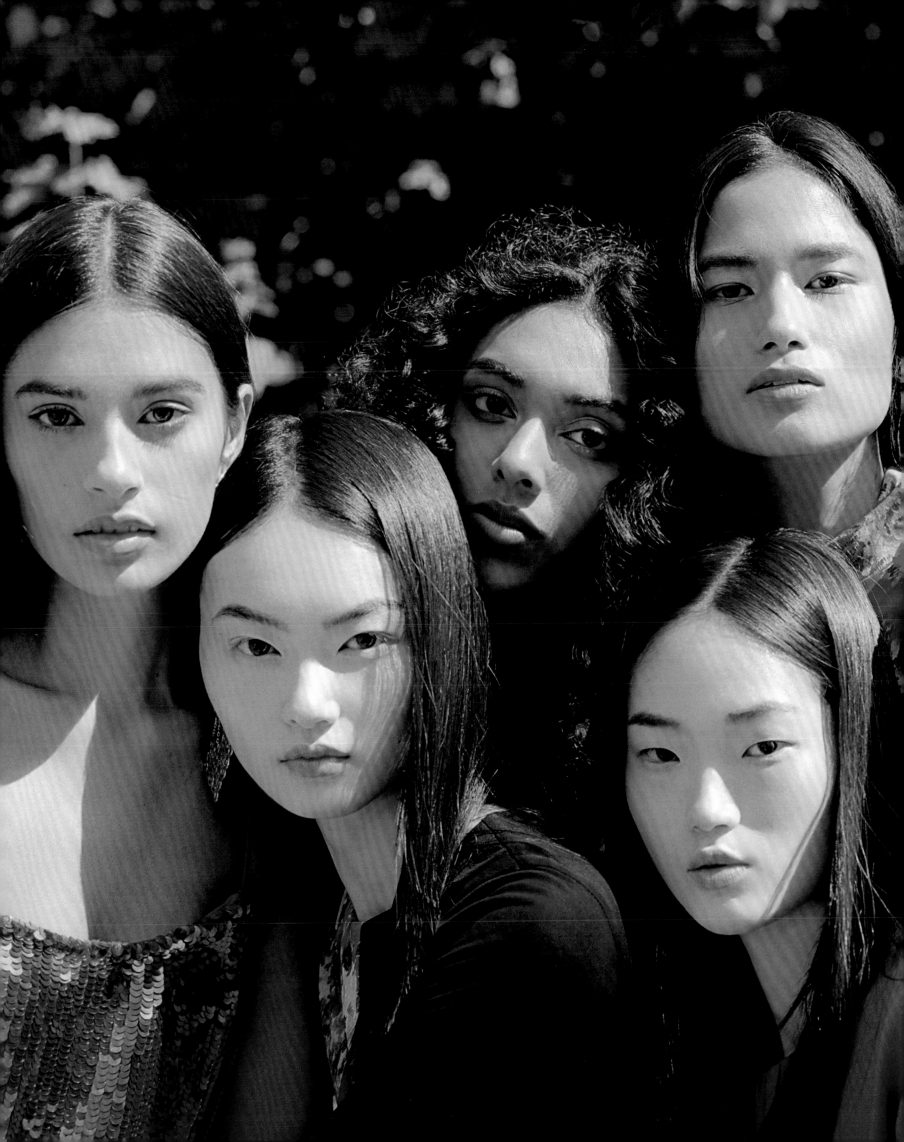

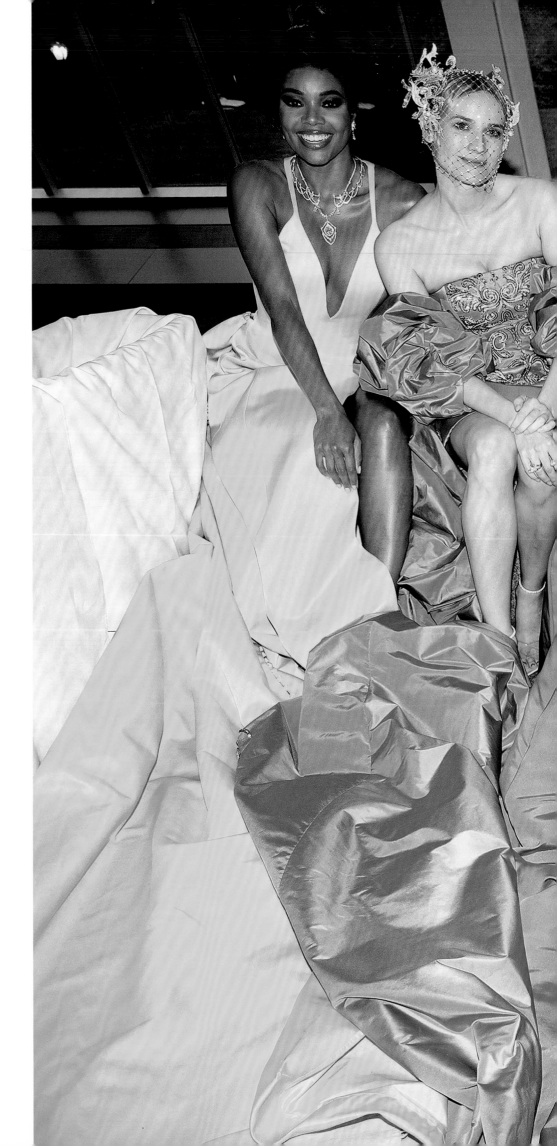

Couture Is Stronger in Color

The Met Gala was a really big moment for us in 2018. It was our first time hosting a table, and we did so with Tasaki, the jewelry brand I am also the creative director of. The Met Gala is one of the biggest nights of the year. It is essentially the Oscars of fashion, and is an enchanting and glamorous evening I eagerly await every year. I love that we get to really celebrate fashion in all of its glory. The theme for 2018 was "Heavenly Bodies: Fashion and the Catholic Imagination," and we celebrated with a group of eight inspiring, international muses—supermodel Ashley Graham, Bollywood star Deepika Padukone, actress Diane Kruger, actress Eiza Gonzalez, actress Gabrielle Union, actress and pop star Hailee Steinfeld, Japanese supermodel Hikari Mori, and Chinese supermodel Ming Xi. With the help of our exceptional muses, our brand ideal that we are stronger in color really came to life. Following the gala, we launched our Atelier Prabal Gurung bespoke couture collection. This will forever be one of my favorite evenings.

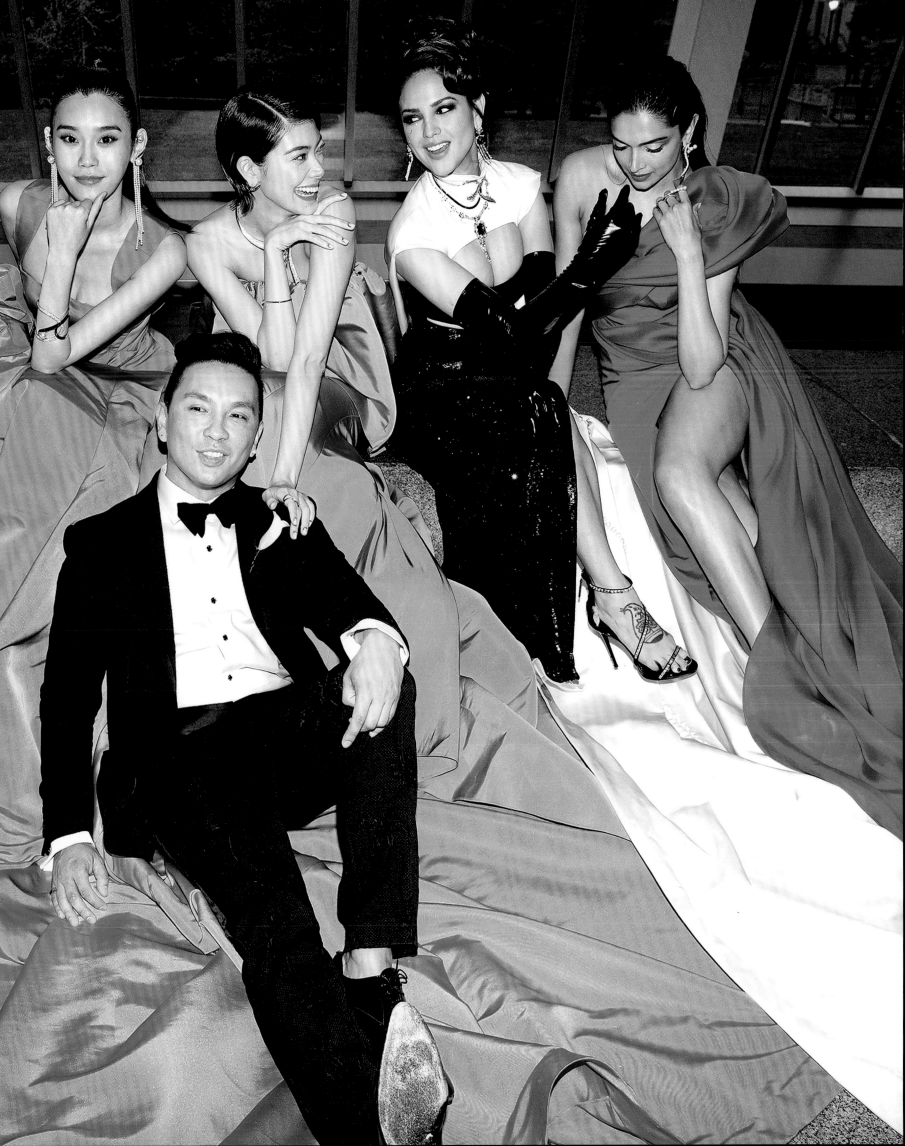

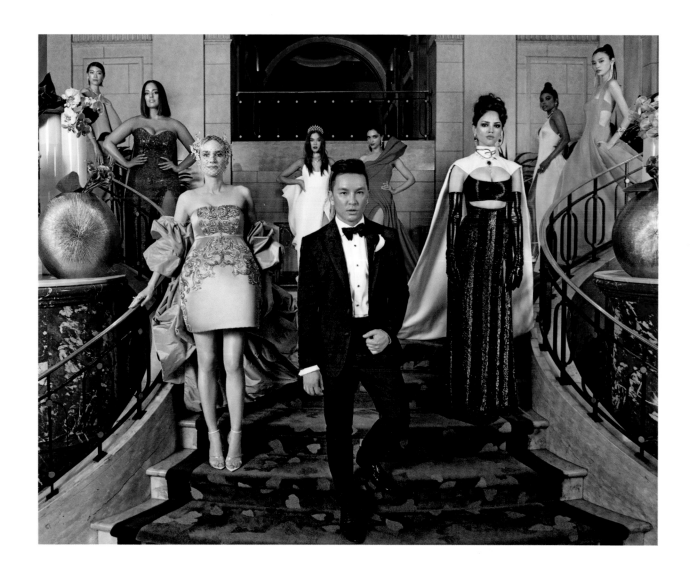

ABOVE: OUR INTERNATIONAL MUSES (FROM LEFT) HIKARI MORI, ASHLEY GRAHAM,
DIANE KRUGER, HAILEE STEINFELD, DEEPIKA PADUKONE, EIZA GONZALEZ,
GABRIELLE UNION, AND MING XI.

OPPOSITE: MOMENTS OF UNABASHED GLAMOUR BEFORE THE MET GALA WITH
ASHLEY, EIZA, DEEPIKA, GABRIELLE, HAILEE, AND HIKARI.

FOLLOWING SPREAD: PRETTY IN PINK. A STUNNING CANDID OF OUR MUSE MING XI.

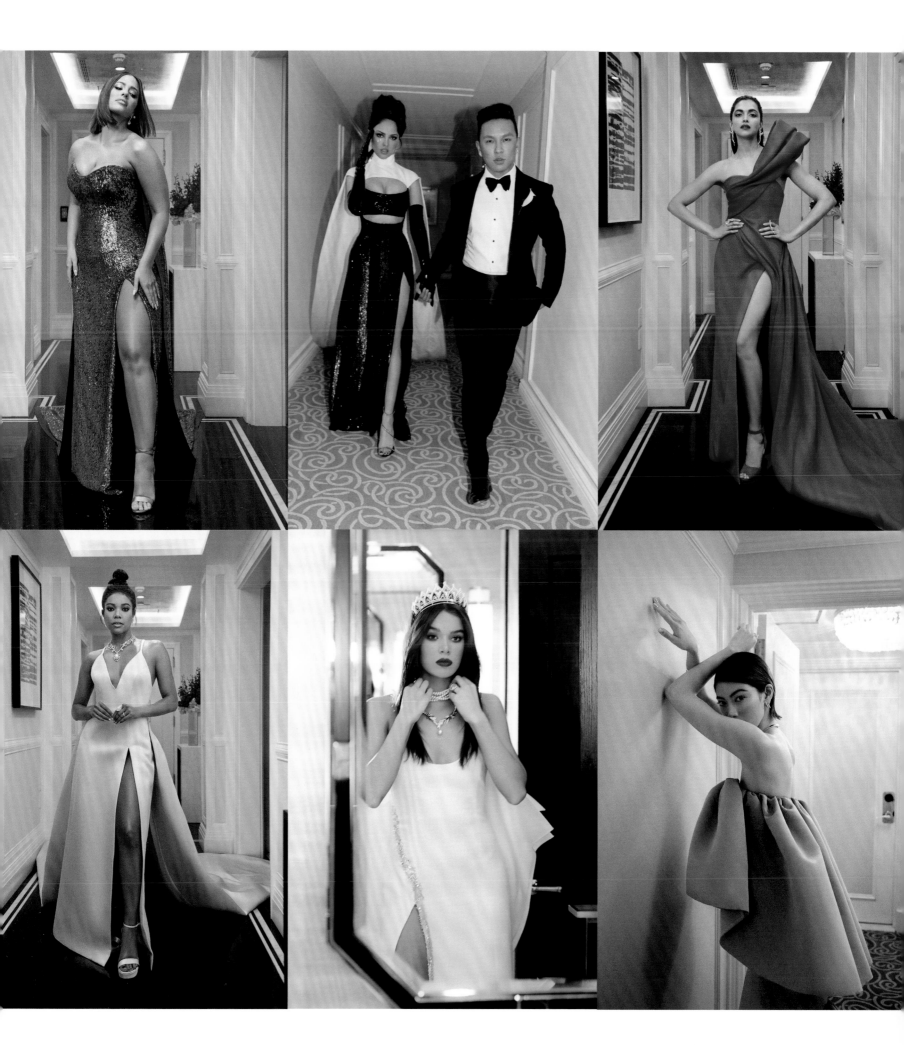

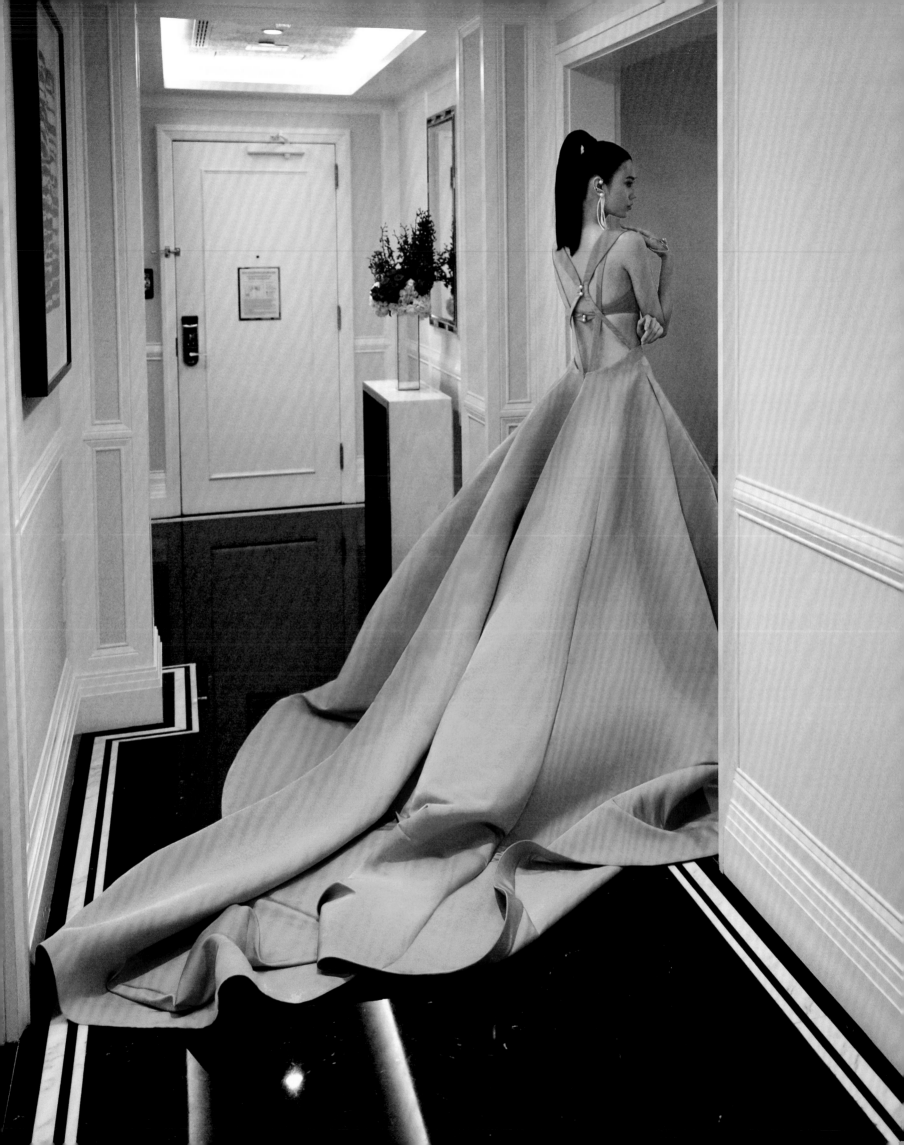

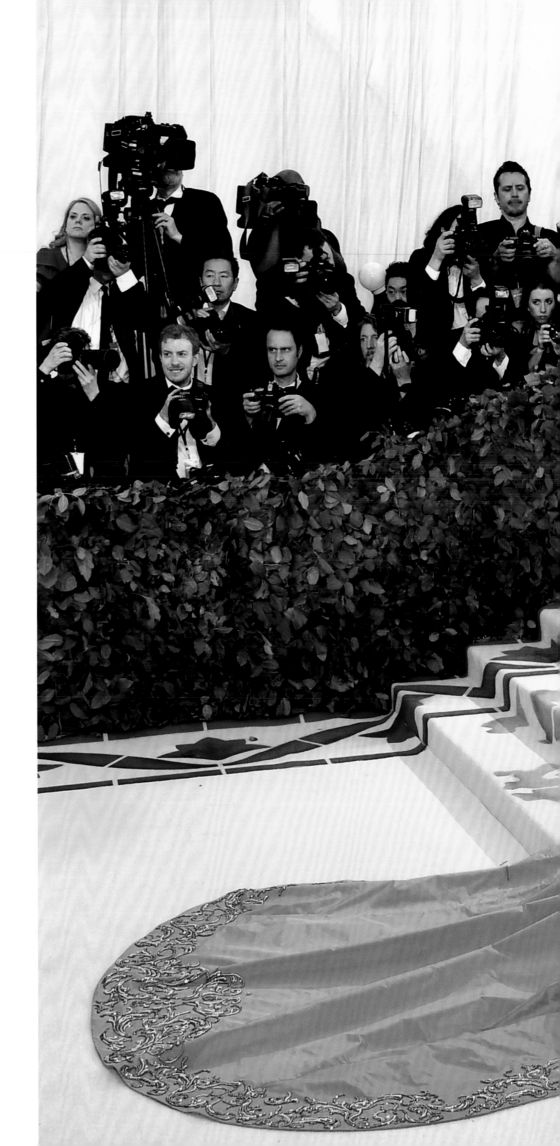

DIANE KRUGER ON THE MET GALA CARPET. DIANE'S LOOK WAS INSPIRED BY THE VIRGIN MARY, ALSO KNOWN AS THE QUEEN OF HEAVEN, A DIVINE BEING WITH GRACE AND COMPASSION. DIANE'S GOWN WAS HAND EMBROIDERED BY ARTISANS IN INDIA—IT TOOK MORE THAN THREE HUNDRED HOURS TO COMPLETE.

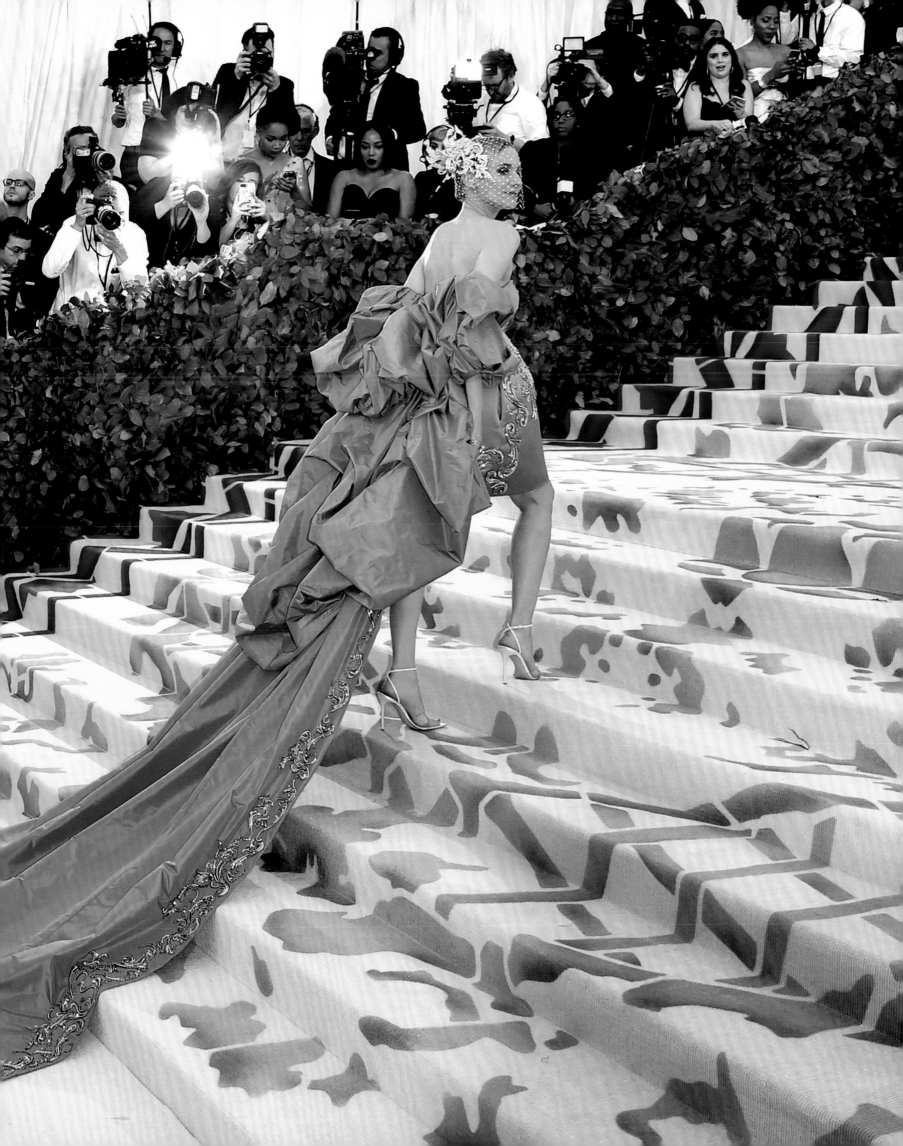

Spring 2019 "Nomadic Voyage"

This story began with a global exploration. A voyage most inspired by my recent travels from indigenous villages of Nepal to the urban streets of Tokyo, London, Mumbai, Paris, Shanghai, Abu Dhabi, and New York. My collection was a cross-cultural journey, one that sees no borders, tied together through the ability to use color as a universal language.

Growing up in Nepal, I would often encounter and interact with the Rana Tharu, a subset of the Tharu community, a spirited group found in the southern foothills of my homeland. A matriarchal culture, the Rana Tharu foster a beautiful, giving community, building their entire livelihood with a strong-willed disposition and their very own hands. With grace and loyalty toward their sacred bonds, the Tharu women are resourceful artists with respect for their land. Though peaceful in nature, the Tharu foster a strong visual identity by honoring the traditionally vibrant attire, which in turn creates a quiet resistance and ever-powerful stance.

We celebrated this craftmanship and joined with modern female artisans in Nepal to hand-embroider organic cotton and hand-dip tie-dye cashmere knits. The ease of cargo, jersey, and denim was met with feather embroidery and hand-pleated chiffon, providing our modern muse with a myriad of choices that celebrate her femininity. Urban cities and traditional cultures inspired the colorful, bold, and eclectic spirit of the collection, dedicated to those explorative and kindred souls who wish to represent their individuality and truths.

In our modern world and current political climate, together we have created a significant social and cultural shift where traditional roles, genders, and identifiers are breaking down. The models came together on this show's runway from over thirty-five countries around the globe, walking with purpose and poise, chosen to represent a piece of our world—one where all of humanity reigns. And amid a time of uncertainty, we continue to build on the power of inclusivity. With this, we introduced our first menswear collection—a melding of our Eastern heritage with the sensibility of urban street culture and an appreciation for Savile Row techniques.

The show closed with a finale of Atelier Prabal Gurung gowns in bright hues of peridot, rhododendron, and cobalt. Made of rich duchesse satins and lush silk failles, they were handcrafted with couture ideals that speak to the bespoke essence. The collection was complemented by Tasaki Atelier earrings, created in Tokyo with the highest-quality stones and pearls from the Tasaki Pearl Farm in Nagasaki.

Our Prabal Gurung world is one of compassion, acceptance, bravery, and conviction, and we hope you create the same for yourself.

OPPOSITE: THE MOOD BOARD WITH INSPIRATION FOR THE SPRING 2019 COLLECTION, A VISION THAT BEGINS WITH THE RANA THARU TRIBE.

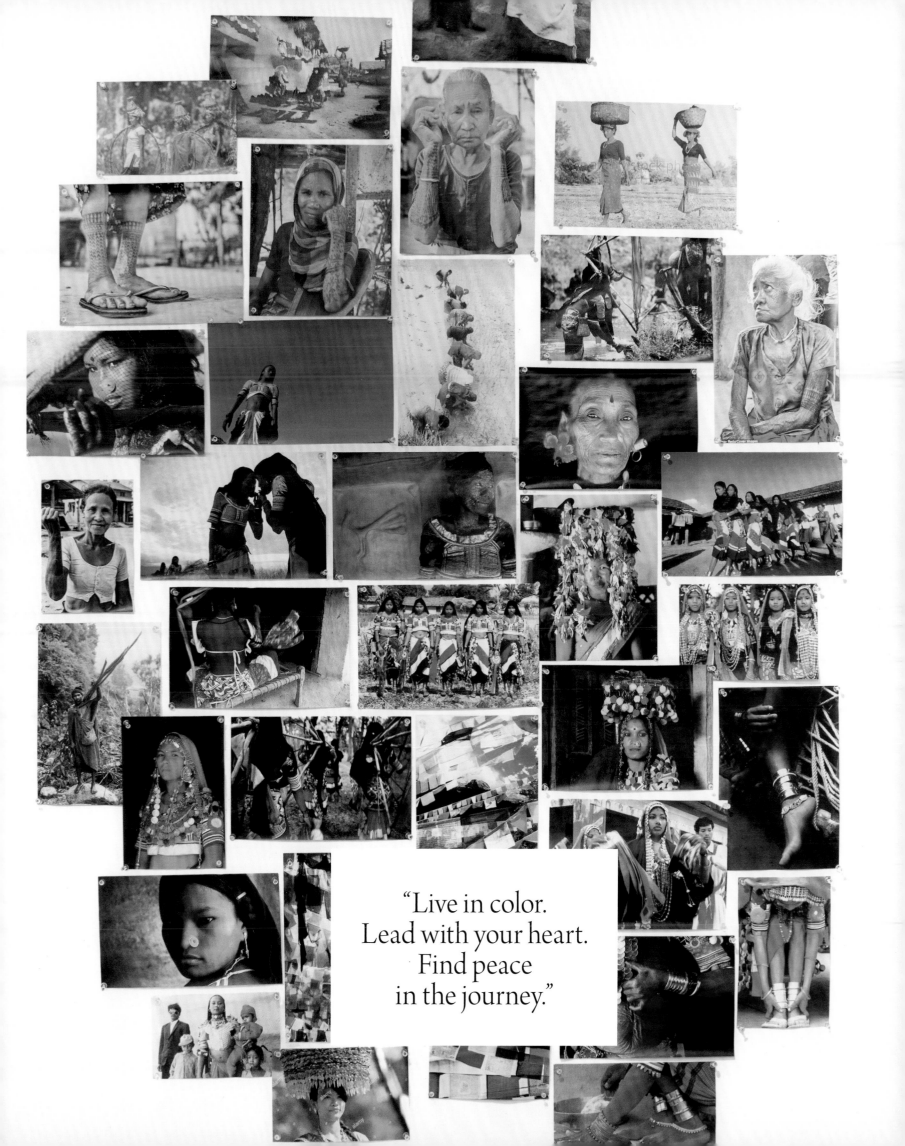

"Live in color.
Lead with your heart.
Find peace
in the journey."

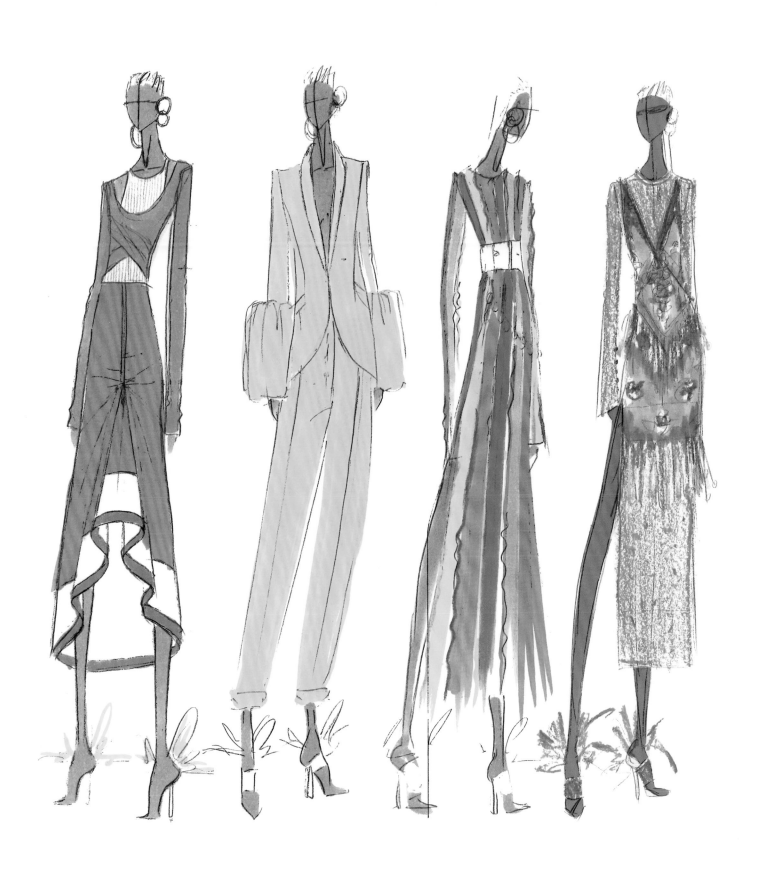

ABOVE: SKETCHES FROM THE SPRING 2019 COLLECTION.

OPPOSITE: A FLUORESCENT FEATHER DETAIL.

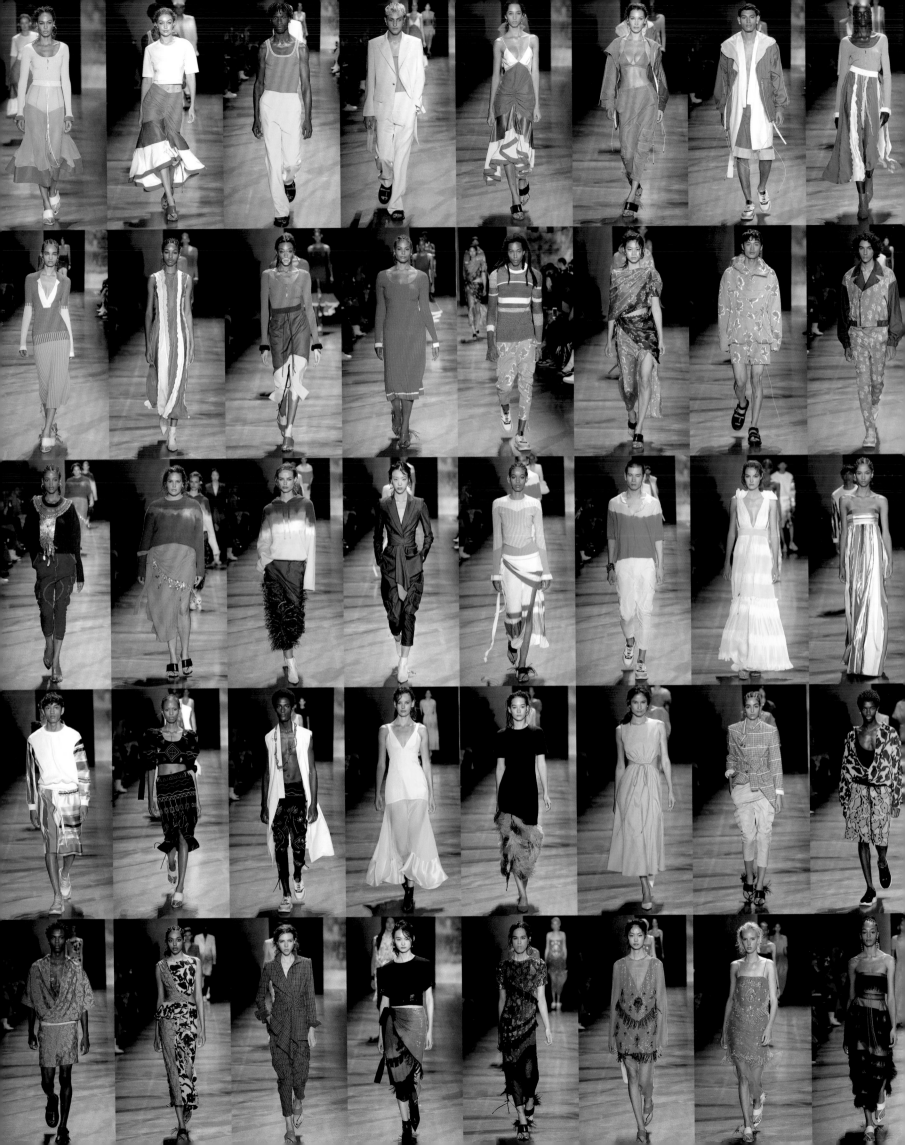

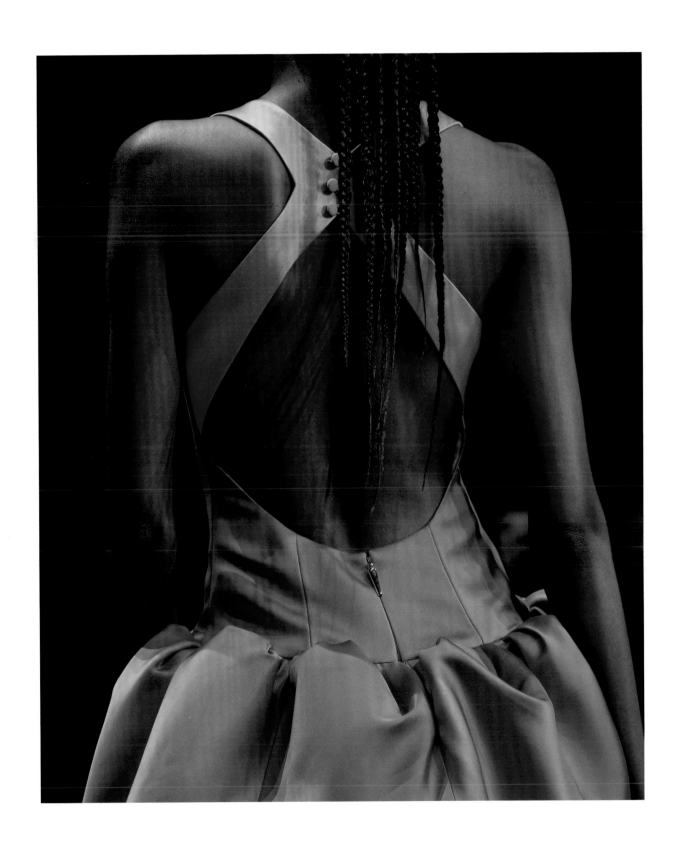

ABOVE: TAMI WILLIAMS CLOSES THE SPRING 2019 SHOW.

FOLLOWING SPREAD: THE FINALE, A BEAUTIFUL AND OPTIMISTIC
MÉLANGE OF COLOR AND TEXTURE.

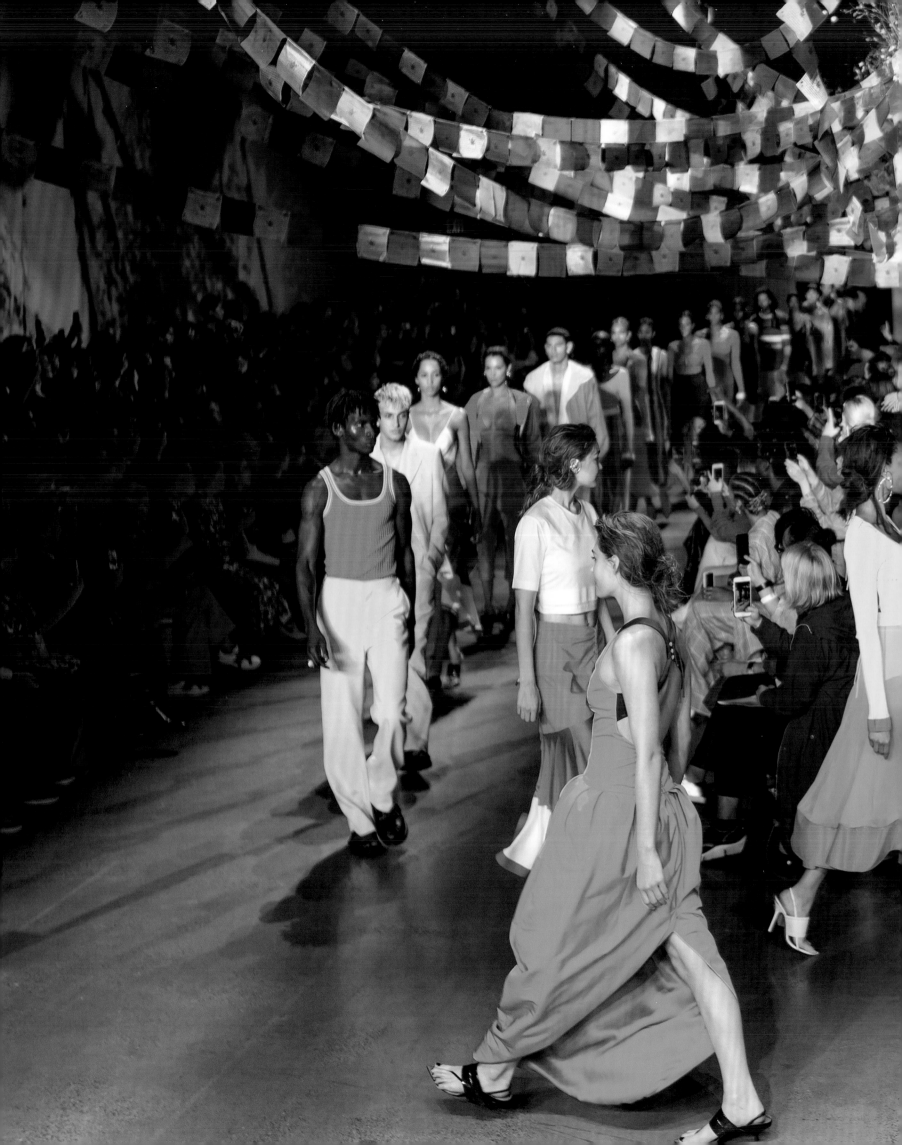

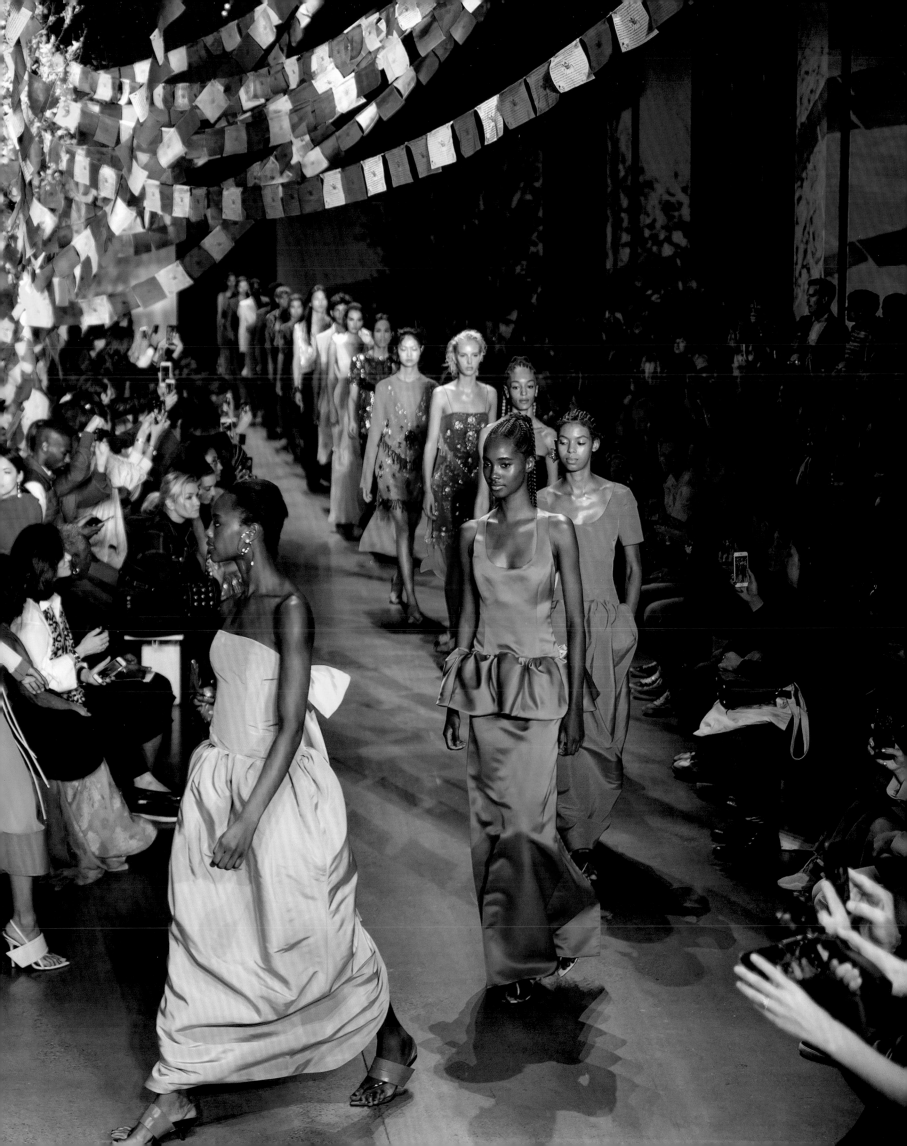

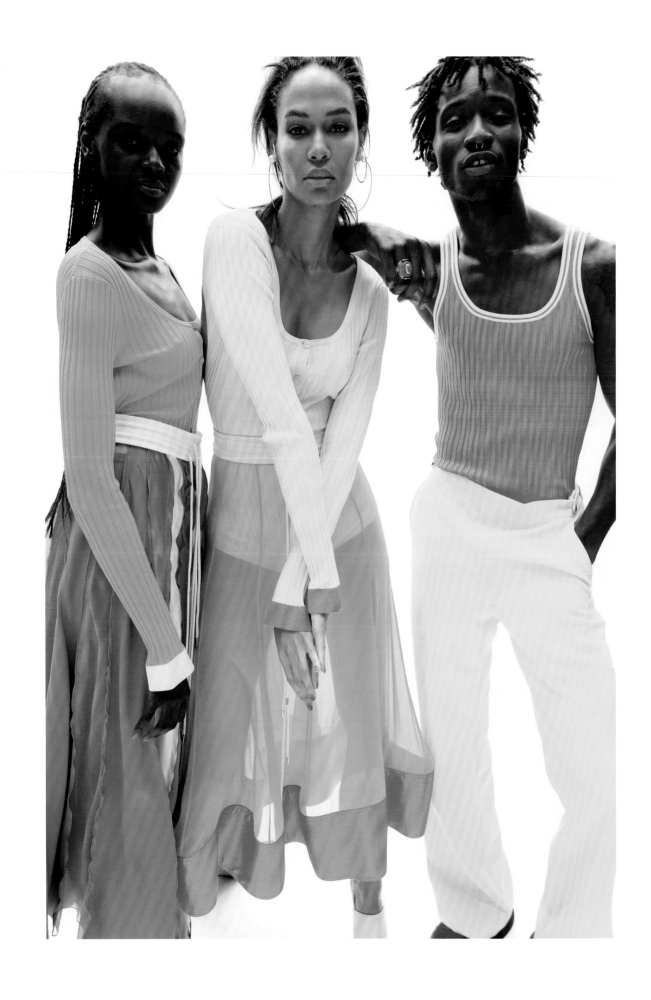

THE MODELS FROM OUR SHOW REPRESENTED MORE THAN THIRTY-FIVE COUNTRIES,
SHOWING THAT WE ARE STRONGER IN COLOR.

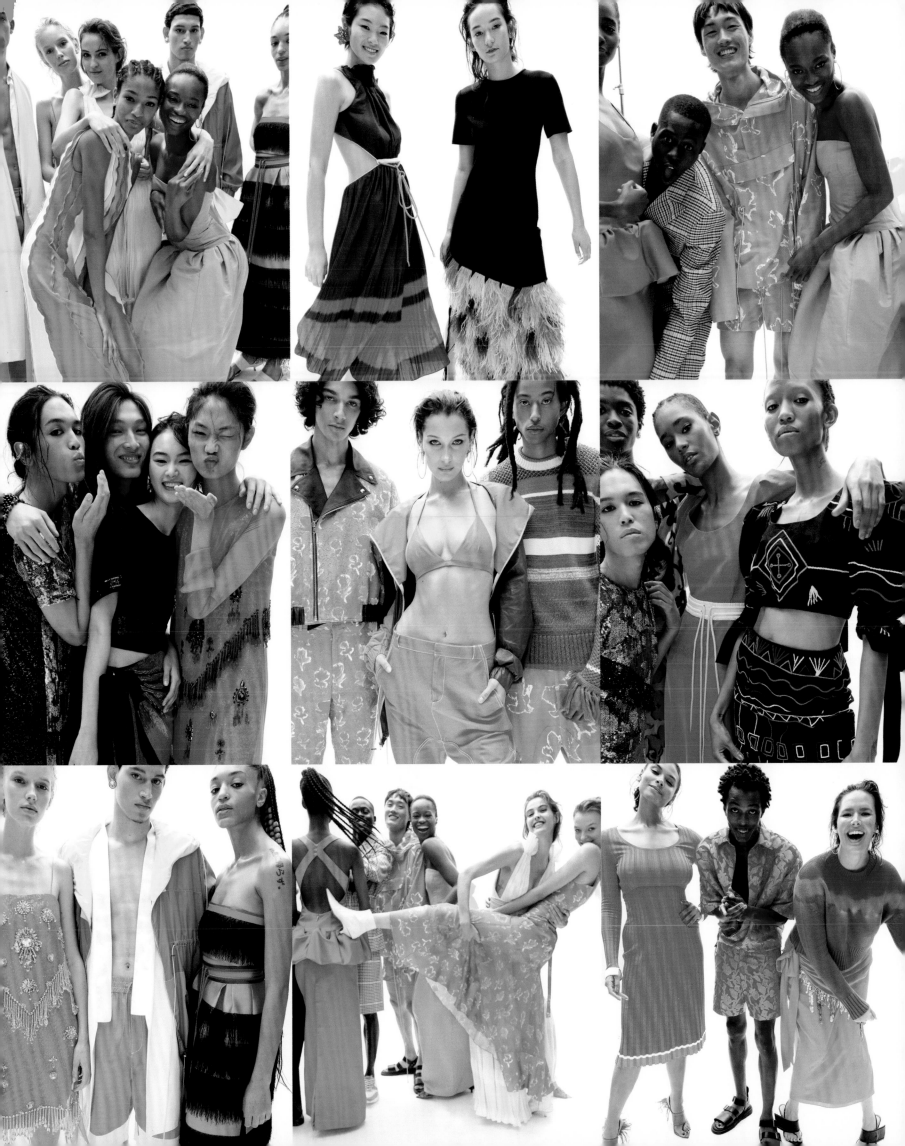

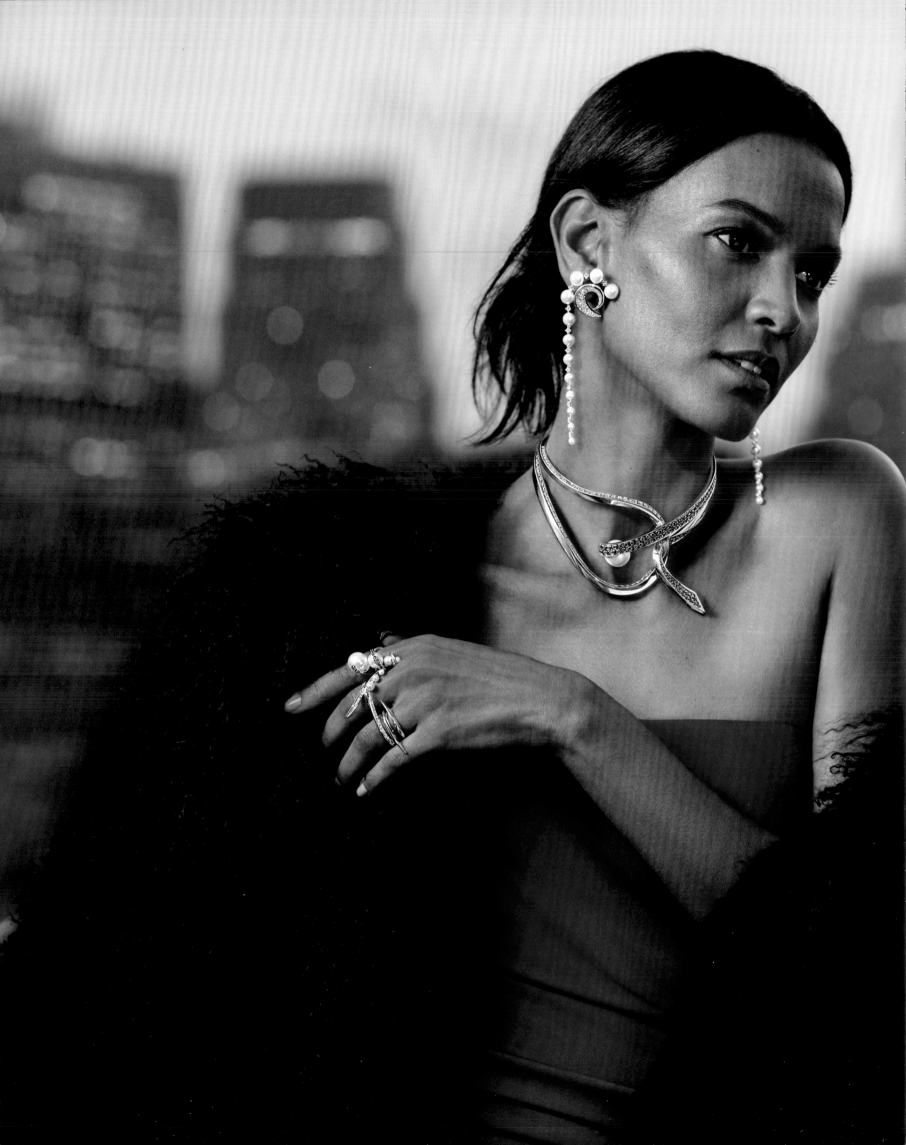

The Power of a Pearl

In 2017, I was appointed creative director of Tasaki, a high-end jewelry brand based in Tokyo. Tasaki jewelry is made of the highest-quality pearls and stones and uses sustainable and ethical production methods. Their precision and level of detail are unrivaled. We shot our first campaign together with the inimitable supermodel Liya Kebede. I was excited to work with Liya—she is such a beautiful global citizen of the world, representing both our and the Tasaki brand ideals. For so long, jewelry has shown a narrow standard of beauty, and been accessible to only a few. With Tasaki, I wanted to push these boundaries, to defy convention in an effort to change the way jewelry is presented. Liya was the perfect muse to embody this mentality. I am grateful to have a partner like Tasaki, who shares in our ethos of creating a more diverse, more representative and more inclusive world.

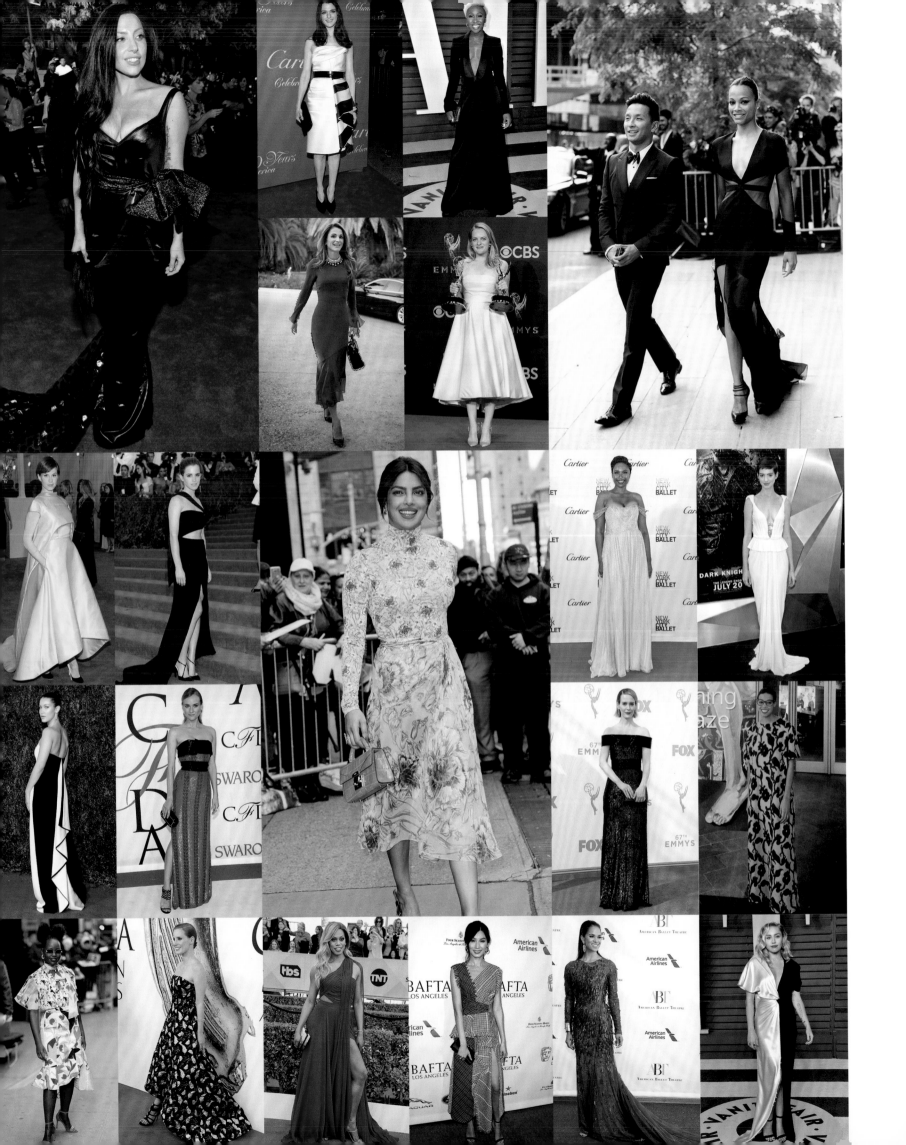

On the Red Carpet

This is our Prabal Gurung world—a global, diverse, representative, inclusive place that is complete with the beautiful, poised, intelligent, graceful, and passionate women who inspire me so deeply. I feel deep gratitude to be able to stand with such strong women in the special moments of their lives and so appreciate the way these incredible muses have shared their platform with me to highlight what we do. I founded the brand on the ethos of celebrating women in all forms. Nothing brings me joy like seeing these talented trailblazers wearing my designs. I am humbled; I am yours, with love.

OPPOSITE

First row: Lady Gaga, Rachel Weisz, Cynthia Erivo, Queen Rania of Jordan, Elisabeth Moss, Zoe Saldana

Second row: Elettra Wiedemann, Emma Watson, Priyanka Chopra, Jennifer Hudson, Anne Hathaway

Third row: Bella Hadid, Diane Kruger, Sarah Paulson, Jordan Casteel

Fourth row: Lupita Nyong'o, Jessica Chastain, Laverne Cox, Gemma Chan, Misty Copeland, Miley Cyrus

PAGE 266

First row: Faye Dunaway, Caroline Issa, Kerry Washington, Gwyneth Paltrow, Mj Rodriguez, Eva Chen

Second row: Jennifer Lawrence, Issa Rae, Greta Gerwig, Kristen Stewart, Rupi Kaur

Third row: Alicia Vikander, Amy Schumer, Sarah Jessica Parker, Nell Diamond, Hailee Steinfeld

Fourth row: Cleo Wade, Tiffany Haddish, Katherine Langford, Mindy Kaling, Rooney Mara

PAGE 267

First row: Ashley Graham, Shea Marie, Caroline Vreeland, Bryanboy, Tina Craig, Irene Kim, Aimee Song, Chriselle Lim, Amanda Seyfried, Kate Hudson, Lauren Santo Domingo, Janet Mock, Cate Blanchett

Second row: Cate Blanchett, Gigi Hadid, Katrina Kaif, Sandra Bullock, Allison Janney, Solange

Third row: Thandie Newton, Indré Rockefeller, Tracee Ellis Ross, Alia Bhatt

Fourth row: Tina Fey, Gal Gadot, Noor Tagouri, Goldie Hawn, Isha Ambani

PAGE 268

First row: Elaine Welteroth, Kate Bosworth, Jaime King, Barbara Bush, Radhika Jones, Constance Wu

Second row: Sandra Oh, Margot Robbie, Camila Mendes, Reese Witherspoon, Julianne Moore

Third row: Lindsay Peoples Wagner, Awkwafina, Mia Moretti

Fourth row: Jiang Yiyan, Emily Blunt, Amy Adams, Michelle Lee, Maggie Betts, Olivia Wilde

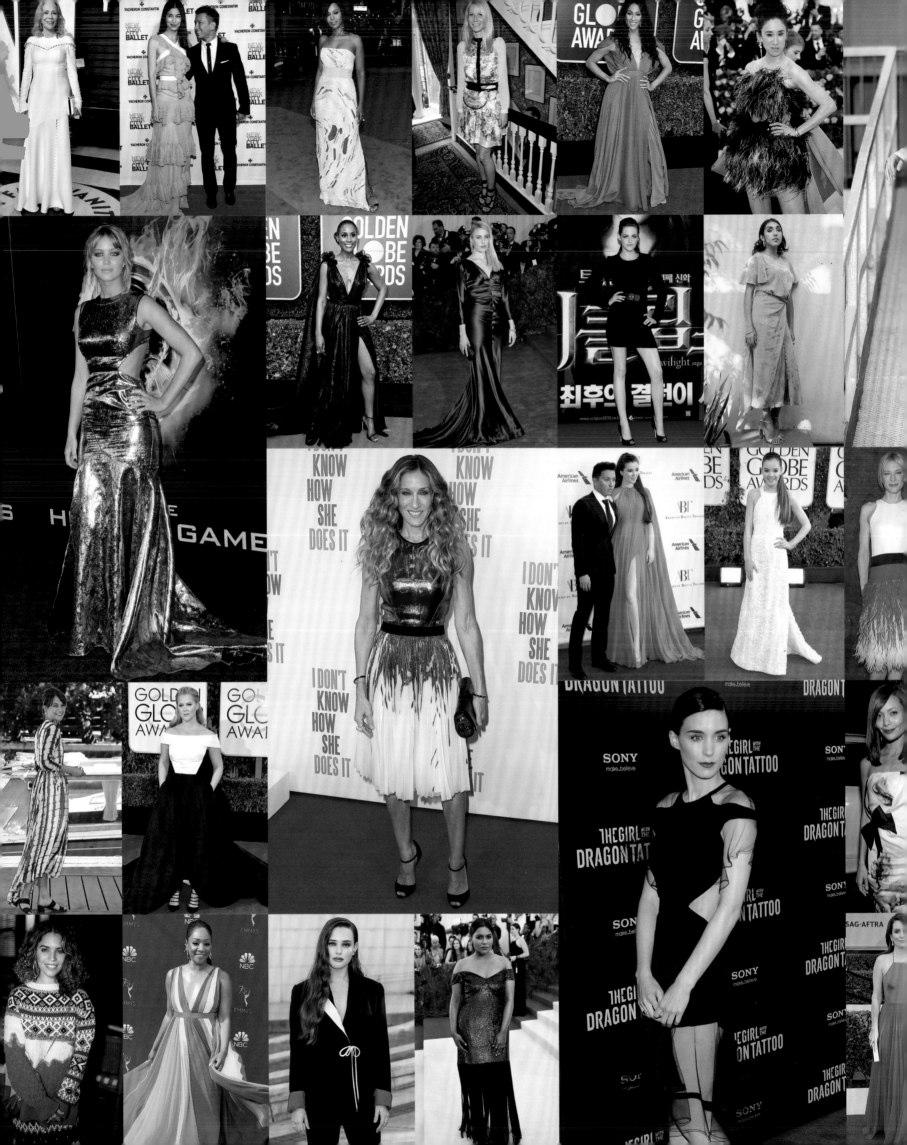

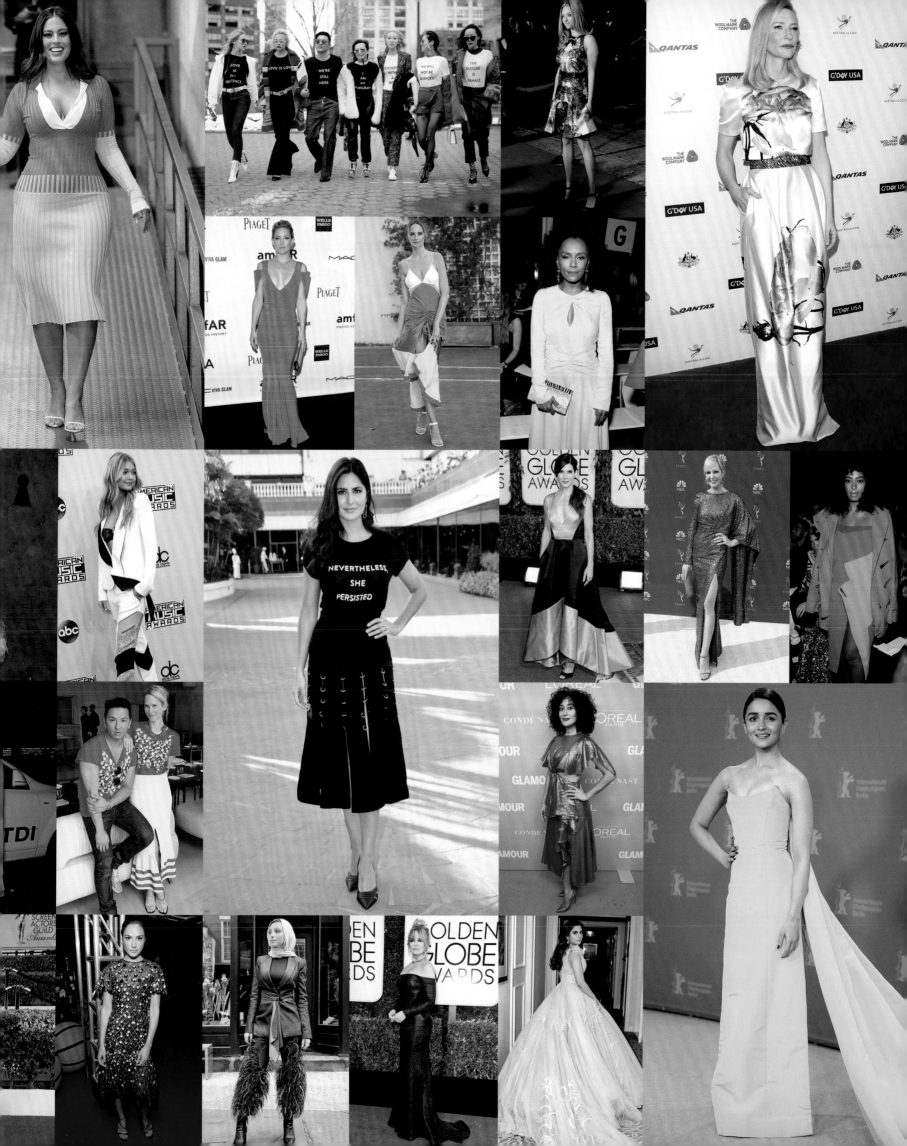

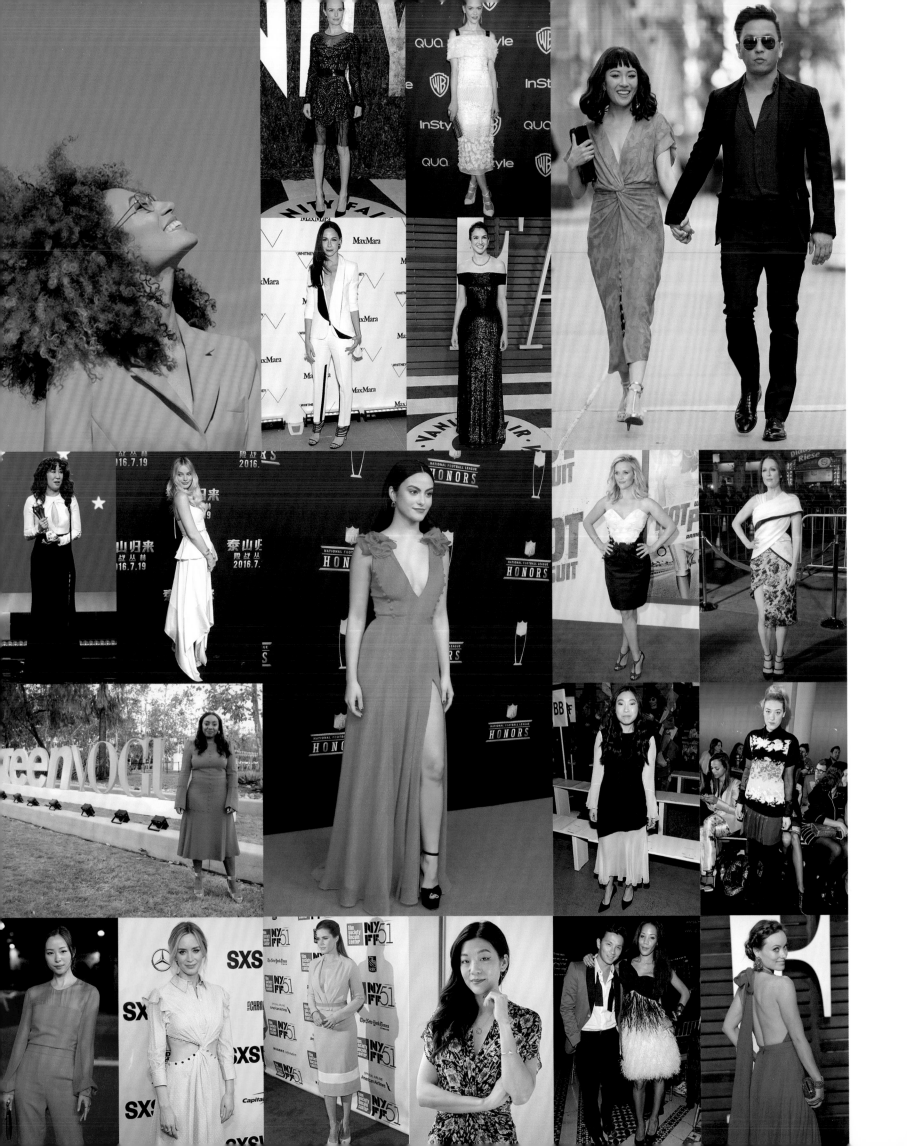

Photo Credits

Photography by Nicholas Alan Cope: 22, 39, 52, 73, 94, 113, 122, 155, 176, 197, 224

Courtesy of Prabal Gurung: 1, 12 (second row, left/middle column, rows one through four; third column, second row; third row, right; fourth row, left), 13 (third row, left/third row, middle/fifth row), 25, 26–27 (background), 31, 33, 35, 40, 43, 47, 51, 55, 57 (background), 58 (background), 65, 71, 75, 76, 77, 87, 92 (background), 108, 111, 121, 126, 141, 150, 161, 166, 174, 185, 211, 212, 214, 229, 255

Camilla Akrans / AUGUST: 138–139

Moeez Ali: 8, 213, 215, 217, 231, 234–235

Neilson Barnard / Getty Images Entertainment: 209

Kelsey Bennett: 80–81, 84, 88–89, 97, 101, 107

Larry Busacca / Getty Images Entertainment: 62, 63, 140

George Chinsee / WWD: 28

Matthew Craig / Blink Media / Skylight Moynihan Station: 132–133

Caroline Cuse: 247 (bottom right), 253, 254

Kashish Das Shrestha / Das Photos Kathmandu est. 1960: 6, 12 (top right), 13 (top left / second row, middle / second row, right), 98–99

Kashish Das Shrestha / Das Studio est. 1927: 12, (bottom right) 13 (third row, right)

James Devaney / GC Images: 219

REUTERS/Jonathan Ernst: 36–37

Courtesy of Filmfare: 221

Seiji Fujimori: 27

Alyssa Greenberg: 170–171, 190–191, 199, 200–201, 205

Andrew Harnik / Associated Press: 194–195

Taylor Hill / Getty Images Entertainment: 250–251

Chris Jackson / Chris Jackson Collection: 70

Daniel Jackson / Art + Commerce: 56, 68–69, 92, 93, 104, 105, 118, 119, 134, 135, 152, 153, 164, 165

Mikael Jansson / Trunk Archive: 137

Taylor Jewell / Getty Images Entertainment: 244–245

Jin and Dana: 242, 243

Kailas / The Licensing Project: 208

Dimitrios Kambouris / Getty Images Entertainment: 206–207

Kishor Kayastha: 4–5, 12 (top left / bottom left), 13 (fourth row)

Daniel King / Home Agency: 50

Dan & Corina Lecca: 112, 130–131, 148–149, 160, 162–163, 172–173, 180–181, 192–193, 202–203, 204, 216, 232–233, 236–237, 238–239, 256

Dennis Leupold / ADB Agency: 240–241

Olivia Locher: 168, 169

Christian MacDonald / Trunk Archive: 110

Julian Mackler / BFA.com: 184

Silja Magg: 183

Jamie McCarthy / Getty Images Entertainment: 120

Lewis Mirrett: 2, 125, 127, 128–129, 136, 142, 146, 151, 157, 158–159, 187

Tom Munro / 2b Management: 82–83

Hans Neumann: 246, 247 (top left / top right / bottom left), 248–249

Courtesy of O, The Oprah Magazine: 30

Josh Olins / Trunk Archive: 262–263

Kate Owen: 144–145, 147

Kyla Rae Polanco: 260, 261

David X Prutting / BFA.com: 175

Bikas Rauniar 13 (top right)

Sandra Semburg: 222–223

Sarahana Shrestha: 114–115, 116–117

Michael Stewart: 227, 258–259

Kevin Sturman: 29, 34, 42, 48–49, 57 (runway), 58 (runway), 60–61, 66, 67, 78, 79, 86, 90–91, 100, 102–103

Sølve Sundsbø / Art + Commerce: 45

Courtesy of Hailee Steinfeld / By Katia Tempkin: 247 (bottom row, middle)

Elias Tahan: 247 (top row, middle)

Photography © Terra Foundation for American Art, Chicago: 59

Courtesy of TOMS: 12 (third row, left / fourth row, second and third images from left)

Marcus Tondo: 257

Joanna Totolici: 179, 182, 188, 189, 218, 228, 230

Courtesy of Vogue India / Photograph by Prasad Naik: 106

PAGE 265

First row: Kevin Mazur/WireImage for MTV, Bryan Bedder/Getty Images, Alberto E. Rodriguez/WireImage, courtesy of Queen Rania Abdulla, Jason LaVeris/FilmMagic, courtesy of Jamie Beck for CFDA

Second row: Dimitrios Kambouris/Getty Images, Rabbani and Solimene Photography/WireImage, Gotham/GC Images, Gilbert Carrasquillo/FilmMagic, Jim Spellman/WireImage

Third row: D Dipasupil/FilmMagic, Rabbani and Solimene Photography/WireImage, Axelle/Bauer-Griffin/FilmMagic, courtesy of Jordan Casteel

Fourth row: Jackson Lee/GC Images, Clint Spaulding/Patrick McMullen via Getty Images, Frank Trapper/Corbis via Getty Images, Steve Granitz/WireImage, Rabbani and Solimene Photography/Getty Images, Axelle/Bauer-Griffin/FilmMagic

PAGE 266

First row: Pascal Le Segretain/Getty Images, Monica Schipper/Getty Images, Nicholas Hunt/Getty Images, David M. Benett/Getty Images, David Crotty/Patrick McMullen via Getty Images, Dimitrios Kambouris/Getty Images for the Met Museum/Vogue

Second row: Albert L. Ortega/WireImage, Frazer Harrison/Getty Images, Larry Busacca/Getty Images, Han Myung-Gu/WireImage, courtesy of Rupi Kaur

Third row: Jacopo Raule/GC Images, John Shearer/Getty Images, Scott Barbour/Getty Images, Randy Brooke/WireImage, George Pimentel/Getty Images

Fourth row: Michael Stewart/WireImage, Steve Granitz/WireImage, Gilbert Carrasquillo/GC Images, Theo Wargo/Getty Images for US Weekly, Larry Busacca/Getty Images

PAGE 267

First row: Gotham/GC Images, Matthew Sperzel/Getty Images, Frazer Harrison/Getty Images, Alberto E. Rodriguez/Getty Images, courtesy of Lauren Santo Domingo, Andrew Toth/Getty Images for New York Fashion Week: The Shows, Paul Archuleta/FilmMagic

Second row: Delphine Achard, David Livingston/Getty Images, Azhar Khan/SOPA Images/LightRocket via Getty Images, Jason Merritt/Getty Images, Steve Granitz/WireImage, Astrid Stawiarz/Getty Images for NYFW: The Shows

Third row: Kevin Parry/WireImage, courtesy of Indre Rockefeller, Dimitrios Kambouris/Getty Images for Glamour, Andreas Rentz/Getty Images

Fourth row: Gregg DeGuire/WireImage, Matt Winkelmeyer/MTV1617/Getty Images for MTV, courtesy of Noor Tagouri, Frazer Harrison/Getty Images, Lena Melnik

PAGE 268

First row: Gotham/Getty Images, Pascal Le Segretain/Getty Images, Gregg DeGuire/WireImage, Jamie McCarthy/Getty Images for Max Mara, Jon Kopaloff/WireImage, courtesy of Elaine Welteroth

Second row: Kevin Winter/Getty Images, VCG/Getty Images, Rich Graessle/Icon Sportswire via Getty Images, Jon Kopaloff/FilmMagic, Gregg DeGuire/WireImage

Third row: Alison Buck/Getty Images for *Teen Vogue*, Jamie McCarthy/Getty Images, Amy Sussman/Getty Images

Fourth row: Elisabetta A. Villa/WireImage, Gary Miller/FilmMagic, Lars Niki/Corbis via Getty Images, courtesy of Michelle Lee, Billy Farrell/Patrick McMullan via Getty Images, Karwai Tang/WireImage

Acknowledgments

Gratitude—an immeasurable amount—is what I feel every time I reflect on my life and especially on my decade-long career. I believe I am the product of love, faith, and support from so many people, especially a lot of women and a few good men. For that and more, I want to thank the following people who've made this book and my dream a possibility.

Caitlin DiStefano, for believing in my dreams and being willing to jump on this crazy ride for almost a decade. Thank you for your endless patience, loyalty, and friendship. I couldn't have done this without you.

SJP, I can't help but wonder what my life would be if I never met you. I am forever grateful for your love, loyalty, support, and friendship. You, my friend, show up for me every time. I hope I do that for you as well. For that and more, my heartfelt gratitude.

Hanya Yanagihara, your friendship, love, and compassion and your advocacy for minorities through your work are not only impactful but immensely inspiring. I am forever grateful for our friendship and mind-bending conversations over momos.

Everyone at Abrams, especially Sarah Massey, who believed that my story was worthy of being told and for making this book come to life.

Tenzin Wild and Magnus Berger, thank you for your critical eyes. Your partnership means the world to me, and this is just the beginning.

Shaun Beyen, for your help, guidance, and friendship.

Lauren Cooper, for your endless passion and vigor. This book may be my labor of love, but this is your blood, sweat, and tears. It wouldn't have been possible without you. Thank you.

Anna Wintour, for allowing me to be my own person and for your support, advice, and honest opinions. I am eternally grateful.

Michelle Obama, for making my American Dream come true. Your love and support over the years have meant a lot to me, and your fiftieth birthday was the best dance party I've ever been to.

Oprah Winfrey, for inspiring me to live my dreams.

Caroline Brown, for your mentorship, friendship, and pragmatism. I am immensely grateful.

My mentors Carolina Herrera, CFDA, especially Steven Kolb and Lisa Smilor, Cynthia Rowley, Daniella Vitale, Domenico De Sole, DVF, Ed Filipowski, John Demsey, Mark Lee, Paula Sutter, Tommy Hilfiger, and Wen Zou, for your invaluable advice. To all our retail partners, factories, editors, stylists, reviewers, models, agencies, musicians, producers, hair and makeup team, backstage production team, and creative individuals who have shown so much faith and support, thank you.

To my PG team members, from each department, past and present, who have worked *with* me and not *for* me, thank you. It would take me pages to fully express my gratitude—I wouldn't have come this far without your beliefs and relentless hard work.

Tyler Rose, for helping me start the journey of my brand; Jin Kay, for balancing it; and especially Michael Creegan, for allowing a rebirth of the design department, breathing life into it, and being the best collaborator and my biggest support, thank you. Antonio Azzuolo, for bringing our menswear vision to life, Thomas Chen, and the whole design team, our hardworking interns; I am immensely grateful to all of you.

Tiina Laakkonen, for the magic you helped me create for the first few years. For your belief in me before the world had any faith. Thank you for your love, support, and friendship.

To my Tasaki family, thank you for these amazing few years. The pearls of wisdom are invaluable.

The pillars of our foundation, Shikshya Foundation Nepal: Rati Shah, Riva Thapa, Rupali Golcha, Kumudini Shrestha, and Pravesh Gurung, for relentless passion and empathy. I am so thankful for your love for the cause and the children.

To all the celebrities—actors, singers, politicians, leaders, creative forces, and their incredible style architects—thank you for all these years of love and support.

To all the models who graced our shows and campaigns, worked with us for our lookbooks, and beyond—thank you for bringing the vision to life: Amanda Murphy, Ashley Graham, Bella Hadid, Candice Swanepoel, Caroline Trentini, Ellen Rosa, Gigi Hadid, Joan Smalls, Karlie Kloss, Liu Wen, Liya Kebede, Ming Xi, Rosie Huntington Whiteley, Taylor Hill, and Varsha Thapa, for your relentless support through the years.

To my friends, colleagues from the industry, and beyond, thank you for impacting my journey for the past decade. Wish I had many pages to thank each and every one of you, so my sincerest apologies if I miss someone: 4AM, A Models Amsterdam, Ade Samuel, Aeri Yun, Alex Harrington, Alex White, Alia Bhatt, Alyssa Greenberg, Ami Sehmi, Andrew Shang, Andrew Serrano, Annabelle Harron, Anne Slowey, Anthony Turner, APM, Art Department, Art Partner, Art & Commerce, Aurora

James, Bandana Tewari, Barbara Berman, Baron & Baron, Bethann Hardison, Bing Chen, Bon Duke, Booth Moore, Brad Goreski, Bridget Foley, Brigette Kolson, Bryan Bantry, Bryan Boy, Calypso Lawrence, Caroline Cuse, Caroline Issa, Cathy Horyn, Charlotte Tilbury, Chris Habana, Claire Richardson, Cindi Levie, Cleo Wade, Creative Exchange Agency, Cristina Ehrlich, Dan Jackson, Dan and Corina Lecca, Dan Martensen, Danielle Nachmani, David Moran, Dao Yi Chow, Darpan Udas, David Bonnouvrier, Deena Aljuhani Abdulaziz, Demi Moore, Deepika Padukone, Diane Kendal, Diana Balcanu, Diane Kruger, Didier Malige, DNA, Dominic Kaffka, Edward Enninful, Elaine Welteroth, Elettra Wiedemann, Elin Svahn, Elizabeth Saltzman, Elizabeth Stewart, Elizabeth Von Der Goltz, Emmanuel Barbault, Elite, Eric McNeal, Eric Wilson, Erica Cloud, Erin Walsh, Etienne Russo, Eva Chen, Exposure Model Management, Ezra Williams, Eyesight, Fabricio Cardenas, Ford, Frederic Sanchez, Fusion, George Fountas, Glenda Bailey, Hampton Carney, Hans Neumann, Heroes, Home Agency, Hilary Leroux, Huma Abedin, Identity Models, IMG, Indre Rockefeller, Inez and Vinoodh, Ikram Goldman, Ilaria Urbinati, Isha Ambani, Ivan Bart, James Scully, Jane Kim, Jason Bolden, Jason Rembert, Jeanann Williams, Jennifer Diamond, Jennifer Sunwoo, Jessica Paster, Jessie Betts, Jill Lincoln and Jordan Johnson, Jin + Dana, Jimmy Paul, Jin Soon Choi, John Pfeiffer, Joe Mangrum, Joanna Totolici, Joe Zee, Julia Von Boehm, Julian Watson Agency, Kate Young, Ken Downing, Kevin Sturman, Kevin Tachman, Karen Kaiser, Karla Welch, KCD, Kelsey Bennett, Kim Hasteriter, Koel Purie, Kyla Rae Polanco, Lauren Santo Domingo, Law Roach, Leslie Fremar, Lewis Mirrett, Linda Fargo, Lindsay Peoples Wagner, Long Nguyen, Lynn Yeager, MAC, Madeline Boutelle, Maida Boina, Major, Management + Artists, Margarita Dalisay, Mark de Paola, Mark Holgate, Maria Lemos, Mariel Haenn, Marilyn, Marina Larroude, MC2, Meredith Koop, Meredith Melling, Mia Moretti, Micaela Erlanger, Micah McDonald, Micah Schifman, Michael Stewart, Michelle Lee, Michelle Lee Casting, Mickey Boardman, Miguel Enamorado, Moeez Ali, Monique Pean, Muse Model Management, Nancy Rogers, Nasiba Adlova, Natasha Poonawala, New York Models, Next, NiCE, Nicholas Mellamphy, Nicky Yates, Nicole Phelps, Odile Gilbert, One, One Kick, Paola Corso, Pascal Dangin, Paul Hanlon, Paul Wilmot, Penny Lovell, Petra Flannery, Phillip Picardi, Phillip Lim, Philip Price Fry, Priyanka Chopra, Philip Treacy, Piergiorgio Del Moro, Rachel Zoe, Radhika Jones, Rachna Shah, Rebecca Corbin Murray, Red Model Management, Red Scout, Rob Zangardi, Robin Givhan, Ricki De Sole, Roopal Patel, Rosemary Fietelberg, Sally Singer, Samantha Kain, Samantha McMillen, Sandra Amadour, Sarah Harris, Sara Moonves, Sebastian Perrin, Shaun Beyen, Silent, Skylight, Soul Artist, St. Claire's, State, Stella Greenspan, Stella Kim, Stevie Hyun, Streeters, Supreme, Susan Plageman, Tala Yasseri, Tara Swennen, Tarana Burke, Taylor Martin, The Ground Crew, The Identity, The Industry, The Lions, The Society, The Wall Group, Thierry Dreyfus, Thomas Carter Phillips, Thomas Kikis, Tina Craig, Tina Leung, Tom Eerebout, Tom Van Dorpe, Trey Laird, Trouble Management, Two Management, Tyler McCall, Ulrich Knoblach, Yumi Shin, Vanessa Barbosa, Villa Eugenie, Virginia Smith, VNY, Wayman Bannerman, Wendi and Nicole Ferreira, Wilhelmina, Women 360, Women, Zoe Saldana.

To BONY—Barbara Bush, Danny Shea, Isabel Wilkinson, Kyle Hotchkiss Carone, and Nell Diamond for the love and laughter. Maggie Betts, for your friendship, love, and inspiring conversations. David Yassky, Mike Andrus, and Sam Spector, for your support, especially with the production of my first two collections from your apartments. I will always cherish those moments. Adam Shapiro, Jeff Trosch, Shaun Lee Lewis, and Yuki James, for your endless love, support, friendship, and sista-hood. My dearest friend Damien Nunes, for your quiet strength, support, and pragmatism, for being able to put up with me and always being able to see me. Thank you, I am grateful for our for twenty years of friendship. Karan Johar, thank you for your love, wisdom, humor, and, above all, friendship, which means the world to me. Deep SJB Rana, who accepted and celebrated me since we were kids. Thank you.

To my father, for teaching me the importance of forgiveness.
 Rajesh Lal Shrestha, for believing in me and seeing my potential before anyone else.
 Paul, I had given up on love until you came along. Thank you for showing me what love truly is. I love you.
 My niece, Vaidehi, and nephew, Arhant, you have shown me what hope looks like and I love you two with all my heart.
 To my mother, Durga Rana, for always being my rock, for your endless love and belief in me. For always seeing me and allowing me to be myself. Thank you. I love you.
 To my sister, Kumudini, and my brother, Pravesh, my moral compass, my integrity barometers, I wouldn't have made it this far if I didn't have you two. You are my lifeline and my best friends. I love you both with all my heart.

To all the women and men, whom I don't know personally yet have supported me in this journey, whether by wearing my clothes—buying, renting or borrowing them—or through the countless words of encouragement you have shared via emails, tweets, and DMs, or perhaps a silent prayer you sent my way. I feel you, I feel the love, I feel the energy. For that, for seeing me: I thank you. From the bottom of my heart, from every ounce of my being.

PAGE 1: A HAND-PAINTED NEPALESE BRUSHSTROKE, A SPIRITUAL PRINT FROM THE SPRING 2016 COLLECTION.

PAGE 2: A STRIKING RED MOMENT, ONE OF OUR SIGNATURE COLORS, ON THE FALL 2014 RUNWAY.

PAGES 4–5: AN ABSTRACTED PHOTOGRAPH OF NEPAL'S STRIKING LANDSCAPE.

PAGE 6: A SPIRITUAL TEMPLE IN NEPAL. THIS IMAGE SO BEAUTIFULLY CAPTURES THE SPIRIT OF MY HOMELAND.

PAGE 8: A DETAIL OF THE HAND-EMBROIDERED IKAT SKIRT FROM THE FALL 2018 COLLECTION.

PAGES 12–13: NEPAL HOLDS SO MANY MEMORIES—OF MY FAMILY, THE RICH LANDSCAPE, MY FOUNDATION.

Editor: Sarah Massey
Art Direction and Design: Magnus Berger & Tenzin Wild for The Last Universe
Production Manager: Anet Sirna-Bruder
Cover and chapter opener photography: Nicholas Alan Cope

Library of Congress Control Number: 2018958846

ISBN: 978-1-4197-3810-4
eISBN: 978-1-68335-664-6

Text copyright © 2019 Prabal Gurung

Cover © 2019 Abrams

Printed and bound in China
10 9 8 7 6 5 4 3 2 1

Abrams books are available at special discounts when purchased in quantity for premiums and promotions as well as fundraising or educational use. Special editions can also be created to specification. For details, contact specialsales@abramsbooks.com or the address below.

Abrams® is a registered trademark of Harry N. Abrams, Inc.

ABRAMS The Art of Books
195 Broadway, New York, NY 10007
abramsbooks.com